Early Maritime Artists
of the Pacific Northwest Coast

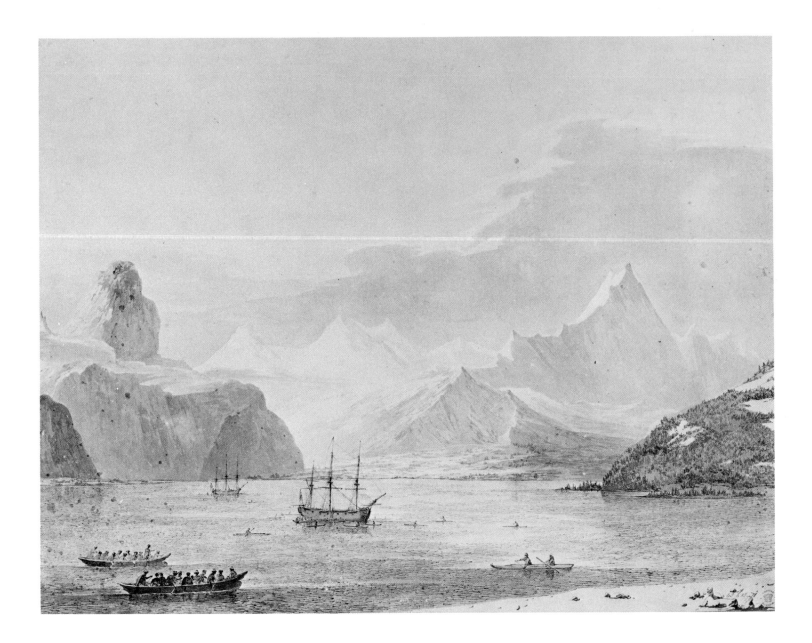

The Resolution *and Discovery* in Snug Corner [Cove], Prince William Sound, 1778

Drawing by John Webber; courtesy The British Library, Add MS 15514 f8.

Early Maritime Artists of the Pacific Northwest Coast, 1741–1841

JOHN FRAZIER HENRY

University of Washington Press *Seattle & London*

This book was published with the assistance of a grant from the
National Endowment for the Humanities.

Library of Congress Cataloging-in-Publication Data

Henry, John Frazier, 1908–
 Early maritime artists of the Pacific Northwest
Coast, 1741–1841.

 Bibliography: p.
 Includes index.
 1. Drawing—18th century. 2. Drawing—19th century.
3. Northwest Coast of North America in art. 4. Scien-
tific expeditions—Northwest Coast of North America—
Pictorial works. I. Title.
NC87.H46 1984 741′.092′2 83-23518
ISBN 0-295-96128-7

Preface

This book grew out of some twenty years of research into drawings and paintings depicting scenes of the Northwest Coast of North America, as seen by its first explorers and traders of the eighteenth century. I initially compiled a slide documentary on the works of these maritime artists for museums, historical societies, and other interested organizations, and wrote several articles for publication. These efforts then led me into the present work, of greater scope in both time and geographical area.

This book would not have been possible but for the gracious and efficient assistance of many individuals and institutions listed below:

In Australia: National Library of Australia, Canberra; Mitchell Library, of the State Library of New South Wales, Sydney.

In Canada: Richard A. Pierce, Queen's University, Kingston, Ontario, to whom I have an immense debt of gratitude, since without his offer of his great store of scholarly research and many publications on the Russian presence in America, I would have little of significance on that subject other than the published journals in this country; Pierce's colleague, L. A. Shur; Tomàs Bartroli, University of British Columbia; Douglas Cole of Simon Fraser University, who was exceptionally generous and helpful; Maurice Hodgson; Provincial Archives, Victoria, B.C.; Anne Yandle, Special Collections Division, University of British Columbia Library; Public Archives of Canada and Parks Canada, Ottawa.

In France: Admiral Maurice de Brossard, Brunoy; Archives Nationales, Archives de France, Bibliotheque Nationale, and Photographie Giraudon, all in Paris; Service Historique de la Marine, Vincennes.

In Great Britain: Lieutenant Commander A. C. F. David of the Hydrographic Department, Taunton, who has been exceedingly kind and helpful, not only with his detailed knowledge of the Vancouver material, but also in many other ways; M. L. Stebbins of the British Library, London, who has made special efforts in my behalf; Guildhall Library of the City of London; National Maritime Museum, Naval Historical Library, and Public Records Office, all in London; N. M. Plumley, librarian and archivist of Christ's Hospital in Sussex.

In Russia: Svetlana G. Fedorova, Moscow, whose excellent work on Russian America has been translated and edited by Richard A. Pierce and Alton S. Donnelly; Saltykov-Shchedrin State Public Library, Leningrad.

In Scotland: National Library of Scotland, Edinburgh.

In Spain: Mercedes Palau de Iglesias, Museo de America, Museo Naval, and Ministerio de Asuntos Exteriores, all in Madrid.

In Switzerland: Bernisches Historisches Museum, Bern.

In the United States: at the University of Washington in Seattle, and its Suzzallo Library, the very heart of this book was made possible through the exceptional help of then director Robert D. Monroe, and Dennis Andersen and Sandra Kroupa of the Historical Photography Collection; and of Andrew Johnson, Susan Cunningham, and Glenda Pearson of the Pacific Northwest Collection. Through their kindness, I was able to photograph many drawings in the collections of the UW Libraries, and, except where otherwise noted, the photographs in this book are mine. The current director, Carla Rickerson, has continued to provide generous assistance and cooperation.

v

I am grateful to Marino Kraabel, Slavic Section, Suzzallo Library, for her unstinting aid in Russian and French translation, and for biographical research; Paul Meyer, photographer, and other personnel of Instructional Media Services; Bill Holm, of the Thomas Burke Memorial Washington State Museum, who has encouraged and aided me in so many ways from the beginning; Eugene Kozloff, acting director, Zoology and Friday Harbor Laboratories; the staff of the *Alaska Journal*, Edmonds, Washington; Emily Blackmore, San Francisco; William M. Roberts of the Bancroft Library, University of California; Archibald Hanna of the Beinecke Library, Yale University; Donald C. Cutter, University of New Mexico, for making available the fruits of his excellent published material concerning the Spanish presence on the Northwest Coast; the Columbia River Maritime Museum, Astoria; the Concord Antiquarian Society; Clarence W. and Elizabeth DuBois; James R. Ellis, Bellevue, for his continuing encouragement; Iris H. W. Engstrand of the University of San Diego; Marjory B. Farquhar of Berkeley; Frick Reference Library, New York; the late Erna Gunther, for the considerable resources of her private library; Julius Gassner, University of Albuquerque, for help with La Pérouse; my brother Franklin M. Henry, of the University of California, for special services over and beyond the call of duty; John Howell Books, San Francisco; the late Robert Hitchman, Seattle, for the invaluable contact with Lieutenant Commander David; C. Jared Ingersoll for the John Boit portrait; Ann S. Lainhart of the New England Historic Genealogical Society, for special assistance in constructing a valid biography of George Davidson, for whom none has previously existed; the Library of Congress; Harry M. Majors of Seattle, who has rendered notable assistance; the Lilly Library, Indiana University; Massachusetts Historical Society, Boston; Paul Mellon Collection, Upperville, Virginia; Middlesex County Courthouse, Cambridge, Massachusetts; Murray Morgan of Auburn, Washington, who has been openhanded with encouragement and suggestions; Museum of New Mexico, Santa Fe; New Haven Colony Historical Society; Oregon Historical Society; Peabody Museum, Harvard University; Seattle Public Library; DeGolyer Library of Southern Methodist University, Dallas; Peabody Museum, Salem; Elmer E. Rasmuson and the National Bank of Alaska, Anchorage; Rasmuson Library, University of Alaska; Dorothy Jean Ray, Port Townsend, Washington; Gray H. Twombly, M.D., New York; University Press of Hawaii; James W. VanStone of the Field Museum of Natural History; Vicky Wyatt, for exceptional volunteer research in the Beinecke Library, Yale University.

And, finally, to my wife Jean, for her steadfast encouragement and belief in the value of this project, for unselfishly allowing me to utilize boundless time and energy, as well as some of our funds, to make it possible, I am deeply grateful.

Contents

Introduction

In the eighteenth and nineteenth centuries, venturesome men spent years surveying the coast of the Pacific Northwest, recording the region and its inhabitants, and sometimes making, or losing, fortunes in trade. The legacy of their adventures exists in their journal and logbook descriptions and in the drawings, paintings, and charts of the previously unrecorded coastline. This book presents scenes of the Northwest Coast of North America through the eyes of its first maritime explorers.

Had it not been for a four- to five-foot long, furry, amphibious creature of the Northwest Coast, this book might never have been written. To its great misfortune and near extinction, the sea otter (*Enhydra lutris*) was insulated against the frigid waters of the North Pacific by a deep, soft, lustrous brownish-black fur that was fated to arouse the greed of man.

Survivors of the Russian Bering voyage of 1741 along the Aleutian chain of islands to the American mainland brought home not only skins of the sea otter, but descriptions of islands whose beaches and waters teemed with these animals. The reports soon resulted in a great movement of Russian traders and hunters toward the North American coast, to harvest the riches of this fur.

Similarly, when reports of the value of sea otter skins sold in China by members of the Cook expedition reached the shrewd merchants of England and the United States, the result was a growing number of fur-trading vessels bound for the Northwest Coast to share in the newly discovered wealth. Later, the first Russian, English, and American traders were followed by official voyages of exploration and survey to establish claims of national sovereignty. Only the Spanish resisted the temptations of the fur trade in favor of saving souls and acquiring territory, while also engaged in making maps and investigating the coast.

The intrusion of the maritime traders was to have a profound and eventually negative effect on native cultures. In some areas their encroachment was at first vigorously repulsed; in others, the natives were dazzled by the opportunities to amass wealth in the form of firearms, metal tools, and articles of personal adornment, some as gifts. Less welcome gifts included the introduction of venereal disease and smallpox, with devastating results. Many tribes were exploited in varying degrees of harshness, as in the Aleutian Islands and on the Alaskan coast. Some maritime traders dealt fairly, according to their personal values, others murdered or robbed without hesitation.

The application of the term "Northwest Coast" to any part of the western coast of North America is somewhat arbitrary because of the lack of definite political or physical boundaries, other than the waters of the Pacific Ocean washing against the continent's edge. My own definition is based on practical considerations involving the total amount of graphic material available from the region. Thus, for my purpose, the southern boundary is the Oregon-California border, the northern boundary is Point Barrow at the northernmost part of the United States, and including the Alaskan Peninsula, the Aleutian Islands, and St. Lawrence Island in the Bering Sea. The exclusion of renderings from the California coast is necessary because of the sheer volume of drawings and paintings available for this vast area, which would likely require a companion volume.

For convenience I have used the word "drawing" as an all-inclusive term to describe pencil or ink drawings, color washes, watercolor paintings, and watercolor drawings. The selection of drawings was based largely on subject interest, including native peoples, their villages and dwellings, water craft, armed conflicts, and the ships and boats of the white intruders.

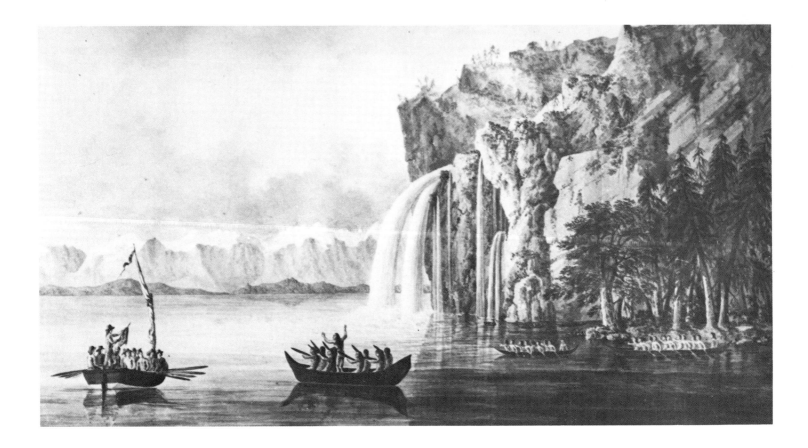

"View of Vernacci Channel," Knight Inlet, 1792

Drawing by José Cardero; courtesy Museo de América, and Oregon Historical Society.

Some original drawings are compared with their engraved versions, when the latter are available and if marked differences exist. I have generally ignored frequently published drawings and engravings in favor of less familiar work, although some well-known drawings appear here because they were the only available specimens of the artist's work on the Northwest Coast. Portraits and autographs of some of the artists are included for possible insight into the artist's character and style. Some coastal profiles provide examples of an essential and utilitarian contemporary form of art.

Botanical and zoological drawings have been omitted (with a few exceptions) regardless of merit or charm. The basis for such exclusion, simply stated, is that flora and fauna show little or no discernable change in the past 240 years, whereas the products and trappings of humans may either have vanished or been altered to an enormous degree. In addition, the great number of drawings by naturalists would exceed the capacity of this book.

In this volume, the term "artist" applies to both professionals and amateurs, as well as to draftsmen, surveyors, cartographers, navigators, and ship captains—in short, anyone on a voyage in this time and place who drew, or attempted to draw, what he saw.

Not all voyages of exploration included artists, although in the period before the invention of photography, the failure to utilize this resource would today seem tantamount to moon exploration without cameras. The three voyages captained by James Cook all had skilled professional artists, while Vancouver's voyage had no one officially assigned to that duty. Fortunately for posterity, Vancouver recognized the lack: "It was with infinite satisfaction that I saw, amongst the officers and young gentlemen of the quarterdeck, some who, with little instruction, would soon be enabled to . . . draw landscapes, make faithful portraits of the several headlands, coasts, and countries, which we might discover . . . without the assistance of professional persons."[1] He was able to persuade the Admiralty to include a supply of drawing materials.

It was a rare fur-trade voyage that produced drawings as a byproduct of the collection of furs. A notable exception was the second voyage in 1790 of the *Columbia* under Captain Robert Gray. He enlisted twenty-two-year-old George Davidson, a housepainter with some artistic ability, with the expectation of obtaining a visual record of the voyage (see pp. 174–78).

Some of the most valuable drawings were produced by men not motivated by an official directive, who possessed the ability and incentive to portray scenes which stimulated their imaginations. José Cardero, a cabin boy on the Malaspina voyage of 1791, for example, apparently had no formal training in art, but possessed native ability coupled with an urge to draw (see facing page and pages 160, 162–65).

In both published and unpublished journals mention is made of Northwest Coast drawings, some of which may still exist. In addition, an unknown number of mariners made drawings for their pleasure, without necessarily keeping their own account of the voyage. An example is described in the journal of John R. Jewitt, who was one of two survivors when the crew of the fur-trader *Boston* was massacred in Nootka Sound in 1803. Jewitt, the ship's armorer, or blacksmith, was permitted by Chief Maquinna to retrieve among tools and other items, "a collection of drawings and views of places" made by William Ingraham, the second mate. Jewitt was rescued in 1805 and later recorded that he gave the drawings to one of Ingraham's relatives.[2]

Another example is contained in the journal attributed to William Sturgis, who sailed with the *Eliza* in 1799. He describes making two drawings of native dwellings in the Queen Charlotte Islands.[3] I have attempted to locate these among the descendants of Sturgis, without success.

Ship's officers who had taken formal training in navigational schools also received instruction in drawing, enabling them to produce some of the exquisite coastal profiles illustrated in this book. An appreciation for skill in drawing by seamen was one of the major reasons for establishing a drawing school in 1693 at Christ's Hospital in Sussex, England. The drawing school was part of the school of mathematics, training boys for the Royal Navy and the merchant marine. Drawing masters placed primary emphasis on sketching seaviews and coastal profiles, which helped raise the standard of draftsmanship in the navy. Other countries also recognized the importance of such training. Peter the Great established a school of navigation and mathematics in Russia early in 1701.[4]

Prior to the departure of an official voyage of exploration detailed instructions were issued by the government, covering every aspect of its expectations. If an expedition artist were included, more or less itemized directions were set forth for his guidance. Orders to La Pérouse in 1785, for example, stated that the "draughtsmen" were to sketch "all the views of the land, and the remarkable situations, portraits of the natives of the different countries, their manner of dress, their ceremonies, their pastimes, their edifices, their vessels, and all the production of the earth and of the sea."[5]

The need for accuracy might be stressed, although it could be reasonably expected that an experienced artist would conscientiously render faithful images. Perhaps for this reason artistic specifications for the Billings Russian expedition of 1787–92 were cursory, almost an afterthought: "You are likewise to make . . . even drawings of the most curious productions of nature . . . and take views of the coast and remarkable objects."[6]

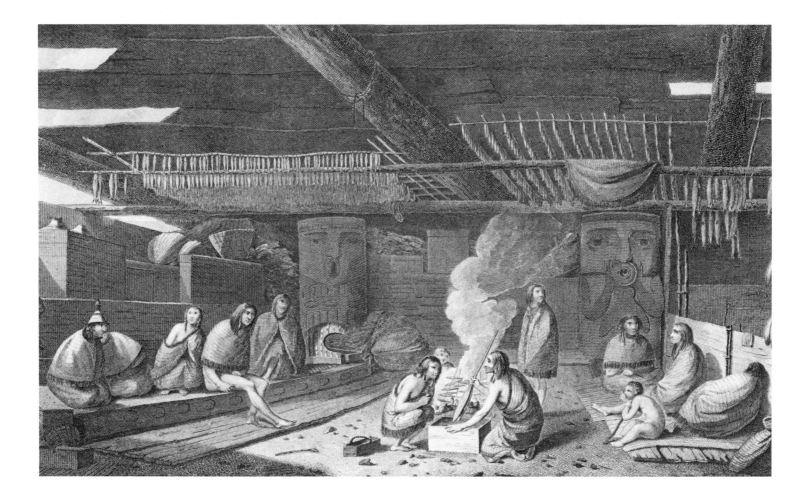

"The Inside of a House at Nootka Sound," 1778

Engraving of a drawing by John Webber, in atlas to Cook's *Voyage*, pl. 42; courtesy Pacific Northwest
Collection, University of Washington Libraries.

For the Staniukovich voyage of 1826–29, the Russian Imperial Academy of Arts set forth standards: the artist was to strive for accuracy, avoid drawing only from memory, and shun the embellishment of what he saw.[7]

Some professional artists had an unfortunate tendency to stylize their renderings. One of the few criticisms aimed at John Webber concerned his unnatural elongation of figures in groups. This slight distortion can be seen in his drawings on pages 77 and 79.

After the voyages had ended, some artists, and perhaps most, produced copies of their drawings, either as gifts for friends and shipmates, or for sale. These later versions differ in various degrees from the originals. John Webber was one professional artist who produced income for years by selling copies. Amateur George Davidson made an unknown number of copies, usually no two the same, so that it is impossible to know which version is the most faithful to the original scene.

When engravings were made from drawings to illustrate published journals, occasional changes would be made by the engraver, usually not for the better (see, for example, pp. 146 and 147). (Some of the more difficult research for the book has been obtaining prints of the original drawings in order to illustrate such changes.)

The engravers of the drawings done on the Vancouver voyage included some of the finest in Britain. In preparation for the work of engraving, the sketches were redrawn by William Alexander. Some changes were made in drawings used to illustrate the text, presumably for human interest, and probably on Admiralty instructions. One drawing by Humphrys done near Port Dick, which contained no native craft in the original, was reproduced as plate XIII in Vancouver's *Voyage of Discovery*, with the addition of numerous baidarkas (kayaks).[8]

In the case of the Spanish voyages, artists called "finishers" redrew originals for publication, sometimes altering them according to their inclination or the direction of their superiors. Italian artists in Acapulco, who joined Malaspina on his return from the Northwest Coast, "improved" the faithfully accurate drawing by José Cardero of the elevated burial chamber of a Tlingit Indian chief at Mulgrave Sound (see pp. 162–63). Cardero and Tomas de Suría were engaged with a group of twelve other artists from Mexico, to complete the preliminary sketches done by Atanásio Echeverría during the mission to Nootka Sound in 1792.[9] In this case, at least the two had actual experience in the area, and hence their redrawn sketches may be considered accurate (see pp. 167–70).

Some doubt exists among anthropologists as to the accuracy of the artists' depictions of facial features of Northwest Coast natives, owing to their similarity to European features. After studying many drawings from the same region, executed at different times, and examining contemporary written descriptions, I believe that the facial representations are reasonably correct.

Some may question the round, "unIndianlike" features of Tlingit Indians as portrayed in this work, but their validity is supported in firsthand accounts. One of Malaspina's lieutenants, Antonio de Tova Arredonda of the *Atrevida*, wrote in his journal that "they [the Tlingit] have generally a round face, a large mouth, large tightly spaced teeth, a wide nose, and small but black and brilliant eyes . . . we had some of them wash themselves to ascertain their true color, which of their faces is as white as the people of south Europe."[10]

In 1779 Father Riobo, a Jesuit priest with the Artega expedition, described the Tlingits at the southeastern end of their territory at Bucareli Sound: "Among these Indians three shades of color are found: some in complexion and features are very light Europeans; others have more the appearance of Indians especially in hair features and color; others again are just Indians like the rest found in America."[11]

It would be virtually impossible to assemble all of the drawings made during voyages along the Northwest Coast in the hundred-year span covered by this book. The Russians alone made more than fifty voyages to help supply their American colonies, some of which took place after 1841 and hence were beyond the scope of this book. Spain launched not less than thirteen voyages between 1774 and 1793.[12] British fur-trading vessels in the twenty-year period 1785 to 1805 totaled at least forty-six, while American vessels in the same period totaled eighty-five. At least three French voyages were made in addition to that of La Pérouse. The combined list reaches nearly two hundred. The number of British and American voyages made after 1805, of whatever sort, would add about one hundred to the total. (The actual number may be more, although it cannot be ascertained since Howay takes no notice in his *List of Trading Vessels in the Maritime Fur Trade*, of the number of years occupied by a voyage, or of the number of voyages made by any one vessel.)

It can only be conjectured as to how much additional graphic material is in existence beyond that covered in this work. Conceivably it is large. There must exist numerous Russian drawings from their many voyages, most of which would be difficult, if not impossible, to obtain in the West. Frank Golder had an impressive list of drawings, compiled before 1917 with the help of Russian scholars and cultural institutions. At this time these are not readily available to American researchers.[13] This book will have been successful if it causes some of these unknown drawings to emerge from obscurity, and if future researchers update and enlarge upon its contents.

Overleaf: "A New Chart of the World on Mercator's Projection, with the Tracks & Discoveries of the Latest Circumnavigators," prepared by Samuel Dunn, Mathematician, 1789–94. Courtesy Pacific Northwest Collection, University of Washington Libraries

"Harbour of St. Paul in the Island of Cadiak," 1805

From a color lithograph based on a drawing by Yuri Lisianskii, in his *Voyage*, facing p. 191; courtesy Pacific Northwest Collection, UW Libraries.

"High mountains, low hills with beautiful vallies and little streams running between them, green and partially wooded islands, with the neighbourhood of a sea that yields fish in the greatest abundance, render this situation at once advantageous and agreeable. The settlement consists of about thirty buildings, the principal among which are, the church, the barracks, the compting-house, the warehouses, the houses of the director and the clergyman, the school, and the shops of the handicraft workers: at a little distance are to be seen the habitations of the Aleutians" (Langsdorff, Voyage, p. 66).

PLATE 1

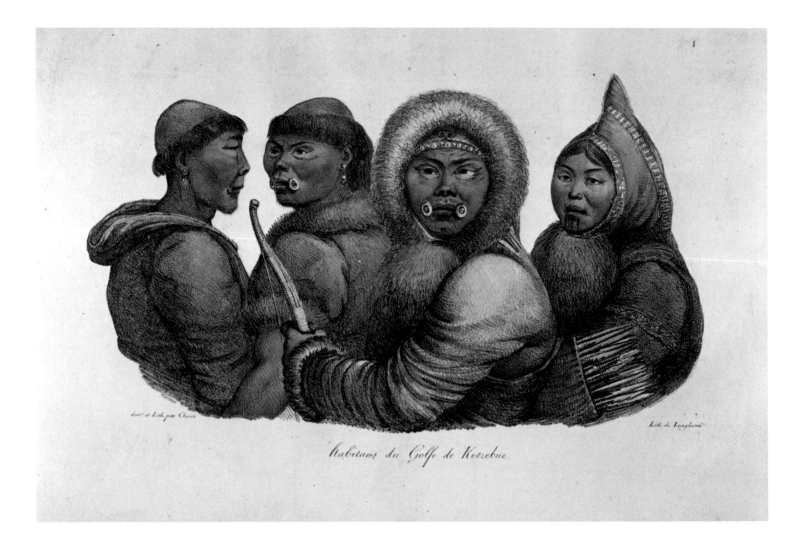

dess.' et Lith. par Choris

Lith. de Langlumé

habitans du Golfe de Kotzebue.

"Inhabitants of the Gulf of Kotzebue," 1816–17

Color lithograph of drawing by Louis Choris, pl. 1 in his *Voyage*; courtesy Pacific Northwest Collection, UW Libraries.

"Several men had tatooed faces; others had passed pieces of bone as ornaments through holes pierced next to their lower lip. This ornament is common in the Golfe of Kotzebue, except that the bone fragment is larger, and made more precious by a blue glass button [bead] in its middle" (Choris, Voyage, *p. 5 of "Kamtchatka").*

In 1826 Beechey also mentioned that the appearance and behavior of two men "led us to conclude that the large blue glass labrets indicated a superiority of rank . . . no reasonable offer would induce them to part with the ornaments" (Beechey, Narrative *[1968], 1:458).*

Other features include characteristic tonsures of two men, left, bead earrings and a beaded brow band, both made of trade beads, and the tatooed chin of the woman.

PLATE 2

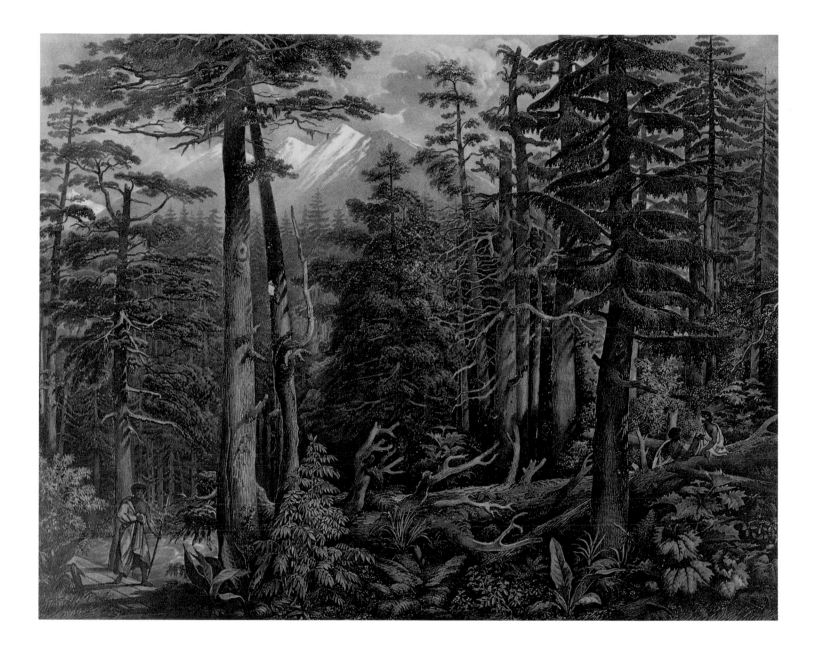

"A forest on Sitka Island," 1827

Lithograph of a drawing by A. F. Postels, in Litke, atlas to *Voyage*, pl. 8 (copy of Tsar Nikolai I); courtesy Lilly Library, Indiana University.

"Barely a few steps into the forest one is surrounded by the thickness of the vegetation. An indescribable feeling takes possession of the soul at the sight of this ancient and lonely wilderness, where, for numberless centuries, trees have fallen only because of age" (Litke, atlas to Voyage, *"Explanation of Plate"*).

PLATE 3

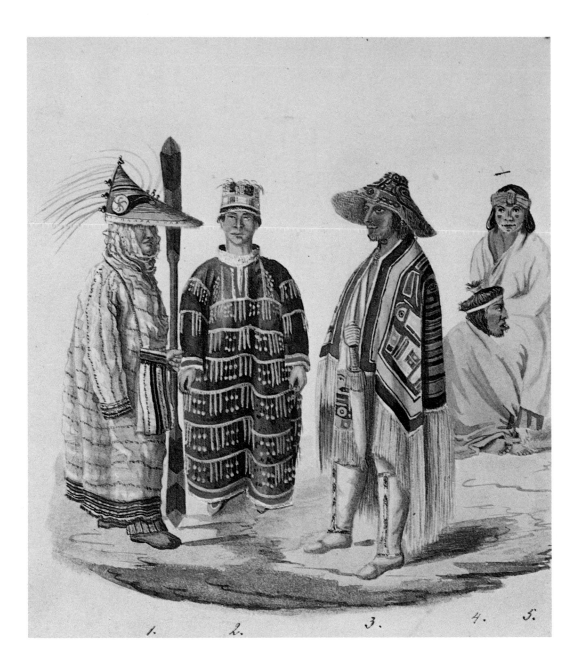

Native costumes of the Aleutian Islands and the Alaska mainland, 1827

Drawing attributed to A. F. Postels; courtesy Edmund Carpenter.

The Aleut man on the left is wearing a waterproof parka of sea mammal intestines, gut and skin strips, and decoration of dyed skins. The middle figure is a Koniag native from Kodiak Island, wearing a gown of cormorant skins and down strips. The Tlingit chief on the right is clothed in a Chilkat blanket, spruce root hat, and Athapaskan leggings traded from the mainland interior. The chief's costume, including the dagger and sheath, is presently lodged at the Anthropological Museum of the Lomonosov University in Moscow (Bill Holm, personal communication).

The background figures are unidentified as to origin, but the seated man is wearing a bead chin ornament.

PLATE 4

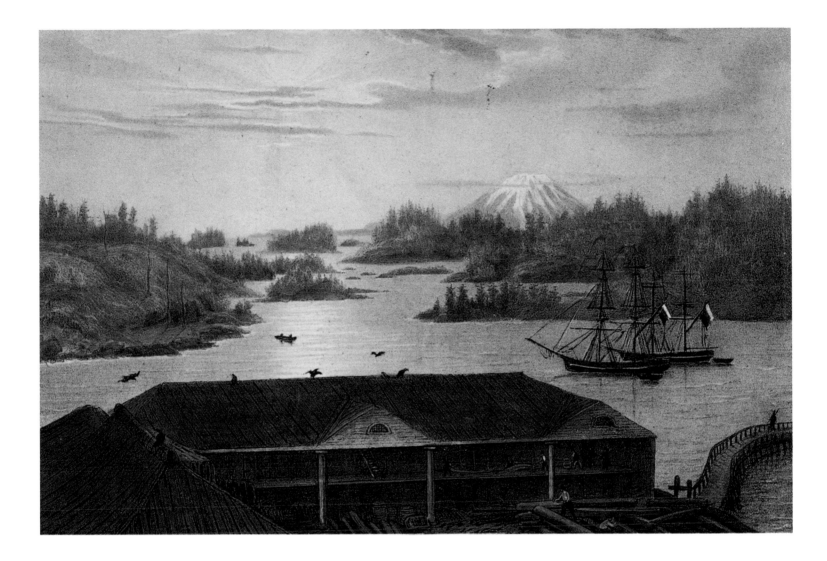

"View of Sitka Bay, from the governor's house," 1827

Lithograph of a drawing by F. H. von Kittlitz, in Litke, atlas to *Voyage*, pl. 3 (copy of Tsar Nikolai I); courtesy Lilly Library, Indiana University.

"The . . . print represents a part of the superb panorama of the sea seen from the windows of the fort. In the foreground one sees a part of the courtyard of the fort surrounded by the principal shops-storage areas of the company. The magnificent vegetation which covers the rocky ground [of the islands] and which bursts out from the sea, gives them a look which is at the same time imposing and pleasant. The mountain . . . is Mont Hyacinthe de la Peyrouse, or in English, Mount Edgecumbe, 2800 feet" (Litke, atlas to Voyage, *"Explanation of Plate" by Kittlitz*).

PLATE 5

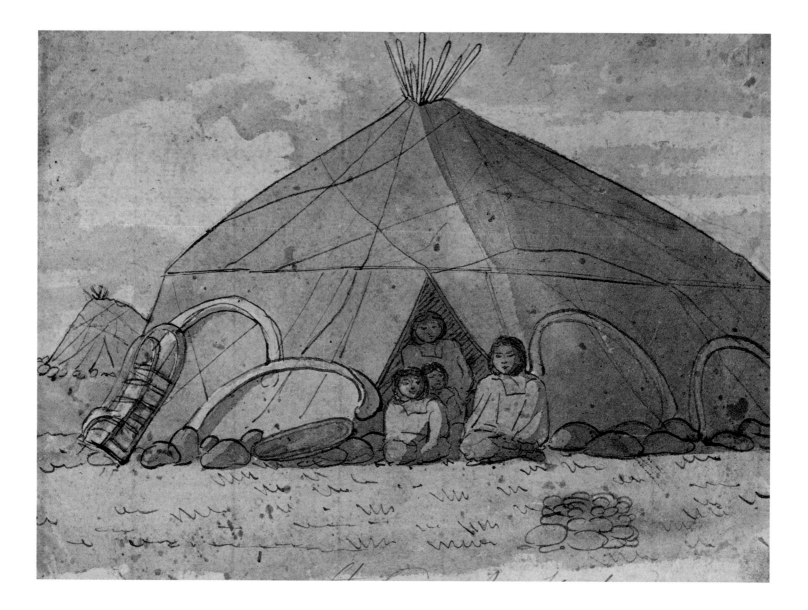

"A leather tent of the Aleuts," 1816–17

Watercolor drawing by Louis Choris; Coe Collection, courtesy Beinecke Library, Yale University.

This "Aleut" lodge is made of walrus hides, stretched over driftwood poles, although whale bones may have been utilized on the lower part. A sledge leans against the left side. Whale ribs with rocks at their base assist in stabilizing the structure against strong winds, frequent in the Aleutian Islands.

PLATE 6

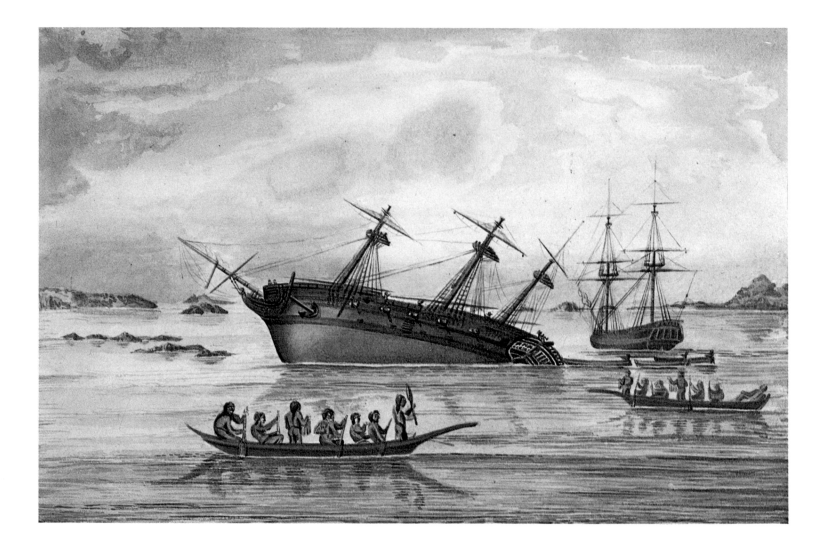

"The Discovery on the Rocks in Queen Charlotte's Sound," 1792

Watercolor attributed to Zachary Mudge; courtesy Dixson Library, Sydney, of the State Library of
New South Wales.

*While the drawing is unsigned, the engraving (see page 109) is so similar that there seems little doubt that
Mudge was the author. The major change in the engraving is the addition of a ship's boat manned by six
seamen, astern of the* Discovery. *Careful inspection of the stern of the* Discovery *shows a whimsical little
figure seated in a relaxed postion, with legs crossed, smoking a pipe (perhaps the leprechaun who caused the
disaster).*

PLATE 7

"View of a Boat Encampment, Pugets Sound, Straits de Fuca," 1792

Drawing by John Sykes; courtesy The Bancroft Library, University of California.

Both this drawing and "View of Observatory Point" (p. 111) are actually copies done on paper "watermarked S&P 1797, which was therefore manufactured two years after Vancouver's expedition return to England." The Admiralty had refused to return Sykes' drawings made on the voyage, although they gave Sykes permission to make copies. A. C. F. David has pointed out that the signature on the drawing is not that of Sykes, which may indicate that the copies were executed at his direction ("Drawings," pp. i–ii).

The locale of this drawing cannot be precisely determined. The title is misleading, since Puget Sound and the Strait of Juan de Fuca are today, and were in Vancouver's time, considered to be separate bodies of water. An observatory tent has either not yet been set up or has already been dismantled.

PLATE 8

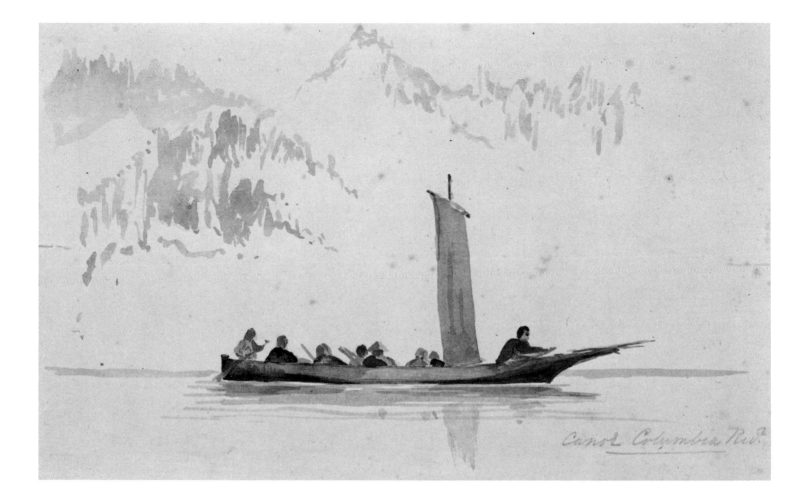

"Canoe, Columbia River," 1839

Watercolor sketch attributed to Edward Belcher; courtesy Special Collections Division, University of British Columbia Library.

Apparently sails for canoes came into wide use only after European contact with the natives. Sail material could be cedar bark mats, animal skins, or thin cedar shakes lashed together; rigged as tall, narrow square-sails, laced to upper and lower yards. Such a rig would be suitable only before the wind. James Swan reported seeing a canoe with bark-mat sails on four masts, and others with more than one (Durham, Indian Canoes, *p. 74). Occasionally a chief would receive a gift of canvas for a sail.*

 This same type of northern canoe may be seen in John Webber's drawings of Indians in Resolution Cove (p. 76), more than sixty years earlier. Two observers on Cook's voyage mentioned the lack of sails at Resolution Cove: "They know nothing of the use of sails having none among them" (Surgeon David Samwell's journal in Beaglehole, Cook Journals, *3:1102). "There is not the smallest appearance of their ever using Sails, nor cou'd we perceive they had any idea of their use" (Captain James King's journal, ibid., 3:1410).*

PLATE 9

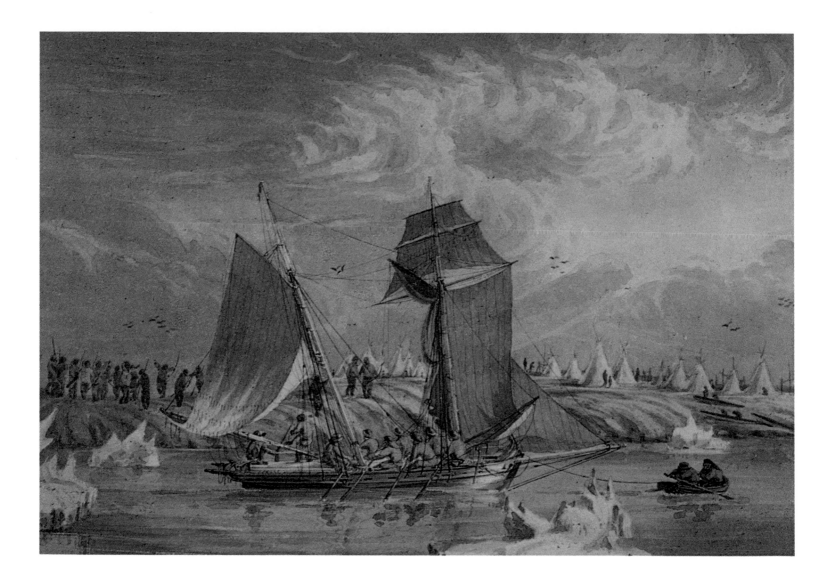

"H.M.S. Blossom's barge leaving Point Barrow," 1826

Watercolor drawing by William Smyth; Alaska and Polar Regions Department, Rasmuson Library, University of Alaska, Fairbanks, donated by the National Bank of Alaska.

After a hostile reception by the Eskimos at Point Barrow, the barge continued south along the shore, passing several villages. At one place, "nineteen of the natives came down opposite us, armed with bows, arrows, and spears, and imagining that it was our intention to land, motioned us to keep off, and seemed quite prepared for hostilities. Notwithstanding this show of resistance, we still advanced nearer to the shore, as being more out of the current . . . at the same time having the arms in readiness in case of an attack. When within about thirty yards of the beach, we lost the wind, and continued pulling and towing along shore, the natives walking abreast of us on the beach" (Smyth's account in Beechey, Narrative, *1:426).*

This drawing was not reproduced in the Narrative.

PLATE 10

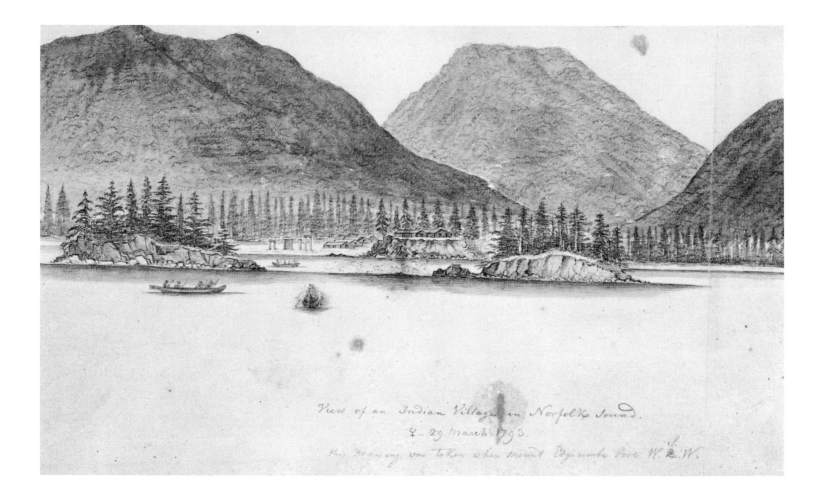

Within the drawing, handwritten:

View of an Indian Village in Norfolke Sound.
♀ - 29 March 1793.
this drawing was taken when Mount Edgecombe bore W.½.W.

"View of an Indian Village in Norfolk Sound," 29 March 1793

Watercolor drawing by Sigismund Bacstrom; from the Collection of Paul Mellon.

The exact location of this Kolosh Tlingit village cannot be determined, since Bacstrom described it only as being in Norfolk Sound, in latitude 57 degrees, "when Mount Edgecombe bore W.S.W." This could have placed it in Katlian Bay, latitude 57°10', in the north end of the Sound, which is sheltered and has a group of islands on the north side. Professor Bill Holm, however, believes this village may have been the one situated at the present site of the city of Sitka.

PLATE 11

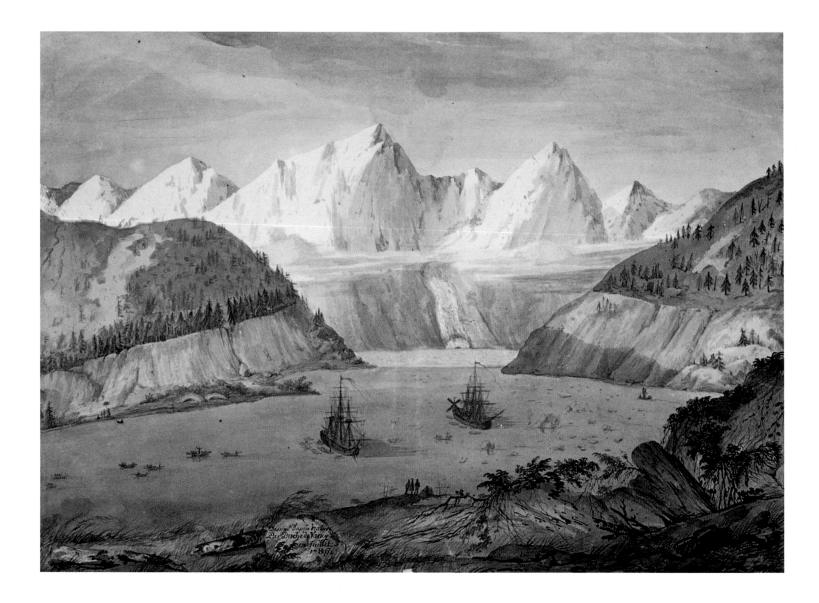

"View of Port des Français," 1786

Drawing by Gaspard Duché de Vancy; courtesy Service Historique de la Marine, Vincennes.

"Some of the Indians were continually about our ship in their canoes, and spent three or four hours before they began to barter a little fish, or two or three otter-skins, taking every opportunity to rob us, catching at every bit of iron that could easily be carried off" (La Pérouse, Voyage, 1:398).

 A survey party is on the beach at the left, setting up a marker. Small ice floes, broken off from the glacier in the distance, are floating to the right. The Astrolabe, anchored at right, bears on the stern a windmill, a device not commonly seen aboard a ship. This came about through the urging of "the superintendents of the victualing department, [who] persuaded that kiln-dried corn would keep better than flower or biscuit, had proposed to us to take on board a large quantity. . . . to grind it we were furnished with millstones . . . which were to be worked by four men" (ibid., 1:356).

PLATE 12

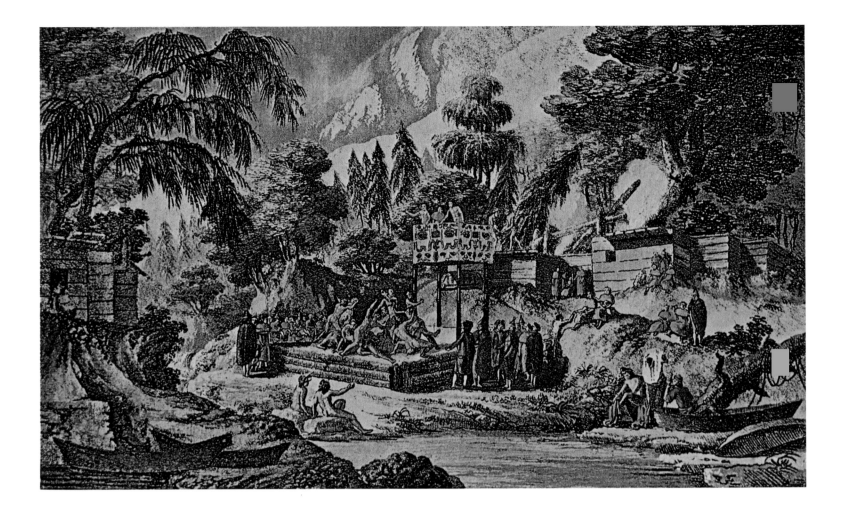

The coming-of-age celebration of Princess Izto-coti-clemot at Nootka, 1792

"Improved" version of drawing by Atanásio Echeverría; courtesy Iris H. W. Engstrand, and Ministerio de Asuntos Exteriores, Madrid.

"As soon as the menstrual flow appears in a girl for the first time, they celebrate . . . and her name is also changed. We were present to congratulate Maquinna for that of his daughter Izto-coti-clemot, who before this time was called Apenas. The savage pomp with which they solemnize this function is worthy of note. . . . on top [of a platform] they constructed a kind of balcony, entirely enclosed by planks. Both this and the columns were painted white, yellow, red, blue, and black, with various large figures of poor design. They were also decorated with mirrors of various sizes; and two busts, with arms open and hands extended, were placed in the corners to signify the magnificence of the monarch. . . .

"Maquinna took his daughter by the hand, conducted her to the balcony, placed her in its center, and remained at her right; at the left was his brother Quatlazape. The assembly of numerous natives occupying the leveled arena and beach became profoundly silent. The chief directed his voice to all: 'My daughter Apenas (he told them) is no longer a girl, but a woman: from this time forth she will be known by the name Izto-coti-clemot; that is, the great Taisa of Yuquatl.' All responded with a shout . . . an expression which equals our viva" (Moziño, Noticias de Nutka, pp. 34–37).

PLATE 13

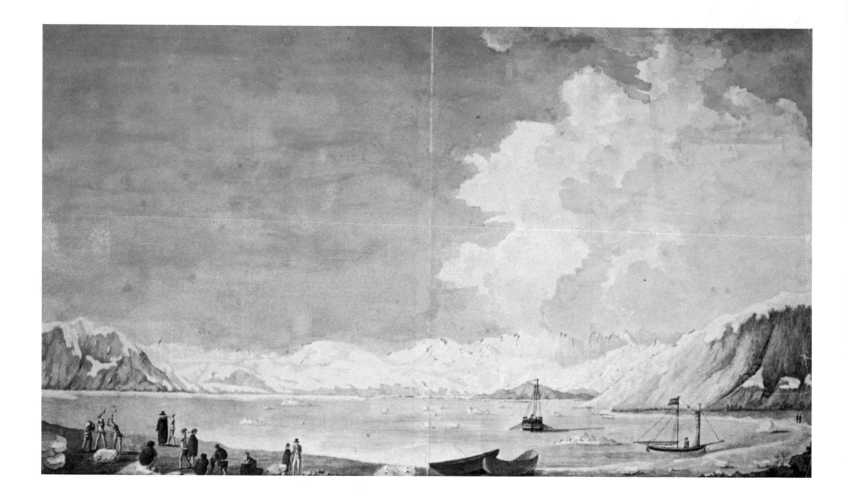

Port Desengaño (Disenchantment Bay), 1791

This is an "improved" version of a drawing by José Cardero; courtesy Museum of New Mexico, and Museo Naval, Madrid.

The corvettes entered this bay from Port Mulgrave by a passage through a mountain range. When the opening was first viewed by Malaspina, it was thought that it might lead to the fabled Northwest Passage (see also p. 151).

Before leaving the area, the explorers "left enclosed in a bottle, together with the inscription of our survey, the date on which we had taken possession in the name of his Majesty, proved by a coin buried at the side of the bottle" (Malaspina, Voyage, 2:74).

PLATE 14

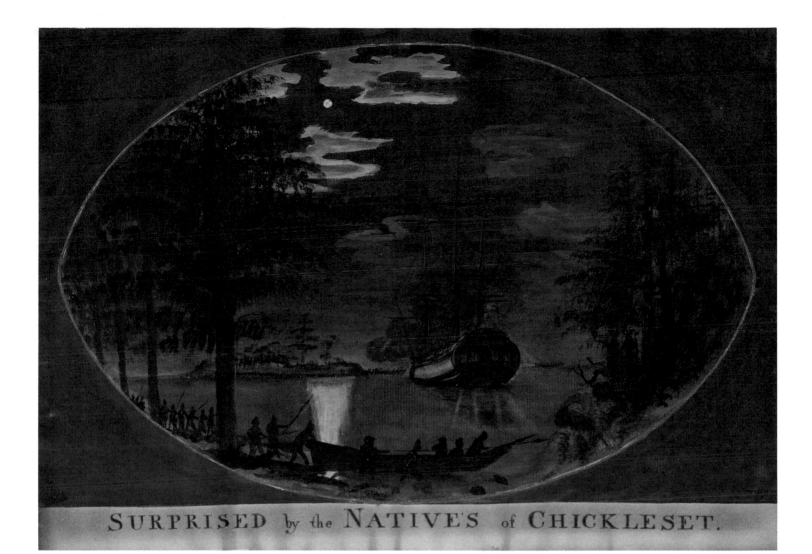

SURPRISED by the NATIVES of CHICKLESET.

"Surprised by the Natives of Chickleset," 1792

Drawing by George Davidson; courtesy Oregon Historical Society.

"At 10 in the evening, a number of large canoes full of People, came into the Cove. They halted near some rocks about Pistol shot from the Ship, and there waited about ten minutes, during which time all hands was brought to arms, upon deck in readiness to receive them. Soon after a large War Canoe, with above 25 Indians, paddled off for the Ship. We hail'd them, but they still persisted, and other canoes was seen following, upon which Capt. Gray order'd us to fire, which we did so effectually as to kill or wound every soul in the canoe. She drifted along side, but we push'd her clear, and she drove to the North side of the Cove . . . 'twas bright moon light and the woods echoed with the dying groans of these unfortunate Savages" (from Boit's journal in Howay, Columbia Voyages, *pp. 400–1).*

The cove, named Columbia's Cove by Gray, is unnamed on modern charts, and is on the north side of Nasparti Inlet, on the west coast of Vancouver Island.*

*Through my written petition, the original name of "Columbia's Cove" was officially restored to Canadian hydrographic charts and to the British Columbia *Gazeteer* in 1983.

PLATE 15

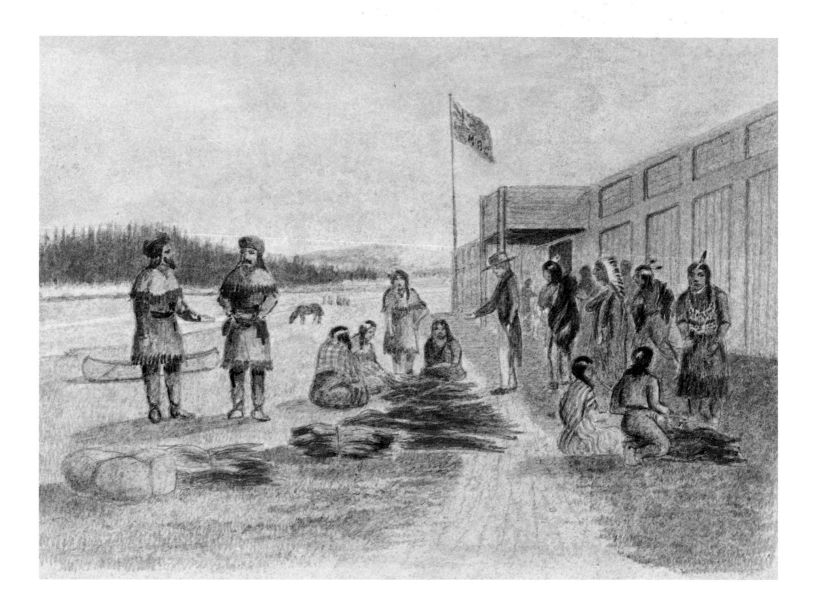

Hudson's Bay Company post, Fort Walla Walla, 1841

Pastel drawing attributed to Joseph Drayton; courtesy Oregon Historical Society.

This drawing was probably made long after the end of the expedition. Either because of faulty memory or artistic license, Drayton included an improbable eastern Canada birchbark canoe and an extensive growth of trees beyond the riverbank, in an area which was actually a treeless desert. The configuration of the post's entrance, however, corresponds almost exactly with Drayton's small drawing in Wilkes' Narrative *(4:39).*

Indians from various places were camped near the post, including members of the Cayuse, Walla Wallas, and Nez Perce. The chiefs of the two latter tribes may be depicted in this sketch, as "they were going to the Shaste [Mt. Shasta] country to trade for blankets, powder and ball, together with trinkets and beads, in exchange for their horses and beaver-skins" (Wilkes, Narrative, *4:397). The dress of the male Indians at right may have been drawn later from memory, as the costumes seem atypical of the area (Bill Holm, personal communication).*

PLATE 16

The Russian Voyages

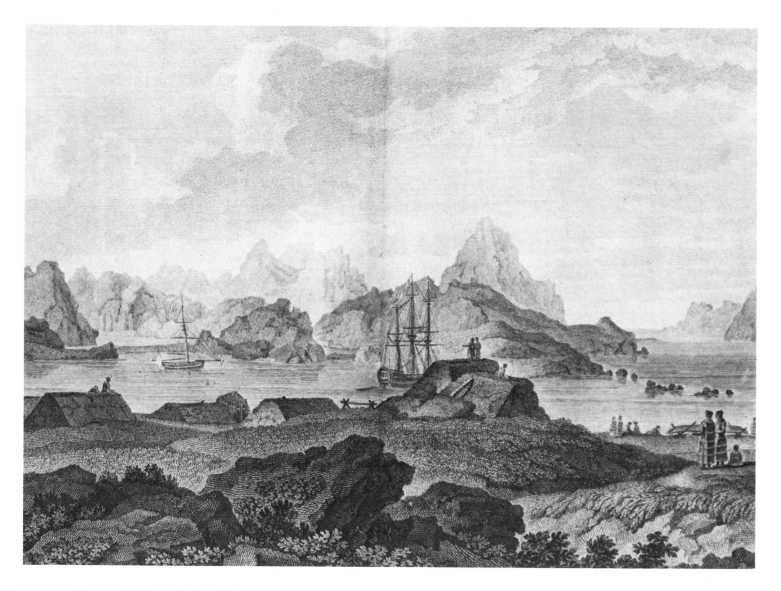

"Captains Harbor on Unalaska Island," 1790

Engraving of a drawing by Luka Voronin, in Sarychev's atlas to *Puteshestvie*, pl. 14; courtesy Pacific Northwest Collection, University of Washington Libraries.

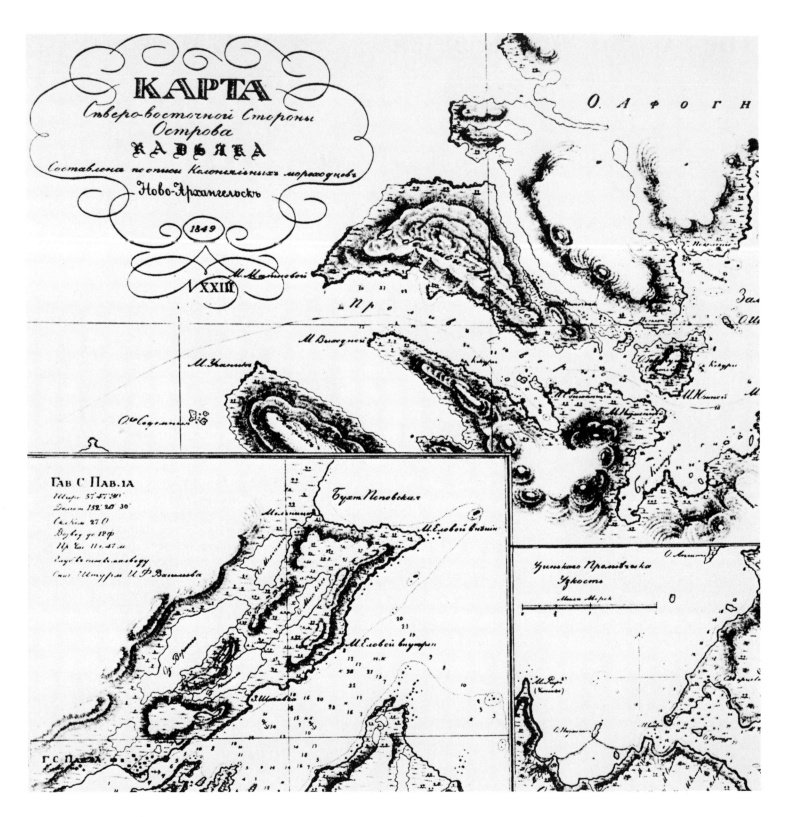

Northeast side of Kodiak Island; the large inset is St. Paul Harbor. In atlas of maps compiled by Captain M. D. Teben'kov in 1852, reproduced at Limestone Press, 1981. Courtesy of Richard A. Pierce

The Second Voyage of Vitus Bering, 1741–42

In 1724 Peter the Great of Russia appointed Vitus Bering, a Dane, to conduct an expedition to northeastern Siberia, for the purpose of determining whether the land mass of Asia stretched indefinitely eastward, or whether a great continent, separated by a sea or strait, lay to the east of Kamchatka.

The expedition's findings were inconclusive, and it returned to St. Petersburg in March 1730. Peter having died in the meantime, Bering persuaded Empress Catherine to send him on another attempt in 1733. This second expedition suffered from the outset from poor organization, quarrels and jealousies among officials, and deliberate lack of cooperation by local officials. As a result, construction of the two ships was delayed, and the expedition did not sail from Petropavlovsk until June 4, 1741.

Bering commanded the *St. Peter*, Lieutenant Alexei Chirikov the *St. Paul*. Each vessel was eighty feet long, mounting fourteen guns. The artistic record of the voyage was made chiefly by three men: Fleet Master Safron Khitrov, Lieutenant Sven Waxell, and Clerk Friedrich Plenisner.

The ill-tempered but brilliant German scientist, Georg W. Steller, sailed with Bering. Trained in both medicine and botany, Steller had an intense desire to establish his reputation as a naturalist by way of participating in a voyage of exploration. When he learned that there might be a place for him on the *St. Peter*, he traveled by dog team to see Bering at Petropavlovsk, and accepted Bering's offer of the post of mineralogist. Unofficially, Steller reported, Bering promised to "give me all possible opportunities so that I might accomplish something worth while . . . [and] to give me as many men as I should want whenever needed."[1] Thus was the foundation laid for the unhappy relationship between the aging Bering and his officers and the abrasive and opinionated young Steller. Bering failed to keep his promise to Steller, who was permitted only three landings during the entire voyage.

Just two days into the misfortune-ridden expedition, the *St. Paul* and the *St. Peter* were separated by heavy fog. Chirikov sailed east to the American mainland and sent his only two boats ashore with fifteen men, who disappeared and were never seen again. He returned home in October of the same year.

After searching for the *St. Paul* without success, Bering sailed southward as far as 45° 16', without locating the "Juan de Gama Land" shown on astronomer Delisle de la Croyère's chart. Convinced that it did not exist, Bering consulted his officers, then headed northeast, hoping to find land where the ship's water supply could be replenished. The American mainland was finally sighted on July 16, and a great mountain was seen in the distance—Mt. St. Elias at 18,008 feet.

On July 20, after sailing cautiously through the fog, the *St. Peter* anchored on the west side of an island seventeen miles long, the end of which lay only two miles off the mainland. Bering gave it the name of St. Elias (today's Kayak Island) and sent a landing party to explore it and a neighboring island. Concerned about the late season and signs of scurvy on board, Bering appeared on deck "two hours before daybreak . . . and, without consulting anyone, gave orders to weigh anchor."[2] It was a prudent decision, as the wind was then favorable for leaving a dangerous area containing reefs and shallows.

During the ensuing nearly four months, the *St. Peter* slowly proceeded westward toward Kamchatka, making occasional landfalls along the Aleutian peninsula and islands. A landing was made on one of a group of islands to refill water casks. Bering gave the island the name Shumagin to honor a seaman who had died of scurvy and been buried there. Later in the season a series of gales threatened the ship, and scurvy prevailed to a degree that left barely enough men able to handle the sails.

Steller's continuing discontent, combined with his supreme egotism and ambition, resulted in almost continuous friction on the *St. Peter*. Only eight days into the voyage, Steller had criticized the ship's officers, all experienced seamen, for changing the ship's course and refusing to consider his advice: "When it was most necessary to apply reason . . . the erratic behavior of the naval officers began. They commenced to ridicule sneeringly and to leave unheeded every opinion offered by anybody not a seaman, as if, with the rules of navigation, they had also acquired all other science and logic."

To Steller's credit, he knew much about scurvy and its treatment. He also was a superb observer and logician. From the visual evidence of "objects floating in the sea which kept to a definite direction frequently even contrary to that of the winds," he felt that adjustments should be made in the ship's reckoning of actual distance traveled.[3] His theory, put to the ship's officers, drew an amused reaction; however, the error in longitude that resulted proved his point.

In early November 1741, Bering and his men realized they had to locate an anchorage for the winter. During the maneuvers, the *St. Peter* was driven ashore by a gale and wrecked. Fortunately, it rested on a sandy beach, which aided in its later salvage. Bering did not survive the winter, and Sven Waxell took over command of a thirty-six foot sloop built from the remains of the wreck. Also named the *St. Peter*, she carried the forty-five survivors to the Kamchatkan coast in only four days, and finally to safety at Petropavlovsk on August 27, 1742, a total of twelve day's sailing.

The voyage succeeded in establishing the existence of the vast Alaskan peninsula, stretching over four hundred miles from the mainland.[4] The cost in human life was great—out of the total of 153 men on the two ships, 54 lost their lives.

Sofron Khitrov

The Russian General Naval List of 1885 shows that Sofron Khitrov entered the service in 1723 as a "navigation-student," and was appointed a second mate on March 19, 1730.* On May 21, 1731, he was "sent on the [first] Kamchatka expedition, in the Okhotsk fortress, as steersman of second class." During the second Kamchatka expedition ten years later, he was made a fleet master, and later the same year was promoted to lieutenant.[1]

An excellent relationship seems to have existed between Khitrov and his immediate superior, Lieutenant Sven Waxell, who had high regard for his ability. Judging from graphic evidence, Khitrov had considerable talent as a cartographer. In his logbook of the *St. Peter* he drew a chart of Kayak Island, with the coastal mountains in profile. He also made a chart of the Shumagin Islands, as well as others.

Waxell's good opinion of Khitrov was not shared by German naturalist Georg Steller. Whether there was justification for Steller's many charges against Khitrov may never be known. Steller accused him of carelessness that resulted in reducing the food supplies for the voyage. He also blamed him for using

*The Saltykov-Shchedrin Library in Leningrad has been unable to name the birthplace or birthdate of Khitrov, but states that "the family is very ancient. The arms of the Khitrovo family are shown in the general Armorial of noble families."

unseaworthy freight boats to transport supplies, resulting in their abandonment, and for using enforced native labor in winter, which delayed the expedition by a critical month.[2]

After the shipwreck of the *St. Peter*, Steller continued his harsh criticism. On November 15, 1741, after all the sick had been removed from the wreck, he claimed that "Master Khitrov also implored us for God's sake to take him into our company and give him a corner, because he could not possibly remain among the crew, who day and night let him hear reproaches and threats for past doings . . . all of us objected [as he] was the chief author of our misfortune."[3]

On one occasion Lieutenant Waxell also was critical of Khitrov, but carefully avoided using his name, referring only to "the officer-of-the-watch." This involved an incident at the end of August 1741, when an anchorage was found among the Schumagin cluster of islands. Khitrov proposed that, while the longboat was employed in watering the ship, he take the yawl, a much smaller and therefore less seaworthy craft, ashore to reconnoitre. On a small island twelve nautical miles away, smoke had been seen, suggesting the presence of natives. Waxell refused permission on the grounds that the anchorage was insecure and that the ship would have to put to sea very quickly if the weather changed.[4]

Bering overruled the decision, and Khitrov proceeded, with written orders. In a rising sea, the yawl was swamped in the surf. Two days later during a lull in the wind, the six men had to be rescued by the longboat, and the yawl was abandoned. The next day the storm had turned to a gale, requiring the anchorage to be shifted. Waxell concludes his account of this incident: "Thus all that I had prophesied had come to pass, except that, praise be to God, none had been lost."[5]

Following the return of the expedition to Petropavlovsk, Khitrov remained on duty under Waxell, according to the Naval list of March 5, 1746, and was appointed to verify the maps of the Kamchatka expedition. (He was then commanding officer of the fleet of imperial yachts.) In 1749, "in recognition of his enduring numerous untold adversities," during his participation in the Kamchatka expedition, he was appointed a "Second Captain" and subsequently became director of the Moscow Admiralty Office. He attained the rank of commander in 1751, and rear admiral in 1753. He died in 1756.[6]

In the Chugach mountains of Alaska, his name was given in 1960 to the Khitrov Hills, a fifteen-mile-long group of nunataks (isolated hills and peaks projecting above the surface of a glacier), lying between Bering and Steller glaciers.

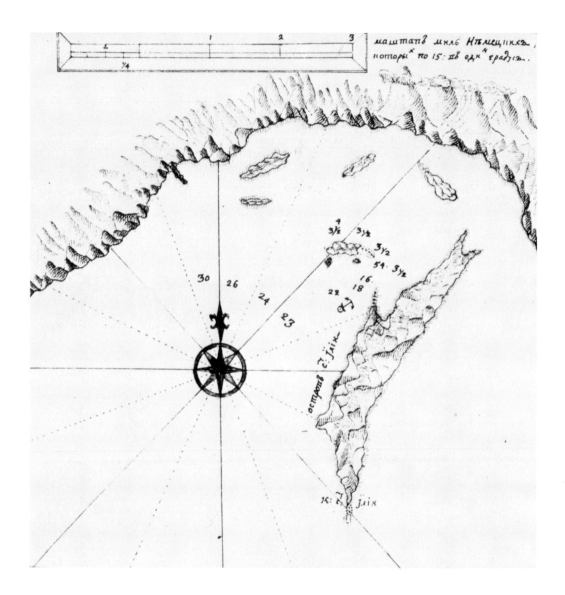

Earliest map of St. Elias (Kayak) Island, 1741

Drawn by Sofron Khitrov; in F. A. Golder, "Papers relating to the Russians in Alaska," vol. 3, n.p.; courtesy Pacific Northwest Collection, University of Washington Libraries.

This is the earliest known map of Kayak Island and the coastal range, dominated by Mt. St. Elias (18,008 feet). The drawing of the mountains resembles a coastal profile, although obviously not intended to be accurate. Khitrov entered in his logbook on July 26, 1741: "This island stands out alone in the sea like a stone column. . . . The Captain Commander sent me with several men in the longboat to examine the strait and seek a good anchorage. The mainland has high snow-covered mountains and volcanoes. . . . On that island there was discovered an earthen hut . . . on the beach were seen human tracks in the sand" (Golder, Bering's Voyages, *1:99).*

5 The Second Voyage of Vitus Bering

Friedrich Plenisner

Georg Steller, unlike many naturalists, was not adept at drawing. Since there was no room on the *St. Peter* for Steller's own draftsman,[1] Bering agreed that during the expedition he could call on the artistic services of Friedrich Plenisner, a competent artist and Bering's personal clerk. Fortunately, Plenisner was both a friend and a countryman of the hypercritical Steller. Evidence of the friendship lies in the remarkable absence of criticism of Plenisner in Steller's usually painfully forthright journal.

After the wreck of the *St. Peter* on Bering Island, Plenisner, Steller, and three other Germans aboard agreed to "a community of goods with regard to the victuals we still had left and arranged our housekeeping in such a manner that at the end there might be no want." On one hunting expedition for the group, Steller and Plenisner, with two servants, were caught for four days in a severe unexpected snowstorm in early April. They survived by taking refuge in a cave found by Steller's cossack.[2]

After the survivors of the wreck returned to Kamchatka, Plenisner lived with Steller on the mainland during the winter, presumably working on sketches for Steller's reports. Later he rose in government service, becoming commander of the fortress of Okhotsk in 1759. His earlier interest in drawing appears to have diminished as he progressed in local government. He has no sketches listed in Golder's *Guide to Materials for American History in Russian Archives* or in the *Great Soviet Encyclopedia*. He retained his interest in exploration, however, organizing expeditions "for the exploration of Chukotka and the islands of the Arctic and North Pacific," although he did not actually participate. Plenisner may have been well ahead of the scientific thinking of his day, when about 1765 he advanced the theory that the continents of Asia and America were once united by a land bridge.[3]

In 1764, having attained the rank of colonel, he unaccountably withheld his cooperation from the secret expedition led by Krenitsyn and Levashov. He went as far as opening mail addressed to Krenitsyn, which drew the attention of Catherine II.[4] Her instructions to the Billings Expedition were explicit: "you are to represent to the Governor-General, that he is to give the most absolute orders through his whole government, that nobody should be curious in opening letters sent by messengers with private reports, as it happened during the Expedition under the command of Captain Krenitzin . . . at the port of Ochotsk, by the Commander Feodor Plenisner."[5]

Plenisner's tact and judgment seem to have steadily deteriorated henceforth, as indicated by other mishandled incidents. He was finally dismissed from service in 1772 on the recommendation of the governor of Irkutsk.

During the next two years he underwent trial for various offenses, but was released and moved to St. Petersburg with his family in 1776. He died two years later. One contemporary described him in his later years as "energetic but haughty, strict with his subordinates and fond of good living."[6]

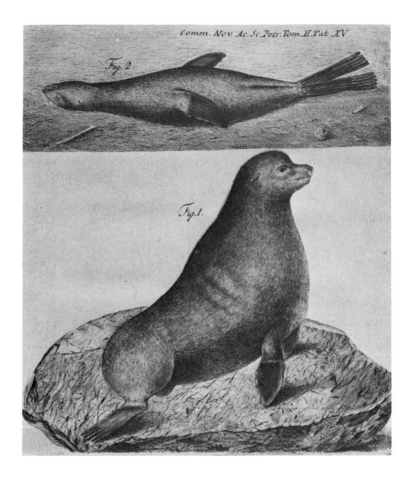

Steller's fur seal, 1741

Drawing attributed to Friedrich Plenisner, reproduced in Steller's "De bestiis marinis," pl. 15; courtesy Historical Photography Collection, UW Libraries.

"During the whole of May and half of the month of June we lived on the meat of the young and female sea bears [fur seals] which are much more tender to eat [than the older animals]. . . . It was a great consolation to us to find that our command could be sustained a whole week on two or, at the most, three such animals In certain places where they completely covered the ground they often forced us to make a detour over the mountains" (from Steller's journal, in Golder, Bering's Voyages, *2:177, 224–25).*

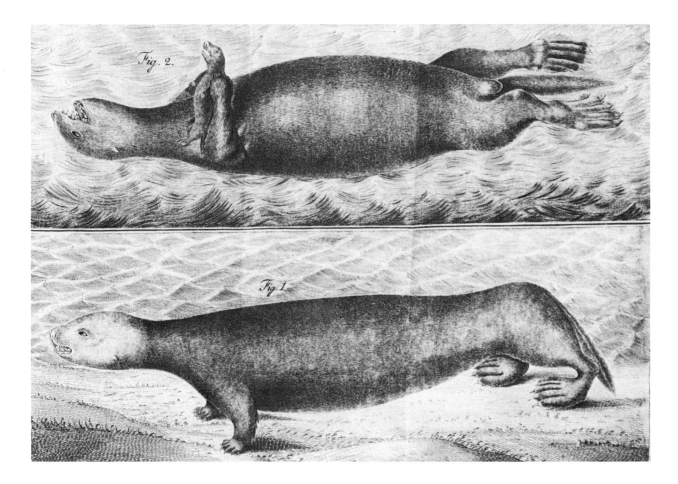

Steller's sea otter, 1741

Drawing, probably made at Steller's request, attributed to Friedrich Plenisner, reproduced in Steller's "De bestiis marinis," pl. 16; courtesy Historical Photography Collection, UW Libraries.

"It is a beautiful and pleasing animal, cunning and amusing in its habits, and at the same time ingratiating and amorous. Their love for their young is so intense that for them they expose themselves to the most manifest danger of death. When [their young are] taken away . . . they cry bitterly like a small child . . . if they have the luck to escape they begin, as soon as they are in the water, to mock their pursuers in such a manner that one cannot look on without particular pleasure. This animal deserves from us all the greatest reverence, as for more than six months it served us almost exclusively as food" (from Steller's journal, in Golder, Bering's Voyages, 2:220–21).

Sven Waxell

Sven Waxell was born in 1701 in Stockholm, where his father was a tavern keeper. At fifteen he began a period of service in the British navy, presumably as a midshipman. In 1725 at the age of twenty-four, he entered the Russian navy. After rising to the rank of lieutenant, he volunteered for the second Bering voyage of exploration and served on the *St. Peter*.[1]

Much responsibility seems to have devolved upon Waxell from the outset of the voyage, due to the continued poor health of Vitus Bering, who was fifty-nine at the beginning, and who spent most of his time in his cabin. In accordance with Russian naval regulations, whenever key decisions had to be taken affecting the safety of all, the entire ship's company was consulted. Virtually the executive officer of the *St. Peter*, Waxell must have taken a leading part in these consultations.

Waxell's character, which emerges from the pages of his journal and the official logs (including that of his subordinate, Fleet Master Sofron Khitrov), shows "an excellent seaman and a good, conscientious and humane officer . . . a brave and prudent man [with] a sufficiently strong character to be able to go against the letter of his instructions on occasion . . . [and] considerate of his men."[2]

These qualities were put to the test when Bering died. A revealing passage in Waxell's journal, published as *The American Expedition*, concerns a problem of morale which confronted him, in the dead of winter, immediately upon taking command:

Although I was then on my back and in a very weak state, I assumed those duties. However, I considered it most advisable to carry them out with the greatest mildness and calmness. That was no place for exerting one's power and authority. . . . There were, though, certain members of our company who criticized my attitude on this point and told me to my face that I was not discharging my duties in accordance with the regulations and ukases. For example, several of the men had began to amuse themselves with cards, once they were able to get about again, or even just able to sit upright. This card-play was represented to me as something at variance with the commands of Her Imperial Majesty and therefore I, as the senior commander, ought to forbid it. My answer to this was that the regulations or ukase against playing cards had been made without any thought of this desert island, because at that time it had not yet been discovered. If they had had any inkling then of our men's cardplaying and of our pitiable circumstances, I was sure that they would have introduced a special paragraph giving permission for all suitable pastimes [pp. 135–36].

After the crowded escape ship returned to safety at Petropavlovsk, Waxell eventually returned to St. Petersburg in 1749. There he was assigned the task of examining all journals and logs of both ships, in order to draw a map of the area explored. During this period he wrote his account of the voyage, which was published nearly 190 years later by a Danish publishing house that had acquired his manuscript.

Waxell placed much of the blame for the disasters suffered by the expedition on the inadequate map of the astronomer Delisle de la Croyère, which showed a nonexistent "Juan de Gama Land." Delisle, who sailed on the *St. Peter*, had, on the recommendation of the Russian Academy, been given charge of the "astronomical, physical, and other scientific observations of that nature." His chart, and some others of the period, gave credence to the purported discovery by a Spanish navigator, Juan de Gama, during a voyage from China to New Spain prior to 1649.[3] Precious time was wasted searching for the land, delaying the *St. Peter* until the season of storms and gales. Waxell's anger lasted: "My blood still boils whenever I think of the scandalous deception of which we were the victims."

Promoted to "captain of the first rank," Waxell continued in the navy, spending ten years in the Baltic in command of various ships. After 1758 he was transferred to the huge naval base at Kronstadt as Intendant. It is believed that he retired in 1761. His death came on February 14, 1762, at the age of sixty-one. Sixteen years of his life had been devoted to Bering's second expedition.[4]

Waxell Ridge (4,000 to 10,000 feet) in the Chugach Mountains of Alaska was named for him.

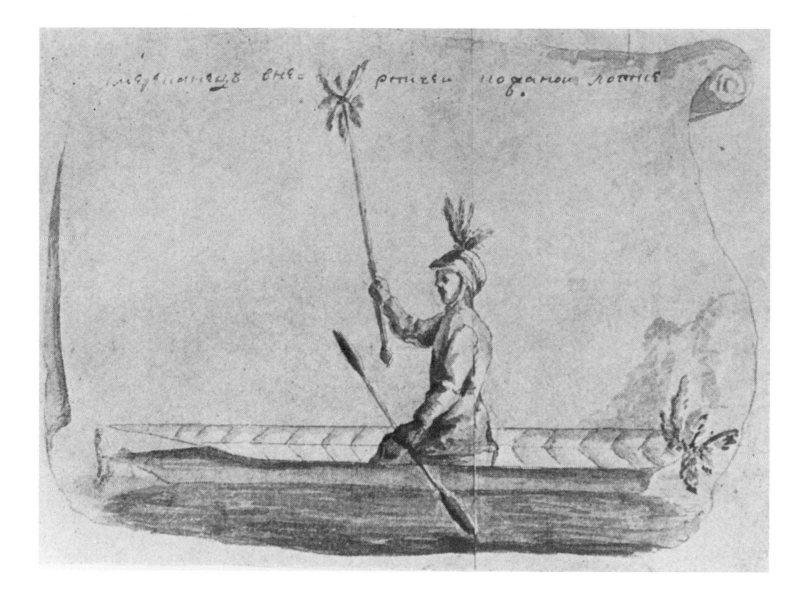

Bering's first encounter with an Aleut, 1741

Drawing attributed to Sven Waxell on a 1744 chart of the voyage of the *St. Peter*, from Golder, *Bering's Voyages*, 1:facing p. 149; courtesy Pacific Northwest Collection, UW Libraries.

"We saw two small boats paddling toward our vessel from shore . . . both men began . . . to make an uninterrupted, long speech in a loud voice. . . . One of them came very near . . . took from the sticks lying behind him one . . . painted red, placed two falcon wings on it and tied them fast with whalebone, showed it to us, and then with a laugh threw it towards our vessel into the water" (from Steller's journal, in Golder, Bering's Voyages, 2:90, 92). *[Throwing the stick may have been meant as an offering to supernatural beings, rather than as an expression of friendship (Jochelson,* The Aleut, *p. 15).]*

It is possible that this sketch was made by Plenisner under Waxell's direction (see Stejneger, Steller, *p. 520), although Waxell himself referred to "the detailed drawing which I made on the map which is sent to the Admiralty College"* (Golder, Bering's Voyages, 1:275).

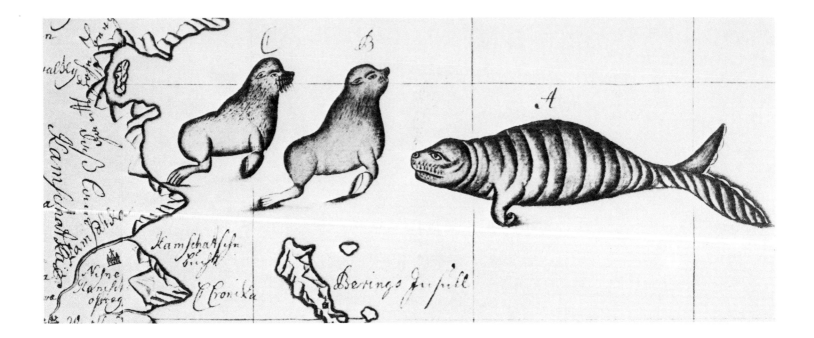

A fur seal, sea lion, and sea cow, 1741

Detail of Sven Waxell's chart of the voyage of the *St. Peter*, in Golder, *Bering's Voyages,* 2: facing p. 229; courtesy Pacific Northwest Collection, UW Libraries.

This drawing was made either by Waxell or by Plenisner under Waxell's instructions. It includes the only known existing contemporary likeness of the northern species of sea cow (Hydrodamalis gigas), *which became extinct in 1768, only twenty-seven years after its discovery by Steller. It was large, varying from twenty-eight to thirty-five feet in length, herbivorous, and almost defenseless. Its presence was fortunate for the voyagers, as a few months after the wreck of the* St. Peter, *sea otters became shy and difficult to hunt* (Golder, Bering's Voyages, *2:139n, 229).*

 "We now soon found ourselves so abundantly supplied with food that we could continue the building of our new vessel without hindrance. All of us who had partaken of it [sea cow meat] soon found out what a salutary food it was, as we soon felt a marked improvement in strength and health . . . with this sea cow meat we also provisioned our vessel for the voyage" (from Steller's journal in Golder, Bering's Voyages, *2:228, 235).*

A Secret Voyage to the Aleutians, 1768–70

Two hundred years ago secret missions by governments were no less customary than in today's world. In 1764, by order of Empress Catherine II, the Admiralty College of Russia prepared plans for an expedition, disguising its purpose by calling it "the commission sent to make an inventory of the forests on the Kama and Belaia rivers."[1] This act was prompted by a report from the governor of Siberia to Catherine, telling of discoveries made by a small expedition exploring for the merchants of Kamchatka. In the mysterious areas to the east, this expedition had found unknown islands and natives with a plentiful supply of furs to trade. Catherine ordered the follow-up expedition to leave as soon as possible to fully explore and map the Aleutian Islands, to make Russian citizens of the natives, and to exact *iasak* (tribute) from them—all in the name of strengthening Russia's legal and practical position in the push toward the great lands believed to lie to the east.[2]

Sixteen men, headed by Captain-lieutenant Petr Kuz'mich Krenitsyn, with Lieutenant Mikhail Dmitrievich Levashov as second-in-command, left St. Petersburg with forty-two carts on July 1, 1764. Once at Okhotsk, Krenitsyn was to obtain ships, or build them if necessary, and recruit local seamen for the voyage.

Through a series of misfortunes and delays, it was not until July 20, 1768, that the *Sv.* [Saint] *Ekaterina* commanded by Krenitsyn, and the *Sv. Pavel* under Levashov, left for the open sea. During the voyage, both officers made sketch maps of islands in the Aleutian chain, sailing as far as Unimak Island, the largest and most distant from Kamchatka of all the islands.[3]

The achievements of this two-year expedition were of major importance for the time, and in the past have not been given their due credit. Detailed descriptions and surveys were made of more than thirty islands, including those in the eastern part of the Aleutian chain that were relatively unknown. Investigators gathered valuable ethnographical materials and information on diverse native tribal groups, which were described under the common name "Aleut." The knowledge gained was instrumental in furthering Russian expansion to the east, including its eventual presence on the American mainland. Many lives were lost in the accomplishment. Of the 215 men in the expedition, 85 died from scurvy or drowning.

Petr Kuz'mich Krenitsyn

Petr Krenitsyn was born in 1728, and was thirty-six when his expedition left St. Petersburg in 1764. He was selected leader by the Admiralty College, which had considered a list of capable naval officers prepared by Admiral Nagaev. Then a veteran of twenty years' service in the Russian navy, Krenitsyn had served under Nagaev during a survey of the Baltic Sea, had seen combat, including the siege of the Kolberg fortress, and had also commanded the *Jupiter* and the frigate *Rossiia*.[1]

Krenitsyn met his death by drowning while crossing the Kamchatka River on July 5, 1770, near the end of the returning sea voyage. According to an English historian in 1780, the tragedy occurred in "a canoe belonging to the natives."[2] In 1827 Admiral Krusenstern named the southwest tip of the Alaska Peninsula "Cap [Cape] Krenitzin" in his honor. It was probably Captain Tebenkov in 1852 who named the Krenitzin Islands, a group of seven or more islands in the Aleutian chain, placing it on his map as "Ostrova Krinitsyna."

Mikhail Dmitrievich Levashov

Mikhail Levashov is known to have been born in 1738, hence he was twenty-six when the Krenitsyn-Levashov expedition left St. Petersburg in 1764.* As a midshipman in some of the same ships as Krenitsyn, he had "displayed great courage in battle," and was recommended by Krenitsyn for appointment as his second-in-command.[1] He was knowledgeable in science and an experienced seaman, as well as a capable cartographer and draughtsman. He made many sketches during the voyage, and recorded numerous ethnographical observations, both in his journal and in notes accompanying the sketches.

*Biographical information on Levashov exists in Russian institutions, but is not available to Western researchers.

"Ritual dance of the Aleuts," 1769

Detail on a map drawn by Krenitsyn, first published in Fedorova, *The Russian Population*, pl. 2; courtesy of Svetlana G. Fedorova and Richard A. Pierce.

This map was copied in the early 1770s from an original "map of newly discovered American islands," drawn by Petr Krenitsyn. The copy is at the Archives of Russian Foreign Policy (Fedorova, The Russian Population, *pp. 353–54). The title reads: "Americans at play and dancing, in their manner of amusing themselves."*

After Krenitsyn's death by drowning in 1770, Levashov returned to St. Petersburg as leader of the expedition. He turned over records, journals, copies of his notes, and a number of his drawings to the Admiralty. These in turn were given to the naval hydrographer, Admiral Nagaev, who reported on his analysis of the material to the Admiralty College on November 22, 1771. He also called for formal recognition of the two surviving officers of the original six, resulting in Levashov's promotion to "captain of the first rank," at age thirty-three, which began a long and honorable naval career.[2]

In 1827 Admiral Krusenstern honored him by giving the name "Port Levashef" to the bay at the head of Captains Bay on Unalaska Island.

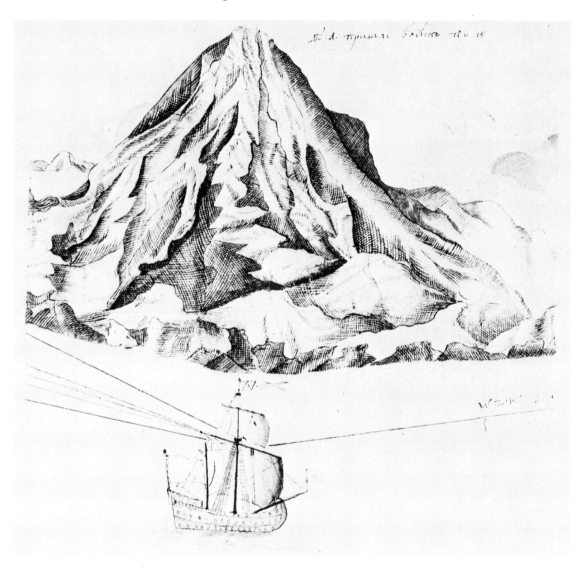

Levashov's ship St. Paul *in the Aleutian Islands, 1768–69*

From an atlas of drawings by M. D. Levashov in the Hydrographic Section, Ministry of Marine, Petrograd, photocopied by F. A. Golder; courtesy Pacific Northwest Collection, UW Libraries.

This copy made by Frank Golder in the 1920s may unfortunately have omitted a portion of the original drawing. Presumably, the lines had compass points marked at their ends, and there might have been additional text to identify the island bearing the lofty mountain.

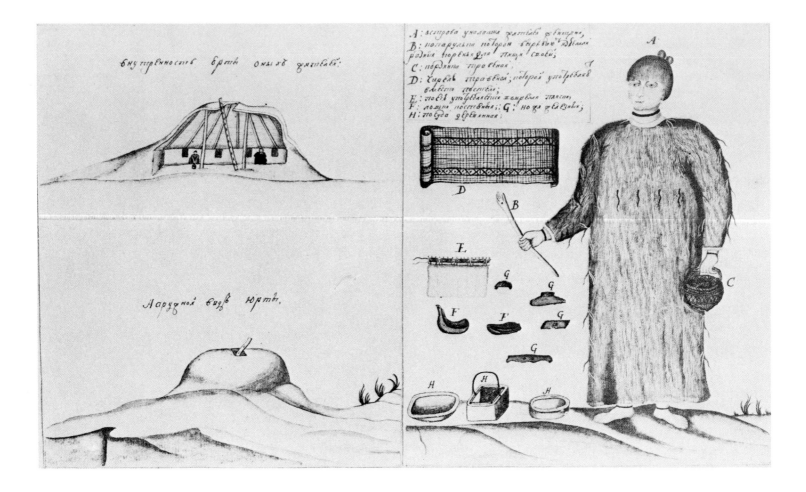

Aleut woman and native hut, Unalaska Island, 1767

From an atlas of drawings by M. D. Levashov in the Hydrographic Section, Ministry of Marine, Petrograd, photocopied by F. A. Golder; courtesy Pacific Northwest Collection, UW Libraries.

At left are views of the inside and outside of an Aleut yurt. At right, according to the legend, are: (A) a native woman, (B) a digging stick, (C) a grass basket, (D) a grass sleeping mat, (E) a dancer's belt, (F) spoons of bone, (G) iron knives, (H) wooden utensils. The frames of the yurts were made either of whale ribs or of driftwood (Jochelson, The Aleut, *p. 21). Sarychev recorded that "they are covered with grass and mud, and instead of a door have an opening, which is too low to enter without stooping. From this opening you ascend by a beam . . . into the interior of the hut" (*Voyage, *2:8).*

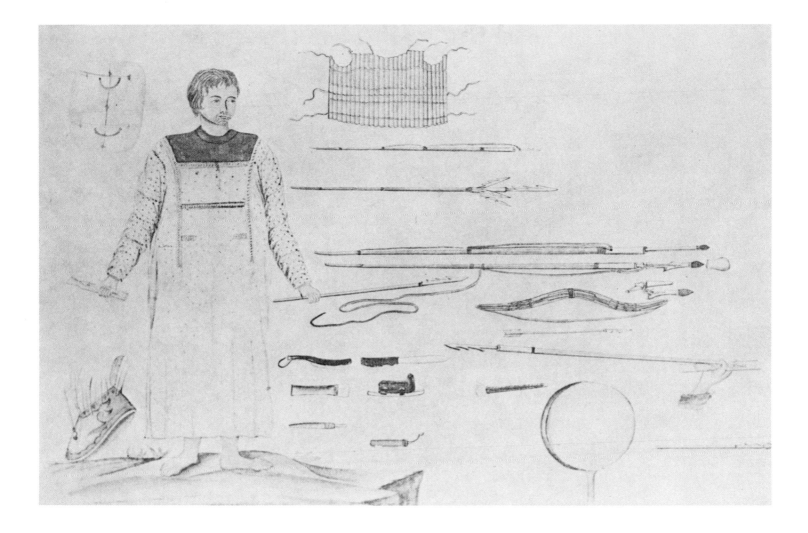

Aleut man, with hunting and fishing equipment, Unalaska Island, 1767

From an atlas of drawings by M. D. Levashov in the Hydrographic Section, Ministry of Marine, Petrograd, photocopied by F. A. Golder; courtesy Pacific Northwest Collection, UW Libraries.

At top left and middle are a shield and wooden slat armor used in warfare; below are various spears, knives, and tools. At lower right is a spear with its notched throwing stick, which enables it to be cast with great force and accuracy.

Joseph Billings and the *Slava Rossjii*, 1787–92

Concerned by news of a French expedition to the Pacific under the command of La Pérouse, which might establish a French claim to a fur-trade port on the Northwest Coast, the Russian crown reacted by an *ukase* dated August 8, 1785, detailing plans for a countering expedition.[1]

Instructions issued through the Admiralty College required Joseph Billings, an Englishman in Russian naval service, to head "an expedition of discovery to the most eastern coasts and seas of Her Empire." He was to chart the northeast coast of Siberia, and construct "an exact chart of the islands in the Eastern Ocean extending to the coast of America; in short, for bringing to perfection the knowledge . . . of the seas lying between the continent of Siberia and the opposite coast of America."[2]

By the middle of October 1785, the expedition had been sent off in small detachments on the arduous overland trip to Okhotsk, where ships were to be built. Five years later—after an intervening Siberian survey under Billings' direction—on May 1, 1790 the expedition finally departed eastward on the *Slava Rossjii*. In 1791 an additional vessel, the *Chernui Orel*, joined the expedition in the Aleutians, wintering at Illiuliuk (Illuluk) Bay on Unalaska Island. By March of 1792 seventeen men had died of scurvy, and others were unwell, making it difficult for the remainder to overhaul the ships for sea duty. Billings and his party, which had returned to the Siberian mainland in the *Chernui Orel* to complete the surveys mandated by the *ukase*, had their own troubles. The hostile Chukchi had destroyed the surveying instruments and impeded any further exploration. Billings sent word to one of his officers, Gavril Sarychev, stating his intention of immediately returning to Yakutsk.[3]

This action signalled the end of the Billings' expedition for all practical purposes, although it did not officially end until 1794. Billings retired on a commander's pension in Moscow in 1797.[4]

Billings' rather meager achievements were due in part to the Admiralty College having overestimated his abilities, being unduly impressed by his connection with Cook's third voyage. In 1776, at age eighteen, he had been enrolled as an able seaman under Cook on the *Resolution*, and at some point during the voyage had served as an astronomer's assistant. While in St. Petersburg, perhaps as mate of a merchant ship, he joined the Russian navy as a midshipman in 1783.[5] He was given the expedition command at age twenty-seven, only two years after enrolling, probably over the heads of other more qualified officers.

His third-in-command, Gavril Sarychev, was a perceptive observer and forthright in his account of the voyage. He generally refrained from criticizing his commander, but on one occasion involving a narrow escape, he could not resist:

Towards evening, we were enveloped in a thick fog. Captain Billings directed our course by an English map, taken during Cook's voyage, far more northerly than the Copper Islands are there given. As this direction, according to the Russian map, would have led us strait to the middle of the Copper Islands, I made my representations to Captain Billings, who paid so little regard to the Russian map, that I persuaded him, with difficulty, to alter his course two rumbs more northerly, and by that means alone we escaped the impending danger; for the next morning the mist clearing away, we saw we had passed the northern point of the Copper Island by no more than two hundred fathoms; nay, that from the stern of our ship we could distinguish the rocks concealed under water.[6]

Historians differ in their evaluations of this nine-year expedition. Bancroft, in 1886, felt that "the geographical results may be set down at next to nothing," whereas a London biographical dictionary in the same year claimed that "by it were made many large additions to our knowledge of the geography of those inclement regions."[7] A detailed and illustrated journal by Sarychev and numerous sketches by Luka Voronin are a valuable historical record of the expedition.

Gavril Andreevich Sarychev

Among the officers of the Russian navy, there were many who would have conducted the expedition much more creditably than the Englishman [Billings]: every thing useful that was effected by it, was done by Captain Sarytscheff, who alone possessed any extraordinary scientific knowledge of his profession . . . without his exertions . . . Russia, in all probability, would not have had a single chart by the leader of the expedition. (Krusenstern, Voyage Round the World, 1:xviii)

Third-in-command of the Billings expedition, Gavril Sarychev also possessed considerable ability in drawing. This is evidenced by his 250-page journal of the voyage, lodged in Russian naval archives, which contains many sketches of the North Pacific.[1] Born in 1763, he was twenty-two at the start of the venture. Limited biographical data is available in Russian dictionaries, but clues to his character emerge from the pages of his published account.

Sarychev was both admired and liked by Martin Sauer, secretary to the expedition; "[Sarychev] was the only scientific navigator in our Expedition: a gentleman, who possessed that particular modesty which is always the companion of merit, with feelings the most acute, refined by true sentiments of honor."[2]

While the expedition was in one of its overland phases on the Kamchatka Peninsula, Sarachev learned to use a dog sledge during the winter, accumulating some useful information; "you must never let your dogs go loose. If ever you are overturned, you must rather be dragged along in the snow than leave your hold, for it is a great disgrace to lose your dogs, and be obliged to wade through the snow on foot."[3]

Discovering that some of the bays on the western side of Unalaska Island had not been surveyed, Sarychev embarked "in a treble-seated baidar [baidarka or kayak], attended by a few islanders in single-seated ones. I was obliged after the manner of my companions to draw on an upper garment of fishes' entrails, to put a wooden hat on my head, and take the oar in my hand."

Except for one experience involving a threatened attack which was foiled, Sarychev completed his surveys in harmony with the natives: "the Aleutians have a good natural understanding, very considerable talents, and a quick comprehension; some of them were very expert at cards, draughts, or even chess, in which none of our companions could excel them." He found them hospitable: "I myself was witness to their sharing the half of their own provisions with perfect strangers from other islands . . . without receiving any compensation."[4]

Sarychev returned to Russia to resume his navy career, one which soon became illustrious. Promoted to admiral some time prior to 1806, he became a member of the Board of Admiralty, and, in 1829–30, headed the Navy Ministry. He wrote several books on navigation, and compiled the first regulation map of Saint Petersburg, also writing numerous articles for *Notes of the Hydrographic Department*. He died in 1831, at age sixty-eight.

The United States Coast and Geodetic Survey used an atlas containing many Sarychev surveys in preparing its definitive *Dictionary of Alaska Place Names*. Four natural features on the Alaskan coast and in the Aleutian Islands are named for Sarychev: Sarichef Cape, named by Litke in 1836, Sarichef Island, named by Kotzebue in 1816, Sarichef Strait, and Sarichef Volcano.

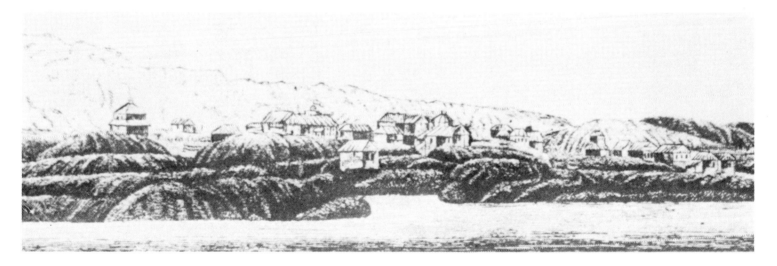

"The settlement of St. Paul at Kodiak Island," c. 1808–10

Drawing attributed to G. A. Sarychev, reproduced in *Dictionary of Alaska Place Names*, fig. 13; courtesy Pacific Northwest Collection, UW Libraries.

Sarychev's great 1826 atlas was published when he was Hydrographer-General for the Imperial Russian Admiralty. It contained twenty-six maps and plans, including some by other explorers and navigators. Sarychev himself made many drawings during the first Billings expedition; these are located in Russian naval archives.

Luka Alekseevich Voronin

Detailed orders for the Billings expedition of 1785 called for the services of a competent artist, since there were to be descriptions and drawings of "the most curious productions of nature," as well as of "the furs, dresses, arms, and manufactures" of the region. The customary charts were to be made, taking "views of the coast and remarkable objects."[1]

The artist selected was Luka Voronin, who had recently received a first degree certificate from the Academy of the Arts in St. Petersburg. Voronin was only twenty years old in 1785 when the expedition began its long overland journey to the Siberian coast.[2] He may have endured an overnight visit in the dwelling of a friendly native better than his companions, Captain Billings and Dr. Merck, the naturalist. In his account of the expedition, Martin Sauer relates the incident: "Upon our arrival skins of rein-deer and other animals were spread for our seats before the fire. When we were placed, the hostess presented each with a thin slip of the skin of a marten, and immediately after with fish, and the meat of the deer boiled; but the intolerable stench of the hut took away all appetite on our part . . . though we were well guarded by our soldiers and sailors . . . we passed a sleepless night."[3]

Near dark the following day, after a fruitful period of exploring, surveying, botanizing, and sketching, the party embarked to return to the *Slava Rossjii*, but "the sea was rough and the current against us . . . the wind freshened, and it rained hard." Making no headway, they anchored to await daylight, but the next day brought a repetition of bad weather. By late in the afternoon the wind had dropped, enabling them to reach the ship by midnight, a day and two nights after leaving the native hut.

Following the expedition's return to St. Petersburg, Voronin was employed by the Admiralty as a draughtsman. Details of his later life are not readily available, but it is known that "he made numerous sketches of the shores of Chukotsk Sea, of river Kolima, of Kuril and Aleut islands, of Kamchatka peninsula, and of scenes of common life of the peoples populating these regions."[4]

Martin Sauer's account of the Billings expedition includes several engravings for which the contemporary British illustrator and engraver, William Alexander, improperly took credit as the original artist. These were signed "Alexander del." (delineator), and in one case, "Drawn by W. Alexander." All appear to be drawn and "improved" from Voronin's sketches, for the purpose of engraving. Alexander was not a member of the Billings expedition, nor is there any mention of his participation in any other voyage on the Northwest Coast in the *Dictionary of National Biography*.

This misappropriation of a portion of Voronin's credit as draughtsman apparently did not bother Sauer, who in his preface noted that "I am equally sensible of Mr. Alexander's merit in the judicious arrangement of the drawings and costumes, which has enabled me to present the Engravings, exact in their resemblances, and executed in a manner highly pleasing to myself."

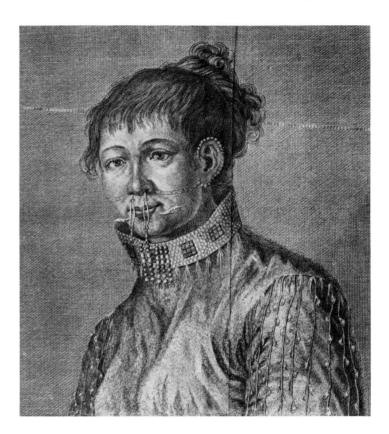

"Woman of Unalaskha," 1790

Engraving of a drawing by Luka Voronin, in Sarychev's atlas to *Puteshestvie*, pl. 18; courtesy Pacific Northwest Collection, UW Libraries.

"[The garment] is made like a carter's frock . . . with a round upright collar, about three inches high, made very stiff, and ornamented with small beads sewn on in a very pretty manner. Slips of leather are sewn to the seams of this dress, and hang down about 20 inches long, ornamented with the bill of the sea-parrot, and beads. A slip of leather three or four inches broad hangs down before from the top of the collar, covered fancifully with different coloured glass-beads, and tassels at the ends: a similar slip hangs down the back. Their ornaments are rings on the fingers, ear-rings, beads and bones suspended from the septum of the nose, and bones in the perforated holes in the under lip. Their cheeks, chin, and arms, are punctured [tattooed] in a very neat manner" (Sauer, Account, p. 155).

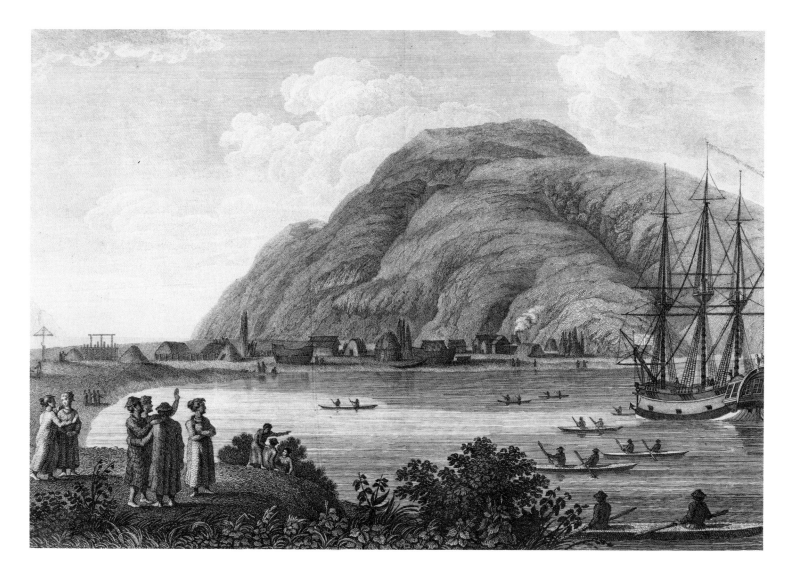

"View of the establishment of the merchant Shelikhov on the island Kad'iak," 1790

Engraving of a drawing by Luka Voronin, in Sarychev's atlas to *Puteshestvie*, pl. 36; courtesy Pacific Northwest Collection, UW Libraries.

This was the original location of the trading establishment of G. I. Shelikhov, in Three Saints Harbor on Kodiak Island, settled in 1784. It was later moved by Baranov to the more suitable location of Pavlovsk (St. Paul), near the northeast end of the island (Tikhmenev, Russian-American Co., *pp. 14, 31). The vessel is the* Slava Rossjii.

"The islanders flocked to us every day, as curious and wondering spectators, and particularly admired the extraordinary size of our vessel compared with their barges [baidaras]" (Sarychev, Voyage, 2:18). "About two hundred of the daughters of the chiefs are kept . . . as hostages [apparently] they are perfectly well satisfied" (Sauer, Accounts, p. 171).

"There are storehouses, warehouses, etc. rope-walk, smithy, carpenter's shop, and cooperage. Two vessels (galliots) of about 80 tons each are now here, quite unrigged, and hauled on a low scaffold near the water's edge. These are armed and guarded, and serve for the protection of the place" (Sauer, Account, pp. 172–73).

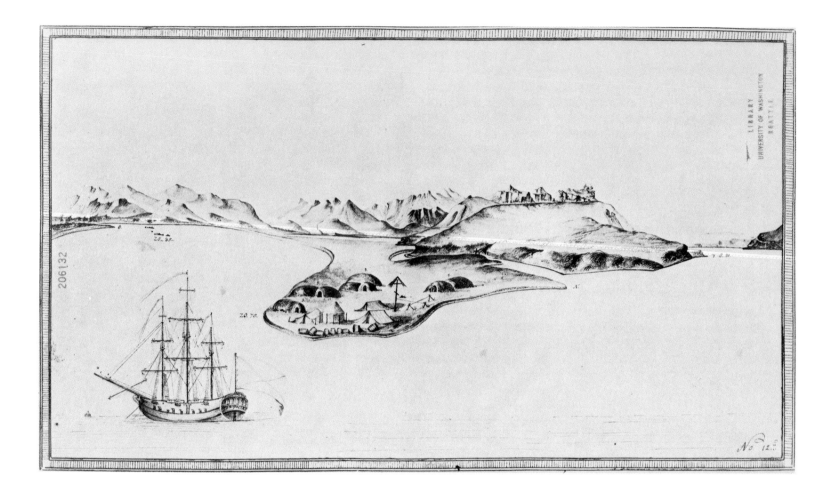

"Islands of Unalaska: The Captains Harbor," 1790

Drawing by Luka Voronin in F. A. Golder's portfolio, "Alaska Scenes," from the Hydrographic Section, Ministry of Marine, Petrograd; courtesy Pacific Northwest Collection, UW Libraries.

A careful comparison of this drawing with a modern nautical chart (NOAA no. 16529, Unalaska Island and Dutch Harbor) finds similar configuration and landmarks, with some allowance for the artist's perspective. Based on this study, it appears that the small settlement may well be that of Ilivliuk (Illuluk) described by Sarychev: "Illuluk lies on the eastern part of Captain's-bay, at the mouth of a brook. It contains four large jurts, or huts, constructed of mud, and logs of wood, which are driven hither by the currents of the sea" (Sarychev, Voyage, 2:10). However, there were other small villages in the area.

 The vessel's name, Slava Rossjii, appears on its stern. Ashore, an observatory tent has been set up with other tents. Two yurts at the right are the "store barracks." On the hill beyond is a cross labeled "where lies the body of the pilot." The barrels strewn along the beach are probably watercasks. Surgeon David Samwell's journal of Cook's Discovery (1778), according to Fedorova, also describes Illuluk (but not by name): "The Factory consists of 5 or 6 Houses . . . there were two Towns at a little distance from each other with 5 or 6 Houses in each & a large Cross erected with some figures and Letters carved on it" (Beaglehole, Cook Journals, 3:1138–39; Fedorova, The Russian Population, p. 217).

The Slava Rossjii *in Beaver Inlet, Unalaska Island, 1790*

Drawing by Luka Voronin in F. A. Golder's portfolio, "Alaska Scenes," Hydrographic Section, Ministry of Marine, Petrograd; courtesy Pacific Northwest Collection, UW Libraries.

"We came to anchor at eight P.M. *opposite the habitations of the natives. We sent an officer to sound, and hauled into the bay about 40 fathom from shore. Captain Billings landed with his astronomical tent; Dr. Merck went out on an excursion for curiosities; and Captain Saretcheff, with assistants, was sent to survey; while I employed myself in getting the best information that I could obtain of the inhabitants" (Sauer, Account, p. 154).*

At least two native villages appear on the distant shore, one above the ship's foremast, the other at the left end of the beach. In attempting to show the curvature of the shore, Voronin distorted his perspective.

The Voyages of James Shields, c. 1791–98

When the Vancouver expedition was surveying in Alaska waters in 1794, the *Chatham* was just off the shore of Yakutat Bay when the crew heard a gunshot from land. "This was soon accounted for by the appearance of five Kodiak Indians in two skin canoes, who repaired on board the *Chatham*, and acquainted Mr. Puget that there was a party of nine Russians on shore, from whom they brought a letter addressed in English to the commander of either the Discovery or Chatham."[1] The letter, dated June 13, was from James Shields, an Englishman building ships for the Russians at Blying Sound on the Kenai Peninsula.

Shields had somehow discovered that Vancouver needed a protected bay with beaches suitable for grounding the *Discovery* for maintenance and repair. He wrote Vancouver that the work "could no where be better performed than in Blying Sound," and offered his assistance. Vancouver was impressed: "His letter did great credit not only to his abilities and understanding, but to the goodness of his heart."

Shields had been a lieutenant in the "Ekaterinburg regiment" of the Russian army, later taking employment, probably in 1791, with the Russian trader Shelikov, who was attracted by his experience both as a shipwright and a mariner. An early task assigned to Shields was to build the ship *Severnyi Orel* (*Northern Eagle*) at Okhotsk, for service among the Russian fur-trading posts in the Aleutian Islands and the Alaskan mainland.[2]

In the fall of 1791, Shelikov sent the *Severnyi Orel* to Kodiak under Shields' command, laden with shipbuilding material for Alexander Baranov, chief manager of Russian colonies in America. Construction was to begin on several vessels with Shields' aid, in order "to teach the natives to be sail-makers, riggers, and blacksmiths."[3]

In 1793 Baranov explored Kenai Bay by baidara, an open boat made usually of walrus hide, searching for a site with a suitable supply of trees for a shipyard. Selecting a harbor in Chugach Bay, he ordered Shields to bring craftsmen and materials from Kodiak for the new yard.

Under Baranov, construction began on the three-masted seventy-three foot vessel *Phoenix*, which was completed in 1794. Baranov also utilized Shields' surveying and cartographic skills by having him map the coast from the Queen Charlotte Islands to Cape Edgecomb, near Sitka, as well as other areas.[4]

In 1798 the *Phoenix* was sent to Okhotsk under Shields. On the return voyage in stormy weather, she disappeared with eighty-eight men aboard, including the newly consecrated Bishop Ioasaf. There were no clues to their fate until "the subsequent casting ashore at Sitkha, Kad'iak, and Otter Bay of many items belonging to the ship finally forced acceptance of the sad truth."[5]

A eulogy, of sorts, was recorded in 1835 by Khlebnikov, second-in-command of the Russian-American Company: "Baranov did him justice by recognizing his seamanship. One accident cannot and should not destroy the good name of a man so eager to pursue his duty. Shields had been valuable to the Company, highly so, and his name deserves respect. Sea disasters overtook Laperouse, Flinders and Freycinet, as well as Shields."[6]

According to historian Frank Golder, who conducted research in Russia for several years prior to 1917, an original chart made by Shields ("Iakov Shilts") was lodged at the Military Historical Archive of the General Staff in Petrograd. It was described as about three feet by two feet, a "chart . . . of the navigation from Kodiak along the American coast eastward to about 56°N," on voyages from 1793 to 1797.[7]

In 1932, the United States Coast and Geodetic Survey named Shields Point in his honor. It is located on the north coast of Afognak Island, north of Kodiak, at Phoenix Bay, named after the vessel he built and commanded.

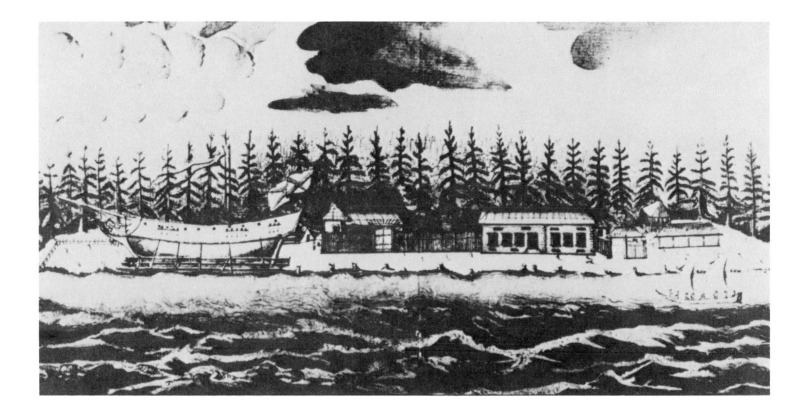

"Voskresenskaia" (Resurrection Harbor), 1794

Drawing by James Shields; courtesy Library of Congress.

"Baranov travelled by baidara around Kenai Bay, chose a harbor in Chugatsk Bay which had a plentiful supply of wood for shipbuilding, and ordered that a ship be built there. This port was named Voskresensk. Shields came from Kad'iak by boat, with craftsmen and materials. A serious difficulty was a lack of tar and pitch; instead pine and fir sap were collected which, when boiled together, produced a gum fit for use in shipbuilding" (Khlebnikov, **Baranov**, *p. 10*).

The city of Seward, Alaska, now occupies this area.

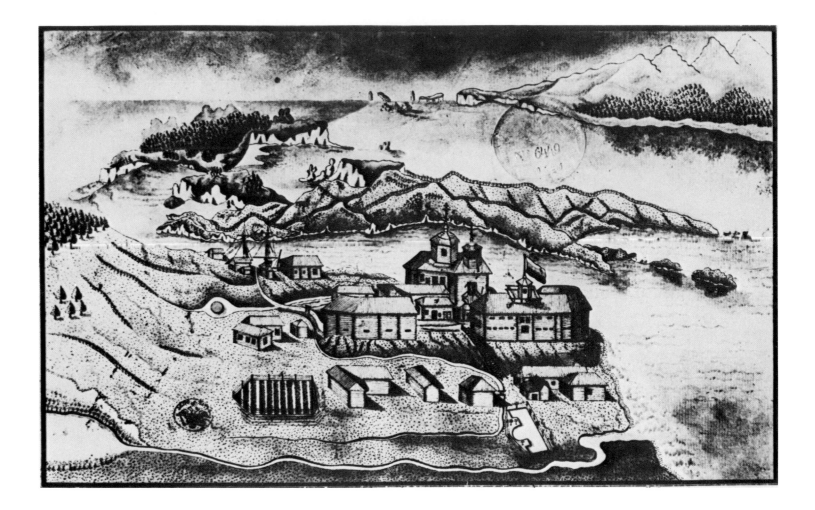

"View of the buildings of Pavlovsk Harbor from the north side," 1798

Unsigned drawing attributed to James Shields, first published in Fedorova, *The Russian Population*, pl. 6; courtesy of Svetlana G. Fedorova and Richard A. Pierce.

This site is now occupied by the city of Kodiak. The original drawing is in the Central State Historical Archive of the USSR.

Krusenstern and Lisianskii
in the *Nadezhda* and the *Neva*, 1803–6

On August 7, 1802, Ivan Fyedorovich Krusenstern, thirty-two years of age, was appointed by the Russian government to head the first Russian round-the-world expedition, a project which he had previously advocated without success. Since it was a joint venture of the Russian navy and the Russian-American Company, the navy would furnish personnel and command, while the company would pay for the ships and all supplies.[1]

Since no suitable vessels were available in Russia, he sent his second-in-command, Yuri Lisianskii, to London, "the only place where we may reckon with any degree of certainty upon the purchase of good vessels." Here two ships were purchased for 22,000 pounds sterling—the 450-ton *Nadezhda* and the 375-ton *Neva*.[2]

After being refitted with the most modern equipment available, the vessels left Kronstadt on July 26, 1803. Krusenstern commanded the *Nadezhda* with fifty-eight men, all volunteers, and Lisianskii the *Neva* with forty-seven men, also volunteers. Three able German scientists were retained to sail aboard the *Nadezhda*: astronomer Horner and naturalists Tilesius and Langsdorff.[3]

The expedition had three objectives: to chart the Far Eastern coast, to assist Ambassador N. P. Rezanov in establishing diplomatic and trade relations with Japan (a mission doomed to frustration and failure), and to visit and report on the Russian establishments at Kamchatka, the Aleutian Islands, and the mainland of Alaska.[4]

Rounding Cape Horn on March 3, 1804, after encountering a heavy gale and low temperatures, the two ships became separated in the fog, and except for brief reunions, completed the remainder of the voyage alone. The *Nadezhda* went on to Nagasaki where Rezanov spent nearly seven months in fruitless negotiation with the Japanese.[5]

One of Lisianskii's most important achievements while on the Northwest Coast was his key participation in the refounding of the Russian settlement at New Archangel (Sitka), which had been destroyed by the fierce and warlike Kolosh Tlingit two years earlier.[6]

After mobilizing a force of nine hundred men, Baranov made a landing, attempting to take the native fortress by storm. The attack was repulsed with heavy loss, and only through shelling by the *Neva* was virtual annihilation avoided. Since Baranov was wounded in the attack, he requested Lisianskii to assume command. The final victory went to the Russians, with Lisianskii reporting the retreat of the Tlingit: "After every thing that could be of use was removed [from Fort Sitka] it was burned to the ground. Upon my entering it, before it was set on fire, what anguish did I feel, when I saw, like a second massacre of innocents, numbers of young children lying together murdered, lest their cries, if they had been borne away with their cruel parents, should have led to a discovery of the retreat to which they were flying!"[7]

After an uneventful return voyage, the *Neva* anchored at Kronstadt on August 5, 1806, and was soon overwhelmed with visitors. Emperor Alexander and the empress-mother toured the vessel, the latter rewarding each member of the ship's company with gifts, including a silver medal especially designed for the occasion.

Georg Heinrich von Langsdorff

Born in Wöllstein, Germany, on April 18, 1774, Langsdorff, even in his early years, had a leaning toward the study of natural history. In 1797 he earned a doctor's degree in medicine and surgery from the University of Göttingen, and shortly afterwards accompanied Prince Christian of Waldeck to Lisbon, where the Prince became general of the Portuguese army.[1]

Langsdorff's interest in natural history continued and deepened, although his years in Lisbon, where he established a medical practice, left him very little time to devote to his studies. He subsequently took the post of surgeon-major for an English regiment in Portugal, serving in the campaign of 1801 against the Spanish. After the peace of Amiens he returned to Germany in 1803.

His pursuit of botany by this time had attracted the attention of a number of prominent French naturalists. He had also been named as a correspondent of the Imperial Academy of Sciences at St. Petersburg. Learning of the impending first Russian round-the-world expedition under Krusenstern in the ships *Nadezhda* and *Neva*, he moved vigorously, but belatedly, to obtain an appointment as a naturalist on the voyage. Although his application was supported by influential individuals, including the counsellor of state, he was informed that Tilesius had already been appointed the official naturalist.[2]

The expedition was to stop for a week in Copenhagen, and by a fortunate circumstance, Langsdorff caught a ship just ready to sail. With a favorable wind they reached Copenhagen in time for him to register at the hotel where most of the expedition officers were staying and where he could plead his case. When the ships left Copenhagen, Langsdorff was aboard the *Nadezhda*. Krusenstern's support may have been the deciding factor. He admired "the enthusiasm of this philosopher, . . . so great was his ardour to join in the voyage, that he was not to be deterred."[3]

After the *Nadezhda* had touched at many parts of the world, including Japan where Ambassador Rezanov was landed to pursue his abortive diplomatic mission, she reached Kamchatka in June 1805. Rezanov was to leave for a tour of inspection of the various outposts of the Russian-American Company in the Aleutian Islands, and eastward to the American mainland. Needing a physician for the journey, he approached Langsdorff.[4]

G. H. von Langsdorff, c. 1812

Frontispiece to Langsdorff, *Voyages*, vol. 1; courtesy Pacific Northwest Collection, UW Libraries.

On June 13, Langsdorff and his new employer boarded the company's ship *Maria*, anchoring in Sea Otters Bay at Unalaska Island on July 16. Debarking, the party immediately set out on the arduous overland trek to Illiliuk, a company post, arriving there at midnight in an exhausted condition, stumbling and climbing over stones and cliffs, and through underbrush.

Leaving Unalaska on July 29, they anchored in Three Saints Bay on Kodiak Island, near the principal factory of the company. By this time Langsdorff was becoming disenchanted with his employer: "though at Kamschatka large promises were made me, both in writing and orally, as to what should be done for the promotion of scientific undertakings, no alacrity has been shewn in fulfilling these promises." In addition, he had become thoroughly appalled at the evidence of oppression and brutality toward the natives. He wrote that he had "seen the Russian Promuschleniks, or fur-hunters, dispose of the lives of the natives solely according to their own arbitrary will, and put these defenceless creatures to death in the most horrible manner. . . . It is revolting to a mind of any feeling to see these poor creatures half-starved and almost naked . . . when at the same time the warehouses of the Company are full of clothing and provisions." He went on to point out that the *promyschleniks* were not much better off themselves, calling them "extremely ill-treated": "the scurvy generally breaks out upon them after a very short stay . . . not a year passes that it does not carry off many."[5] His entreaties on behalf of the oppressed finally did move Rezanov to dispatch the ship *Juno* to San Francisco for a supply of fresh provisions, accompanied by himself and Langsdorff.

The latter's long stay in the northern regions was agreeably broken by the forty-day sojourn in California. The contact with the hospitable Spanish was in such contrast to the disagreeable conditions that he had endured for so long, that on his return, he decided to return to Europe. With Rezanov's consent, he departed for the Siberian mainland on June 19, 1806. Europe was still far away, in both time and distance, as circumstances required him to spend nine months at Kamchatka.[6]

It was not until March 1808, after a long overland journey, that he entered "the magnificent imperial city" of St. Petersburg for the first time. Highlights of his later life include recognition from the Russian emperor, who awarded him a pension of three hundred ducats for life; election as a full member of the Russian Academy of Sciences in 1808; and appointment as Russian consul-general at Rio de Janeiro in 1812.[7] His vice-consul assumed a substantial part of the official duties, so he found ample time to continue scientific research, including some long journeys into the interior, and report on his research to the Academy of Sciences.

In 1821 Langsdorff was called to St. Petersburg, where in recognition of his service for eight years as a consul, the government made him a state councillor and a knight of the order of St. Vladimir. He was then appointed to head the Imperial Russian Scientific Expedition into the remote Brazilian interior, while continuing his office as consul-general.[8]

Early in 1828 Langsdorff and his companions contracted the first of a series of debilitating fevers, probably malaria. His health continued to deteriorate, and within several months he had become "totally deranged in his mind and played no further part in the journey." Returned to Rio de Janeiro, he was taken to Freiburg in the care of a German friend, where he spent his remaining years until his death on June 29, 1852, at the age of seventy-eight.

The magnificent collections of the several Langsdorff expeditions, believed to number in excess of one hundred cases, were sent to Russia between 1822 and 1830. Because of his continuing mental illness, Langsdorff was unable to publish an account of his accomplishments. This could readily have been arranged by the czarist government, whose indifference toward its own expedition allowed a jurisdictional dispute to develop between two competing institutions. This effectively blocked any comprehensive study and report on the botanical and zoological specimens, valuable anthropological data and materials, and geographical, political, economic, and statistical information.[9]

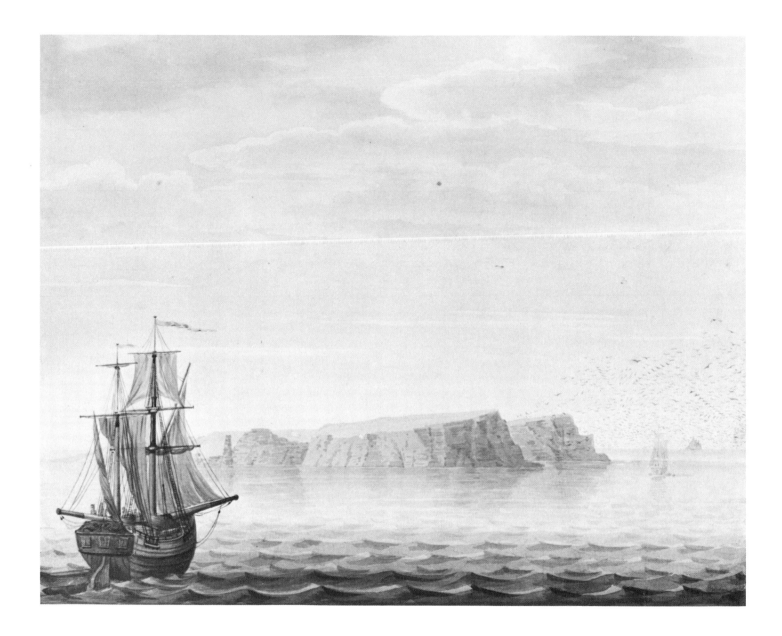

View of St. George Island, 1805

Watercolor drawing by G. H. von Langsdorff; courtesy The Bancroft Library, University of California.

"When we were at the distance of about a sea-mile and a half, a cannon was fired to attract the observation of the inhabitants [Russian hunters], and invite them to the vessel. At the same moment, while the echo of the fire resounded along the steep cliffs, an innumerable flight of birds of various kinds rose terrified along the coast. Without any exaggeration, . . . I can assert, that literally a thick living cloud spread itself around, and that the sea, as far as our horizon reached, was absolutely blackened by the animals" (Langsdorff, Voyages, 2:27).

The vessel in the left foreground is the 150-ton brig Maria, *which carried Langsdorff from Kamchatka to the Aleutians and Sitka.*

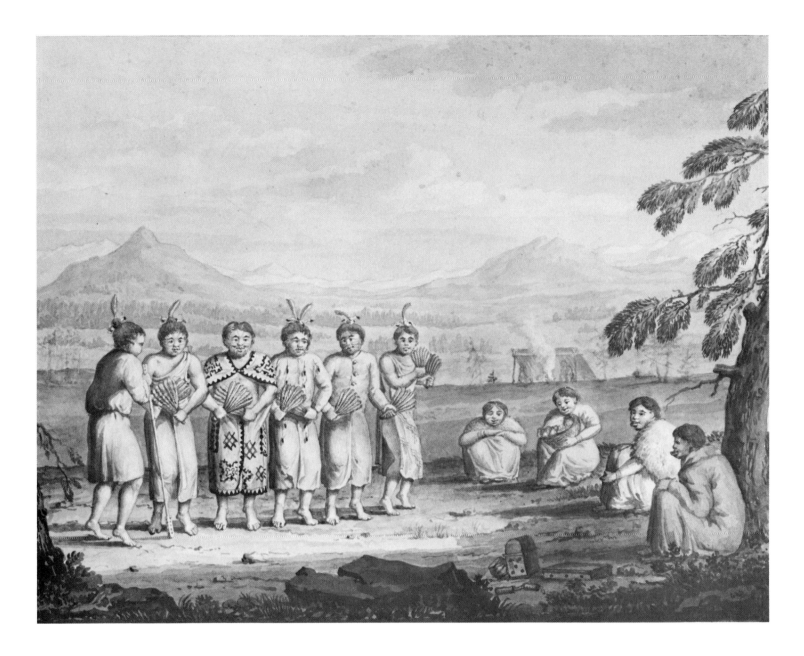

Tlingit Indians dancing at Sitka, c. 1805

Watercolor drawing by G. H. von Langsdorff; courtesy The Bancroft Library, University of California.

"They are dressed in a simple garment . . . which they purchase from the merchants of the United States of America. In their hands they each hold a tail of the white-headed eagle. The foremost dancer has in his hand a stick ornamented with sea-otters teeth, with which he beats time. Some of the dancers have their heads powdered with the small down feathers of the white-headed eagle. The women sit by the dancers and sing: they have the very extraordinary national ornament to the under lip. In the background is a moveable hut of the Kaluschians" (Langsdorff, Voyages, *2:"Explanation of the Plates").*

This drawing, reproduced with minor changes as an engraving facing page 114 of Langsdorff's Voyages, *has two standing figures added in the left background. They appear very faintly sketched in on the original.*

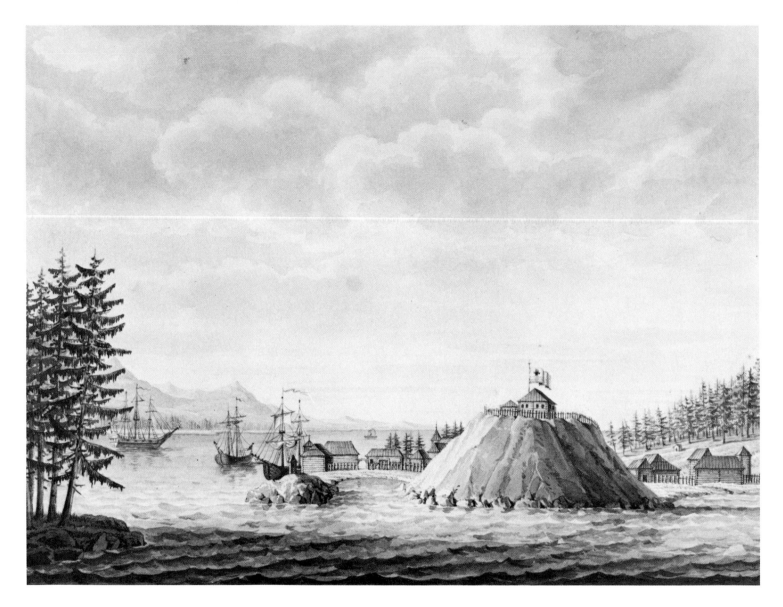

"View of the Establishment at Norfolk Sound," 1805–6

Watercolor drawing by G. H. von Langsdorff; courtesy The Bancroft Library, University of California.

"The settlement of New Archangel [Sitka] . . . was at our arrival quite in its infancy . . . the cape was fortified with large cannon, and some armed vessels of the Russio-American Company were stationed before it, while a regular watch was kept both by day and night. The habitations were for the greater part unfinished, and consisted of small chambers without stoves, with so thin a thatch, that the rains, which we had continually, often came through. The Promüschleniks [Russian hunters or traders] were kept constantly hard at work upon the barracks, warehouses, and other buildings, which were so exceedingly needed" (Langsdorff, Voyages, 2:87).

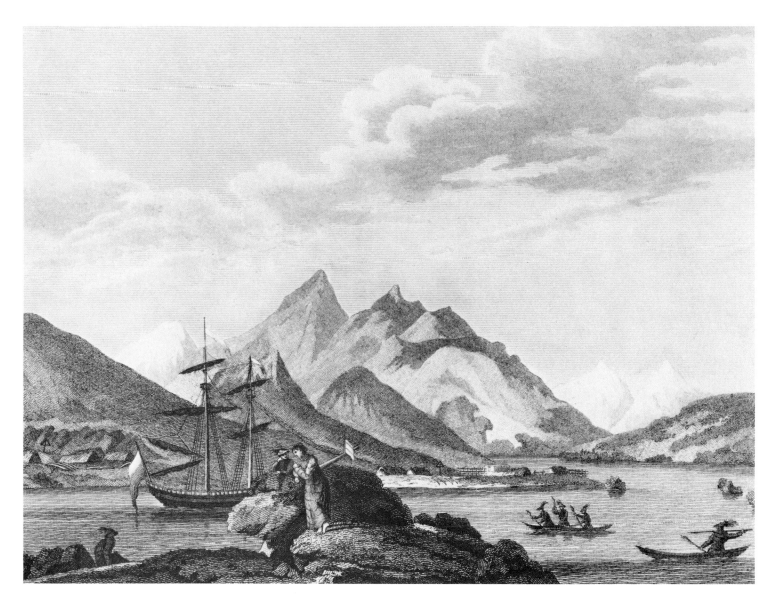

"View of the Russian Settlement at Oonalashka," 1806

Engraving of a drawing by G. H. von Langsdorff, in his *Voyages*, frontispiece to vol. 2; courtesy Pacific Northwest Collection, UW Libraries.

"The village of Illuluk lies upon a small low neck of land. The mounds, which have the appearance of graves, are the earth-huts of the inhabitants. Near them are several crosses, which were erected to the memory of some Russians of distinction who died on this island: a sort of scaffolding is seen not far from them, on which fish are hung up to be dried. In the foreground are some Aleutians in their leather canoes or baidarkas, *who are throwing their javelins. The small long narrow objects upon the ground near the huts are baidarkas turned upside down: when not in use, they are always laid up in this way along the shore"* (*Langsdorff, Voyages, 2: "Explanation of the Plates"*).

The sailing ship was probably the forty-two-ton Rossüslaff *under Captain d'Wolf, on which Langsdorff left Sitka in 1806. The baidarka in the right foreground, with its occupant poised to cast his spear, seems improbable in this setting and was perhaps added for interest.*

Yuri Fedorovich Lisianskii

Of the hundreds of sea captains on the Northwest Coast between 1741 and 1841, few possessed the combination of artistic ability and motivation necessary to supplement their journals with drawings. Yuri Fedorovich Lisianskii was one who did. He also thoughtfully provided a future biographer with highlights of his career.

He states that he was born in Negin, a town in "Little Russia," on April 2, 1773, of "Noble Parents." At the age of ten he entered the Marine Academy at Kronstadt. After years of rigid discipline, studies, and probably a certain amount of hazing by the older cadets, in 1789 he was made a midshipman in the Imperial Russian Navy and immediately entered the Russo-Swedish war, participating in most of the general engagements in the Baltic Sea.[1]

Promoted to a lieutenancy in 1793 at the age of twenty, he was one of a group of sixteen of the most promising junior officers who were ordered to England for training in the British navy.[2] After studying English, he sailed with a British squadron for the coast of North America early in 1794 in the frigate *L'Oiseau*, captured from the French. Nearing the American coast, the squadron captured a large fleet of American ships under French convoy. Lisianskii admired the "superior sailing" of the *L'Oiseau* in this action.[3]

After being refitted in Halifax, his vessel left on a winter cruise, but was damaged in a storm and was forced to land in the West Indies for repairs. Here Lisianskii contracted yellow fever, surviving through the solicitous attention of his captain, who had him moved into his own quarters. He subsequently traveled in the United States, spending the winter of 1795 in Philadelphia, where his Russian accent and uniform doubtless made the handsome young lieutenant interesting to feminine society. He returned to England in 1797.

Following his orders to see as much of the world as possible, he joined the *Raisonnable*, a line-of-battle ship voyaging to the Cape of Good Hope. Here he was transferred to the sixty-eight-gun *Sceptre*, but, with the return of fever, he had to travel inland to recover his health. Leaving the Cape in 1798, he sailed on the *Sceptre* to join the "well-known war against Tippoo Saib," which took him to Madras, and later to Bombay. Here he was promoted to the rank of commander, and ordered to return to Russia.[4]

He canceled his intended journey to China, and returned to England in a "country ship." His orders must have had considerable flexibility, for he spent the winter in England, returning to Russia in 1800. Soon after, he was made commander of a frigate and knighted with the order of St. George. In 1802 he was ordered back to England, to purchase two ships for the coming round-the-world voyage under Krusenstern. Lisianskii was given the command of the *Neva*, with the voyage occupying the next three years.

Following the successful completion of the expedition, Lisianskii, along with several others, received various "permanent honours and rewards," including the rank of post-captain, the order of St. Vladimir, and an annual pension of three thousand rubles.

Yuri Lisianskii, c. 1807

Engraved frontispiece to Lisianskii's *Voyage*; courtesy Pacific Northwest Collection, UW Libraries.

In 1807 he was sent to the Baltic to command a squadron of six sloops of war and four cutters. In addition, he was appointed commander-in-chief of "all the private yachts and vessels of his Imperial Majesty," presumably an honorary post. In 1808 he received the command of a seventy-four-gun line-of-battle ship, but "finding his constitution in a debilitated state, from the different climates . . . and many years at sea," he retired on half pay in 1809, at the age of thirty-six, after twenty-one years of naval service.[5]

From then on he occupied his time with literature and painting. (He also translated into Russian a book on naval tactics by John Clark.) His large ethnographical collection from the voyage was divided between the Rumyantsev Museum in Moscow, and the Kronstadt maritime collection.[6]

Geographical features bearing his name include an island which he discovered in the northwestern part of the Hawaiian Islands, a mountain on Sakhalin Island, a peninsula on the northern shore of the Sea of Okhotsk, and five features on the Northwest Coast. These are on or adjacent to Chichagof and Baronof Islands, and include twenty-five-mile-long Lisianski (sic) Inlet, Lisianski Peninsula and Point, near Sitka, Lisianski River, and thirteen-mile-long Lisianski Strait.

Active to the last, he died February 26, 1837, at the age of sixty-four. The closing pages of his journal contain a sailor's tribute to the *Neva*: "there never sailed a more lovely vessel, or one more complete and perfect in all its parts."[7]

"Novo-Arkhangel'sk, Sitkha, from north side," 1805

India ink drawing by Yuri Lisianskii, first published in Fedorova, *The Russian Population*, pl. 5; courtesy of Svetlana G. Fedorova and Richard A. Pierce.

This drawing was the basis for the color lithograph of Sitka (see p. 35) published in the London 1814 edition of Lisianskii's Voyage. *Lisianskii anchored the Neva off the fort on June 22, 1805: "The next morning I went on shore, and was surprised to see how much the new settlement was improved. By the active superintendence of Mr. Baranoff, eight very fine buildings were finished, and ground enough in a state of cultivation for fifteen kitchen-gardens. His live stock also made no despicable appearance. It consisted of four cows, two calves, three bulls, three goats, a ewe and a ram, with many swine and fowls: an acquisition altogether of great value in this part of the world" (Lisianskii,* Voyage, *p. 218).*

"Northwest side of Pavlov'sk [St. Paul] Harbor," 1805

India ink drawing by Yuri Lisianskii, first published in Fedorova, *The Russian Population*, pl. 4; courtesy of Svetlana G. Fedorova and Richard A. Pierce.

This field sketch was the basis for the color lithograph of the same scene, published in the 1814 edition of Lisianskii's Voyage. *The large island profile at the top is of Kodiak Island. The ship is the* Neva. *A portion of the Russian fort is seen at far right, guarding the harbor and settlement of St. Paul.*

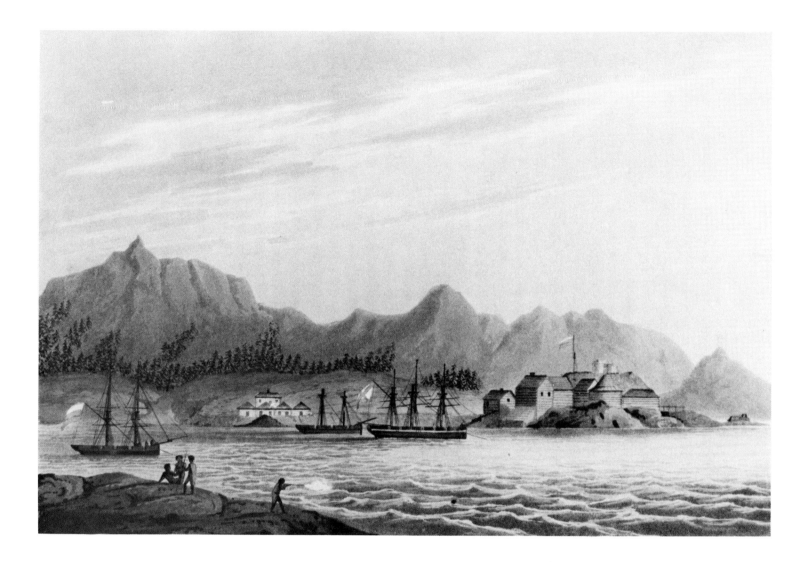

"Harbour of New Archangel in Sitca or Norfolk Sound," 1805

Color lithograph based on a drawing by Yuri Lisianskii, in his *Voyage*, facing p. 218; courtesy Pacific Northwest Collection, UW Libraries.

The three-masted vessel is the Neva.

The Voyages of Ivan Filippovich Vasil'ev, 1807–12

Ivan Vasil'ev was one of the most skilled cartographers employed by the Russian-American Company. He arrived at the company's headquarters at Sitka in September 1807, on the *Neva* under the command of L. A. Hagemeister. His maps were considered to be of excellent quality, and were often accompanied by sketches of Russian settlements.[1]

In 1810 the noted explorer V. M. Golovnin, accompanied by his navigator, felt that it should not be assumed that Vasil'ev's chart of Sitka Sound was accurate. He traced his own verification, but was pleased, perhaps even astonished, to discover it was made "with such precision, that it brings Mr. Vasil'ev great honor. That is why I affixed his plan with very few changes in my atlas, as one which I believe entirely correct." This was high praise indeed from a man who seldom withheld forthright criticism, and who had publicly questioned the cartographic skill of the illustrious Yuri Lisianskii.[2] A modern Russian scholar describes Vasil'ev's sketches of the settlements at Pavlovsk harbor and Sitka as "distinguished by a simplicity and lack of pomposity, that is also evidence of their trustworthiness."[3]

From the rank of "Assistant Navigator 14th class," Vasil'ev rose to the position of commander of the Russian-American Company brig *Finlandiia*.[4] It was probably with this vessel in May 1812, that Vasil'ev was ordered to take supplies and aid to eleven *promyshlenniks* of the company. They had been landed on inhospitable Mednyy Island, near Bering Island, in 1805, to hunt animals for furs. After a seven-year lapse without visits from company ships, they assumed that they had been abandoned. After voicing their complaints to Vasil'ev, most of the men agreed to stay on for one more year. Soon afterward Vasil'ev rescued a *promyshlennik* from neighboring Bering Island. "One had to witness his astonishment, exultation, and gratitude, to be able to describe it! For a long time he could not say a word and just wept, remaining on his knees with his hands raised to heaven."[5]

He recounted the hardships of his existence on the island:

On several days I did not have a thing to eat; there was plenty of fish in the river, but how to catch them? Necessity taught me to make a hook out of a nail, and I caught fish. Then I had to think about how to obtain fire, which I needed both to cook food and to keep warm. . . . I found a rock, and some fungus from the purple willows growing on the island, and managed to strike a fire. Never in my life have I been as happy as at that moment! At the place where I had landed there was not much possibility of obtaining food; so I crossed over to the other side of the island and settled by the river, which had an abundance of fish. For the winter, I returned to the original spot, where I found all the fox furs which I had left in the *yurta* and which were spoiled by now. I did not mind that, for I could only think about keeping myself alive. Winter came; the *yurta* was buried in snow; my clothing and footwear were worn out. The greatest need was fire, and I had great difficulty in making it. At this point I wept bitter tears over my fate: left alone by the whole world on an empty island, without food, without clothing, without help!

Vasil'ev drowned on July 15, 1812, in the Okhota River, while attempting to cross it in a baidarka from the ship *Neva*, anchored in the bay of Okhotsk.[6] Features named in his memory include Vasilief Bank, seven miles from Sitka, and Vasilief Rock on the west coast of Baranof Island.

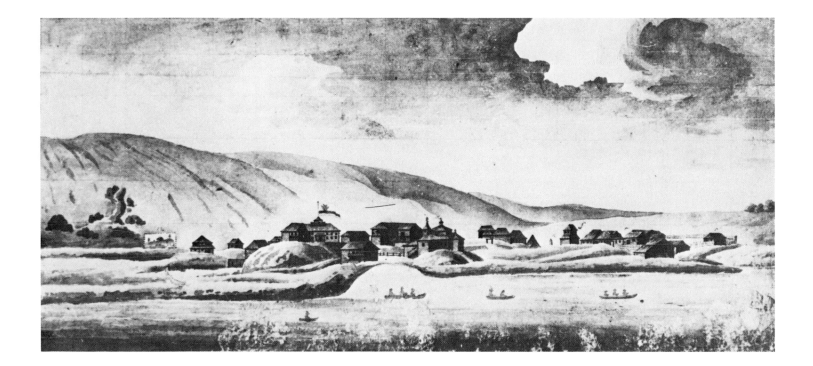

"The main Russian-American settlement on the island of Kad'iak," 1808

Drawing by "the navigator assistant of the 14th class," I. F. Vasil'ev, on a map published in Fedorova, *The Russian Population*, fig. 7; courtesy of Svetlana G. Fedorova and Richard A. Pierce.

A cemetery may be indicated by the mysterious small rectangle enclosed by black dots, adjacent to the last building on the left. Close scrutiny discovers two crosses and perhaps a chapel; however, it is some distance from the church seen in the middle of the drawing, surmounted by two crosses.

Otto von Kotzebue and the *Rurik*, 1815–18

The concept of an independent and privately financed voyage of exploration to the north of the Bering Sea was conceived by the wealthy and public-spirited Russian nobleman Romanzoff. He was, according to his friend and admirer Admiral Krusenstern, a man "distinguished for elevated views, and for whom bold enterprises have a particular charm."[1]

The count had long pondered on the failure of the polar explorations to locate a northern passage across North America, and finally decided to finance a Russian attempt with his own funds. A collateral goal of the expedition was to examine, in baidarkas and with land parties, the coast of America, "which was not seen by the celebrated English navigator [Cook] on account of the shallowness of the water." It was also expected that "a rich harvest of objects of natural history" would be gained from two crossings of the "South Sea."

Since funds were not unlimited due to his other expenses and "patriotic undertakings," Romanzoff and his adviser Krusenstern concluded that the vessel should be small, only 180 tons, with a crew of twenty seamen. Its size would also be advantageous in limited depths. The vessel was built in Abo, and Lieutenant Otto von Kotzebue, who had served under Krusenstern, was chosen as commander. In addition to the finest British navigational instruments, Krusenstern took advantage of a new discovery made in England, which consisted of preserving in tin boxes fresh meat, vegetables, soup, and milk, "in short eatables of every kind, for years together, in a perfectly fresh state."[2]

The expedition left Kronstadt about July 30, 1815, and after a stop at Copenhagen, set sail with thirty-three persons aboard, including Louis Choris as artist, Dr. Frederick Eschscholz as surgeon, and the noted Louis Adelbert von Chamisso as one of the two naturalists. A great storm blew up as the *Rurik* rounded Cape Horn in January of the following year, with severe damage to the ship and its contents. Nevertheless, landfall was made at Avacha Bay at Kamchatka in the middle of July.

In early August Kotzebue, sailing eastward, entered a large inlet, "the current running broadly into the entrance," where he imagined that "I stood at the entrance of the long sought N.E. passage, and that fate had chosen me to be the discoverer." His hopes were soon dashed, as he continued northward and found only a large sound, which he named after himself "in compliance with the general wish of my companions."[3]

After sailing to California and wintering in Hawaii, the *Rurik* returned to the Aleutians in April 1817. There the ship encountered a severe storm during which Kotzebue sustained severe internal chest injuries. As a result the *Rurik* began the long homeward voyage, reaching Kronstadt on August 3, 1818.

The voyage attained a fair measure of success, since it explored a portion of the coast "not seen by the celebrated English navigator," even though Kotzebue was forced to turn back short of Cook's farthest north latitude of more than 70 degrees.

Louis (Loggin Andrevitch) Choris

Some of the most magnificent drawings made on the Northwest Coast emerged from the gifted eye and hand of the young artist and lithographer, Louis Choris. He was twenty when chosen to accompany Kotzebue in the *Rurik* as the expedition artist.

Choris was born March 22, 1795, in the Russian city of Jekaterinoslaff. He was of German origin, and was educated in the Kharkov *Gymnasium*. It is believed that he studied art in Moscow, following which he was employed as an artist on the research expedition of naturalist F. A. Marschall de Bieberstein, in the Caucasus mountains. Choris was then only eighteen.[1]

After returning from the Kotzebue voyage, he studied further in Paris under two noted artists, Gerard and Regnault. It may have been during this period that he developed his skill as a lithographer. As a painter, he was already talented, according to the explorer Krusenstern, a patron of Kotzebue, who tendered an accolade: "The richness of the portfolio which he has brought home . . . and the praise which has been bestowed upon him by the most celebrated artists of St. Petersburg, as well as by the president of the Petersburg Academy, fully justify the choice of this young and deserving artist."[2]

Also at this time, he displayed his drawings and sketches from the voyage to "many distinguished persons in Paris," and was encouraged to publish them. Accordingly, he signed up a list of 188 subscribers, among whom were the kings of France and Prussia, the emperor of Russia, Russian statesman and general G. A. Potemkin, and a long list of other royalty, generals, and ambassadors, One "Dumas" was a subscriber, perhaps the father of the famous novelist and playwright. Prince Galitzin, the Russian minister of education, subscribed to twenty copies, as did the French minister of the interior. Sixty-two copies went to libraries.[3]

Priced at thirty-three francs, the work contained numerous color lithographs, with authoritative monographs on each ethnic group portrayed. Bearing the title *Voyage pittoresque autour du monde*, it was a large and handsome volume, and must have been a resounding artistic success, if not a financial one. In 1826 he published another work of color lithographs, *Vues et paysages des regions equinoxiales. Receuil de tetes et de costumes des habitants de la Russie* was published posthumously.

Little information is available concerning Choris' life. Some insight into his character may be gained from his "Port San-Francisco et ses habitants," of which a translation was published in 1913. In it, he described the natives:

In winter, bands of Indians come from the mountains to be admitted to the mission, but the greater part of them leave in the spring. They find it irksome to work continually and to have everything supplied to them in abundance. In their mountains, they live a free and independent, albeit a miserable, existence. Rats, insects, and snakes,—all these serve them for food; roots also, although there are few that are edible, so that at every step they are almost certain to find something to appease their hunger. They are too unskillful and lazy to hunt. They have no fixed dwellings; a rock or a bush affords sufficient protection for them from every vicissitude of the weather. After several months spent in the missions, they usually begin to grow fretful and thin, and they constantly gaze with sadness at the mountains which they can see in the distance.[4]

And Choris was impressed by the industrious manner in which the American captains pursued the smuggler's trade:

Two hundred and fifty American ships, from Boston, New York, and elsewhere, come to the coast every year. Half of them engage in smuggling with enormous profit. No point for landing goods along the entire Spanish-American coast bathed by the Pacific Ocean, from Chili to California, is neglected. It often happens that Spanish warships give chase to American vessels, but these, being equipped with much sail, having large crews, and having, moreover, arms with which to defend themselves, are rarely caught.[5]

Choris' sketches apparently enlivened the expedition on more than one occasion. Kotzebue relates that near Norton Sound, the natives "were quite beside themselves," when Choris quickly sketched the features of an old man, and "the son held his sides with laughter when he saw his father's face drawn in the book."

On another occasion, Kotzebue invited aboard the *Rurik* three members of the Tschukutskoi at St. Lawrence Bay on the Siberian coast, who "live in eternal enmity with the Americans." They immediately recognized several portraits that Choris had drawn along the coast by "the bones below the under lip." One of the Tschukutskoi drew his knife, saying with conviction that if he should meet "such a person with two bones," he would instantly "pierce him through."[6]

For a year or two prior to 1828, Choris traveled in the West Indies, perhaps on a sketching trip for another volume of lithographs. After touring the area, he arrived in Vera Cruz on March 19, 1828, and accompanied the Englishman Henderson into the hinterland. But on March 22, the explorers were attacked by bandits and Choris was killed. Henderson escaped and was able to help retrieve Choris' body, which was buried in Plan-del-Rio.[7]

Kotzebue gave the artist's name to Choris Peninsula, which is located at the east side of Kotzebue Sound.

St. Lawrence Island in Bering Strait, 1817

Pencil sketch by Louis Choris; Coe Collection, courtesy Beinecke Library, Yale University.

Kotzebue made three separate landings on hundred-mile-long St. Lawrence Island during 1816 and 1817. This drawing is superimposed on an earlier sketch. The groups of vertical lines in the right background may represent house frames made of whale ribs (Nelson, The Eskimo, *pp. 257–59). "After we had sailed round a promontory which projected from S.E., and . . . discovered, in a low spot on the shore, some habitations consisting of tents and huts, I steered thither in order to acquaint myself with its inhabitants. When our boats were put into the water, we saw through our telescopes some people, loaded with baggage, fleeing from their habitations into the mountains, and others arming themselves with lances for our arrival. On the landing-place when we came, we found twenty tall and robust men, who looked at us with fearful friendliness, without stirring. While we were conversing with them a baydare was drawn along the strand by dogs, which just came from the Tschukutskoi, and the people shewed us some of the things they had obtained there" (Kotzebue,* Voyage, *2:174).*

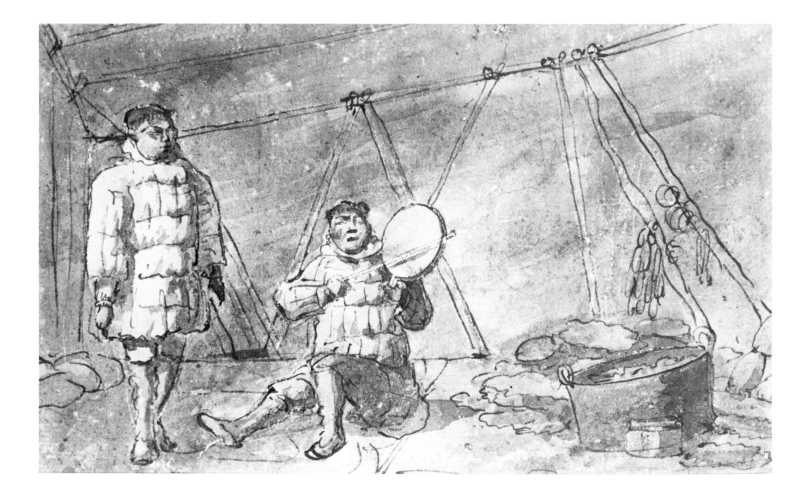

"Interior of a summer hut on St. Lawrence Island near Bering Strait," 1816

Watercolor sketch by Louis Choris; Coe Collection, courtesy Beinecke Library, Yale University.

This drawing was reproduced as a color lithograph in Choris' Voyage, *with more detail. The scene was described by Kotzebue after his first landing on St. Lawrence Island on July 27, 1816: "A filthy piece of leather was spread on the floor for me to sit on; and then they came up to me one after the other—each of them embraced me, rubbed his nose hard against mine, and ended his caresses by spitting in his hands and wiping them several times over my face. My host . . . probably the chief of his countrymen present, after our meals ordered a dance; one of them stept forwards, made the most comical motions with his whole body, without stirring from his place, making the most hideous grimaces; the others sung a song, consisting of only two notes, sometimes louder, sometimes lower, and the time was beat on a small tambourine" (Kotzebue,* Voyage, *1:191–92).*

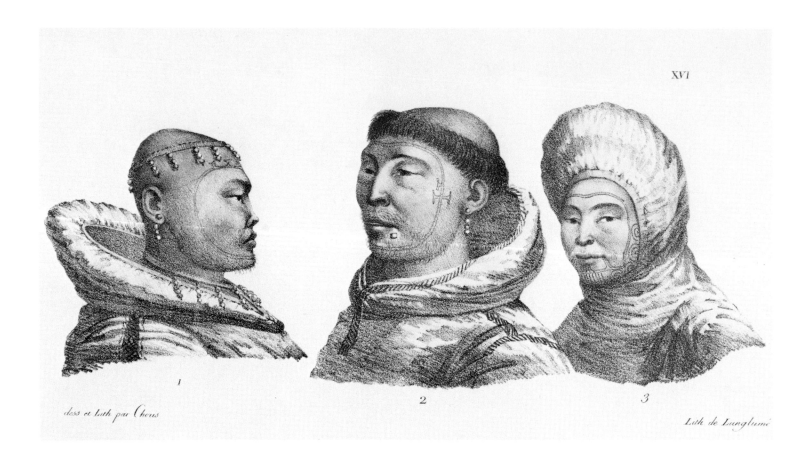

dess et lith par Chois

1 *2* *3*

Lith de Langlumé

"Inhabitants of St. Lawrence Island," 1816–17

Color lithograph of a drawing by Louis Choris, pl. 16 in his *Voyage*; courtesy Pacific Northwest Collection, UW Libraries.

The two men of St. Lawrence Island are tonsured, a practice followed in many areas along the Bering Sea coast. "Many had their heads shaved round the crown, after the fashion of the Tschutschi, the Otaheitans, or the Roman Catholic priesthood in Europe, and all had their hair cut short" (Beechey, Narrative, 1:332).

All three Eskimos are tattooed, a practice considered by Nelson, some sixty-five years later, to have "attained its greatest development" on St. Lawrence Island, as well as on the nearby Siberian coast. The woman at right fits Nelson's description: "On St. Lawrence Island and the adjacent Siberian coast women have the sides of their faces and their arms and breasts covered with finely designed patterns of circles and scroll work, sometimes crossed by straight lines" (Nelson, "The Eskimo," pp. 50–51).

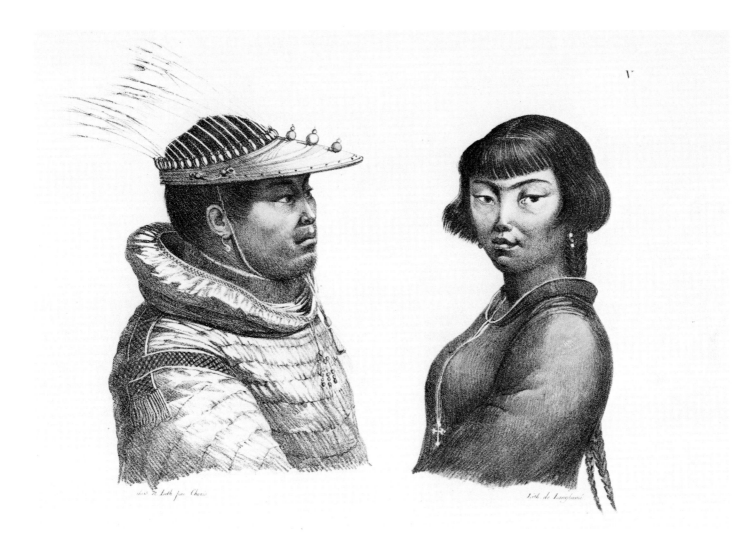

V

"Inhabitants of the Aleutian Islands," 1816–17

Color lithograph of a drawing by Louis Choris, pl. 5 in his *Voyage*; courtesy Pacific Northwest Collection, UW Libraries.

The classic Aleut hunting hat was described by Langsdorff about 1804: "The most elegant and most expensive head-dress is a sort of wooden hat. . . . These people, who but seldom get a piece of good wood of some inches in circumference, are frequently occupied a whole week in forming it into a plank, and working it, so that it may be rendered pliable by lying in the water. When this is done, they endeavor by degrees to draw the two ends of the plank towards each other, and to fasten them together with the tendon threads, so as to form a pyramidal shape hat . . . they then proceed to paint it with earth and ochre, which they procure from the distant volcanoes, and ornament it with ivory figures carved from the teeth of the sea-cow, with glass or amber-beads . . . or with the bristles from the beard of the sea-lion" (Voyage, pp. 38–39).

V. M. Golovnin and the *Kamchatka*, 1817–19

Vasilii Mikhailovich Golovnin, age forty-one, was instructed "by the Royal command of His Imperial Majesty," to take charge of the newly built sloop *Kamchatka* in 1817. Several objectives were specified: to deliver equipment and supplies to Okhotsk and Kamchatka, to visit outposts of the Russian-American Company and investigate the treatment of natives by company employees, and to "determine the exact geographical location of islands . . . not yet surveyed by astronomical measurements, and to explore by means of small craft the northwest coast of America between latitudes 60° and 63° which Captain Cook could not approach because of shallow waters." These small craft tracings were contingent upon the extent of similar work by the earlier Kotzebue expedition.[1] The official artist for the voyage was young Mikhail Tikhanov, who had been an outstanding student at the St. Petersburg Academy of Fine Arts.

In England, Golovnin was to secure nautical charts, books, and instruments, and particularly some recently developed scurvy preventatives consisting of "tea, sugar, mustard, essence of lemon, essence of spruce, and some others." The *Kamchatka* left Kronstadt with a favorable wind on the morning of August 26, 1817, "the day of the Battle of Borodino, forever memorable to all Russians."[2]

Golovnin reached Kamchatka on May 2, 1818. After a stay of a month and a half, he left to begin his inspection of the Russian outposts. He was severely critical of the Russian-American Company for permitting American fur traders to trade with the Aleuts and Indians. He felt the company was negligent in failing to request aid from its government. "Keeping smugglers from one's shores is perfectly permissible," he wrote, "especially since the government of the United American Provinces has already declared that it cannot forbid its subjects to raid wherever they wish and that each one is personally responsible for his actions abroad and for transgressing foreign regulations."[3]

This round-the-world expedition seems most remarkable for the forthright personality of its commander, as reflected in the candid observations and criticism throughout his journal. The voyage itself was largely uneventful in terms of danger. The *Kamchatka* returned to Kronstadt in September, 1819, after two years and ten days.

Mikhail Tikhanov

In 1823 the Russian Admiralty decided that it should no longer delay publication of the account of Vasilii Mikhailovich Golovnin, commander of the naval sloop *Kamchatka* during his voyage from 1817 to 1819. The delay had been occasioned by the Admiralty's failure to arrange for the engraving of seventeen illustrations by Mikhail Tikhanov, the talented expedition artist who had been recommended for his post by the director of the St. Petersburg Academy of Fine Arts. When the volume finally appeared in print, it included a notice that in order to satisfy "public curiosity, the Department of the Navy decided to publish it without the engravings, which no doubt will soon appear." They were, in fact, not to appear for many years.[1]

Tikhanov was born about 1789 as a serf. The owner of the estate to which he belonged noted his talent in drawing, and had the insight and humanity to enroll him in the Academy of Fine Arts in 1806, at the age of seventeen. As a student he was outstanding, receiving medals for the excellence of his work. He was given his freedom from serfdom in 1815, but stayed on at the Academy until he was appointed to the *Kamchatka* to accompany Golovnin.[2]

During the expedition, Tikhanov produced at least forty-three paintings in soft pastels, of which five were done at California, nineteen at Alaska and the Aleutian Islands. As with other government artists of the period, his drawings were made carefully realistic to comply with his instructions, natives being depicted in both full face and profile.

One of his most important drawings from a historical standpoint was of the great and sometimes controversial Alexander Baranov, for twenty-eight years the chief manager of Russian colonies in America. The likeness has been reproduced innumerable times in books and articles, all from the same original source—a lithograph made from one of Tikhanov's preliminary sketches for an oil portrait of Baranov, which is lodged in a Moscow museum. No portraits of Baranov by other artists have appeared, therefore history seems indebted solely to Tikhanov and his commander for this significant event.[3]

That Tikhanov had a sense of humor is evidenced by his only known self-portrait, a striking sketch made in Manila of a thief running away in a bazaar, after having seized his hat.

Toward the end of the voyage Tikhanov became seriously ill. His irrational behavior became so pronounced that when the *Kamchatka* returned to Kronstadt, he was placed in a mental institution. He did not recover, but was pensioned in 1822. A fellow artist cared for him until his death in 1862 at the age of seventy-three.[4]

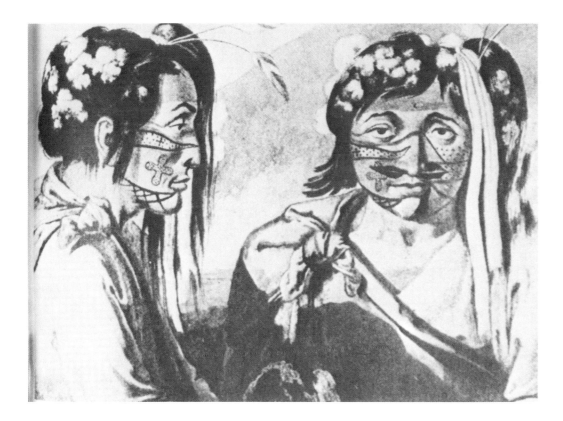

"A Copper River inhabitant," 1817

Watercolor drawing by Mikhail Tikhanov. Courtesy Richard A. Pierce and L. A. Shur; reprinted from *The Alaska Journal*, 6(1):45, by permission of Alaska Northwest Publishing Company.

The Copper River emerges into the Gulf of Alaska about forty miles northwest of Kayak Island, where Bering anchored in 1741. The area surrounding the lower river is the habitat of the Eyak, forming a virtual enclave in Tlingit territory. The facial decoration of this man is painted, rather than tattooed (Birket-Smith and de Laguna, The Eyak pp. 60–61, 352). He wears clusters of eagle down on his hair, with strips of white ermine skins hanging at the side.

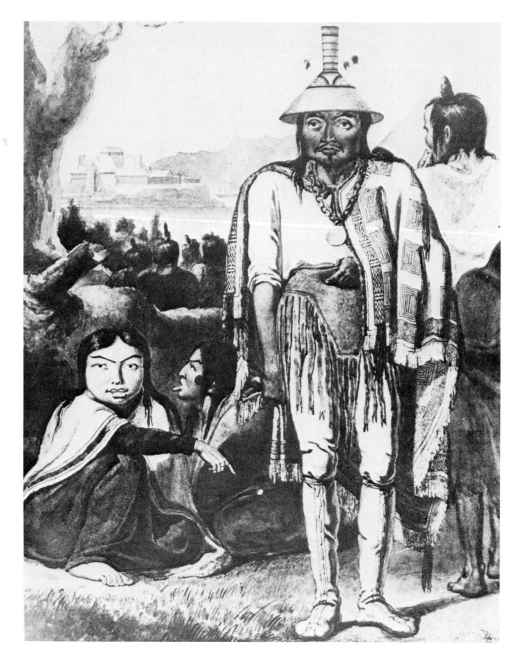

"Tlingit chief Kotlean from Sitkha (Baranof) Island," 1817

Watercolor drawing by Mikhail Tikhanov. Courtesy of Richard A. Pierce and L. A. Shur; reprinted from *The Alaska Journal*, 6(1):43, by permission of Alaska Northwest Publishing Company.

According to Pierce and Shur, this may be the "celebrated leader of the attack in 1802 which wiped out the Russian force at Old Sitka." Khlebnikov relates that on the occasion of Baranov's retirement as head of the Russian-American Company in 1818, "the famed toion Kotleian, respected by Baranov for his intelligence and bravery, and who had harmed Baranov more than anyone by destroying the fort—even he appeared before him, and they made their peace" (Baranov, p. 99). The chief is wearing a crest hat with potlatch rings, made of woven spruce root. The fortress of Sitka is in the background.

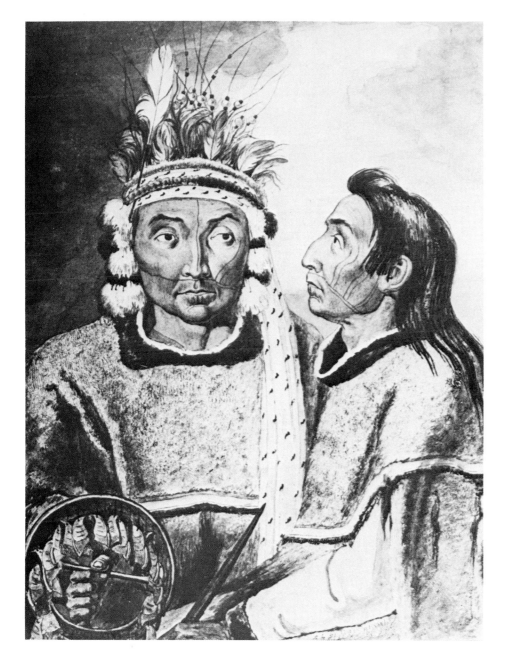

"Toion Nankok of Kodiak, baptized Martin," 1818

Sketch by Mikhail Tikhanov. Courtesy Richard A. Pierce and L. A. Shur; reprinted from *The Alaska Journal,* 6(1):49, by permission of Alaska Northwest Publishing Company.

The Aleut chief is wearing a ceremonial headdress incorporating feathers, sea lion whiskers strung with trade beads, and an eagle feather stuck in the headband. He is holding a dance rattle clustered with puffin bills, and a dagger.

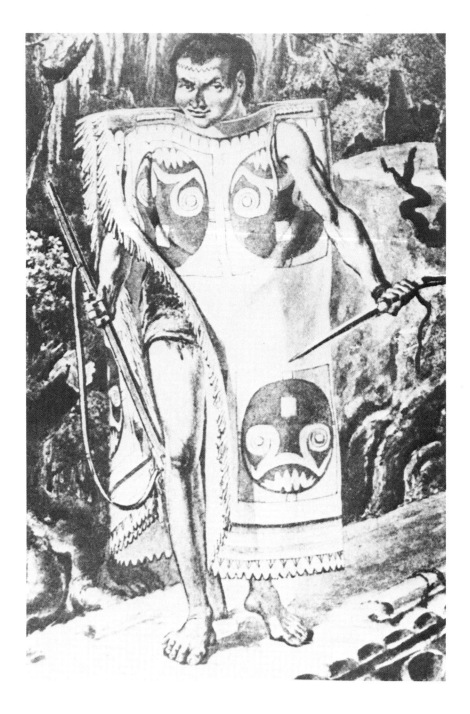

"Kolosh (Tlingit) leader, Baranof Island, in war dress," 1817

Drawing by Mikhail Tikhanov. Courtesy Richard A. Pierce and L. A. Shur; reprinted from *The Alaska Journal*, 6(1):46, by permission of Alaska Northwest Publishing Company.

The Tlingit is wearing elkhide armor, and holds a dagger and a trade musket.

The Voyages of Pavel Mikhailov, 1826–29

Among the more than fifty voyages made to supply Russia's American colonies was that of the naval sloop *Moller*, sailing around the world under M. N. Staniukovich in 1826–29. Pavel Mikhailov was assigned by the Academy of Arts to accompany the voyage as its official artist, based partly on the quality of drawings he had executed on the earlier world-girdling voyage of the sloop *Vostok*, under the command of F. F. Bellingshausen in 1818. This voyage was famous in Russia because of its discoveries in Antarctica. It became well known also because of Mikhailov's numerous sketches and watercolors, many of which were published in 1831 in the Bellingshausen atlas.[1]

Mikhailov was born in 1786 in St. Petersburg. When he was nine his father, a retired actor, had the foresight to enroll him in a school of the Academy of Arts. After graduation he made a specialty of portrait and miniature painting. When he obtained his post on the *Moller* in 1826, he was forty years old, and a mature and experienced artist. Nevertheless, he received the customary detailed official instructions—accuracy above all, no drawings were to be made only from memory, and embellishment or exaggeration was to be avoided. Mikhailov carried out his instructions by portraying many natives in both full face and profile, taking care in depicting clothing and decoration. As a result, his drawings are a valuable ethnographic resource.

The *Moller* arrived at Petropavlovsk on June 18, 1827. Continuing to the Aleutians, seven days were spent at Unalaska Island. A stay of a month was made at Sitka, after which the *Moller* left for Hawaii, and spent the winter months at Honolulu. The following year, she returned to Unalaska on April 27. After calling at other Russian outposts in the Aleutians, she sailed to the north side of the Alaska Peninsula, where Staniukovich surveyed the rugged coastline from Isanotski Strait to the mouth of the Naknek River. After another cruise along the islands to Kamchatka, he headed for the South Pacific, then home, arriving at Kronstadt on August 23, 1829. The full history of the voyage is almost unknown, as Staniukovich did not publish his journal.[2]

After the return, Mikhailov became impoverished, was perhaps in ill health, and attempted without success to secure a pension. He spent the remainder of his life living with another artist, and died of tuberculosis on September 12, 1840, at the age of fifty-four.

Self-portrait by Pavel Mikhailov, 1820s

Courtesy Richard A. Pierce and L. A. Shur, reprinted from *The Alaska Journal*, 8(4):360, by permission of Alaska Northwest Publishing Co.

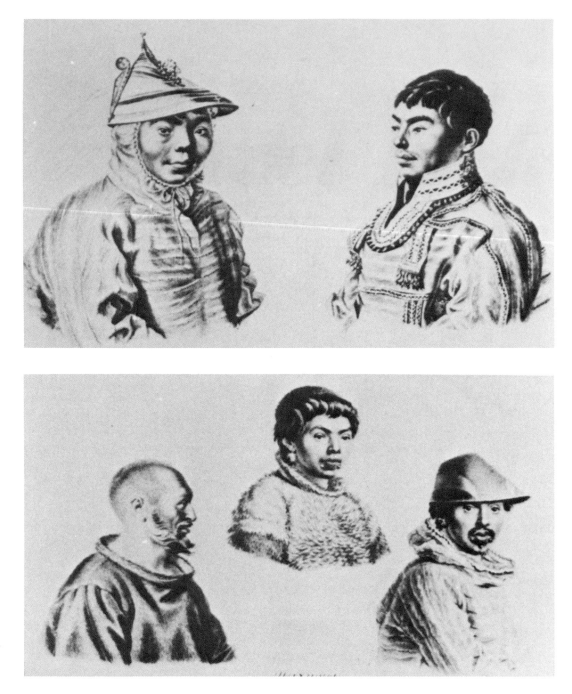

Aleut costumes, 1827

Drawings by Pavel Mikhailov; courtesy Richard A. Pierce and L. A. Shur; reprinted from *The Alaska Journal*, 8(4):362, by permission of Alaska Northwest Publishing Company. The original sketches are in the State Historical Museum, Estonian, S.S.R. at Tallinn.

(Top) An everyday Aleut kamleika (skin garment) and a ceremonial kamleika.

(Bottom) The Takhuty, inhabitants of the Naknek River area on the Alaska Peninsula, wearing labrets.

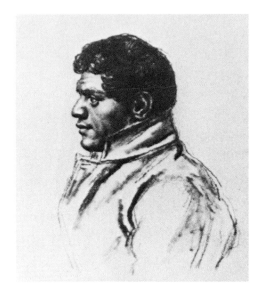

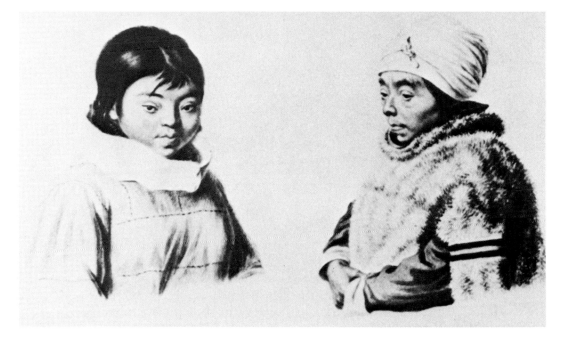

*"A young Creole at Sitka," and "A girl of Unalaska Island and
an old woman," 1827*

Drawings by Pavel Mikhailov; courtesy Richard A. Pierce and L. A. Shur; reprinted from *The Alaska Journal*,
8(4):361, by permission of Alaska Northwest Publishing Company. The original drawings are in the State
Historical Museum, Estonian S.S.R. at Tallinn.

*(Top) A pencil sketch of an employee of the Russian-American Company. A Creole was the child of a Russian
man and a native woman. "They form a class of their own having the same rights as the meshchanstvo
[townspeople, or the lower middle class] in Russia, with the additional advantage of exemption from taxes"
(Tikhmenev,* Russian-American Co., *p. 446).*

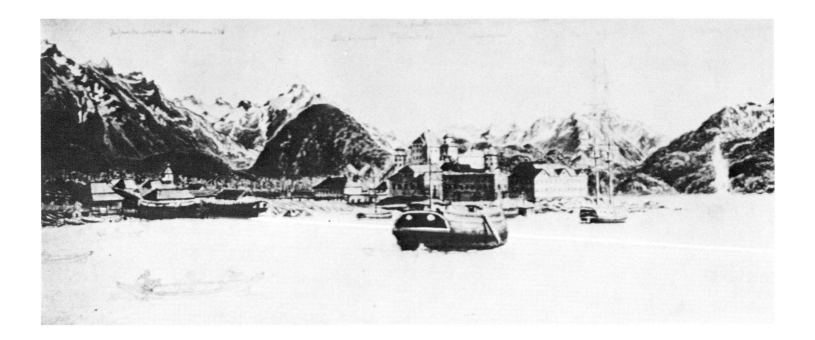

Unfinished watercolor of Sitka, 1827

Drawing by Pavel Mikhailov. Courtesy Richard A. Pierce and L. A. Shur; reprinted from *The Alaska Journal*, 8(4):360, by permission of Alaska Northwest Publishing Company.

The ship in the foreground is the brig Buldakov, *built in 1817 at Fort Ross, the California outpost of the Russian-American Company. Pencil notes on the drawing, perhaps made by the author, identify most of the ships. (Had the sketch been finished, Mikhailov would probably have reduced the impossibly lofty masts of the vessel at the right.)*

The faint pencil sketches of Tlingit canoes at the left are believed to be the earliest known dated drawings of this type of canoe (Bill Holm, personal communication).

Feodor Litke and the *Seniavin*, 1826–29

When the *Seniavin* left Kronstadt on August 20, 1826, it was beginning the last of the great Russian scientific expeditions to the Northwest Coast of America. She was a newly built naval vessel, ninety feet long with sixteen guns and a complement of sixty-two men, including officers and scientists. There were fifteen additional men bound for duty at the two ports of Okhotsk and Petropavlovsk. Her commander was Feodor Petrovich Litke, age twenty-nine, who at twenty had served under Golovnin on the round-the-world voyage of the *Kamchatka* in 1817–19. Admiralty instructions called for exploration and surveys along the coast of Siberia, and the shores and islands of the Bering Sea and Bering Strait. The *Seniavin* was to be accompanied as far as Petropavlovsk by the naval sloop *Moller*.[1]

Litke entered Sitka Bay on June 12, 1827, and remained there five weeks making observations. Meanwhile, supplies and equipment for the Russian-American Company were unloaded and replaced by thirty-five tons of stone ballast. Captain Chistyakov, Company general manager, made a gift of wheat flour and two barrels of raspberry jam to the crew.

After a three-week voyage to Unalaska through stormy weather with rain and fog, the *Seniavin* arrived at Captain's Harbor to unload wheat during a ten-day stay. In contrast to some contemporary accounts, Litke commented on the surprising cleanliness of the native dwellings, as compared with those of Russian peasants.[2]

After completing surveys and astronomical observations in the Aleutian Islands, Litke arrived at Petropavlovsk on the Kamchatka Peninsula on September 12. At the end of October, the *Seniavin* set sail for the South Pacific. During November and December investigations and observations were conducted in the Caroline Archipelago. Eleven days after leaving the Carolines, Litke discovered a previously unknown group of twelve islands, which he named after his ship.

Following another season along the Siberian coast and the Aleutians, the voyage ended at Kronstadt on August 25, 1829. Litke's expedition "according to the judgment of the [Russian?] specialists . . . was the most interesting and fruitful of all of the 29 scientific expeditions of the nineteenth and twentieth centuries . . . and brought Litke world-wide fame."[3]

Friedrich Heinrich von Kittlitz

Friedrich Kittlitz was born February 16, 1799 in Breslau. His father was a Prussian captain and his mother the sister of a Russian field marshall, Count Diebitsch Sabalkanski. Although early in his life he exhibited an aptitude for drawing, he entered military service at fourteen as a volunteer in his father's artillery battalion. This action made him a participant in the campaign of the Prussian, Austrian, and Russian allies against Napoleon, after his escape from Elba in 1815.

During his military career he won advancement in rank, but still found time to cultivate his deep interest in natural history, with an emphasis on ornithology. He obtained permission to resign from military service upon learning of the proposed voyage of the *Seniavin* under Litke in 1826. Assisted by his uncle's influence, he was accepted aboard as "natural historian" specializing in ornithology.

Immediately after the *Seniavin*'s return in 1829, Kittlitz published his zoological discoveries and observations in technical journals, but was ill at the time Emperor Nicholas gave a reception in honor of the expedition members. Because Kittlitz failed to attend, he did not receive his portion of the generous rewards given the others. The Russian Academy, however, employed him at an annual salary of 2,500 rubles to organize his collections made during the voyage.

It was not until 1858, almost twenty years after returning, that Kittlitz published his description of the voyage. In the intervening years he had mastered the difficult art of engraving, so that he could illustrate the volume with twenty-four of his own engravings of his drawings. In his introduction, he remarks that prior to the departure of the *Seniavin*,

the botanists of St. Petersburg suggested that . . . as many portraits and characteristic sketches of the vegetation as possible should be taken.

Although unacquainted with botany, I was deeply interested in carrying out this suggestion, and in my mind conceived a series of pictures. . . . Setting out with the determination to construct a view, I generally succeeded in accomplishing it during the short time that we used to remain at anchor in each place. . . . I may also be blamed for undertaking the execution of the plates on copper myself, instead of assigning them to more artistic hands. . . . It is perhaps not generally known how extremely difficult it is to obtain from the hands of an engraver or lithographer a correct copy of a picture . . . but proofs are furnished by a series of expensive illustrations in works of travel, which convey no idea of the scenes represented, though it was not from want of good original drawings.[1]

Since his efforts had failed in attempting to obtain compensation equal to that given other members of the Litke voyage, he returned to Germany and soon joined Eduard Rüppel's expedition to Abyssinia. During this venture, he had the misfortune to contract a fever while on the Nile, forcing his return to Europe. From 1832 to 1845 he lived in Cologne, completing his best-known work, *Vegetations-Ansichten von Kustenlandern*. This production won the praise of the great naturalist Alexander von Humboldt, and a glowing tribute in a German biographical dictionary, *Allgemeine deutsche biographie*, published eight years after his death on April 10, 1874, at age seventy-five: "seldom have artist and scholar been so united in one person."

In later years, after a marriage at age forty-five which produced three children, he gave lectures on scientific subjects and occupied himself with "aesthetic and philosophical studies." The same German source pronounced his eulogy: "he was an admirable person, but had no business aptitude. This lack, fortified by extreme honesty and exaggerated sense of responsibility, hindered him in enjoying the fruits of his talents and knowledge. In consequence many of his works remained unfinished."

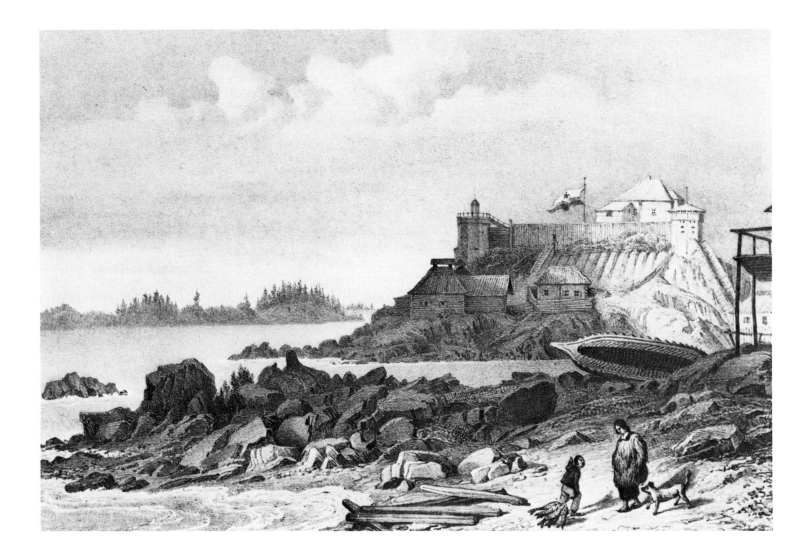

"The Establishment at New Archangel," Sitka, 1827

Lithograph of a drawing by F. H. von Kittlitz, in Litke, atlas to *Voyage*, pl. 3 (copy of Tsar Nikolai I); courtesy Lilly Library, Indiana University.

In 1818, nine years before Kittlitz made this drawing, Golovnin, on the voyage of the Kamchatka, *described the scene: "The Fort stands atop a high rock elevation right at the harbor, and, considering the chief purpose for building it, is the Company's Gibraltar. Located on high ground, surrounded by a heavy palisade with wooden towers serving as bastions, and supplied with fifty cannon of various types and calibers, as well as a sufficient number of small arms and ammunition, it is indeed awesome and impregnable to the local savages; but against a European power, even against a single frigate, it is hardly a real fort" (Kamchatka* Voyage, *p. 124).*

View of the Russian colony at "Novo Arkhangelsk," 1827

Lithograph of a drawing by F. H. von Kittlitz, in Litke, atlas to *Voyage*, pl. 7 (copy of Tsar Nikolai I); courtesy Lilly Library, Indiana University.

"The . . . print represents the inside of the city in its most important and most crowded area. The church [is] on the right of the spectator, and . . . is rather richly decorated. It is probably on a Sunday, and divine service will soon begin, as we can judge by the special attire of the Indian. . . . According to convention . . . this rock belongs to the natives. Quite often a large crowd of curious natives . . . occupy all the top of the rock, and stay there for hours on end, silent, crouching, wrapped in the large folds of their blankets, with their eyes fixed on the street, which in fact is deserted most of the time. Even though they do not show . . . much interest in the Christian religion, they like to be passive spectators of the religious ceremonies, and . . . never fail to wear their ceremonial attire, following the example of the inhabitants of the city" (Litke, atlas to Voyage, "Explanation of Plate" by Kittlitz).

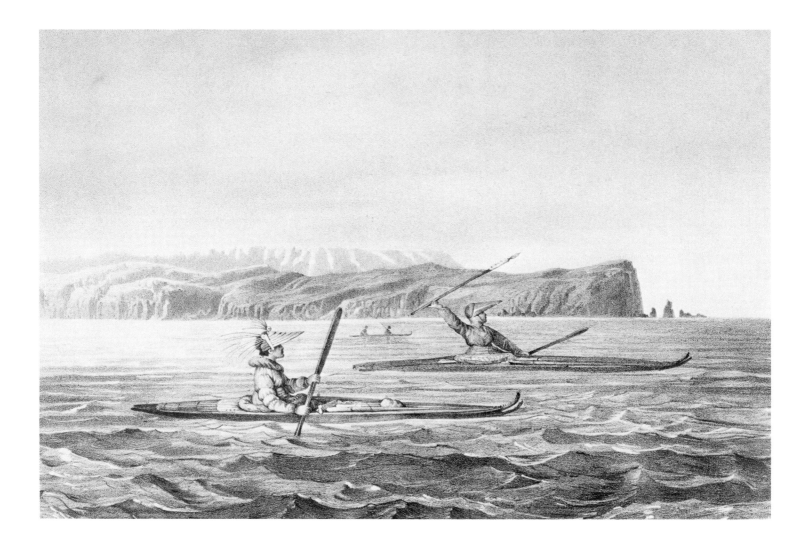

"Inhabitants of Ounalachka with their canoes," 1827

Lithograph of a drawing by F. H. von Kittlitz, in Litke, atlas to *Voyage*, pl. 10; courtesy Pacific Northwest Collection, UW Libraries.

"It is really interesting to see one of these island inhabitants go off for a hunt, carrying his canoe on his back as others carry their bow and quiver. In fact, the canoe can be compared to a quiver, since the javelin and the stick which is used to throw it are attached by straps to the top of the canoe, and can readily be pulled in the same manner as an arrow is pulled from its quiver. The elegant hat worn by the hunters belongs to the ancient national costume of the Aleuts, and is becoming every day more rare among them. It is made with wood which after being soaked for a long time becomes malleable, somewhat like papier-mâché. Its ornaments are made of carved bones, in which the Aleut excel, and also of glass beads and sea lion whiskers, on which even more beads are threaded, and which give to the head of the hunter a resemblance to the head of that animal" (Litke, atlas to Voyage, *"Explanation of Plate"* by Kittlitz).

Aleksandr Filippovich Postels

Born in 1801, Aleksandr Postels at the age of twenty-two had acquired a doctor's degree from the University of St. Petersburg. Remaining at the university for postgraduate studies, he also for a time taught a course in nonorganic chemistry, before joining the Litke expedition in 1826.[1]

The scientific personnel of the voyage included a competent naturalist, Mertens, who collected more than 2,500 plants. Mertens leaned heavily on Postels and Kittlitz to make drawings of the specimens, although he drew many himself. Postels alone made almost a thousand drawings, including many of fish. As he was also Litke's mineralogist, he collected more than three hundred mineral specimens.[2] While ashore at Valparaiso in March 1827, Litke accompanied Postels and the other scientists, climbing up and down the narrow steep trails which served as streets, but soon found their energy, bent on discovery, beyond his capacity.

Litke was impressed that Postels and Kittlitz took care in depicting plants in their living environment, noting that "views of the flora presenting the whole assemblage of plants which give to each country a special character, have, up to now, been neglected by voyagers to far-away countries, but Mr. Postels and Mr. Kittlitz on the advice of their friend Dr. Mertens, have assembled a very large number of drawings of this type."

Exploration on the Siberian coast began in August 1828. Litke wrote in his account of the expedition, entitled *Voyage autour du monde*:

I left with the large canoe and one baidarka. . . . These types of excursions for the purpose of exploring—which usually are not to the taste of a botanist or zoologist—were always very much preferred by Mr. Postels; for they afforded him the means to explore over a larger space and over more places, the rocks and mountains along the shore, and he could augment his collection without overloading himself [p. 205].

Later, after taking to overland exploration, Litke pleased the artist by assigning the name "Cape Postels" to an extension of the coast. The next morning, Litke and Postels climbed Mount Elpyghyne to observe the surrounding area. Postels made drawings of the strange shapes of the mountains; "the name 'Devil's punch bowl' which one sees on some English maps, would not fit better. These 'cups' are so frequent here."[3]

Returning from the expedition in 1829, Postels resumed his connection with the University of St. Petersburg, rising in rank until it was reorganized in 1836, when he lost his position. Fortunately, he was also on the faculty at the Main Pedagogical Institute, teaching mineralogy and geology. His career in teaching was then secure, and in 1839 he received the title of "Ordinary Professor." In addition, he taught natural sciences at the School of Jurisprudence. For nearly twenty years he was director of the Second *Gymnasium* in St. Petersburg, later becoming a board member. He died in 1871 at age seventy.[4]

"Algarum Vegetatio," 1827

Drawing by A. F. Postels, in *Illustrationes Algarum*, Postels and Ruprecht, n.p.; courtesy Beinecke Library, Yale University.

While the figures in the drawing are not identified, the person kneeling to obtain an underwater specimen is likely Mertens, the expedition naturalist. The Cossack (?) soldier is both a guard and a bearer of Merten's trophies. The scene may be in the vicinity of Sitka Sound, as the topography and plant life is characteristic of the area.

There are nine identifiable underwater plants in the sketch, the one in the extreme lower right being Nereocystis luetkeana *(bladder kelp), named after the expedition leader (Eugene Kozloff to Henry, 1980).*

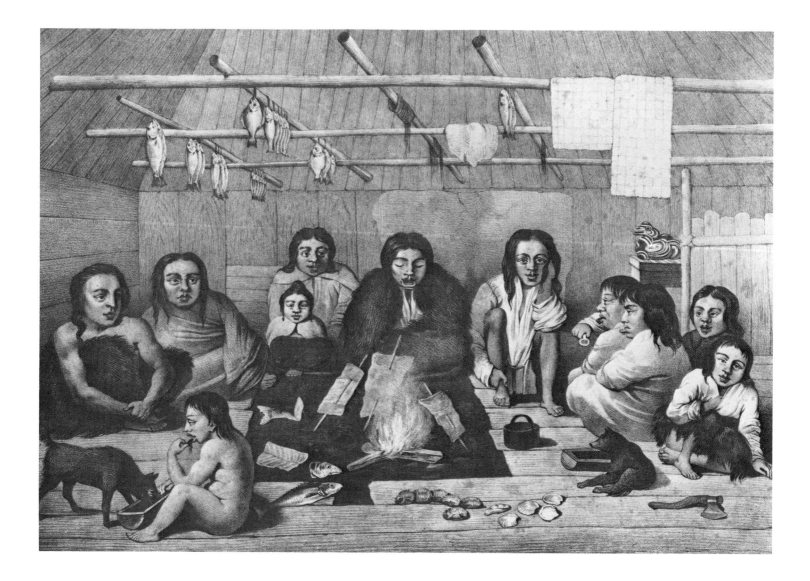

"Interior of a Kolosh hut," 1827

Lithograph of a drawing by A. F. Postels, in Litke, atlas to *Voyage*, pl. 4 (copy of Tsar Nikolai I); courtesy Lilly Library, Indiana University.

"The hut . . . is one of those lucky to [be] close to the establishments of the Russian colony along the bay of Sitkha. Due to the fact that it is close . . . and due also to the example of the Russians, it is elegant and solid. It is constructed of planks, and planks also cover the ground, except a small square space for the fire. This is where, under the roof, the family gathers together, spending all of its time in [almost] total inaction. At the moment shown . . . the family is occupied in preparing dinner. It is very easy to see here that love of cleanliness is not the principal virtue of the Caloche. In a corner . . . one can see the idols of the family, representing several animals. Next to it are scattered a few toys and a mask painted with different colors and carved in a very artistic manner" (Litke, atlas to Voyage, *"Explanation of Plate" by Postels).

The British Voyages

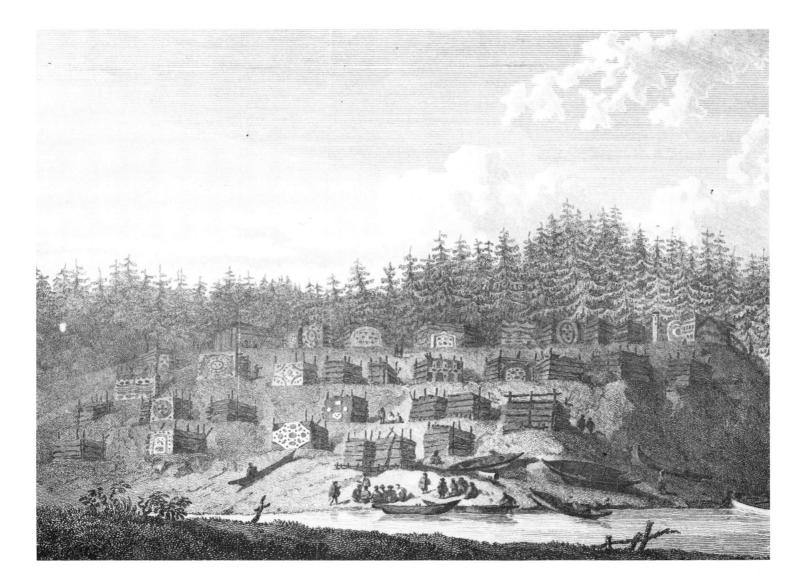

"Cheslakee's Village in Johnstone's Strait," 1792

Engraving of a drawing by John Sykes, in Vancouver, *Voyage*, 1:facing page 346; courtesy Pacific Northwest Collection, University of Washington Libraries.

From James Cook, *A Voyage to the Pacific Ocean*, vol. 3, London, 1784. Courtesy Pacific Northwest Collection, University of Washington Libraries

James Cook's Last Voyage, 1776–80

When Captain James Cook left Plymouth on July 12, 1776, on his third and last voyage, he was in command of the *Resolution*, followed several days later by the sister ship *Discovery*, under Captain Charles Clerke. Cook carried "Secret Instructions" from the Admiralty "to find out a Northern passage by Sea from the Pacific to the Atlantic Ocean." He was to proceed to the Cape of Good Hope, search to the south for some islands "said to have been lately seen by the French . . . proceed to Otaheite or the Society Islands . . . land Omiah [Omai] at such of them as he may chuse."[1] (Omai was a native Tahitian who returned to England with Cook on the second voyage.)

From Tahiti Cook was to sail directly to the "Coast of New Albion" without any attempt at new discoveries, then north along the Coast as far as latitude 65°, searching for, and exploring "such Rivers or Inlets as may appear to be of a considerable extent and pointing towards Hudsons or Baffins Bays."

Landfall was made at Cape Foulweather on today's Oregon coast on March 7, 1778. Proceeding northward, Cook watched the shore for a suitable harbor where water and fuel could be replenished, and storm damage repaired. On March 22, such a harbor seemed to appear in the distance, but as the *Resolution* sailed closer it was seen to be closed off by low land. Cook called the point of land "Cape *Flatery*," writing that "it is in the very latitude we were now in where geographers have placed the pretended *Strait of Juan de Fuca*, but we saw nothing like it, nor is there the least probability that iver any such thing exhisted."[2] (Cook would have sighted it in a matter of hours, had not nightfall been imminent, forcing the ships to stand off the coast for safety.)

By morning there had begun a succession of storms which drove the ships well out to sea. When the gales ended nearly a week later, Cook was off today's Nootka Sound, where he remained for four weeks repairing the ships, replenishing firewood and water, and trading with the Indians. His was the first European landing on the British Columbia coast.

Leaving Nootka, Cook resumed his northward progress along the great semicircular sweep of the continental shore, washed by the waters of the Gulf of Alaska. As it bent westward, the ships briefly investigated Prince William Sound. Continuing past today's Kenai Peninsula, by May 22 they were at the entrance of an inlet (Cook Inlet), which seemed to stretch indefinitely to the north. Well over a week was spent tracing the supposed river "70 leagues or more from its intrance without seeing the least appearance of its Source."[3]

All along the coast Cook had observed the natives and their abundance of sea otter skins. Before leaving Cook Inlet, he wrote that "there is no doubt but a very benificial fur trade might be carried on . . . this vast coast, but unless a northern passage is found it seems rather too remote for Great Britain to receive any emolument from it."[4]

Heading north into the Chukchi Sea, the ships were unable to sail beyond 70° 44' north, due to a frozen barrier extending "as far as the eye could reach."[5] After sailing along the ice for twelve days, Cook explored the Aleutians for two months, then returned to Hawaii where he met his untimely death at the hands of natives at Kealakekua Bay.

The following spring, with Captain Clerke in command of the expedition, the ships returned to the north Pacific, arriving at Avacha Bay on the Kamchatka coast on April 28, 1779. The summer campaign included more futile attempts to penetrate the ice barrier, but they were stopped at 70° 33', a few miles short of Cook's farthest north latitude.[6]

In July Clerke had to make a final decision, "this Sea is now so Choak'd with Ice that a passage I fear is totally out of the question."[7] So ended, with the greatest reluctance, the agonizing attempt of the Cook expedition to discover the Northwest Passage. Clerke died a month later of consumption.

Returning by way of the China Sea, with Captain John Gore now the expedition commander, the ships finally reached England, anchoring in the Thames on October 4, 1780, after an absence of over four years. Achievements of the expedition include the first drawing of a reasonably comprehensive map of the Northwest Coast, and the discovery of the Hawaiian Islands. The question of the existence of the fabled Northwest Passage, however, remained unsolved.

William Bligh

When Captain Cook sailed from England in 1776, his muster list included twenty-three-year-old William Bligh. Bligh was destined to become almost as well known as his great captain, but for less creditable reasons.

According to his own account, Bligh was born in Tinten, Cornwall, in 1753. At the age of sixteen, he was enrolled on the British naval vessel *Hunter* and received his warrant of midshipman on February 5, 1771. During the next five years, he served on the *Crescent* and the *Ranger*. When he was discharged from the latter he was still a midshipman, a rank much lower than that of many of his contemporaries whose careers were aided by social or political influence.[1]

Bligh was both ambitious and industrious, applying himself so assiduously that he received his certificate as a master only two months after leaving the *Ranger*. Within the next month, his ability in cartography and surveying resulted in his selection by Cook as master of the *Resolution*.

During the four years of the voyage, Bligh's irascible and autocratic manner developed to a disagreeable maturity, making him hot-tempered, with a talent for a rough and sarcastic tongue. Occupying a responsible position, he was mentioned in Cook's journal, never unfavorably, as exploring and sounding harbors and inlets. He made many surveys and charts during the voyage, but, when the journal was published, credit for these was given to Henry Roberts, his own assistant, who had copied Bligh's charts for the engraver.[2] Although Bligh's name does appear under his own skillfully executed coastal profiles, the deep resentment engendered by the lack of recognition for his cartography, embittered him for what should have been rewarding memories of one of the greatest voyages of exploration of all time.

William Bligh as a young man, 1781

From Rawson, *Bligh*, facing p. 12, source and artist unknown; courtesy Pacific Northwest Collection, UW Libraries.

Bligh received his lieutenant's commission in 1781, at the age of twenty-eight. He may have had a portrait painted at that time, though his apparel does not seem to be a naval uniform. That he was left-handed seems certain, as the sword in on the right side. It is puzzling to note what seems to be an epaulette hanging from the right shoulder. Perhaps the costume is his own version of an undress uniform, quasi-military in design.

After the voyage, he vented his frustration in numerous critical notes in the margins of his personal copy of the three-volume account of Cook's third voyage, now lodged in the Admiralty Library in London. The title page reads, "Illustrated with Maps and Charts, from the original drawings made by Lieut. Henry Roberts, under the direction of Captain Cook." Bligh annotated this with: "None of the Maps and Charts in this publication are from the original drawings of Lieut. Henry Roberts, he did no more than copy the original ones from Captain Cook who besides myself was the only person that surveyed & laid the Coast down, in the Resolution. Every Plan & Chart from C. Cook's death are exact copies of my Works. Wm. Bligh."[3]

Bligh's notes assumed a defensive tone in the portion of the journal dealing with Cook's death at the hands of enraged natives at Kealakekua Bay, Hawaii. At least one historian has concluded that the premature and unauthorized firing from the boat occupied by Bligh, Lieutenant Rickman, and a detachment of marines, which killed a high chief, was "an important factor, if not the actual cause, of Cook's death."[4]

By the time the division of profits from the sale of Cook's journal had been determined, with half (over £2,000) going to Cook's family, Bligh's protests were recognized: "the remaining eighth [after other divisions] was for a disgruntled Bligh, in recognition of his work as surveyor and cartographer."[5] Bligh's share approached £400, which one suspects he might have preferred to exchange for his name on the famous title page.

After the end of the voyage on October 4, 1780, when the customary promotions were made, Bligh was passed over, and did not gain his lieutenancy until 1781, after a period of battle experience.[6] In that year, commanding the fifty-four gun *Glatton* at the battle of Copenhagen, he received Commodore Nelson's personal commendation. Bligh is best known for his command of H.M.S. *Bounty* in 1787, commissioned to transport breadfruit trees to the West Indies; the mutiny in April 1789; and the incredible 4,000 mile voyage of Bligh and eighteen others cast off in an open boat.

In 1805 he was appointed governor of the penal colony at New South Wales, where previous governors had been unable to control the corruption. Composed of convicts, former prisoners, free settlers, government officials, and a military garrison, it presented extraordinary difficulties to an administrator. Ten years previously, the then governor had urged the removal of the military corps, on the grounds that its conduct was the "most violent and outrageous ever heard of in a British regiment." Bligh's stringent regulations brought the inevitable clash, and he was imprisoned for two years by mutineers. He was eventually freed by the replacement governor, and returned to England. His courage, resolution, and imprisonment "caused the recall of the NSW Corps, who by long residence had become the most powerful and perhaps the most evil factor in the community . . . it indirectly led to the reform of the Law Courts, to the removal of the restrictions on trade and commerce and to the general betterment of the conditions of life."[7]

After his return to England, he received the routine promotions to rear admiral, then to vice admiral of the blue in 1814. He died in 1817 at the age of sixty-four.

Geographical features named after him include Bligh's Cap, a high rocky island off Kerguelen Island in the southern Indian Ocean, named by Cook; Bligh Island in Prince William Sound named by Vancouver; and Bligh Island in Nootka Sound, named by the Canadian Hydrographic Office in 1862.[8]

Views of the Land on the West Coast of AMERICA, to the Westward of Cook's River.

View of the Land to the N.d of Foggy Island A bearing S.W.½ W.7 lea.d dist. and B.West 4 lea.d dist.

View of the Land to the West.d of Pinnacle Point when the Point bore N.W.5 or 6 leagues dist.

N.B. Highland was seen to the N.E. of Pinnacle Point, but it was too cloudy to see any part distinctly.

View of the Land when Pinnacle Point bore N.½ W. 6 or 7 lea.

Mount S.t Elias.

View when Mount S.t Elias bore N. W.b W. 20 lea.s

William Bligh's coastal profiles, 1778

From Cook and King, *Voyage*, 2: facing p. 411; courtesy Pacific Northwest Collection, UW Libraries.

Bligh's artistic ability found an outlet in his expressive drawing of coastal profiles, of a quality occasionally lacking in the work of some of his contemporaries. "His coastal profiles go beyond the seaman's conventional formula and are treated as fragments of landscapes, presenting planes of recession seen in perspective; careful in the eye-sketching of inland detail, he lays down relief features in plan on his charts by a sensitive hatching technique which recalls the best contemporary work of military engineers" (Beaglehole, Cook Journals, *3:ccxvi).*

Detail from engraving of a coastal profile by Bligh, in Cook and King, *Voyage*, 2: facing p. 411.

"Today we saw the high Mountain called by Bering Mount S.t Elias, it is the highest Mountain we have seen on the Coast and is covered with Snow, it rises in the form of [a] Piramid with its base in a ridge of Mountains and may be seen at sea at the distance of 60 or perhaps 70 Leagues" (Beaglehole, Cook Journals, *3:1105).*

William Ellis

While Cook's third voyage enjoyed the services of a professional artist, no naturalist was provided, as was done for the first two voyages. Explicit Admiralty instructions, on their face, seemed beyond the capacity of one artist alone to carry out: "You are also carefully to observe the nature of the Soil & the produce thereof; the Animals & Fowls that inhabit or frequent it; the Fishes . . . and in case there are any, peculiar to such places, to describe them as minutely, and to make as accurate drawings of them, as you can."[1]

Fortunately, for Cook and for posterity, William Anderson, surgeon on the *Resolution*, filled in as unofficial naturalist. He was aided by William Ellis, second mate of the surgeon on the *Discovery*. Ellis had an ability to make "charming and delicate" watercolors, as well as accurate renderings of birds. After attending Cambridge University, Ellis had received his medical education at St. Bartholemew's Hospital in London. He gained his mate's warrant on March 12, 1776, and joined the *Discovery* ten days later. Surgeon's mate David Samwell described him as a "genteel young fellow and of a good education."[2]

Captain Charles Clerke dictated a sickbed letter to Ellis' patron Sir Joseph Banks in England, only twelve days before he died at sea in August 1779: "I must beg leave to recommend to your notice Mr Will. Ellis one of the Surgeon's mates who will furnish you with some drawings & accounts of the various birds which will come to your possession, he has been very useful to me in your service in that particular, & is I believe a very worthy young man & I hope will prove worthy of any services that may be in your way to confer upon him."[3]

Banks should have been pleased with the high quality of Ellis' bird sketches. Although friendly to him in the past, he nevertheless abandoned any further support after Ellis permitted an illegal publication of his journal of the voyage. Admiralty instructions on this score were specific, enjoining Cook and Clerke to take care "before you leave the Sloop to demand from the Officers & Petty Officers the Log Books & Journals they may have kept, & to seal them up for our Inspection, and enjoining Them & the whole Crew, not to divulge where they have been, until they shall have permission so to do."[4]

In spite of this, Ellis had somehow managed to keep his journal, or perhaps a copy, and could not resist the temptation to raise money by selling it to a bookseller for fifty guineas. This resulted in the publication in 1782 of two volumes bearing his name as author. He was one of three participants in the voyage who improperly published accounts. Apparently no action was taken by the Admiralty to prevent their issuance, as all were reprinted, some even before the official account was published in 1784. (The reprints included French and German versions.)[5]

While the two Ellis volumes cannot be compared in quality with the magnificent official version, it is by far the best of the three unauthorized printings. It seems to be a straightforward account, although abridged, and is illustrated with twenty-two engravings of indifferent quality from Ellis' drawings. A modern historian notes that "the student of history turns to them [the three illegal publications] for the details of events on the *Discovery* . . . which are only incidentally mentioned, if at all, in the official report."[6] Nevertheless, Ellis' descriptions could be disappointingly brief, compared to more detailed contemporary accounts. Here he describes what appears to be the Indian village at Friendly Cove:

It consisted of two rows of houses, very ill built, and admitting both wind and rain; the stench was very disagreeable, and might be smelt at some distance. Their furniture consisted of a few baskets and boxes, in which they put their fishing-tackle, &. the remaining part of the house being ornamented with rows of dried fish. Upon the beach were ninety-four canoes, and the number of inhabitants were computed to be about four hundred.[7]

Ellis was proficient as an engraver, as well as an artist. In view of the discredit he obtained by his publication, it is startling to find that he engraved two of the plates of Webber's drawings in the official version—plate 21, a scene in the south Pacific, and plate 45, "A view of Snug Corner Cove, in Prince William Sound." One might logically assume that these were executed prior to publication of his journal, and that his illegal act brought about a decision not to retain him for further engraving.

Although his birthdate is unknown, he was likely in his middle thirties when he died from a fall off the mainmast of a ship in Ostend, "on his way to Germany, where the Emperor had engaged him on advantageous terms to go on a voyage of discovery."[8]

w Ellis fecit 1779

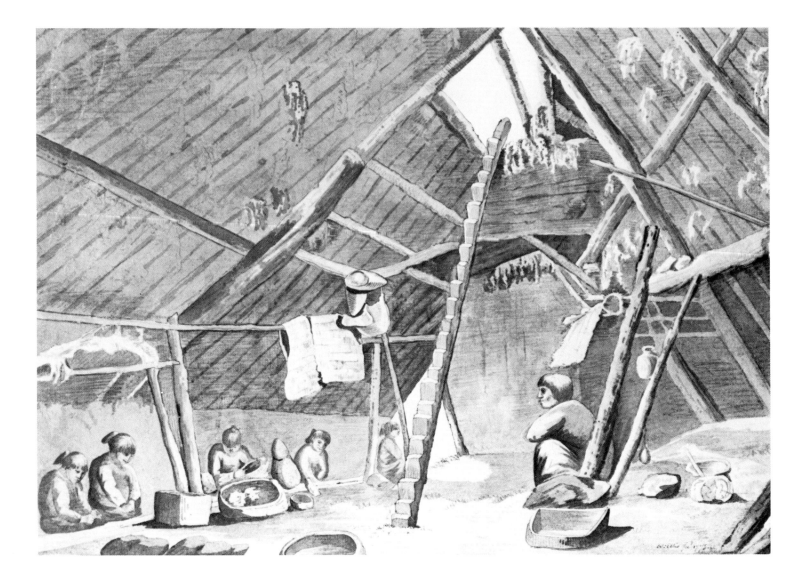

"Inside of a hut [at] Unalaschka," 1778

Watercolor drawing by William Ellis; Rex Nan Kivell Collection, NK 53/N, courtesy National Library of Australia, Canberra.

They dig an oblong hole in the earth, about four feet deep . . . at the ends . . . they fix two strong wooden posts, to which are fastened ridge poles, which are supported by other wooden posts, . . . upon these ridge poles are secured other pieces of wood, upon which they form the roof. . . . The sides of the house are formed by poles which reach obliquely from the ridge poles to the earth . . . over the whole, they place a layer of dried grass, upon that a quantity of earth, and so on alternately. . . . From the hole on the top, is fixed a kind of ladder . . . though this mode of descent was very aukward to us, the natives pass and repass with the greatest ease. They are not very expensive in their household-furniture, which consists chiefly of wooden bowls, troughs, and platters, of various sizes . . . and a copper kettle for the purpose of boiling fish. They procure fire by rubbing two pieces of dry wood against each other, and instantly make it blaze by powdering a little sulphur . . . upon the down of birds, which is placed upon straw for that purpose" (Ellis, Authentic Narrative, 2:48–50).

"*Outside of the Huts at Unalaschka,*" 1778

Watercolor drawing by William Ellis; Rex Nan Kivell Collection, NK 53/M, courtesy National Library of Australia, Canberra.

"The outside of the house is cover'd with a clay mould & grass which becomes indurated & excludes all wind & rain; & from the weeds growing about them, & their throwing on the sides & top all kind of dirt, their houses look rather like small hillocks of Old manure" (King's journal in Beaglehole, Cook Journals, 3:1428).

"View of Ship Cove, in King George's [Nootka] Sound," 1778

Watercolor and ink drawing by William Ellis; Rex Nan Kivell Collection, NK 53/J, courtesy National Library of Australia, Canberra.

"In the Morning we warp'd into the Cove, dropt the small Bower . . . & steadied with hawsers from the bows and Quarters to the trees on each side the Cove. Set the observatory up, on a rock in the N part of the cove close to the Ship; fixed up some instruments in it; the rigging of the foremast was lifted for the Carpenters to repair the bibs, we had found the Starboard one at sea to be sprung, we now perceived the Larboard one to be in no better condition & the Larboard Tressle tree sprung. Whilst the Carpenters were repairing these defects & caulking, the party on shore were cutting wood, & making a convenient place to water at. The Armourers had the forge set up to repair Iron work, & make hoops for the Tressle trees" (King's journal in Beaglehole, Cook Journals, 3:1396–97).

Henry Roberts

Henry Roberts was born in Shoreham, Sussex. Though there is some confusion about the date of his birth, historian J. C. Beaglehole accepts the time as about 1747, and it is known that he was an able seaman (A.B.) on the *Resolution* during Cook's second voyage. When news of Cook's projected third voyage became known, Roberts hastened to join, signing the muster list of the *Resolution* on February 10, 1776. Just over a month later, he was promoted from A.B. to master's mate. He was considered to be a skillful draughtsman, as well as a cartographer, "a man with a charming talent for illustrating a journal with wash-drawings,"[1] although no drawings done on the Northwest Coast could be located.

Roberts had great admiration for his captain, and lamented Cook's death in his journal: "returned on board not being able to get the body of our lost Commander, whose death occassioned concern, & sorrow, in every countenance; such an able Navigator, equalld by few and excelled by none, justly stiled father of his people from his great good care and attention, honored, & beloved by those who knew, or ever heard of him."[2]

After the *Resolution* returned to England, John Gore, who had succeeded to its command after Clerke's death, wrote to the Admiralty from Deptford on October 7, 1780, sending "the remainder of the Mapps and Journals on board the Resolution. Mr Roberts is Charg'd with the Care of Them And bears you This. He was principal assistant Hydrographer to Capt Cook and is most certainly a verry Deserving young man."[3]

An uneasy question survives about the circumstances under which Roberts was given credit for drawing the charts of the voyage, and for which he was severely criticized by William Bligh, who claimed authorship (see p. 65). It may never be known whether Roberts was a willing partner in this injustice.

Three weeks after the end of the voyage, Roberts received his lieutenant's commission. From 1781 to 1784 he was assigned to the task of redrawing charts of the voyage, in preparation for engraving. In the fall of 1789 he was given command of the *Discovery* (a ship later sailed by Vancouver,) for an expedition which never materialized. A promotion to commander came in 1790, and he received his rank of captain on August 28, 1794.[4]

Following a period on half pay, he commanded the *Undaunted*, a thirty-eight-gun frigate, during 1795 and 1796 in the West Indies. After participating in two naval landing actions, he died in the West Indies August 25, 1796, at the age of forty-nine. The service record of the *Undaunted* shows that she was wrecked on Morant Keys, West Indies, only two days following his death, while under the command of Captain Robert Winthrop.[5]

George Vancouver named Point Roberts after him in 1792. It is located at the boundary line between British Columbia and the state of Washington.

Henry Roberts, 1780s

Courtesy National Maritime Museum, London.

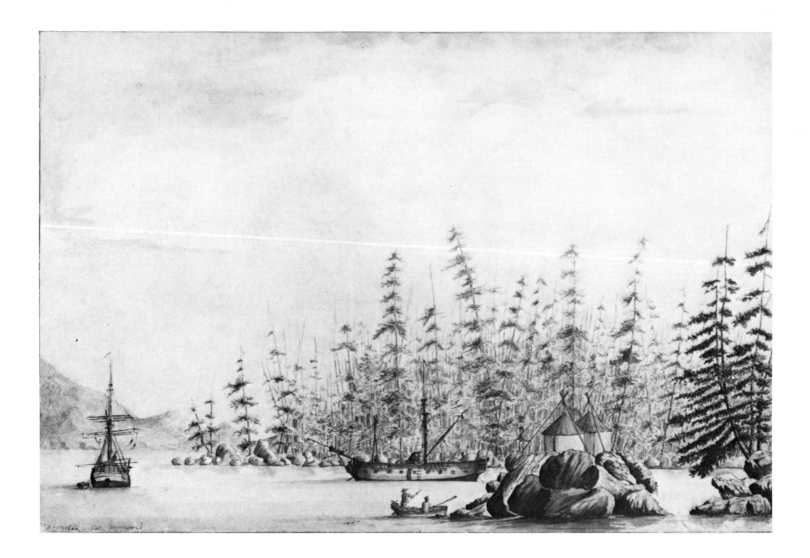

View of Resolution Cove, Nootka Sound, 1778

Drawing attributed by the author to Henry Roberts; courtesy National Library of Australia, which records: "Artist Unknown, the Discovery and Resolution anchored at Nootka Sound, 1778. Pen, ink and watercolour drawing."

The Discovery *is moored at the left, the* Resolution *at the right, with a tackle set up to assist in replacing the damaged mizzenmast. In the foreground are the two observatory tents on "Astronomer's Rock," with a sentry standing guard.*

Another view of the Resolution *in Ship (Resolution) Cove, Nootka Sound, 1778*

Unsigned drawing, possibly by Henry Roberts; courtesy Mitchell Library of New South Wales, ref. PXD 59, no. 125.

This view may have been taken shortly before the mizzenmast was found damaged on April 7: "in the after-noon it blew exceeding hard squalls, right into the Cove; in one of these, the head of the Mizen mast gave way under the rigging. . . ." On the other hand, it may have been drawn after the 21st, when the carpenters "got the Mizen mast in & rigg'd it & got the Topmast on end; the Carpenters making a Foretop-mast in the room of the one carry'd away" (Beaglehole, Cook Journals, *pp. 1399, 1401).*

A line of steps, or perhaps hand lines, can be seen ascending the steep left face of Astronomer's Rock, to the observatory tents.

The Mitchell Library has recorded this sketch as "possibly by J. Webber." As it is quite unlike his style, or that of William Ellis, I attribute it to Henry Roberts.

John Webber

Two hundred years ago, a young London-born artist stood on the deck of a sea-worn sailing ship, quietly absorbing the wild beauty of a majestic panorama of blue-green hills climbing into the distance of lofty snow-covered peaks. The scene he studied was on and beyond the mysterious reaches of Nootka sound, on the rugged west coast of Vancouver Island. It was pure chance which brought him . . . an unlikely contingency which was to result in the first visual records of the Indian life of this wild and forbidding coast, never before touched by Europeans. (Henry, "Captain Cook's Artist," p. 11)

Abraham Wäber, John Webber's father, was a Swiss sculptor who emigrated to London in about the year 1740, changed his name to Webber, and married an Englishwoman in 1744. John Webber was born October 6, 1751, one of at least six children. Due to his father's financial problems, John was sent to Berne at about the age of six to live with an unmarried aunt.

When he was fifteen, recognizing that he had artistic ability, his Berne relatives applied to the city's Corporation of Merchants for a grant to enable him to study art. From 1767 to 1770 he worked under Johann Ludwig Aberli, the leading artist of Berne.

Armed with letters of introduction from Aberli and others, at nineteen he went to Paris for further training. J. G. Wille, recipient of the letters, was a successful German engraver in Paris. He encouraged Webber to frequent his studio, and to accompany him on sketching trips in the countryside. Some of Webber's sketches of "picturesque peasant scenes," presumably from this period, are lodged in a Berne museum.

John Webber, 1780s

From Beaglehole, *Cook Journals*, 3:following p. 1xxx; courtesy Pacific Northwest Collection, UW Libraries; reproduced by permission of Bernisches Historisches Museum, Berne.

Leaving Paris after five years, Webber moved to London, where he found employment with a dealer in remodelled houses. His assignment included decorating them with murals of landscapes and mythological figures. His employer apparently admired his work, encouraging Webber to enter a painting in the Royal Academy's annual exhibition. At this juncture, Fate took a strong hand in the progress of the twenty-four-year-old artist. He entered three paintings at the exhibit, which caught the eye of Daniel Carl Solander, the brilliant Swedish botanist who had been with Cook on the two previous voyages. Solander had worked closely with Sir Joseph Banks, president of the Royal Society, who was influential with the Admiralty. It was this connection that led to Webber's appointment as draughtsman to Cook's third voyage, just ten days before he was to report for duty.[1]

Webber's salary was set at one hundred guineas yearly, at which point a typical bit of "eighteenth-century chicanery" came into play. He was officially entered on the ship's records as an able seaman, thus collecting the additional pay without performing the arduous duties required of an A.B. Such "swindles" against the Admiralty were frequently practiced; Cook himself had enrolled his two small sons as able seamen at ages five and six.[2]

It may well be that the additional pay was well justified, in view of the rather detailed charge to Cook by the Admiralty:

Whereas we have engaged Mr John Webber Draughtsman and Landskip Painter . . . in order to make Drawings and Paintings of such places in the Countries you may touch at in the course of the said Voyage as may be proper to give a more perfect Idea thereof than can be formed by written descriptions only . . . taking care that he does diligently employ himself in making Drawings or Paintings of such places . . . as may be worthy of notice . . . also of such other objects and things as may fall within the compass of His abilities.[3]

That Webber performed well, and beyond expectation for an expedition artist, is evidenced by the unusually large number of high quality drawings and paintings produced during the four-year voyage. In the words of Bernard Smith in *European Vision and the South Pacific, 1768–1850*, "no voyage undertaken in the days before photography ever returned so well documented with pictorial illustrations, nor had so great an area of the earth's surface come under one artist's observation" (p. 78).

After the voyage, Webber was retained by the Admiralty at a salary of £250 annually to supervise the work on more than sixty engravings which illustrate the published journal. When the task was completed, he received the right to use his two hundred expedition drawings as he wished. Based largely on their quality, he was elected an associate of the Royal Academy in 1785 and was made a full member in 1791.[4]

With the prominence he acquired from the expedition drawings, Webber was able to produce an income which allowed a comfortable living, including sketching trips to Switzerland, Northern Italy, and areas in England and Wales. When he died on April 29, 1793, at the age of forty-one, as the result of kidney disease, his will had provided substantial bequests to friends and relatives. Admirably, he also remembered the Company of Merchants in Berne, which had so generously supported his early training. His ethnological collection from the voyage had previously been given to the city.

Canadian historian Douglas Cole, who has conducted definitive research on Webber, located a Swiss source which commented on his "noble bearing and pleasant humour, his quiet but penetrating conversational manner." Cole has assessed Webber favorably as an artist: "an excellent landscapist . . . his draughtsmanship is good, he possessed a fine sense of composition and his choice of subjects was interesting and appropriate . . . although he gives a characteristic but inappropriate elongation to all his figures."[5]

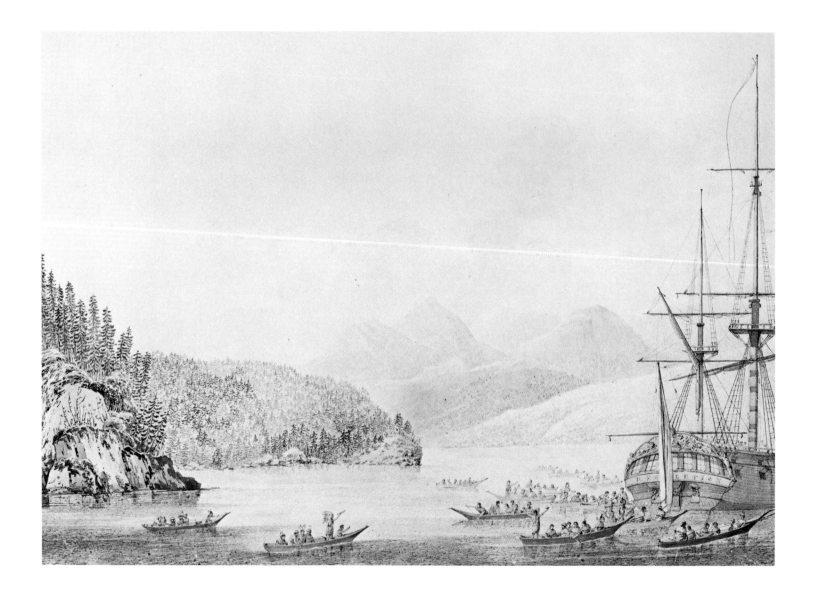

A View in Ship Cove, Nootka Sound, 1778

Drawing by John Webber; courtesy The British Library, London, Add. 15514.10.

"We had every day new Visitors, who generally came in large boats, & apparently from some distance. On their arrival they always perform'd what seemd a necessary ceremony, which was pulling & making a circuit round both Ships with great swiftness, & their Paddles kept in exact time; one man would stand up in the middle with a Spear or rattle in his hand, & a mask on which was sometimes the figure of a human face, at others that of an Animal, & kept repeating something in a loud tone; At other times they would all join in a Song, that was frequently very Agreeable to the Ear, after this they always came alongside & began to trade without Ceremony" (King's journal in Beaglehole, Cook Journals, 3:1397).

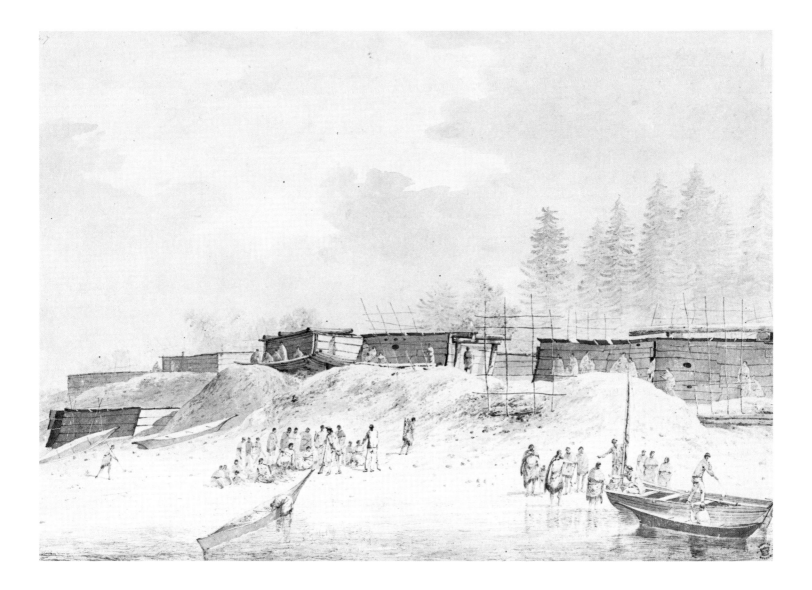

"View of the outside of a house at Nootka," 1778

Drawing by John Webber; courtesy The British Library, Add. 15514.7.

"Their houses or dwelings are situated close to the shore. They consist in a long range of buildings, some of which are one hundred and fifty feet in length, twenty four or thirty broad and seven or eight high from the floor to the roof, which in them all is flat and covered with loose boards. The Walls . . . are also built up of boards and the framing consi[s]ts of large trees or logs. They first fix firm in the ground three rows of large posts, on these are fixed longitudanally, large trees the whole length of the building, a cross these they lay the boards that serve for the covering. . . . Many of these boards are thirty feet in length and from three to five broad, and are all procured by splitting large trees. Some of these buildings are raised on the side of a bank, these have a flooring consisting of logs supported by post[s] fixed in the ground; before these houses they make a platform about four feet broad . . . and so allows of a passage along the front of the building" (Beaglehole, Cook Journals, 3:317).

Walrus hunt in the Arctic, 1778

Sketch by John Webber; courtesy Public Archives of Canada, Ottawa, C2620.

The field sketch from which many finished versions were derived.
 "On the ice lay a prodigious number of Sea horses and as we were in want of fresh provisions the boats from each ship were sent to get some" (Beaglehole, Cook Journals, *3:419).*

Hunting "sea horses" in the Arctic, 1778

Watercolor by John Webber; courtesy Historical Photography Collection, UW Libraries.

"They lay in herds of many hundred upon the ice, huddling . . . and roar or bray very loud, so that in the night or foggy weather they gave us notice of the ice long before we could see it" (Beaglehole, Cook Journals, *3:419*).

The walrus meat, for most, was a welcome variation from salt meat. "For my own part I declare I think them pleasant and good eating; and they doubtless must be infinitely more nutritive and salutary than any salt Provision" (Clerke journal in ibid., *3:419n*).

Webber must have made multiple copies of this scene, with variations, as he did with his other drawings after the voyage (compare with field sketch, p. 78). This may have been one of his earlier renditions, done before some friend pointed out the fallacy of depicting a boat laden with seven full-sized men, floating so high in the water. Later versions showed a normal waterline.

Portlock and Dixon's Expedition of 1785–88

In 1785 the King George's Sound Company, led by Richard Cadman Etches, and supported by a number of wealthy London merchants and members of the nobility, equipped two vessels for "prosecuting and converting to national utility the discoveries of the late Captain Cook." The patrons spent a day aboard ship and christened each vessel. Etches reported that "as an emblem of so novel and enterprising an undertaking, Hope, leaning on an anchor, was painted on their colours."[1]

Etches had selected thirty-seven-year-old Nathaniel Portlock as leader of the expedition and captain of the larger vessel, the *King George*. Portlock had been a master's mate under Charles Clerke on the *Discovery* during Cook's third voyage, and had been promoted to lieutenant after returning to England. George Dixon was appointed captain of the *Queen Charlotte*.

The two vessels left the British coast on September 16, 1785. Cape Horn was rounded in rough weather, and anchors were dropped in Kealakekua Bay in May of the following year. This was an imprudent choice, since it was the scene of Cook's murder by the natives only seven years earlier. As the "vast multitude" became increasingly "daring and insolent," it became imperative to leave the anchorage.[2] Provisions had to be obtained elsewhere in the islands.

The ships arrived at Cook Inlet on July 20, then traded down the coast, also searching for a desirable spot to winter, unaccountably without success. Failing to enter Nootka Sound because of adverse winds, a course was set for the Hawaiian Islands. Returning to Prince William Sound in late April, 1787, the ships separated, Dixon trading southward, while Portlock remained in Alaskan waters.

After acquiring a satisfactory cargo of furs, the two ships arrived separately at Hawaii, then sailed on to Canton to dispose of their furs.[3] Leaving China on February 6, 1788, they separated near the island of Java for the sake of a faster homeward voyage. The *King George* arrived in England on August 24, the *Queen Charlotte* a fortnight later.

The voyage successfully established the commercial advantages for future fur trading on the Northwest Coast. The profit for the sale of furs, however, failed to meet the high expectations of the backers "owing to their own inexperience; for when [the vessels] arrived at Canton, and even a month after that period, prime sea-otter skins sold from eighty to ninety dollars each." The cargo of skins was large, over 2,000 prime furs, but company rules required that all sales be handled by the East India Company. When finally sold, the market had dropped to less than twenty dollars. Nevertheless, Portlock concluded that "this branch of commerce . . . is perhaps the most profitable and lucrative that the enterprising merchant can possibly engage in."[4]

George Dixon

George Dixon's birthdate is unknown, but he was old enough to have held the position of armorer on James Cook's *Discovery*, from 1776 to 1780.[1] During the five-year interval between the *Discovery*'s return to England and Dixon's appointment to the *Queen Charlotte* in 1785, he most likely had the command of at least one merchant ship.

The group of merchants who formed the King George's Sound Company, had selected Nathaniel Portlock as captain of the *King George* and head of the expedition. Portlock, who had also served on the *Discovery*, may have been instrumental in selecting Dixon for his post, "both of us having accompanied captain Cook in his last voyage into the Pacific Ocean, were deemed most proper for an adventure which required no [small] common knowledge and experience."[2]

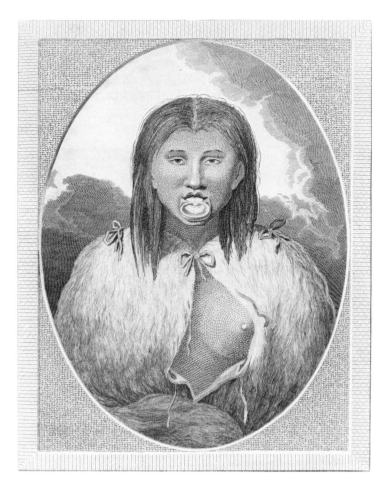

"A young woman of Queen Charlotte's Islands," 1787

Engraving of a drawing by George Dixon, in his *Voyage*, facing p. 226; courtesy Pacific Northwest Collection, UW Libraries.

One of the native chiefs, after inspecting the Queen Charlotte, *returned to his canoe "very well pleased," and permitted his wife a similar privilege: "When she got on the quarter deck [she] gave us to understand that she was only come to see the vessel, and with a modest diffidence in her looks endeavored to bespeak our indulgence and permission for that purpose. She was neatly dressed after their fashion; her under garment, which was made of fine tanned leather, sat close to her body, and reached from her neck to the calf of her leg: her cloak or upper garment was rather coarser, and sat loose like a petticoat, and tied with leather strings . . . Captain Dixon made her a present of a string of beads for an ornament to each ear, and a number of buttons" (Dixon,* Voyage, *p. 226).*

The bared breast was a device often used by engravers to differentiate the sexes. It seems certain that this modest woman did not so pose for Dixon's convenience.

Dixon had acquired a certain amount of skill in surveying, which he employed to advantage, filling in the details of Cook's general outline of the coast. While acknowledging "that we have made considerable additions to the geography of this coast," his record of the voyage includes the disclaimer that "much remains to be done; indeed, so imperfectly do we still know it, that it is in some measure to be doubted whether we have yet seen the main land; certain it is that the coast abounds with islands, *but whether any land we have been near is really the continent*, remains to be determined by future navigators." Their "imperfect" understanding included the failure to distinguish Queen Charlotte Sound as a "passage to the southward," even though they sighted it.[3]

While the title page of *A Voyage Round the World* bears Dixon's name as author, he gave the task of actually writing it to "a person on board the *Queen Charlotte*, who has been totally unused to literary pursuits, and equally to a sea-faring life. However, to obviate any objection that might possibly arise from his deficiency in nautical knowledge, I have been particularly careful in correcting that part of the work" (p. xxiii). The inexperienced ghost-writer was William Beresford, listed as "Assistant Trader" on the muster roll of the *Queen Charlotte*.

After the voyage, Dixon published two pamphlets containing a devastating attack on the veracity of published claims made by John Meares, who was on the Northwest Coast at the same time (see p. 92). The greater part of these two tracts was also apparently written by someone other than Dixon.[4]

Little is known of Dixon's life after the return of the *Queen Charlotte* to England in 1788. He may have been the George Dixon listed in a contemporary dictionary as a "teacher of navigation . . . and author of 'The Navigator's Assistant'" (published in 1791). His death is believed to have occurred about 1800.

Several geographical features of the Northwest Coast were named for him. The most important is Dixon Entrance, which lies between the Queen Charlotte Islands and the Prince of Wales group to the north. The name was given by Sir Joseph Banks after Dixon's return to England. Dixon Glacier, Dixon Harbor, and Dixon River in British Columbia were also named after him.[5]

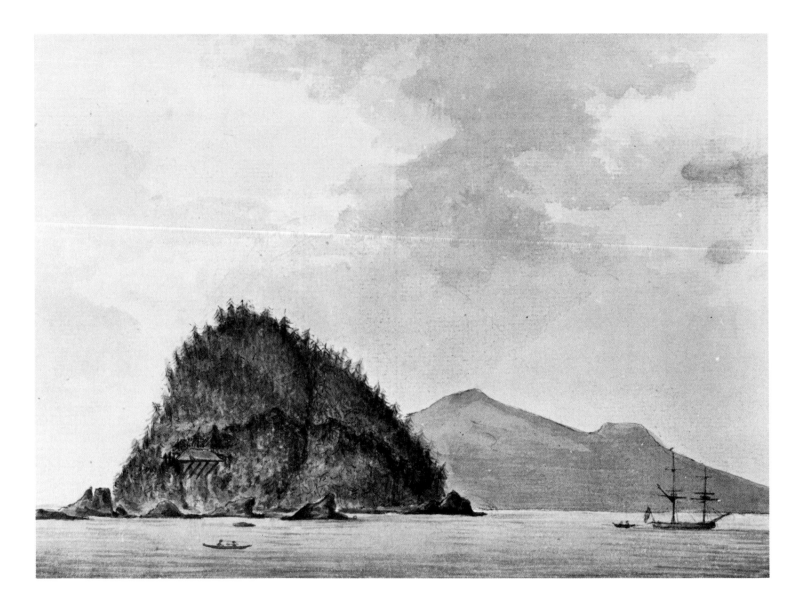

Hippa Island, Queen Charlotte Sound, 1787

Drawing attributed to George Dixon; Rex Nan Kivell Collection, courtesy National Library of Australia, Canberra.

This appears to be the original drawing from which an engraving (see p. 83) was made for Dixon's Voyage. *The drawing has a faint line penciled above the island, as a direction to the engraver to enlarge it and bring it closer to the viewer. The canoe and ship are still in the same position, but the engraving shows the ship under sail, rather than at anchor.*

 Howay states that these "fortified retreats were common in the Queen Charlotte Islands" (Columbia Voyages, *p. 98n). Similar fortified positions were noted by explorers in the South Pacific. As a participant in Cook's third voyage, Dixon perhaps had the opportunity to view the fortified "Hippah island" at Queen Charlotte Sound, New Zealand, described by Anderson as a place of refuge, "with only one path on the west side so difficult of access that by a few it might be defended against hundreds" (Anderson's journal in Beaglehole,* Cook Journals, *1:800).*

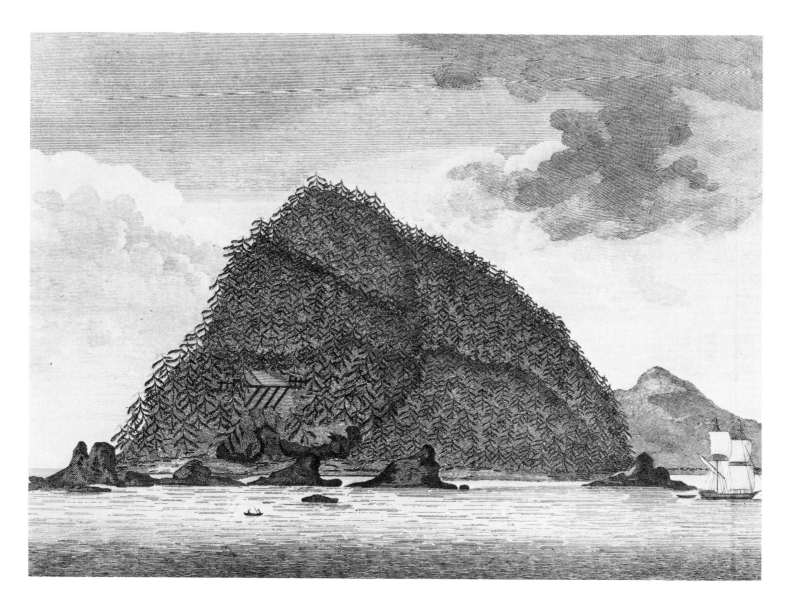

"A View of Hippa Island, Queen Charlotte Isles," 1787

Engraving of a drawing by George Dixon in his *Voyage,* facing p. 205; courtesy Pacific Northwest Collection, UW Libraries.

"We saw several canoes putting off, on which we shortened sail, and lay to for them, as the wind blew pretty fresh. The place these people came from had a very singular appearance, and on examining it narrowly, we plainly perceived that they lived in a very large hut, built on a small island, and well fortified after the manner of a hippah, on which account we distinguished this place by the name of Hippah Island.

"The tribe who inhabit this hippah, seem well defended by nature from any sudden assault of their enemies; for the ascent to it from the beach is steep, and difficult of access; and the other sides are well barricadoed with pines and brush-wood; notwithstanding which, they have been at infinite pains in raising additional fences of rails and boards; so that I should think they cannot fail to repel any tribe that should dare to attack their fortification" (Dixon, Voyage, p. 205).

*"A View of Mount Edgecombe, taken from the Ship at Anchor
in Norfolk Sound,"* 1787

Engraving of a drawing by George Dixon in his *Voyage*, facing p. 192; courtesy Pacific Northwest Collection,
UW Libraries.

*"Norfolk Sound, at least that part where we lay at anchor, is situated in 57 deg. 3 min. North latitude; and
135 deg. 36 min. West longitude. In that situation, Mount Edgecombe bore from us West by South, a very
few miles distant. The shore here . . . abounds with pines; there is also witch hazle . . . various kinds of
flowering trees and shrubs, amongst which were wild gooseberries, currants, and rasberries; wild parsley is
found here in great plenty; we picked great quantities of it, and it eats excellently, either as a sallad, or
boiled amongst soup. The saranne, or wild lillyroot, grows here in great plenty and perfection"* (Dixon,
Voyage, pp. 184–85).

James Hogan

On the roster of the *King George* when she left England in 1785 was the name "James Hoggan, surgeon." The ship's surgeon was often a key figure among the officers of a vessel, usually being well educated, with a wide range of interests in addition to medicine. Hogan was no exception. Details of his life are lacking, but it is evident that he was a person of sensibility. In addition to his medical expertise, he may have been an amateur ornithologist and an accomplished artist, since his name appears on one of the avian engravings in Captain Portlock's journal. He may also have drawn some of the unsigned sketches of birds.[1]

Portlock seems to have had considerable respect for Hogan's abilities. When the *King George* arrived in the Hawaiian Islands in June 1786, Hogan had much to do caring for those ill with scurvy. On the island of "Atoui," Portlock involved Hogan in a politically risky medical problem. The king, Taaao, came to Portlock with his elderly uncle, Neeheowhooa, a great warrior and "a person of the first consequence," and "begged of us to cure him." According to Portlock, the old chief's appearance

bespoke the hardy veteran; his body was almost covered with scars, and he was quite a cripple; and to add to his distressing situation, he had entirely lost one eye, and the other was in a weak state, occasioned by some wounds he lately had received in battle, and which were beyond their art to heal. I recommended him to the care of my surgeon, who washed his wounds, applied dressings to them, and gave him some fresh ones, which he was directed to make use of once a-day. Neeheowhooa seemed perfectly to understand the surgeon's instructions, and promised to follow them in the most punctual manner. After remaining on board a few hours, Taaao and his uncle left us, highly pleased with the treatment they had received [pp. 177–78].

On the homeward voyage, after leaving Macao in February 1788, Portlock found "a number of the ship's company ill with fluxes, and others with fevers, owing (in the opinion of the surgeon) chiefly to their hard drinking whilst at Wampoa." In the Sunda Strait, Dixon asked Hogan to prescribe for his own surgeon on the *Queen Charlotte*, who was ill. "The Queen Charlotte's Peruvian bark being very indifferent," Portlock sent a supply from his own stock along with Hogan. The next day, however, "the Queen Charlotte hoisted her colours half mast high; on this we shortened sail, spoke her, and found her surgeon dead."

Near the island of Java, Portlock and Dixon agreed to separate for the sake of faster passage home. Since this meant that the *Queen Charlotte* would be without medical assistance, Portlock sent Hogan to examine its sick, and try to anticipate their medical needs for the next few months. Six weeks earlier, Portlock and Hogan had boarded the *Queen Charlotte* to inspect the sick, and decided, since they "were in a fair way of recovery," not to remove them to the *King George*. As it was, it was nearly five months before the faster vessel made its landfall in England, with the *Queen Charlotte* two weeks behind.

James Hogan's name survives today on Hogan Island, two and a half miles long, near the settlement of Chichagof on the west coast of Chichagof Island. Portlock apparently changed his mind after assigning this name on his sketch map, since he gave the island the name "Vincent Island" on his general chart.

"A View of the Volcano, Cook's River, taken from Coal Harbor," 1786

Engraving of a drawing by James Hogan, from Dixon, *Voyage*, facing p. 62; courtesy, Pacific Northwest Collection, UW Libraries.

Dixon's bearing ("59 deg. 28 min. North latitude, and 151 deg. West longitude" [Voyage, p. 67]), except for an apparent half-degree error in longitude, would identify the Burning Mountain as Iliamna Volcano at 10,016 feet, one of the peaks in the Chigmit Mountains in the Aleutian Range.

Some thirty-five years after the eruption, John Nicol, one of the crew of the Queen Charlotte, *remembered the spectacular view as possibly more dramatic than it actually was: "At the entrance of Cook's River is an immense volcanic mountain, which was in action at the time, and continued burning all the time we lay there, pouring down its side a torrent of lava, as broad as the Thames. At night, the sight was grand, but fearful" (Nicol, Life, p. 78). Dixon and Portlock agree on something less sensational: "a considerable smoke issued from its summit, which is very lofty, but we saw no firy eruption" (Dixon, Voyage, p. 62; see also Portlock, Voyage, p. 110).*

A small mystery surrounds the question of how Hogan's drawing, presumably executed on the King George, *ended up in Dixon's book. A logical explanation could be that Hogan allowed Dixon to use his sketch on condition that a competent engraver (Barlow) be employed to copy it, as opposed to P. Mazel (?), who so miserably bungled the reproduction of young Woodcock's drawings.*

Joseph Woodcock

Prior to leaving England in 1785 with the *King George* and the *Queen Charlotte* on a fur-trading voyage to the Northwest Coast, Captain Portlock acceded to the request of supporters of the voyage that he accept nine young boys for training: "Several gentlemen's sons . . . were put in my care, for the purpose of being early initiated in the knowledge of a profession which requires length of experience, rather than supereminence of genius."[1]

Portlock engaged William Philpot Evans and Joseph Woodcock, two students from the Christ's Hospital school trained by the master of mathematics, who he hoped would simultaneously be "able to assist in teaching the boys the rudiments of navigation, and might be usefully employed in taking views of remarkable lands, and in constructing charts of commodious harbors."[2] (In 1553, Edward VI had been so deeply moved by a sermon that he ordered an unused Franciscan convent remodeled into a charitable school. Thus, Christ's Hospital was established at Horsham in Sussex. The mathematical school was opened as an important adjunct in 1673 with the support of Charles II. A drawing school was added in 1693.)[3]

In about 1772, young Joseph Woodcock's mother had petitioned Christ's Hospital, stating that her first husband had died "near four years ago and left her in poor circumstances with three children to provide for, one of whom is since dead and the other two are at this time on her charge." Young Joseph was admitted to the school on the presentation of William Hallett, presumably his stepfather, from the London parish of Allhallows Barking, where Joseph was born in November 1767. On February 9, 1775, at age seven, he was issued a school uniform. Mathematical school records indicate little about him. In June 1785 "he was indentured at the age of 17.2 to Captain Nathaniel Portlock in the King George for the South Seas Trade" as an instructor.[4]

Early in the voyage two of Woodcock's young charges had near-fatal accidents. One boy fell from the topmast onto the main chains, but was unhurt; the other was rescued after he fell overboard[5] Once on the Northwest Coast, however, with Woodcock and his nine pupils still intact, the *King George* commenced trading.

In early August 1787, Portlock encountered Indians who asked to exchange individuals as hostages, "as they seemed to betray neither a mischievous nor thieving disposition, I had no objection." There also was the advantage of Portlock's representative observing "what number of sea-otter skins they possessed."

During later trading Portlock "found it absolutely necessary to conform to their custom . . . for more than once, when I refused to exchange hostages [due to bad weather] they were immediately alarmed." The tension was eased when he allowed a hostage to go ashore with them. The Indians were eager to serve, sometimes more than half a dozen volunteering in exchange for one Englishman.[6] They were doubtless making their own observations.

Woodcock became a specialist in this hostage custom, often living with the natives for short periods, usually just overnight. Certainly some discomfort must have been involved, but on the question of whether he was a volunteer or was drafted for the duty, Portlock is silent. He does describe one sojourn at length:

Woodcock having frequently been on shore as an hostage, was well known to the natives, and they seemed very fond of his company. On one of these occasions he remained among the Indians for three days; during which time he had a good opportunity of seeing their customs and mode of living . . . their filth and nastiness were beyond conception; their food, which consisted chiefly of fish, was mixed up with stinking oil, and other ingredients equally disagreeable, and the remains of every meal were thrown into a corner of their hut. This uncomfortable situation frequently induced Woodcock to take a ramble into the woods; but he was always very narrowly watched by some of his new companions, who seemed to apprehend that he was endeavoring to make his escape from them. Once . . . one of them soon put a stop to [his whistling] by laying his hand on Woodcock's mouth; being apprehensive that he meant the whistling as a signal for some of his companions to come for him. Except their watching him so closely, they treated him with great kindness; and at their meals always gave him what they considered as choice dainties, mixing his fish with plenty of stinking oil, which in their opinion gave it an additional and most agreeable relish; and he found it no easy matter to persuade them to let him eat his fish without sauce. . . . These poor wretches, by living in so filthy a manner, were entirely covered with vermin. . . . Poor Woodcock soon became as much incumbered . . . and he felt his situation extremely disagreeable. . . . At length he persuaded one of the women to rid him of the vermin [pp. 284–86].

Portlock's journal does not mention any drawings done by Woodcock while with the Indians, although it seems likely that he would have taken his sketching materials along. The location of his original sketches, which were the basis for the engravings, is unknown.

He was nearly twenty-one when he returned to England. With experience at sea, and his mathematical and navigational skills, he may have begun a career in either the navy or merchant shipping. A natural choice would have been to join a fur trade voyage to the Northwest Coast, but his later career is regrettably undocumented.

Portlock gave Woodcock's name to a point at the northern entrance to McLeod's Harbor on the west side of Montague Island, which lies toward the outside of Prince William Sound. The name did not survive, however, and appears only on Portlock's chart.[7]

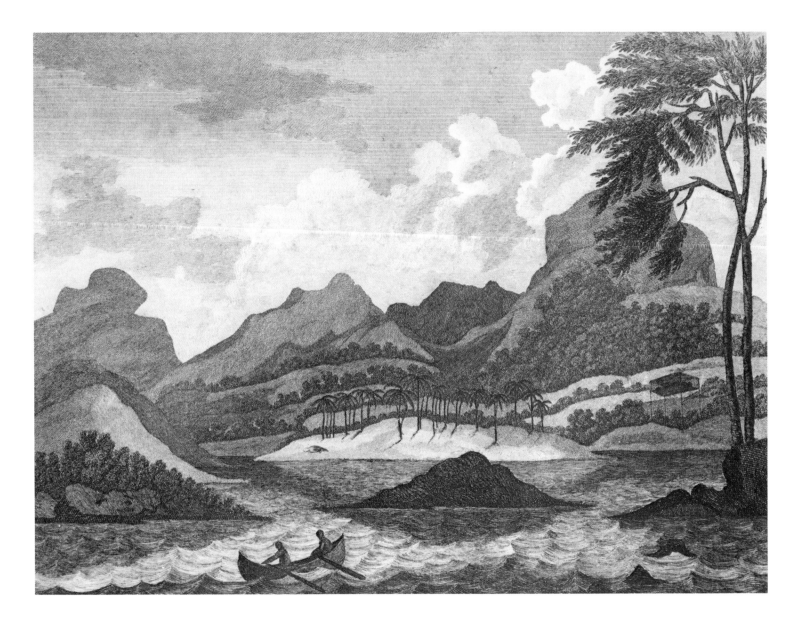

"View in Portlock's Harbour," 1786

Engraving of a drawing by Joseph Woodcock, from Portlock, *Voyage*, facing p. 280; courtesy Pacific Northwest Collection, UW Libraries.

The engraver has taken several liberties with the original, including the addition of a grove of nonexistent palm trees. As though to reassure the viewer, he placed a seal on the beach. Portlock's text confirms the elevated structure on the far right: "This edifice was composed of four posts, each about twenty feet long . . . in a quadrangular form. About twelve or fifteen feet from the ground there was a rough boarded floor . . . in the middle an Indian chest was deposited, which most likely contained the remains of some person of consequence; and on that side . . . to the Westward . . . there was painted the resemblance of a human face" (Portlock, Voyage, p. 280).

This bay is located on the west side of Chichagof Island, and in 1891 was regarded by a survey officer as "the same as Kuk-san [village] of the Tlingit Indians" (Dict. Alaska Names, s.v. "Portlock Harbor").

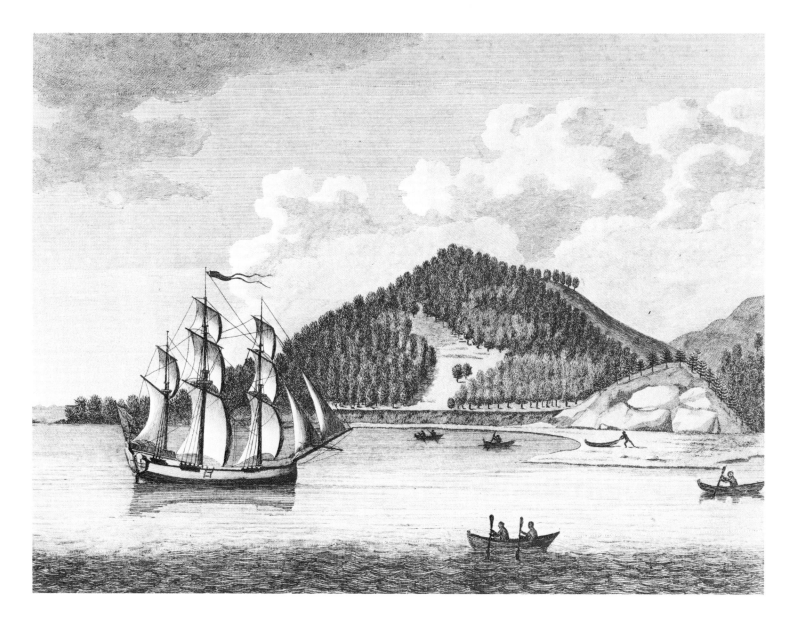

"A view in Coal Harbour, in Cook's River," 1786

Engraving of a drawing by Joseph Woodcock, from Portlock, *Voyage,* facing p. 108; courtesy Pacific Northwest Collection, UW Libraries.

"We landed on the West side of the bay, and in walking round it discovered two veins of kennel coal, situated near some hills just above the beach, about the middle of the bay; and with very little trouble several pieces were got out of the bank, nearly as large as a man's head. In the evening we returned on board, and I tried some of the coal we had discovered, and found it to burn clear and well" (Portlock, Voyage, *p. 108).*

This harbor lies in Port Graham, in Cook Inlet. The engraver has made some amusing changes from the original, since it is inconceivable that Woodcock would have drawn the native baidarkas (kayaks) to resemble European planked boats rowed by oars. The native double-bladed paddle, however, is accurately represented. The vessel is probably the King George.

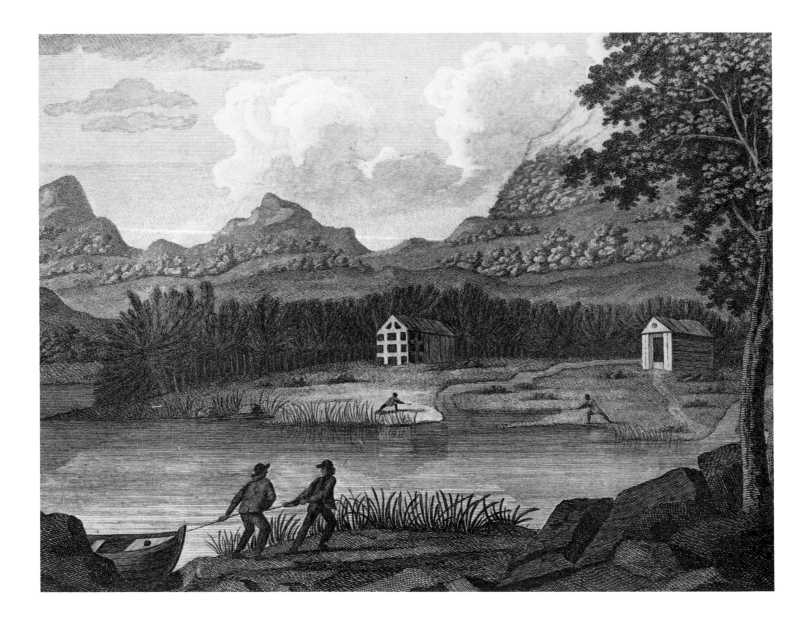

"A view in Goulding's Harbour," 1786

Engraving of a drawing attributed to Joseph Woodcock, from Portlock, *Voyage*, facing p. 270; courtesy Pacific Northwest Collection, UW Libraries.

"In the forenoon I went in the whale-boat, accompanied by Mr. Wilbye and one of the young Indians, to visit their residence. . . . we arrived at the Indian's habitation about noon, and found one small temporary house, and the ruins of two others which had been much larger, and appeared to have been made use of as winter habitations; the uprights or supporters were still remaining, and some boards that were intended for a floor" (Portlock, Voyage, p. 270).

 This is actually a bay in the north part of Portlock Harbor, and was named by Portlock after his publisher.

John Meares and the *Nootka* and *Felice*, 1786–88

John Meares first appeared on the Northwest Coast in 1786, when he induced a group of employees of the East India Company to outfit the *Nootka* in Bengal, for the purpose of circumventing its monopoly on trade. Landfall in Prince William Sound was made dangerously late in the season.[1]

Bad weather had already set in, but Meares was determined to spend the winter trading for furs in these inhospitable surroundings. The healthier alternative of wintering in Hawaii "would, in all probability, have put an end to the voyage," he wrote, "as our seamen were becoming extremely dissatisfied."[2]

By the beginning of 1787 temperatures had dropped severely, heavy snows had descended, and the ship was fast in the ice. As many as thirty men were ill with scurvy at one time. The first officer "got rid of it by continually chewing the young pine branches, and swallowing the juice; but, from the unpleasant taste of this medicine, few of the sick could be prevailed upon to persist in taking it." Twenty-three died during the winter, including the surgeon, a particularly grievous loss.[3]

By May Meares' situation had become desperate, in spite of the improved weather. The *Nootka* was no longer seaworthy, and the remaining crew was too limited in numbers and strength to work the ship. Unexpectedly, assistance was offered by Captain Nathaniel Portlock of the *King George*, a licensed fur trader from England, on condition that Meares cease his illegal trade and quit the coast. Portlock provided medical and other supplies, repaired the *Nootka*, and sent two seamen to reinforce its small crew.[4]

Meares returned to the Northwest Coast in 1788 with the *Felice Adventurer* (which was possibly the *Nootka*, renamed), and the *Iphigenia Nubiana*, owned and outfitted by a group of British merchants in India and Canton. Meares was in overall command aboard the *Felice*, and William Douglas was captain of the *Iphigenia*. To bypass the restrictions of the East India and South Sea companies, Meares obtained Portuguese papers, flags, and commanders, with the English captains appearing as supercargoes.[5]

Meares intended to utilize a low-priced and undemanding labor force. More than half the crews were Chinese, "shipped as an experiment . . . hardy, and industrious, as well as [an] ingenious race of people . . . they live on fish and rice . . . requiring but low wages." Most of the Chinese were artisans.[6]

Leaving China in January, Meares arrived at Nootka in May. Using land at Friendly Cove, with permission of Chief Maquinna, he constructed a small house and commenced the building of the *Northwest America*, a small vessel more convenient for local trading.[7]

After trading along the coast during the summer, Meares took aboard the furs collected by the *Iphigenia*, also a large quantity of "fine spars, fit for topmasts, for the Chinese market," and in the *Felice* departed for China. At Canton, he and his associates, now owning three vessels, merged with the London Company, which possessed valid trading licenses but only one ship. Meares remained in Canton as manager for the new concern, and apparently never again returned to the Northwest Coast. The *Felice* was sold and replaced by another vessel.[8]

The *Iphigenia* remained at Nootka under Portuguese colors and papers, as no word had yet been received of the legitimizing of its illegal venture. Soon afterward the Spanish commandant Esteban Martínez would arrive at Nootka with two armed ships, setting the stage for a dispute over claim to the territory between Spain and Britain that would profoundly influence the future of the Spanish Empire in North America.[9]

John Meares

Meares was apparently born about 1756, since he was "more than twenty-two" when he passed his naval examination September 17, 1778, to receive the rank of lieutenant. He had entered the British navy seven years earlier on the ship *Cruiser*, as a "captain's servant."[1]

After the peace of 1783, when many naval ships became inactive, Meares like other officers entered the merchant marine. He found a berth as captain of a ship bound for India. In Calcutta, Meares, who had a talent for presenting schemes which appeared plausible, managed to interest some distinguished persons in backing a plan to acquire two vessels which "were fitted out in the ports of the East, by the commercial zeal of British subjects in that part of the globe."[2]

Succeeding voyages were made in other vessels, until at Nootka Sound in 1789, two of Meares' ships were seized by the Spanish commandant at Friendly Cove for falsely representing their ownership as Portuguese.[3]

Meares returned to England early in 1790, and presented to the government an exaggerated account of the seizure, which, together with subsequent reports of other alleged infringements by Spain of territory claimed by England, inflamed official and public opinion against Spain. England assembled a great fleet of war, but under this threat the Spanish government acceded to British demands. Thus had the mendacious captain become an early actor in the series of events which led to Spain's relinquishing her claims, based on prior discovery and symbolic acts of possession, to the mainland of the Northwest Coast.

The unusual public interest in the dispute led Meares to publish a narrative of his voyages, expressing his belief in the account of the mythical Admiral de Fonte and his alleged discoveries, and of the apocryphal voyage of Juan de Fuca through a passage across the North American continent, from the Pacific to the North Atlantic.[4]

Publication brought an emphatically negative response from George Dixon, who, as captain of the fur trader *Queen Charlotte*, had been on the Northwest Coast at the same time as Captain Portlock in the *King George*. Both vessels had been operating under a license from the South Sea Company, a British firm holding exclusive rights to trade on the American coast. Meares, however, was trading without a license.[5]

John Meares, c. 1790

From frontispiece to Meares, *Voyages*; courtesy Pacific Northwest Collection, UW Libraries.

Dixon's "Remarks on the Voyages of John Meares, Esq." charged Meares with numerous inaccuracies and a false claim for credit rightfully belonging to others. Dixon had expected Meares' *Voyages to the Northwest Coast* to enhance his own knowledge: "guess, then, Sir, my surprise when I found your pompous publication scarcely anything more than a confused heap of contradictions and misrepresentations."[6] Meares replied with a weak and unconvincing rebuttal in "An Answer to Mr. George Dixon."

Posterity has judged the character of Meares through the research of Judge F. W. Howay, Canadian historian, in *The Meares-Dixon Controversy*:

These three pamphlets . . . cast grave doubts not only upon the veracity of Meares as regards the disputed facts, but also upon the whole of his statements. . . . He endeavored to magnify his own explorations at the expense of his predecessors; . . . he made many statements . . . without any knowledge of the facts, with a reckless disregard of the truth . . . in the discussion of the price of sea-otter skins [which he tripled above the going price in order to increase his claim] he has omitted material factors, falsified documents, and made knowingly untrue statements [and] is not entitled to have credence placed in his unsupported testimony . . . this opinion has been shown to be in accord with that of his contemporaries [pp. 4, 22].

Meares does not seem to have had any further active service in the Navy, but nevertheless was promoted to the rank of commander on February 26, 1795. He died in 1809, at the age of fifty-three.

Meares' ability as an artist is questionable because of his careless disregard for the truth. His published journal contains only one signed drawing bearing his name. There are some unsigned sketches of indifferent quality, whose authorship is unknown. It is probable that his appealing seascape, "The Country of New Albion" (page 94), was refinished (from Meares' rough sketch) by the gifted British book-illustrator Thomas Stothard, who signed other drawings in Meares' book. Nevertheless, Meares did have a gift for colorful description, as, for example, in his report of a spectacle at Friendly Cove:

On the 16th, a number of war canoes entered the cove, with Maquilla and Callicum; they moved with great parade round the ship, singing at the same time a song of a pleasing though sonorous melody:—there were twelve of these canoes, each of which contained about eighteen men, the greater part of whom were cloathed in dresses of the most beautiful skins of the sea otter, which covered them from their necks to their ancles. Their hair was powdered with the white down of birds, and their faces bedaubed with red and black ochre, in the form of a shark's jaw, and a kind of spiral line, which rendered their appearance extremely savage. In most of these boats there were eight rowers on a side, and a single man sat in the bow. The chief occupied a place in the middle, and was also distinguished by an high cap, pointed at the crown, and ornamented at top with a small tuft of feathers.

We listened to their song with an equal degree of surprise and pleasure. It was, indeed, impossible for any ear susceptible of delight from musical sounds, or any mind that was not insensible to the power of melody, to remain unmoved by this solemn, unexpected concert. The chorus was in unison, and strictly correct as to time and tone; nor did a dissonant note escape them. Sometimes they would make a sudden transition from the high to the low tones, with such melancholy turns in their variations, that we could not reconcile to ourselves the manner in which they acquired or contrived this more than untaught melody of nature. There was also something for the eye as well as the ear; and the action which accompanied their voices, added very much to the impression which the chaunting made upon us all. Every one beat time with undeviating regularity, against the gunwale of the boat, with their paddles; and at the end of every verse or stanza, they pointed with extended arms to the North and the South, gradually sinking their voices in such a solemn manner, as to produce an effect not often attained by the orchestras in our quarter of the globe.

Regardless of his undesirable traits, his place is secure at one of those significant turning points in history, as an early participant in events which might very well have changed the future shape of the United States. According to historian Warren L. Cook, "had the Nootka crisis and Bourbon dethronement [losing Spain an essential ally] been averted, it is not improbable that the area could have remained in Latin American hands . . . such a colony . . . would no doubt have considerably altered the history of the Far West."[7]

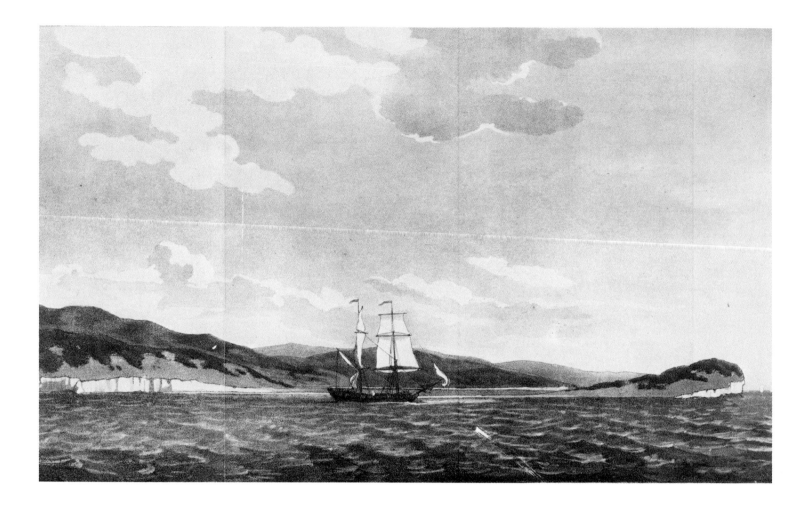

"The Country of New Albion," 1788

Engraving of a drawing by John Meares, in his *Voyages*, facing p. 160; courtesy Pacific Northwest Collection, UW Libraries.

As the Felice *sailed along the stretch of land which is today's Oregon coast, Meares was searching vainly for a bay in which Indians might be found, with furs to trade. One appeared in the distance: "By seven o'clock we were abreast of this opening, the mouth of which, to our great mortification, was entirely closed by a low sandy beach. . . . The bay was named by us Quicksand Bay [today's Tillamook Bay] . . . the distant Southerly head-land, we called Cape Look-out" (Meares,* Voyages, *p. 169).*

Meares' name for the cape was changed in 1857 by the Coast and Geodetic Survey to Cape Meares (Wagner, Cartography, *2:396). Meares may have been unduly cautious in viewing the bay, as it did have an entrance, which was negotiated by Gray in the* Washington *only six weeks later (Howay,* Columbia Voyages, *p. 35).*

George Vancouver and the *Discovery* and *Chatham*, 1791–95

Captain George Vancouver, age thirty-four, a veteran of Cook's second and third expeditions, was selected by the Admiralty to lead an expedition consisting of two well-equipped vessels, the *Discovery* (newly built, not Cook's former ship) and the *Chatham*, with complements of 101 and 45, respectively. Vancouver was instructed to implement the terms of the treaty between England and Spain that restored to England property at Nootka Sound claimed to have been seized by Spain from British subjects.[1]

He was also to search for the mysterious Northwest Passage, conduct surveys of the sea coast, paying "particular attention to the supposed straits of Juan de Fuca," as well as to ascend and chart all inlets and rivers to the limits of navigation.[2]

The expedition left England on April 1, 1791. After surveys on the southwest coast of Australia and stays at Tahiti and Hawaii, on April 17,1792, it made landfall on the coast of "New Albion" at 39° 20' N, about 110 miles north of San Francisco Bay. Proceeding northward, Vancouver entered the Strait of Juan de Fuca (after failing to identify the mouth of the Columbia River), and began an extensive series of surveys which would extend over a three-year period. After the areas to the south had been examined, by August 28 the charting of the maze of waterways to the east and north of Vancouver Island was also complete, and Vancouver was in Friendly Cove, ready to begin negotiations with Spain's representative, Bodega y Quadra.[3]

While the two captains almost immediately found mutual liking and respect, they soon found that their directives from their governments could not be reconciled, and agreed to observe the status quo until clarifying instructions had been received. They parted on the best of terms, planning to rendezvous at Monterey.

Returning to the island of Hawaii for the winter, after surveying the California coast, Vancouver resumed discussions with King Kamehameha, who had proposed a cession of the island to Britain, to gain protection against enemies and traders. In a convocation, the principal chiefs decided in favor; Vancouver then formally took possession "in his Majesty's name."[4] This was an action that Britain, struggling with Napoleon for survival, never officially recognized.

During the 1794 season, Vancouver explored Cook Inlet, beset by drift ice and strong currents, but finally concluded that it was indeed an inlet, rather than a river as recorded by Cook. The survey of the coast nearly complete, Vancouver sent out two separate parties in a determined effort to finish before the onset of adverse weather. On August 19, at Port Conclusion, Vancouver had the crews served extra allowances of grog, in a quantity which "soon prompted a desire for mutual congratulations . . . expressed by three exulting cheers from each [vessel]."[5] The survey was indeed complete.

The ships next sailed for Nootka, where dispatches from the Admiralty were expected. When none arrived, they left on October 16, after a stay of six weeks. A year later, by the middle of October, 1795, both vessels had returned to Plymouth. During the four and a half years of the voyage, the expedition covered about 65,000 miles, while the ship's boats covered about an additional 10,000 miles, mostly under oars.[6]

Some of the earlier British historians tended to underemphasize Vancouver's achievements in favor of Cook's. In one notable case, Vancouver's name or voyage was not even mentioned in an eighteen-volume work on voyages of exploration, compiled between 1811 and 1824 by Robert Kerr. In 1912, however, Edward Heawood, a recognized British authority recorded that "with great determination and perseverance Vancouver had completed perhaps the most arduous survey that it had fallen to any navigator to undertake, and this in spite of serious ill health during the latter part of the voyage."[7]

American historian Robert Greenhow in 1840 also admired Vancouver's achievements, despite what Greenhow believed was his "bitter animosity" toward the United States and its citizens, a prejudice that allegedly arose from the written testimony of Captains Robert Gray and Joseph Ingraham supporting Spanish rights over British claims to Nootka. Greenhow praised Vancouver's journal: "the work is invaluable . . . in none other can be found so much clear and precise information with regard to the northwest coasts of America."[8]

Joseph Baker

In the northwestern part of the state of Washington, there stands a magnificent snow-covered cone of a dormant volcano, exceeding 10,000 feet in elevation. It bears the name of Mount Baker, given by Vancouver to honor a man he regarded as one of his ablest officers, who was first to sight the mountain in the far distance, from the deck of the *Discovery*.

Joseph Baker was born in 1767. As had so many others, he entered the navy at a young age. He would have been about twenty-four when selected by Vancouver as one of his officers. Baker was well known to Vancouver, having served with him as a midshipman and master's mate for some years aboard the fifty-gun, two-decked *Europa*, under Commodore Gardner.[1]

Baker began the voyage in April 1791 as a third lieutenant, and was promoted to second lieutenant on September 26, 1792. This promotion was occasioned by the departure from Nootka of Lieutenant Mudge with dispatches for England. Further reassignments were made when Lieutenant Commander Broughton was detached at California on January 13, 1793, to deliver additional dispatches to England. Baker then became first lieutenant on the *Discovery*, replacing Lieutenant Peter Puget, who succeeded Broughton as commander of the *Chatham*. Later in the year, Vancouver expressed further regard for Baker, when he gave the name Point Baker to the northwesternmost tip of Prince of Wales Island, on the Alaskan coast.[2]

On at least one occasion, however, early in the voyage, Vancouver's temper temporarily eroded his respect for Baker, if we are to believe George Goodman Hewett, the irascible surgeon's first mate on the *Discovery*: "his first Lieutenant [Mudge] he Abused and called a Lubberly Boy upon the Quarter Deck his third [Baker] he behaved [toward] in such an Ungentlemanlike manner to telling him what he reported was a d . . d lie that he refused to dine or communicate with him afterwards."[3]

Vancouver reaffirmed his confidence in Baker at the end of the voyage, when the *Discovery* moored in the river Shannon, where orders were received to "repair immediately to London." He turned command over to "my first lieutenant Mr. Baker, in whose zeal for the service, and abilities as an officer, a long experience justified me in implicitly confiding; I resigned my command of the Discovery into his hands."[4]

After the voyage, Baker had a variety of naval assignments. One of the most unusual and distressing experiences of his entire career may well have been when, still a first lieutenant, he served aboard the *Pompée*. She was anchored at the Nore during the great naval mutiny at Spithead and the Nore in April and May of 1797, when the future of the British navy hung in the balance.

In March 1811, Baker received a commendation after the "repulse of the Danes at Anholt Island," while captain of the thirty-two-gun frigate *Tartar*. After she was lost by "striking on an uncharted bank" in the Baltic some months later (he was cleared of all blame at the customary court-martial), he was given charge of a prisoner-of-war establishment near Bristol.

Baker died in 1817 at the age of fifty, leaving nine children. According to the indefatigable John T. Walbran, whose research for *British Columbia Coast Names* was conducted between about 1896 and 1908, "the figurehead of the frigate [*Tartar*] was sawn off, and now stands in the hall of his grandson's house at South Petherton, Somersetshire."

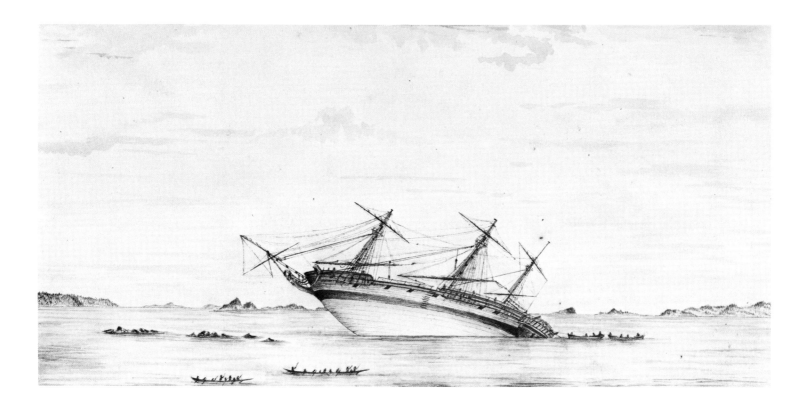

"Situation of the Discovery in Queen Charlotte's Sound," 1792

Drawing by Joseph Baker in his log aboard Vancouver's *Discovery*; courtesy Public Record Office, London, ADM 55/32/159 (Crown copyright).

"Tryed for Soundings occasionally from 90 to 100 Fᵐ no Ground, at ½ past 4, the Ship going at the rate of 3 Knots, struck upon a bed of Rocks, where she hung, We immediately carried out the stream Anchor & hove on it without effect, . . . at ½ past 5 the ebb coming with considerable force upon the Ships counter & her stern being in deep Water, she swung with her head nearly to the tide, & at the same instant careened over to Starboard so as [to] bring her Main Chaine wale within a few inches of the Water, the Spare Topmasts were immediately got over the side for shores, some Water was started in the Hold & some shingle Ballast hove overboard. At 2 AM the Ship floated, without having received any apparent damage" (Baker log, Newspaper–Microfilm Collection, UW Libraries).

 This drawing should be compared with the engraving of Mudge's drawing of the same scene (see p. 109).

Thomas Heddington

Only fifteen years old at the start of the Vancouver voyage, Heddington was the youngest member of the expedition. He was one of four midshipmen on the *Chatham*, whose muster list indicated that he was born in the British town of the same name.[1]

At first glance, it might appear that he had already had some years of naval experience. He first appeared on navy lists in 1786, aboard the seventy-four-gun *Invincible*, at the tender age of nine or ten years. This was an era when a father who wished his son to have a naval career as an officer could take steps through an influential relative or patron to gain seniority by having him entered on the rolls in name only. Naval regulations set the minimum age at thirteen, or eleven for sons of naval officers. Nevertheless, up to 1815 the law was largely disregarded.[2]

After the return of the *Chatham* to England in late 1795, Heddington was made a lieutenant. During the next ten years he served on six vessels "on the Channel and Irish stations," one of them the great ninety-four-gun *Saturn*. He was eventually put in charge "of a Signal-station at Hawkesley Point," then promoted to the rank of commander.[3]

According to William O'Byrne, "he was subsequently, between Feb. 1808 and April, 1814, employed at various places as Regulating Captain, and Agent for Prisoners of War." Marshall's Naval Biography (c. 1830) states that he was "appointed agent for prisoners at Valleyfield near Edinburgh in 1811. He afterwards superintended the impress service at Lynn."[4]

If Heddington were an individual of sensibility, not inured to the sufferings and injustices placed on others, he must have found his interlude in the impress service an agonizing experience. This brutal if necessary supplement to voluntary enlistment employed groups of hardened seamen called press gangs, under command of an officer. Their responsibility was to frequent seaports and waterside villages, with the legal right to seize for naval service any man with a maritime background, regardless of family or other urgent shoreside ties,[5] with the doubtful protection of those with a certificate of exemption, such as farmers.

It was a system which took no account of prior service in the navy or merchant marine. A sailor just returned from a voyage of several years overseas, perhaps not yet even reunited with his family, would be seized and impressed for a further period of years. Merchant ships homeward bound might be stopped by a navy cutter, and some of the crew removed by force.

Extensive research about Heddington has been conducted by Lieutenant Commander (ret.) A. C. F. David of the Hydrographic Office in Taunton, England. In his definitive work "A List of Vancouver's Drawings," he states that Heddington's surveys and drawings were originally deposited in the Hydrographic Office at the end of the expedition. In 1808, according to documents located by David at the Public Record Office in London, Heddington wrote the Admiralty asking for their return. There was no objection to returning the charts, since they were copies, but no mention was made of the drawings. Heddington subsequently picked them up. David also found that Heddingon published two of his drawings of scenes in Hawaii, copies of which are in the Bishop Museum. He has not been able to locate others, despite telephoning every Heddington in the British telephone directory; none was aware of any association with the Thomas Heddington of Vancouver's voyage.[6]

Heddington was promoted to captain's rank (ret.) in July 1851. He died in 1860 at the age of eighty-four.[7]

"Village of the Friendly Indians at the entrance of Bute's Canal," 1792

Engraving of a drawing by Thomas Heddington, in Vancouver's *Voyage*, 1:facing p. 326; courtesy Pacific Northwest Collection, UW Libraries.

"They [James Johnstone and two survey boats] now discovered a pretty considerable village of upwards of twenty houses & about 30 Canoes . . . from which they concluded that its Inhabitants could not be far short of a hundred & fifty. In passing this Village they purchasd from the Natives a large supply of fresh herrings for Nails, & immediately after enterd a narrow Channel leading to the Westward, through which the Water rushd in Whirlpools with such rapidity that it was found extremely difficult even to track the Boats along shore against it, & this could hardly be accomplishd had it not been for the friendly activity of the Natives who in the most voluntary manner afforded them every assistance in their power, till both Boats were safely through these narrows, & then returning peaceably home to their Village clearly shewd that they had no other passion to gratify on this occasion than that of doing a good office to strangers" (Newcombe, Menzies' Journal, pp. 72–73).

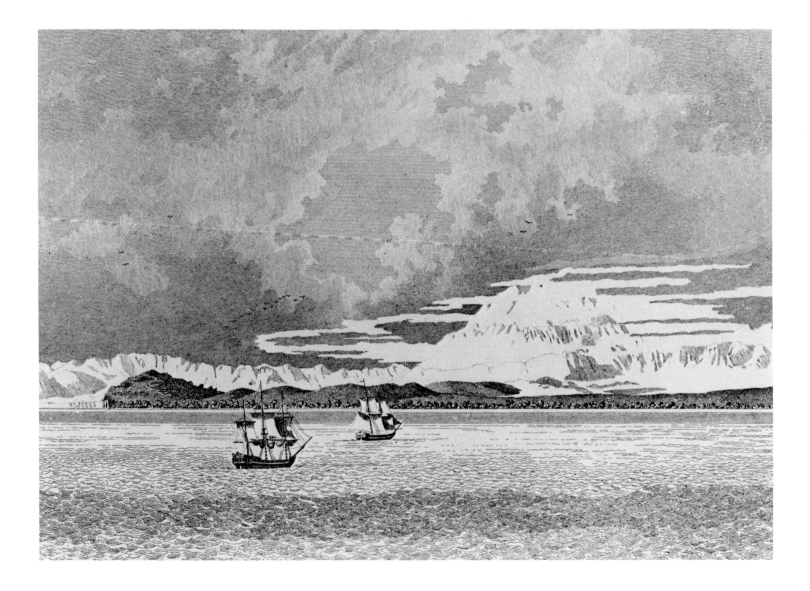

"Icy Bay and Mount St. Elias," 1794

First state of engraving of a drawing by Thomas Heddington, in proof set of plates, charts, and views for Vancouver's voyage, London, c. 1798–1810; courtesy DeGolyer Library, Southern Methodist University, Dallas.

This proof sheet illustrates the first stage of engraving, before highlights have been added. Note that both ships of the expedition are included. The proof sheets of the drawings to the voyage are included in an atlas formerly belonging to Sir Philip Stevens, secretary to the Admiralty. When his library was sold in 1810, the new owner added other material, including the proof sheets which are not bound into the atlas.

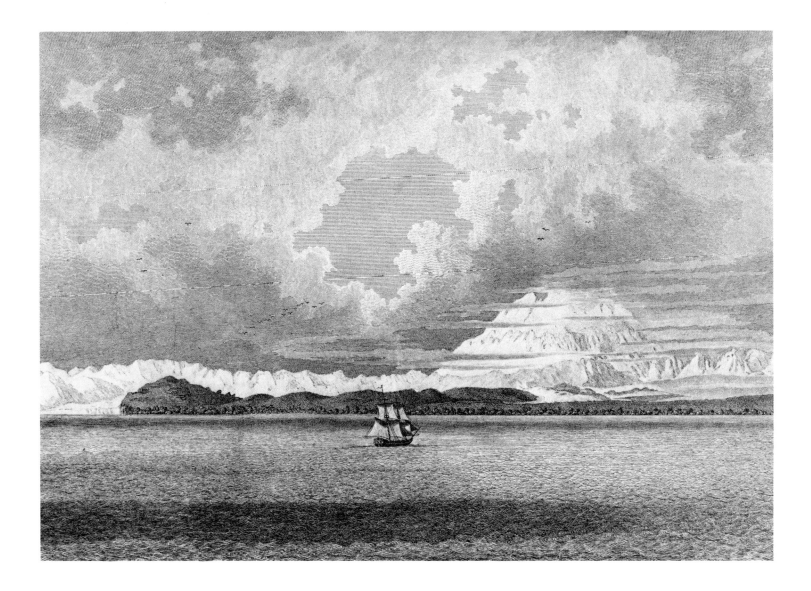

"Icy Bay and Mount St. Elias," 1794

Engraving of drawing by Thomas Heddington, as reproduced in Vancouver's *Voyage*, 3:facing p. 204;
courtesy Pacific Northwest Collection, UW Libraries.

In this final state of engraving (cf. facing page), one ship has been deleted, for unknown reasons. It is conceivable that Heddington's sketch showed no ships, and that Alexander was instructed by the Admiralty to add them for interest.

Vancouver described Icy Bay: "Eastward from the steep cliffs that terminate this bay, and from whence the ice descends into the sea, the coast is again composed of a spacious margin of low land, rising with a gradual and uniform ascent to the foot of the still connected chain of lofty mountains, whose summits are but the base from which mount St. Elias towers, majestically conspicious in regions of perpetual frost" (Voyage, 3:204).

East

"The Westernmost of Scots Islands," 1792

Detail from engraving of a coastal profile by Thomas Heddington, in atlas to Vancouver's *Voyage*, pl. 6; courtesy Pacific Northwest Collection, UW Libraries.

"Not being able to pass to windward of Scot's islands, our course was directed to the north of them, towards cape Scot . . . until about nine in the evening, when the water suddenly shoaled from 60 to 17 fathoms. . . . On this we instantly stood back to the westward, lest we should approach some danger, but we did not perceive either breakers or shoals, although the night was still and clear" (Vancouver, Voyage, 1:383).

These are today known as Scott Islands, and extend about twenty miles westward from Cape Scott, the extreme northwest point of Vancouver Island. The B. C. Pilot *indicates that there are "wide passages between the western islands . . . no soundings have been obtained in them, and strong tiderips and overfalls have invariably been observed . . . a vessel should not pass through them unless compelled to do so" (1933 ed. Southern Portion, p. 325).*

Harry Humphrys

Harry Humphrys was one of at least four individuals on the Vancouver voyage who were born in America. He was about eighteen when he enrolled as a midshipman on the *Discovery*, and during the expedition he was variously ranked as midshipman, master's mate, or able seaman.

According to A. C. F. David of the Hydrographic Office, Taunton, England, "these variations [in rank] were . . . merely administrative ploys and didn't imply that when on the books as an AB he was as such." He points out that the size of the ship's complement imposed a limit on the number of midshipmen and master's mates, which could be circumvented by enrolling "extra 'young gentlemen' who would be entered on the ship's muster lists as ABs."[1]

It was not until late in the voyage that Humphrys received a meaningful advancement. While the expedition was at Monterey preparing for the homeward voyage, Humphrys was promoted from master's mate of the *Discovery* to master of the *Chatham*, a position with heavy responsibilities. According to the Barrie papers at Duke University Library, Humphrys was a cousin of Robert Barrie, a midshipman of about the same age serving on the *Discovery*. Barrie, also an American, was a nephew of Sir Alan Gardner, Vancouver's former admiral in Jamaica, which established an important connection for naval assignments.[2]

A flaw in Humphrey's character appeared in 1798—perhaps it was simply lack of discretion—when he was "tried by courtmartial for disrespect for his Captain, found guilty, dismissed his ship and put at the bottom of the Lieutenant's list."[3]

How many drawings Humphrys made on the voyage is unknown. Judging from his drawing of Friendly Cove, reproduced as an engraving in Vancouver's published journal, he was a competent artist. One of the drawings, its present whereabouts undiscovered, is described by naturalist Archibald Menzies. Menzies and Humphrys were aboard a small boat from the *Discovery*, surveying in Desolation Sound at the northern end of Georgia Strait, when they came to a small cove:

. . . the picturesque ruins of a deserted Village placd on the summit of an elevated projecting Rock excited our curiosity & inducd us to land close to it . . . inaccessable on every side except a narrow pass from the Land by means of steps that admitted only one person to ascend at a time. . . . We found the top of the Rock nearly level & wholly occupied with the skeletons of Houses . . . in some places the space was enlargd by strong scaffolds projecting over the Rock & supporting Houses apparently well securd. . . . We pulled out a little from the Shore & lay on our Oars before the Village while Mr. Humphries took a sketch of it, & tho I can give but a very unequal idea of its romantic appearance, yet I will attempt to follow the expressive strokes of his Pencil in a few words . . . the Summit is occupied with the crouded remains of the Village consisting of posts spurs & planks crossing each other with the utmost confusion in all directions. At the landing place . . . are standing the Posts & Beams of a solitary House which from its size painted ornaments & picturesque shelterd situation seemd to have been the residence of the Chief or some family of distinction.[4]

According to an entry in the Barrie papers, Humphrys died of smallpox in October 1799.

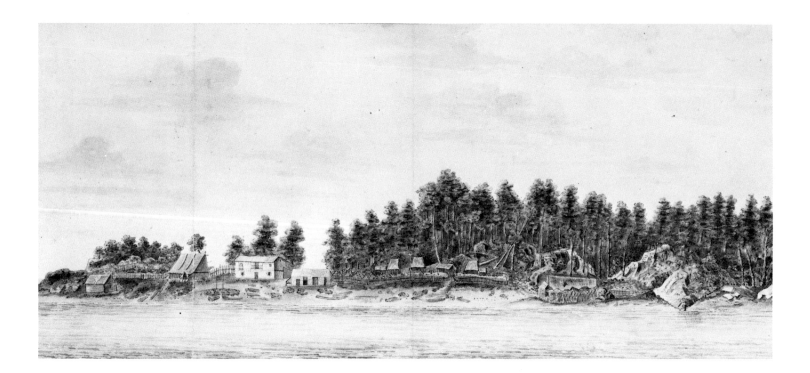

"A View of Friendly Cove in Nootka Sound," 1792

Drawing by Harry Humphrys (MPM 84); courtesy Public Records Office, London (Crown copyright).

If this is the sketch from which the engraving in Vancouver's Voyage *was made, it is evident that the engraver moved the viewpoint considerably to the right, and added watercraft for interest (see p. 105). This sketch, and perhaps others, probably was taken by Humphrys at Vancouver's instruction, as part of his report to the Admiralty on the negotiations with Bodega y Quadra.*

The area at far right was land that Spain offered to relinquish during early negotiations with England.

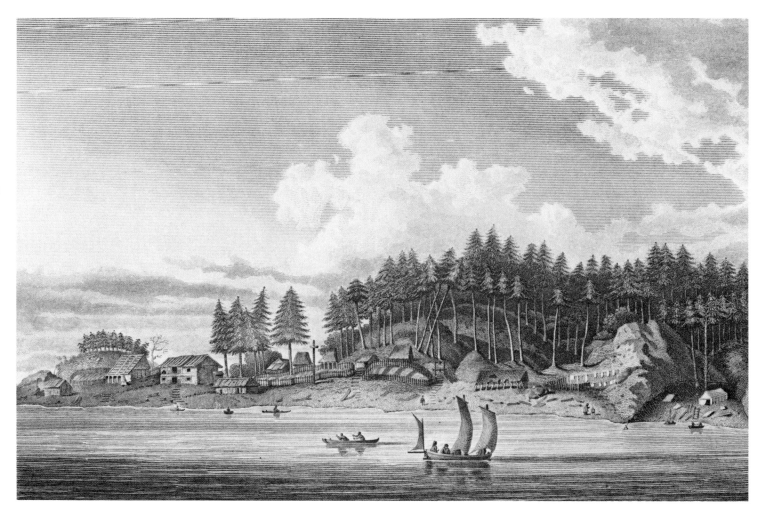

"Friendly Cove, Nootka Sound," 1792

Engraving of a sketch by Harry Humphrys, in Vancouver's *Voyage*, 1:facing p. 467; courtesy Pacific Northwest Collection, UW Libraries.

"After dinner I accompanied Cap^t Vancouver with some of the Officers to pay our respects to Don Quadra Governor & Commandant of the Settlement. We found him on shore at a decent house two story high, built of Planks with a Balcony in the front of the Upper Story after the manner of the Spanish Houses, . . . On our landing the Guard was turned out in honor to Cap^t Vancouver, & the Governor & his Officers receivd us at the door, . . . after leaving the Governor's we took a walk around the place & found several other Houses erected here by the Spaniards as Barracks, Store Houses & an Hospital on the Scite of the Old Village formerly occupied by Maquinna . . . there were also several spots fenced in, well cropped with the different European Garden stuffs, which grew here very luxuriantly. . . . There was a well-stockd poultry yard, & Goats Sheep & Black Cattle were feeding round the Village. Blacksmiths were seen busily engagd in one place & Carpenters in another, so that the different occupations of Building & repairing Vessels & Houses were at once going forward.

"The situation of the Village is upon a rising neck of Land with Friendly Cove & the Shipping right before it, & behind it a high Beach washd by the rude Surges of the open Ocean & along the Verge of its Bank a pleasing path was [found] for walking where the mind could contemplate at ease the fretted wilderness of the briny element foaming against Rocks & Shores" (Newcombe, Menzies' Journal, pp. 110–12).

"Port Dick, the Island W½N," 1794

Drawing by Harry Humphrys; courtesy Hydrographic Department, Ministry of Defence, Taunton, England, reproduced by permission of the Hydrographer of the Navy.

"We now steered towards the northernmost part of the coast in sight . . . placing the southernmost part of the . . . promontory, which we supposed to be the same that Mr. Portlock calls point Gore, in latitude 59° 11′, longitude 209° 49′; the bay or harbour on its west side we supposed to be Port Dick" (Vancouver, Voyage, 3:151).

Instructions to William Alexander for preparation of his copy for the engraver (in indistinct pencil on the bottom margin) include: "Many canoes . . . going into the Creek each canoe carrying 2 people. . . . Indian holding up Skins for traffic" (see David, "A List," p. 7).

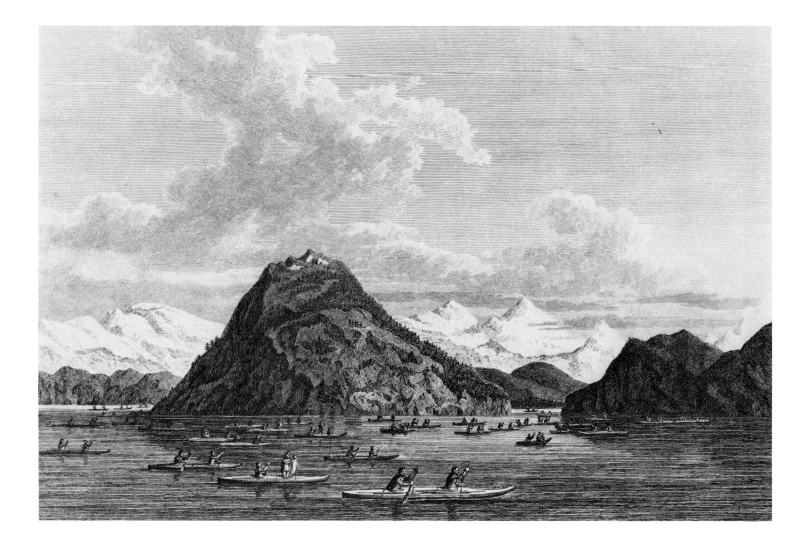

"Port Dick, near Cook's Inlet," 1794

Engraving of a sketch by Harry Humphrys, in Vancouver's *Voyage*, 3:facing p. 150; courtesy Pacific Northwest Collection, UW Libraries.

"The morning of the 16th was ushered in by a sight we little expected in these seas. A numerous fleet of skin canoes, each carrying two men only, were about the Discovery, and, with those that at the same time visited the Chatham, it was computed there could not be less than four hundred Indians present. They instantly and willingly entered into trade, and bartered away their hunting and fishing implements, lines and thread, extremely neat and well made from the sinews of animals; with bags ingeniously decorated with needle work, wrought on the thin membrane of the whales intestines; these articles, with some fish, and some well executed models of canoes with all their appendages, constituted the articles of commerce with these people" (Vancouver, Voyage, 3:150).

This engraving should be compared with the original sketch (facing page), which is devoid of canoes. These details were added in an unrealistic manner, perhaps to correspond with a text reference to a prior encounter which took place as the ships sailed toward Port Dick.

Zachary Mudge

Twenty-one years old at the start of the voyage, Zachary Mudge kept a log embellished with his own watercolor drawings, showing considerable artistic talent.[1] Only one of these, probably a larger copy made for the engraver, was included in the form of an engraving in the official published journal of the expedition (see p. 109). The son of a British physician, he began his naval career at ten, on the *Foudroyant*. When she engaged and captured the French line-of-battle *Pegase* in a celebrated victory in 1782, Mudge was said to have been on board.

At nineteen he was already a lieutenant. His years of naval experience apparently overcame any objection to his youth, as he was promoted to second lieutenant on December 15, 1790, and to a full first lieutenant less than three weeks later, both aboard the *Discovery* before she left England.[2] Vancouver gave Mudge's name to a point at the north end of Georgia Strait. Now called Cape Mudge, it is noteworthy from a mariner's standpoint. Near this area the flood tide from the south meets the flood entering by the north end of Vancouver Island, creating a dangerous race, especially at a time of strong southeasterly winds.[3]

In September 1792, when Vancouver's negotiations with Bodega y Quadra reached an impasse on the issue of British rights in Nootka Sound, it became vital that a full report be sent to London as rapidly as possible. Mudge was chosen for this purpose, sailing to Canton on a small Portuguese brig, the *Fenis and San Josef*, "the accommodation and food being of the meanest description." At Canton, he was to embark on an East India Company ship, and following the receipt of new Admiralty instructions for Vancouver, was to return to Nootka.[4]

Soon after arrival in England, he joined Commander William Broughton, who was in England with dispatches from the *Chatham*. After concluding his mission, Broughton left England in February 1795, on the sloop-of-war *Providence*, with Mudge aboard as his first lieutenant. They arrived at Nootka on March 17, 1796, only to find that Vancouver had completed his surveys and returned to England more than a year earlier. Before quitting Nootka, Broughton and Mudge indulged their curiosity about Cook's anchorage eighteen years earlier: "We made an excursion to Ship Cove [Resolution Cove] where Captain Cook remained on his first entering the Sound during the month of April, we . . . experienced similar or rather worse weather at the same time of the year. We could discover no vestiges to prove that any ship had been there since."[5]

Sailing westward across the Pacific, a survey of part of the coast of Asia then began, ending four years later when the *Providence* struck an unknown coral reef. After a harrowing return to the Chinese coast in the monsoon season, on a small companion vessel overburdened with "112 souls," limited water and provisions, Mudge returned to England.[6]

He was named a commander in late 1797 (but only after the intervention of the influential Lady Camelford), and became a captain late in 1800. In the West Indies he saw active and successful service commanding the thirty-two-gun frigate *Blanche*, which was sunk in battle in 1805, by the overwhelming strength of a French squadron. Mudge was cleared by a court-martial, "though it was questioned at the time whether he had made the best possible defence." Another more detailed account makes one wonder why the doubt, as the French force included "the *Topaze* 40, two heavy corvettes and a brig. His [Mudge's] ship was in poor condition, with foul bottom and rotten hull, so could not escape; he struck after an hour's engagement and the ship foundered not long afterwards." Mudge eventually rose to command of the seventy-four-gun *Valiant* in 1814. He held the rank of admiral on the inactive list at his death in 1852 at the age of eighty-two.[7]

Zachary Mudge

From Edmond S. Meany, *Vancouver's Discovery of Puget Sound*, facing p. 226.

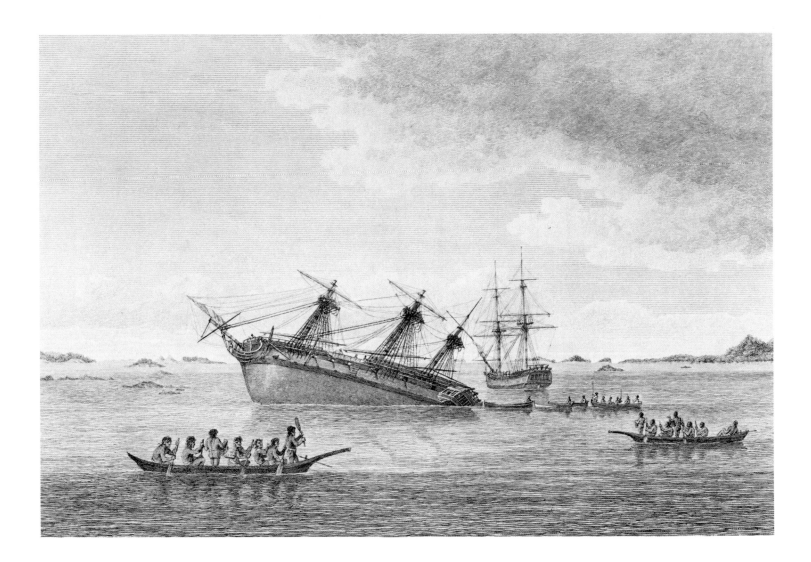

"The Discovery on the Rocks in Queen Charlotte's Sound," 1792

Engraving of a drawing by Zachary Mudge in Vancouver, *Voyage*, 1:facing p. 364; courtesy Pacific Northwest Collection, UW Libraries. Compare with color plate.

*"The fog had no sooner dispersed, than we found ourselves in the channel for which I had intended to steer, interspersed with numerous rocky islets and rocks, extending from the above clutter of islands towards the shore of the continent." As it cleared, Vancouver decided that the passage should logically be traced by the ship, rather than the boats, "although . . . it would engage our utmost attention, even in fair weather, to preserve us from latent dangers" (Vancouver, *Voyage*, 1:363). The ship then grounded. (See, for contrast, Baker's description, p. 97).*

Vancouver admitted that the escape of the Discovery was "a very providential circumstance," as the ocean was calm, and the tide higher than usual, which prevented "immediate and inevitable destruction" (Voyage, 1:364).

John Sykes

Most of the drawings done on the Vancouver expedition, which later were engraved, were made by London-born John Sykes, age sixteen when added to the *Discovery*'s muster list as a midshipman. His father was James Sykes, Vancouver's navy agent in London, regarded by the latter as a personal friend.[1]

John Sykes was born on May 25, 1774. He was officially entered as a captain's servant on the muster list of H.M.S. *Resource*, stationed at Halifax, on Christmas Day, 1783, at the age of nine years and seven months. Later, with the same rank, he was transferred to the *Merlin* at Newfoundland. The initial appointment may have been in name only, which would have been in accordance with naval custom of the day. It seems probable that the transfer to the *Merlin* required his physical presence on the ship, since while there he was listed as an able seaman. In 1789 he was made a midshipman on the *Royal Charlotte*.[2]

In January 1790, Sykes was signed aboard the *Discovery*, newly commissioned under Captain Henry Roberts, who had George Vancouver as his first lieutenant. After the British government abandoned the plan to colonize the Northwest Coast, both Vancouver and Sykes were transferred to the seventy-six-gun *Courageux*, only to be returned to the *Discovery* near the end of the year, with Vancouver as captain.[3]

The muster list of the *Discovery* indicates that Sykes was promoted to master's mate on February 1, 1791, two months before the expedition departed. Curiously, only sixty days into the voyage, he was temporarily reduced in rank to able seaman, although the logs and journals are silent as to the reason. O'Byrne's *Naval Biography*, the contents of which were, for the most part, provided by the subjects in answer to a questionnaire, states that "he [Sykes] accompanied that officer [Vancouver] as Master's Mate in his voyage round the world"[4]

Sykes also provided O'Byrne with a description of his laudable conduct during the voyage, "in a boat with the late Rear-Admiral Spelman Swaine when, by rendering timely assistance, he saved his Captain and some others from being murdered by a party of Indians." No mention of this incident could be located in the journal Vancouver kept while on the Northwest Coast. It might not have occurred there, as natives in other parts of the world were often referred to as "Indians."

There was a dramatic and similar incident on the southeastern Alaskan coast on August 16, 1793, but Vancouver's journal does not mention any participation by Sykes. Sykes' own log indicates that he remained aboard the *Discovery*, though he mentions Vancouver's return: "the Captain with the Pinnace and Launch returned to the Ship, having been absent twenty-one days—on the 12th during the Expedition the Pinnace was attacked by a party of Indians armed with Spears."[5] Vancouver gave Sykes' name to a point at the mouth of Behm Canal, noting that "this, after one of the gentlemen of the *Discovery*, I named *Point Sykes*."

Shortly after their homecoming, Sykes received his lieutenant's commission, partly at the intercession of Vancouver, who discovered that a pending Admiralty order would require transfer of his midshipmen and mates to another vessel, along with the seamen. He managed to get the order modified, to allow them an opportunity to take examinations for lieutenant prior to transfer, which might have delayed advancement indefinitely.[6]

In the next few years, Sykes served on twelve vessels, becoming a commander in 1800. Four years later, because of his part in two naval actions, he received an enthusiastic commendation as commander of the bomb ship *Hecla* at the bombardment of Havre-de-Grace; "on each occasion he was very warmly engaged with the enemy, and displayed a degree of meritorious conduct that gained him the admiration of . . . the senior officer present."[7]

According to the "Obituary of Eminent Persons" column in the *Illustrated London News*, less than a year after being advanced to the rank of admiral of the white, he "died at his residence, Castle-hill, Englefield-green, on the 12th ult. [March 1858], in his 84th year." He had no children, and had married relatively late in life at age thirty-seven.[8]

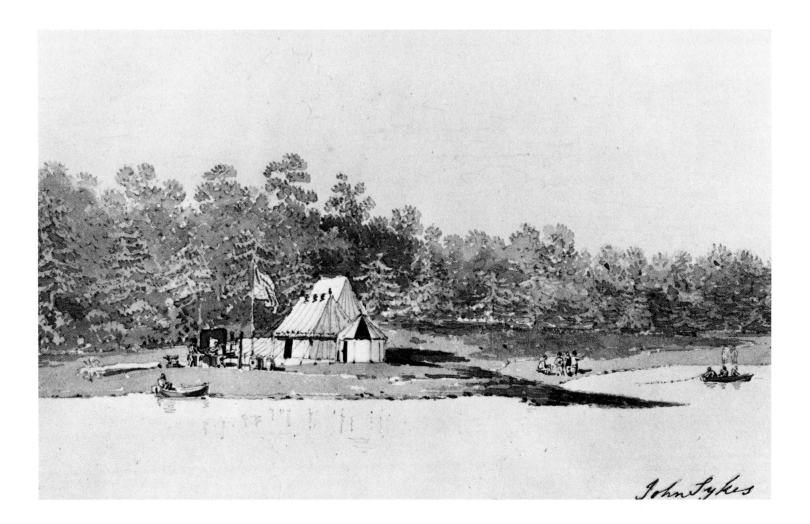

John Sykes

"View of Observatory Point, Port Quadra, Straits de Fuca," 1792

Drawing by John Sykes; courtesy The Bancroft Library, University of California.

The title is misleading, as Observatory Point is the western point of Freshwater Bay, miles west of "Port Quadra," the Spanish name given Vancouver's Port Discovery. This drawing, which was not used in Vancouver's Journal, *is especially interesting in showing a typical camp set up by a surveying crew.*

"A new and more detailed survey technique was developed as the expedition charted the southern shore. Both vessels were anchored when suitable shelter offered and a tented observatory set up ashore for obtaining the gaining or losing rates of the timepieces by daily comparison with the passage of the Sun across the meridian at noon, and for the fixing of geographical position, and determining of the local variation of the magnetic compass with reference to a true bearing of heavenly bodies. Meanwhile two or more boats, each with an officer in charge, were provisioned for three weeks or so and were despatched along the unexplored coastline ahead . . . proceeding steadily under oars that they might follow closely the trend of the coast, upon which, from time to time, the officers landed to take hand-compass bearings of the direction of the coastline . . . The courses and distances covered by the boats were carefully assessed and recorded, so that on return to the ship after a week or two's absence, the work could be transferred to the fair drawing sheet which was kept up-to-date by Lieutenant Baker working steadily away onboard" (Ritchie, The Admiralty Chart, *pp. 41–42).*

BC ± 76

"Four remarkable, supported Poles, in Port Townshend, Gulph of Georgia," 1792

Pencil drawing by John Sykes; courtesy Hydrographic Department, Ministry of Defence, Taunton, reproduced by permission of the Hydrographer of the Navy.

Unlike the engraving of this scene (see facing page), located on the southern shore of Juan de Fuca Strait, only the prow of one boat is visible, with three figures, one standing by the furled sail.

Vancouver was mystified by the poles, which were encountered repeatedly on low land, seventeen on one long sandspit: "their first appearance induced an opinion of their being intended as the uprights for stages on which they might dry their fish; but this, on a nearer view, seemed improbable . . . they were, undoubt-edly, intended to answer some particular purpose; but whether of a religious, civil, or military nature, must be left to some future investigation" (Vancouver, Voyage, *1:225–34).*

Naturalist and surgeon Menzies was equally puzzled: "Each pole was lengthend by two pieces neatly joind together to about 90 feet high terminating with a Trident . . . shord up by four other poles each about 30 feet long. . . . What was the intention or meaning of the Natives in erecting these poles with so much pains & trouble we were at a loss to form the most distant conjecture" (Newcombe, Menzies' *Journal, p. 25).*

Historian Edmond Meany found the answer in 1905 when interviewing elderly Lummi Indians at Bellingham Bay. They referred to a long sandspit, on which "long ago . . . they got many canoe-loads of ducks by large nets. They set great high poles in the ground. From one . . . to another they stretched nets woven of willow twigs. At night or in hazy weather the ducks would strike these nets when the watchers would pull a rope of twisted roots or twigs fastened to a loop of the net and down would come a flap, holding . . . the entire flock of ducks" (Meany, Vancouver, *pp. 85–86).*

"Four remarkable, supported Poles, in Port Townshend, Gulph of Georgia," 1792

Final state of engraving of a drawing by John Sykes, in Vancouver's *Voyage*, 1:facing p. 234; courtesy Pacific Northwest Collection, UW Libraries.

Compared with the pencil sketch (facing page), this engraving shows the addition of reflections of the poles, land, and boats, as well as clouds. In an earlier second stage of engraving, the fourth "remarkable pole" was omitted, but has been reinstated here.

"View of an Indian Village on Pt. Mudge, Gulf of Georgia," 1792

Drawing by John Sykes; courtesy Hydrographic Department, Ministry of Defence, Taunton.

Archibald Menzies, ship's surgeon with Vancouver, described this scene in Discovery Passage, across from the present city of Campbell River: "I landed with Capt Vancouver & some of the officers on the North Point of the Entrance which was afterwards named Cape Mudge. *It forms a steep elevated naked bank on the edge of which we found a considerable village consisting of about 12 houses or Huts plankd over with large boards some of which were ornamented with rude paintings particularly those on the fronts of the houses. They were flat roofed & of a quadrangular figure & each house contained several families to the number of about 350 Inhabitants . . . Ears are perforated for appending Ornaments either of Copper or pearly Shells; the Septum of the Nose they also pierce & sometimes wear a quill or piece of tooth-shell [dentalium] in it. . . . Some had ornamented their faces by painting it with red-ocre sprinkled over with black Glimmer that helped not a little to heighten their ferocious appearance (Newcombe,* Menzies' Journal, *pp. 81–82).*

 Below the title, words have been added in pencil, "Stick across the boats to sit on," probably as an instruction to William Alexander, in the event that this drawing had been selected for publication.

The Voyages of Sigismund Bacstrom, 1791–93

Some of the most valuable drawings of the Northwest Coast were done by Sigismund Bacstrom, to a total of twenty-nine, all characterized by close attention to detail and an obvious attempt to portray the natives as individuals. Little is known of his early life, the date or place of his birth. In his June 1801 petition to the governor of New South Wales, unearthed by Douglas Cole, author of the definitive work about him, Bacstrom claimed to have been "regularly educated at the University of Strasburg as a physician, Surgeon and Chymist." He was in Dutch naval service as a surgeon from 1763 to 1770.[1]

Moving to England, he applied to Sir Joseph Banks for a position on Cook's second voyage, stating that he would be satisfied with only a seaman's pay and "the honour I Should acquire, if I should ever return after having been [on] so extraordinary and curious a voyage, and in Company with so celebrated and respectable personages." Banks retained Bacstrom as a secretary at £100 annually, but subsequently withdrew from the voyage in a dispute over his living arrangements aboard ship. Instead Banks took Bacstrom on a scientific voyage to Iceland, retaining him as his employee until 1775. The next four years Bacstrom worked for Captain William Kent, R.N., a friend of Banks who collected for him.[2]

Following this, for the next seven years he was employed as surgeon during six voyages on merchant ships, including four whaling voyages to Spitzbergen. Bacstrom found the first two cruises rewarding, and wrote an interesting description of his stay on the *Rising Sun*. The whaling ships were another matter entirely, as he wrote in an article for *Philosophical Magazine* (1799): "masters or commanders in the Greenland trade being generally men of little or no education, and consequently void of those liberal sentiments necessary to render the situation of those who accompany comfortable."

By 1786 he was unemployed in England, appealing once more for help from Banks. He could tutor, travel, or assist in chemical experiments, since he knew of a way to use natural magnets to increase vegetable growth. Banks assisted him in several ways, and finally got him a berth on the *Butterworth* under William Brown, who in 1791 led a flotilla of three vessels to the Northwest Coast, arriving in July 1792.

Brown turned out to be uncommonly brutal and unscrupulous, cheating, robbing, and on occasion beating and killing natives without justification. After trading along the northern coast, the *Butterworth* returned to Nootka on October 15. Bacstrom seized the earliest opportunity to leave the ship "on account of the ill and mean usage I received from Capt. W. Brown and his Officers," taking refuge with the Spanish officers at Nootka. A few days later the British trader *Three Brothers* (usually called the *3Bs*) arrived, and her captain, William Alder, took Bacstrom on board "as a Friend and treated me like a Brother."

The *Three Brothers* and her companion vessel, the *Prince William Henry*, were trading illegally, since they were not licensed by either the East India or South Sea companies. The *3Bs* went to Hawaii in December, returning to Nootka in February 1793 to begin trading northward. At Nootka, Bacstrom made a decision which would lead to a series of misadventures.

With Captain Alder's consent, Bacstrom transferred to the American brig *Amelia* as surgeon. After completing the trading season, the *Amelia* arrived at China in November, where she was intercepted by H.M.S. *Lion* and found to belong to two merchants of Mauritius, despite her American colors. Since England and France were at war, she was seized and sold as a prize. While Bacstrom was not detained, neither did he receive $200 to which he was entitled for the voyage. He managed to enroll as a surgeon on the *Warren Hastings*, an ex-East Indiaman from London. At this point the war intervened once again, and this time he was taken prisoner by mutineers and confined on Mauritius.

Six months passed before Bacstrom was allowed to leave Mauritius on an American ship, at a cost of $300 for passage to New York. When nearly to the harbor and shelter, a savage gale forced the ship back to the Virgin Islands. There she was boarded by another British warship, which seized her as a prize because her cargo was of French origin. Apparently Bacstrom had an appealing personality, since at Tortola he was befriended by the governor of the British Virgin Islands, who took him into his mansion for six weeks, then paid for his passage home.

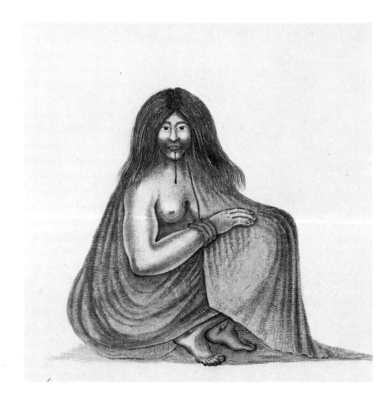

Bacstrom arrived in England in July 1795, after an absence of nearly five years, and voyages on six different vessels. Banks must have been sorely disappointed to learn that all of the specimens collected for him had been lost in the misfortunes of travel. Something not lost, however, was Bacstrom's "system" intended to assist those interested in "comprehending the curious scientific allegories in the Old Testament." He described it as a "true and rational" system, and attempted to obtain a list of subscribers for its publication, possibly with some difficulty. Bacstrom expected to sell his drawings made on the voyage, but a handwritten catalogue dated nearly five years later listed no sales.

Bacstrom's petition in June of 1801 indicated that he was "advanced in years" with "tolerable good Health, the Consequence of a Sober and regular Life." He was then offering the benefits of his scientific knowledge to assist in the discovery of the mineral resources of New South Wales.

Sigismund Bacstrom ad viv: del: 1793.

fecit 1797.

"Cunnyha's Eldest Daughter, named Koota-Hilslinga," 1793

Field sketch by Sigismund Bacstrom; from the Collection of Paul Mellon.

Bacstrom's field notes state that Koota-Hilslinga is a "young woman at Tattesko (Hains's Cove) belonging to Cunniha's family, who was along side the vessel on Mon. 18 March 1793."

The finished Drawing is the
most accurate.
this should be condemned.

The Spanish Ensign 2 Strokes
of bright ~~green~~ Red, white in the middle
yellow

The Light to be all one
way — the Clouds to be light
When dark now —

This part of the
Rock is
~~common~~
brown.

Friendly Cove, Nootka Sound.

Dædalus

Trees dark green
Rocks dark grey, shaded with Prussian Blue.
Water very light indigo
Sand lighter more yellow green than the Trees

Dædalus dark brown Sides

Sky light Indigo —
white Clouds painted on the Indigo
with white — deepened with Indigo

Command's house white
the Sheds and Chapel
Stone grey deepened with
Indian Inks
Land near the wall
grey like the Sheds
exactly

Spanish fort and Command's house
drawn on 7 – 15 Aug.g 1792.

N. 19

"Friendly Cove, Nootka Sound Spanish fort and Command' house,"
August 15, 1792

Field sketch by Sigismund Bacstrom; from the Collection of Paul Mellon.

Bacstrom's drawings of Friendly Cove are of decided historical significance and interest. This view was
made during the brief 120-day life of the ill-conceived Spanish settlement of Núñez Gaona at Neah Bay on
the Strait of Juan de Fuca. Most of the cannon had been removed from Friendly Cove to the new location.
 The Discovery arrived two weeks after this sketch was made. Menzies observed that "this Fort, if it
might be called such, was no other than two Guns mounted on a small Platform on the outer Point of the
Cove, with a Flag Staff on which the Spanish colours were hoisted & a small guard mounted to give it the
appearance of a place of defence" (Newcombe, Menzies' Journal, p. 107).
 The vessel is Vancouver's supply ship Daedalus, which had arrived well in advance of the Discovery
and Chatham.

Spanish fort at Friendly Cove, Nootka Sound, February 20, 1793

Field sketch by Sigismund Bacstrom; from the Collection of Paul Mellon.

This sketch, taken on board the 3-Bs, was taken six months after Bacstrom's first drawing of the fort (see p. 117), following the abortive attempt at a settlement at Neah Bay. The strengthened fort displays more firepower, eight guns now being visible through the embrasures of the rampart, supported by a log foundation. More cannon were presumably mounted on the seaward side, out of sight in this view.

John Boit, who observed the rebuilt fortification thirty-six days earlier, was not impressed: "their fort was no great thing, mounted with 6 twenty four and thirty six pounders—the platform would not bear the weight of metal" (Howay, Columbia Voyages, *p. 411). However, additional guns must have been mounted in the interim.*

Detail of Spanish fort at Friendly Cove, 1793

Section of a finished watercolor drawing by Sigismund Bacstrom; courtesy National Historic Parks and Sites Branch, Parks Canada, Ottawa.

Bacstrom's final watercolors exhibited certain stylistic tendencies which contrast unfavorably with his more freely executed field sketches. The example above displays this in the unnatural rectilinear forms of the rocks.

a View of two Indian Villages round Cape Scott in Lat: nearly 51. Dg. N. at the Entrance of Fitz Hues Sound.

N: 23

"A View of two Indian Villages round Cape Scott at the Entrance of Fitz Hues Sound," 1793

Watercolor drawing by Sigismund Bacstrom; from the Collection of Paul Mellon.

Northwest art historian Bill Holm believes these villages might have been located at Takush Harbour in Smith Inlet, where a village was known to have been built on rocks similar to this. Close inspection of the village at the left reveals what appears to be a large carved figure, partially obscured by smoke.

Holm adds that Vancouver may have described one of these villages after entering Smith Inlet in August 1792: "About half way up the canal a village of the natives was discovered, which our gentlemen supposed might contain two hundred or two hundred and fifty persons. It was built upon a detached rock, connected to the main by a platform . . . constructed for defence. A great number of its inhabitants, in about thirty canoes, visited our party, and used every endeavor, they thought likely, to prevail on them to visit their habitations. They offered the skins of the sea-otter and other animals to barter; and beside promises of refreshment, made figures too unequivocal to be misunderstood, that the female part of their society would be very happy in the pleasure of their company. Having no leisure to comply with these repeated solicitations, the civil offers of the Indians were declined" (Vancouver, Voyage, *1:377).*

Frederick Beechey and H.M.S. *Blossom*, 1825–28

The orders dated May 11, 1825, from the Admiralty to Captain Frederick W. Beechey of the *Blossom*, instructed him to appear in Kotzebue Sound in Bering Strait by July 10, 1826, for the purpose of providing assistance to either Captain Parry or Captain Franklin if they appeared in the area, after their separate attempts to locate the Northwest Passage. Should neither Parry nor Franklin appear, the *Blossom* was to reprovision at a convenient place and return to Bering Strait by August 1 of the following year, remaining there "as late in the autumn of 1827 as the season will admit, and without risking the chance of being obliged to winter on account of the ice."[1]

At Kotzebue Sound, the *Blossom* was to proceed northward, and "examine the coast [placing signals] on every conspicuous cape or height . . . for the purpose of directing Captain Franklin's attention to bottles containing written information." Also, surveys were to be made in certain areas of the Pacific, particularly in the Society Islands. "Rare and curious" specimens of nature were to be collected for museums.

The *Blossom* left England on May 19, 1825, and, after surveying in the South Pacific, picked up dispatches at Petropavlovsk informing Beechey of the safe return of the Parry expedition. In his *Narrative* (p. 350), Beechey recorded entering Kotzebue Sound on July 22, 1826, where supplies were buried for Franklin on Chamisso Island, with clues to its location in white paint on nearby cliffs.

The ship's decked barge and ten men were detached for work in shallow water, surveying and erecting posts and landmarks for Franklin's guidance. Its commander was also to watch for clues that might lead the expedition to a "northeastern passage." Charting of the coast extended as far north as 71° 23', at which point impassable ice was found.

Wintering in the Hawaiian Islands, Beechey returned to Kotzebue Sound on August 5, 1827. After the barge returned from searching the coast for any trace of Franklin, it was placed under the command of Lieutenant Belcher for a more extended survey. This trip resulted in the death of three crewmen and the loss of the barge, in Beechey's words, because of Belcher's anchoring "too close in shore, and by too few a number of persons being left on board" to manage the craft when a savage wind arose.

As neither Franklin nor any trace of him was found, and the weather turned dangerously cold, Beechey left the sound on October 6. After a stay at San Blas to protect resident British merchants against a revolution in progress in the interior, the *Blossom* arrived home on October 12, 1828. Unknown islands had been discovered, many miles of Arctic coastline had been surveyed, and more than 73,000 miles had been sailed (pp. 324, 328–29).

Had not Franklin's overland journey westward been hampered by heavy ice and thick fog, causing him to turn back, he might have encountered Beechey's advance party at Point Barrow, 160 miles further by Franklin's reckoning (146 miles according to Beechey), thus enabling him to complete his transit of the Arctic by land, returning with Beechey to England. Despite the failure to locate Franklin, Beechey was gratified with the results of the barge's exploration: "the farthest tongue of land which they reached is conspicuous as being the most northerly point yet discovered on the continent of America; and I named it Point Barrow, to mark the progress of northern discovery on each side [of] the American continent which has been so perseveringly advocated by that distinguished member of our naval administration."[2]

Frederick W. Beechey

Frederick Beechey was born February 17, 1796, son of a well-known portrait painter, Sir William Beechey, a member of the Royal Academy. He was entered on the muster roll of the *Hibernia* as "First-Class Volunteer" in July 1806, with Lord St. Vincent as his patron. Six months later, at just under the age of eleven, he was made a midshipman. Since Britain's naval war had almost come to an end, he participated in only two actions against the enemy. The first was as a midshipman, aged fifteen years, on the *Astraea* when it captured two French warships on the Madagascar coast in May 1811, after a "long and warmly-contested action."[1]

Prior to his second and last armed naval action, he served on no less than twelve different vessels. While attached to the *Vengeur* he was a member of the abortive British expedition to seize New Orleans, where the British were repulsed with severe losses by American troops under Andrew Jackson.

His participation in the action is described, probably in his own words, in a reply to a request for information from the editor of a naval biographical dictionary: "was in the boats, on 8 January, 1815, when they swept across the Mississippi with a body of troops, seamen, and marines, to create a diversion in favour of the general attack on the American lines."[2] Any mention of the outcome of the battle, which was a disaster for the British, is conspicuously absent.

Shortly after, he was promoted to lieutenant "for this service." On January 14, 1818, he was appointed to the "hired brig" *Trent*, under Lieutenant John Franklin, who served with Captain David

Frederick W. Beechey, c. 1830

Painting by George Beechey; courtesy National Maritime Museum, London.

Frederick Beechey was about thirty-three when his brother made this portrait, perhaps shortly after he returned to England as a new captain.

Buchan of the *Dorothea* in an attempt to traverse the Arctic from the Atlantic to the Pacific. This was the beginning of a friendship with Franklin which was terminated only by the latter's death in a later Arctic voyage in 1847.[3]

Beechey published an interesting account of his 1818 voyage with Franklin, illustrated by excellent engravings of some of his sketches done on the voyage. These portray dramatic scenes, such as the "Attack of Walruses," which depicts walruses nearly destroying one of the *Trent*'s boats with its crew: "They rose in great numbers about the boats, snorting with rage, and it was with the utmost difficulty they prevented upsetting or staving them by placing their tusks upon the gunwales, or by striking at them with their heads." Following the voyage, Beechey received £200 from a Parliamentary reward of £5,000, a bounty given for passing beyond 110° west longitude.[4]

In January 1821 he was appointed to serve on the sloop *Adventure*, and participated in an overland survey on the North African coast, from Tripoli to Derna. After a year, he was advanced to the rank of commander, and placed in charge of the *Blossom* in 1825. The next three and a half years were spent in the Pacific, conducting surveys of selected areas, but with the primary duty of cooperating with the two polar expeditions from the Atlantic by Parry and Franklin.[5]

An account of this voyage was published by Beechey in two volumes, containing a number of sketches, of which only three were by Beechey. Two of these were of scenes at Pitcairn Island, a place of intense interest to Beechey and his officers because of its settlement by the mutineers from the *Bounty*. Only one of the original mutineers was still living.[6]

Beechey was a competent artist who enjoyed sketching, apparently seizing every reasonable opportunity for the purpose. Visiting the encampment of an Eskimo band in the vicinity of Escholtz Bay, he was invited into the tent occupied by a grandmother, her daughter, and the daughter's three girls: "I made a sketch of the eldest girl, very much to the satisfaction [of the mother] who was so impatient to see it finished, that she snatched away the paper several times to observe the progress I was making."[7]

Having gained the rank of captain while still at sea on the *Blossom*, Beechey was assigned to nearly seven years of shore duty. In 1835 he was ordered to the survey vessel *Sulphur* for work along the South American coast. His health failing, he returned home in the fall of 1836. Thereafter until 1847 he conducted surveys along the Irish coast, using steam vessels. In 1850 he became superintendent of the Board of Trade's marine department. In 1855 he was elected president of the Royal Geographical Society. He died on November 29, 1856, at sixty.

Among geographical features bearing his name is Beechey Point at latitude 70° 29', on the Beaufort Sea coast, named by his friend Sir John Franklin in 1828.

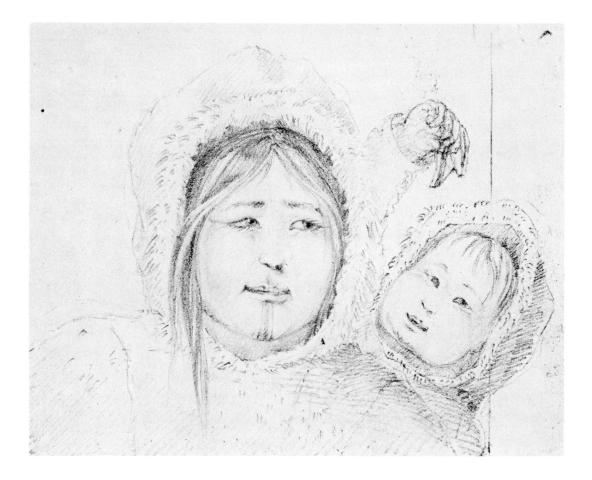

"The mother was rather pretty," 1826

Drawing by F. W. Beechey; courtesy Hydrographic Department, Ministry of Defence, Taunton, reproduced by permission of the Hydrographer of the Navy.

"The mother was rather pretty, and allowed her portrait to be taken. At first she made no objection to being gazed at as steadfastly as was necessary for an indifferent artist to accomplish his purpose; but latterly she shrunk from the scrutiny with a bashfulness that would have done credit to a more civilized female . . . on my attempting to uncover her head, she cast a look of inquiry at her husband, who vociferated 'naga' when she very properly refused to comply" (Beechey, Narrative, *1:385). (The incident took place somewhere between Icy Cape and Cape Beaufort.)*

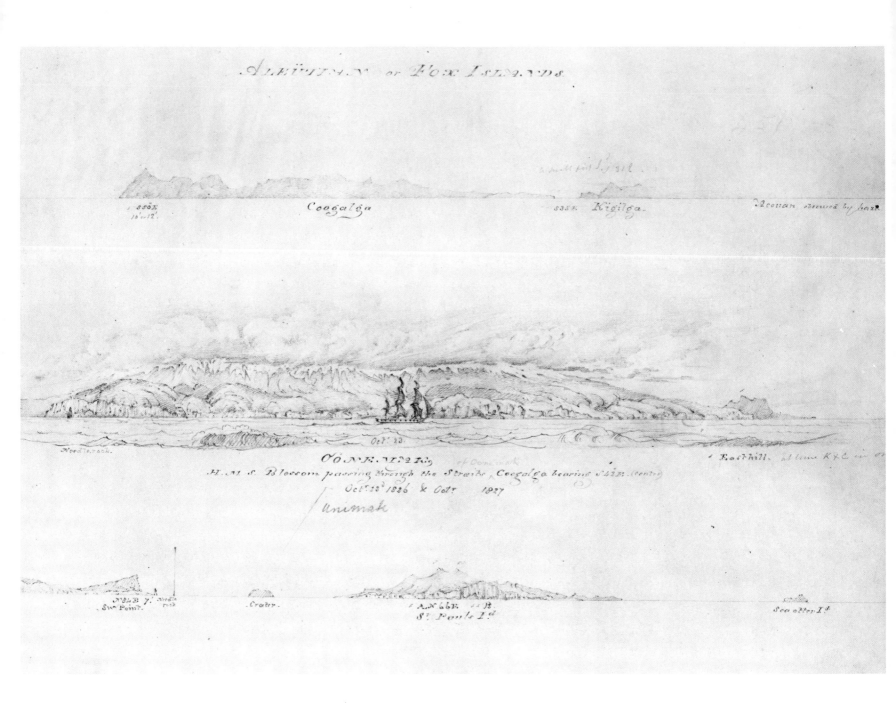

"H.M.S. Blossom *passing through the Straits," 1827*

Drawing by F. W. Beechey; courtesy Hydrographic Department, Ministry of Defence, Taunton, reproduced by permission of the Hydrographer of the Navy.

"Before sunset we got sight of the Needle Rock in the channel of Oonemak [Unimak], and passed through the strait. The strength and uncertainty of the currents about these islands should make navigators very cautious how they approach them in thick weather" (Beechey, Narrative, *2:294–95).*

William Smyth

One of three Admiralty mates on the *Blossom* at the outset of the voyage, William Smyth became the senior mate when one was invalided at Rio de Janeiro. He produced the impressive total of eighty-eight drawings on the three-and-a-half year voyage, of which a large number must have been of plant specimens collected by naturalist George T. Lay and surgeon Alexander Collie.[1] Nine drawings of people and places were reproduced in the two volumes of Beechey's *Narrative*.

When the ship's barge was detached for inshore exploration, Smyth was second-in-command under Elson, the master of the *Blossom*. Starting at Kotzebue Sound, he had the additional responsibility of keeping a journal during the three-week reconnaissance from August 18 to September 10, 1826. It was on this voyage that Point Barrow was discovered, although no landing could be made because of troublesome natives from the large village at the point. In addition, seventy miles of coastline were explored and surveyed.[2]

Beechey was thoroughly pleased with the results, and with Smyth's participation: "to the nearest conspicious object to the southward of Point Barrow I attached the name of [Cape] Smyth, in compliment to the officer who accompanied the boat expedition, and very deservedly obtained his promotion for that service." (Word of that promotion would not be received until a year and seven months later.) According to Beechey's *Narrative*, the barge had reached the "most northerly point yet discovered on the continent of America" (pp. 415, 421). The following year, when the barge was wrecked while under the command of Lieutenant Belcher, Smyth was once more aboard under Elson.

Following the loss of the barge, the body of one of three missing seamen was discovered nearby, and a burial service arranged for the coming Sunday on Chamisso Island. On the previous day as the *Blossom*'s boats under Smyth's command landed to fill water casks, an aggressive group of Eskimo landed from two baidars and created a disturbance with the watering party. At the same time five of the natives, with drawn knives, threatened the two sailors who were in a pit, preparing a grave for their departed shipmate.

It was necessary for Smyth to take action: "The hostile disposition of the natives . . . who were drawn up in a line in a menacing attitude, with their bows ready strung and their knives in their left hands, obliged Mr. Smyth to arm his people, and, in compliance with his instructions, to proceed to drive them off the island . . . each individual had probably singled out his victim, when an aged man of the Esquimaux party made offers of peace, and the arms of both parties were laid aside.[3]

On the homeward voyage, good news awaited Beechey at a South American port: "Arrived at Valparaiso on the 29th of April, [1828] where we had the gratification to find, that his Royal Highness The Lord High Admiral had been pleased to mark his approbation . . . by honouring the Blossom with the first commissions for promotion which had been issued under his Royal Highness's auspices." Smyth had been given a lieutenant's commission.

After the return of the *Blossom* on October 12, 1828, there appears to have been a two-and-a-half-year hiatus in Smyth's naval career. Appointments to active service were difficult to obtain, therefore he may have secured employment in the merchant marine. After the Napoleonic war ended at Waterloo in 1814, drastic cuts were made in the British navy. By 1818, the number of ships was reduced from 713 to 121, the number of enlisted men from 140,000 to 20,000, while the number of officers was also sharply reduced. Only 776 lieutenant-grade officers out of 3,312 commissioned were on active service in 1832, the remainder were on half pay (that is, unemployed so far as the navy was concerned, and permitted to seek other employment).[4]

For four years, from 1831 to 1835, he served on the *Samarang*, on the coast of South America. While on this duty, the merchants of Lima, attracted by the possibility of tapping a new territory for export, proposed that he explore the Huallaga and Ucayali rivers to the Amazon, and beyond. While unable to traverse the entire length of the rivers, "he left little, or it may be said no doubt, of the general fact that from Pozuzu . . . 300 [miles] from Lima, an easy navigable passage exists to the Atlantic, were the banks of the rivers cleared of the barbarous tribes which infest some parts of them."[5]

Following his duty on the *Samarang*, and probably because of his extensive Arctic background, he was sent as senior lieutenant on the *Terror* to the Arctic, from the Atlantic westward under Captain George Back in 1836–37. While unsuccessful in fulfilling all Admiralty expectations, the expedition was, nevertheless, an artistic success, since while the *Terror* was "wedged up by massive ice in the wide ocean for nine whole months . . . many scenes [were] also graphically and beautifully expressed, in numerous exquisite prints by Lieutenant (now Captain) Smyth . . . the tranquillity and constant good humour . . . of Captain Back, and the unremitting exertions of . . . Smyth, are above all praise."[6]

Back gave tribute to Smyth's achievement in uniting the crew, which consisted of

mostly undisciplined colliers . . . and whale-fishermen . . . the want of discipline and attention to personal comfort were most conspicuous [and] such was the unsociability . . . that it was only by a steady and undeviating system pursued by the First-Lieutenant, that they were brought at all together with the feeling of messmates . . . had they been left to themselves, I verily believe a more unsociable, suspicious, and uncomfortable set of people could not have been found.[7]

Returning to England, Smyth was advanced to the rank of commander, and finally to captain on Christmas Day, 1843. He died a rear admiral in 1877, probably in his late seventies.

His report of his exploration for the Lima merchants was published by the Royal Geographical Society in 1836, but it was not until twenty years later that he co-authored *Narrative of a Journey from Lima to Para, Across the Andes, and Down the River Amazon.*[8]

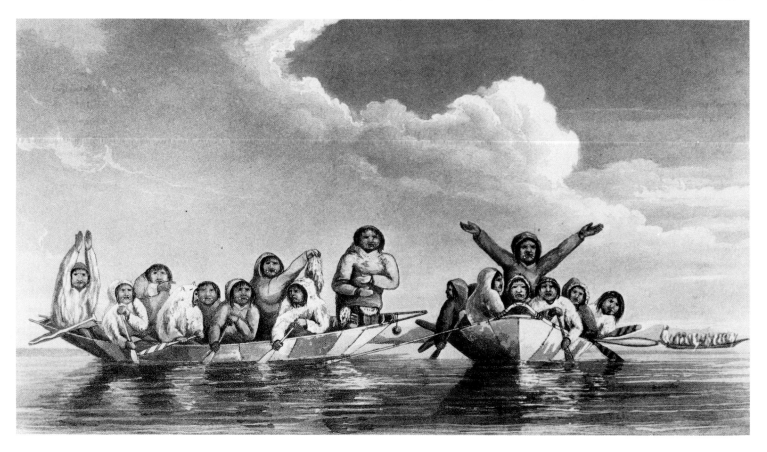

"Baidars of Hotham Inlet," 1826

Engraving of a drawing by William Smyth, in Beechey, *Narrative*, 1:facing p. 343; courtesy Pacific Northwest Collection, UW Libraries.

"We were visited by several baidars, containing from ten to thirteen men each . . . all, without exception, provided with labrets, either made of ivory and blue beads . . . of ivory alone, or of different kinds of stone, as steatite, porphyry, or greenstone" (Beechey, Narrative, *1:343).*

The carrying capacity of these craft was incredible to Beechey, who watched a group of Eskimos land to set up a camp: "From two of these they landed fourteen persons, eight tent poles, forty deer skins, two kyacks, many hundred weight of fish, numerous skins of oil, earthen jars for cooking, two living foxes, ten large dogs, bundles of lances, harpoons, bows and arrows, a quantity of whalebone, skins full of clothing, some immense nets, made of hide, for taking small whales and porpoises, eight broad planks, masts, sails, paddles, etc., besides sea-horse hides and teeth, and a variety of nameless articles" (Ibid., 1:405).

"Point Barrow," 1826

Watercolor drawing by William Smyth; Alaska and Polar Regions Department, Rasmuson Library, University of Alaska, Fairbanks, donated by the National Bank of Alaska.

On August 23, 1826, the Blossom*'s barge arrived off Point Barrow, "the most northerly point yet discovered on the continent of America" (Beechey,* Narrative, *1:415). According to Smyth's journal, "we anchored within the eighth of a mile of the point . . . on the eastern side . . . there was a village, larger than any we had seen before, consisting entirely of yourts" (Ibid., 1:422–23).*

 The small boat carried by the barge is visible at the far left.

"H.M.S. Blossom's *Barge beset in the Ice,*" 1826

Watercolor drawing by William Smyth; courtesy National Bank of Alaska, Anchorage.

"We went to the hill, and there observed the line of ice within the horizon . . . at four, fresh gales with heavy squalls—the ice around us became closely wedged . . . forming a solid mass. On visiting the village (which was about half a mile distant) the natives were uncommonly civil. They resided in tents, the frames of which were made with poles, and covered with seal skins." At the village, the crew traded for *"native boots, etc., for traveling in"* and returned to their tasks, including erecting the usual signal post for John Franklin. Three days later the wind changed, driving the ice offshore and freeing the barge *(from Smyth's account in Beechey,* Narrative, *1:432).*

A group of Eskimos are on the beach near the barge, attempting to interest the British in trade articles. The barge's anchor has been carried up on the shore, to secure it against a wind shift. The tents of the native village are visible in the middle distance.

An engraving from this drawing appears in Beechey's **Narrative**.

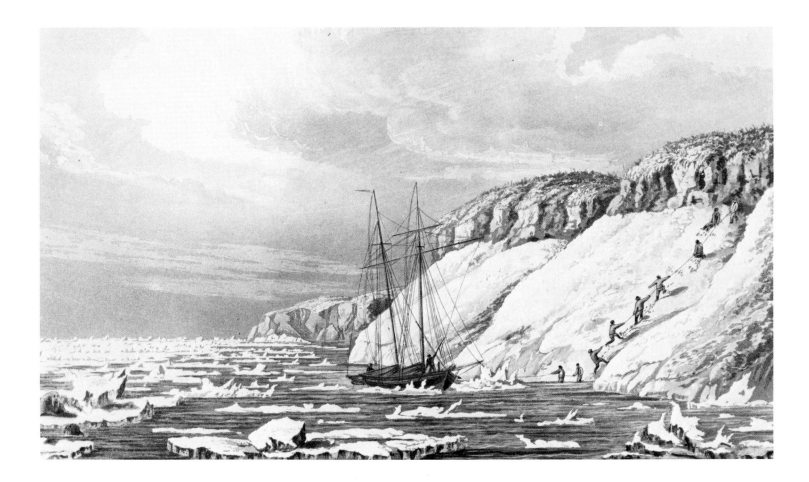

"Tracking the barge round Cape Smyth," 1826

Engraving of a drawing by William Smyth, in Beechey, *Narrative*, 1:facing p. 429; courtesy Pacific Northwest Collection, UW Libraries.

"At three we were alarmed at the sudden appearance of the ice, which was drifting fast down on us. We began tracking the boat along. . . . Here, as in many other places, we had to take the track-line up cliffs, frequently covered with hard snow and ice, which, hanging a considerable distance over the water, prevented the possibility of getting round beneath. The rope was then obliged to be thrown down . . . until the crew hauled themselves up . . . in this manner we continued along the cliff until the beach again made its appearance" (from Smyth's account in Beechey, Narrative, 1:427–28).

Not long afterwards, the aid of six or seven Indians was enlisted at the towline, but "I was frequently obliged to have recourse to the presents to keep them pulling" (Ibid., 1:429).

James Wolfe

James Wolfe was an Admiralty mate aboard the *Blossom* under Captain Beechey, having had prior service with him on the survey ship *Adventure* in the Mediterranean. He had entered the navy in 1814, apparently at the age of fourteen, although one historian states that he was born in 1807 (Withington 1952). According to Beechey, his duties included "attendance at the observatory and the construction of charts."[1]

Writing in a small but legible and heavily slanted hand, he kept a record of the voyage in a volume of 294 pages, entitled "Journal of a Voyage of Discovery in the Pacific and Beering's Straits on Board H.M.S. *Blossom*, Captn. F. W. Beechey, F.R.S. & Mem. Ast. Soc., 'Ours the wild life in tumult still to range.' By James Wolfe, Mate" (quoting Byron's poem "The Corsair").

It contains two charts, two plans, a number of skillfully executed pen-and-ink wash drawings, and four appendices, including a vocabulary of the "Esquimaux" language, and a meteorological journal of seventy pages. His purpose was "to render more lasting the incidents of a voyage which for diversity of scenery has perhaps not been parallelled since the time of the immortal Cook, and [is] intended solely for private perusal."[2]

Captain Beechey thought well enough of his young and enthusiastic junior officer to give his name to a geographical feature in the South Pacific, which possessed a certain wild beauty that must have appealed to Wolfe's poetic nature: "In the Gambier groupe there are several small sandy islands at the S.W. extremity of the chain that surrounds it, over which the sea broke so heavily that they were entirely lost amidst the foam. I named them Wolfe Islands, after Mr. James Wolfe, one of the midshipmen of the ship. We passed them tolerably close, admiring the grand scene which they presented."[3]

Once in Arctic waters, Wolfe, as with other observers on the Northwest Coast, had occasion to note the dominance of native women, trading from a baidara alongside the ship:

The first word they uttered was "Tobacco" and on its being produced a brisk trade commenced, but they would only take that weed in the leaf. One of the women having some blue beads round her neck, made known that they would be acceptable, indeed the women seemed only to wish for beads, the blue color being most prised, yellow they would not have. From their making it a rule to bite them we conceived that they had been duped with compositions of wax etc. By some unlucky accident one of the men let a string of them fall overboard, for which he received some heavy blows from the female to whome they were given, indeed we had reason to suppose that the women (I cannot say the fair or weaker sex) had more sway than is recommended by the good apostle St. Paul.[4]

In 1829, after the voyage, he was promoted to lieutenant, and remained actively involved in surveying, chiefly in Ireland, until his death. Serving on a succession of vessels, he became a commander on February 15, 1843, and for the two years following was in charge of the *Tartarus*, a surveying steamer on the Irish coast. From 1846 to 1849 he was "borne on the books of the Commodore's ships at Woolwich as an additional Commander for surveying duty."[5] He died in 1849 at age forty-nine.

Dawson's *Memoirs* also lists an impressive number of Admiralty charts published from his surveys, a principal one being the "River Shannon from entrance to Limerick on seven double elephant sheets." In 1833 the Royal Geographical Society Journal published his paper "Observations on the Gulf of Arta."

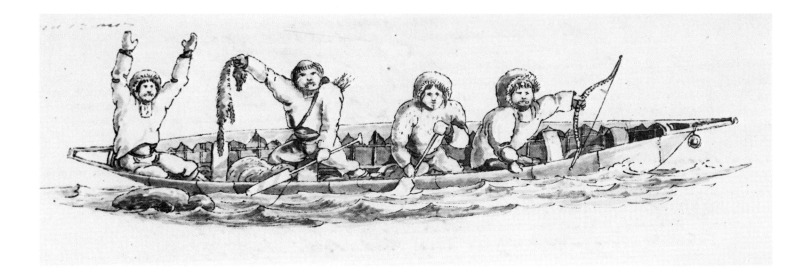

Eskimos alongside the Blossom *in a baidara, 1826*

Drawing in manuscript journal of James Wolfe; courtesy Beinecke Library, Yale University.

"They appeared to have no wish to come on board the Ship but remained quietly alongside; the four boats occupied the whole length of our vessel and a more diverting scene cannot well be imagined than our intercourse with these Islanders. The Ship's side was lined with officers and men holding out tobacco, beads, buttons or whatever was thought likely to be acceptable" (Wolfe, Journal, *p. 111).*

 A tonsure is visible on the head of the Eskimo holding up a furskin for trade. The bladder floating alongside is to keep the craft from being damaged against the side of the ship.

Edward Belcher and H.M.S. *Sulphur*, 1836–42

Captain Edward Belcher, an experienced surveyor, was ordered by the British Admiralty in 1836 to proceed to Panama to take command of the survey vessel *Sulphur*, to replace Captain F. W. Beechey, who, through illness, had to leave the vessel at Valparaiso. The Northwest Coast was the next objective, with surveys made in the vicinity of Prince William Sound, where Belcher was entertained by the Russian Resident in charge of the post at Port Etches.[1]

Proceeding northward, the *Sulphur* narrowly escaped shipwreck when Midshipman Simpkinson went on deck "just in time to see the ship coming slowly round within her own length of a line of tremendous breakers." At Sitka, extensive surveys were made. After being entertained by the Russian governor, Belcher reciprocated by inviting the Russian officers and a large number of the Tlingits to a feast aboard the *Sulphur*. He noted that the Indians "observed great ceremony in their approach . . . the canoes were as fantastic as their occupants . . . carved in grotesque figures, and remarkably well handled."[2]

After turning southward, Belcher arrived at Friendly Cove on October 3. He encountered difficulty in locating it, a surprising fact in view of the charts of the area available from the Cook and Vancouver voyages. According to Simpkinson, "Captain Belcher was obliged to go away in a boat to look for it while the ship hove to in the middle of the sound." Belcher was surprised at its size, and "doubted my senses, that so small a space could have occupied so much type."

Continuing south, the *Sulphur* arrived in San Francisco Bay. Extensive surveys of the Sacramento River were made as far as "one hundred and fifty-six miles from her anchorage . . . in open boats for thirty-one days." The survey had been exhausting: "the work of each day was entirely completed on paper before we retired to rest (sometimes at four A.M.)."[3]

The *Sulphur* moved on to Central and South America, then to Hawaii. Here Belcher sent the smaller consort, *Starling*, to the Columbia River, to prepare for the coming survey in accordance with Admiralty instructions reminding him that "political circumstances have invested the Columbia river with so much importance, that it will be well to devote some time to its bar and channels of approach and its inner anchorages and shores." The Admiralty was in fact concerned with the entire coast: "No consistent account of the currents along the western American coast has been yet framed, though in no part of the world would it be of more importance and value."[4]

Meanwhile, the *Sulphur* proceeded northward to complete assigned duties, including establishing the location and height of Mt. St. Elias. While in the Aleutians, another of several Vancouver chart errors was discovered: "On Friday, the 5th July, 1839, we discovered land on the lee-bow, which clearly showed Vancouver considerably in error."[5]

In January 1840 the *Sulphur* began the homeward voyage, surveying among the Pacific islands, then on to Singapore. From there she was diverted to China, taking part in naval operations in the First Opium War. She left the area late in 1841, returning to England on July 19, 1842, after an absence of nearly seven years.[6]

Edward Belcher

He was the only British Naval officer I have encountered who was so entirely boorish and malicious . . . he was of the middle height and most very dark complexion and a most forbidding countenance. None of his officers but felt his tyranny and experienced the most malignant treatment from him [however] I heard he was estimated as a brave and enterprising officer. (Appraisal of Belcher in Wilkes, *Autobiography*, p. 516, after assisting Belcher in the Fiji Islands in July 1840)

Born in Halifax, Nova Scotia in 1799, to the son of the governor of the colony, Edward Belcher's progress in his earlier years must have been helped by his family connections. He entered the British navy in 1812 at the age of thirteen. After service on several ships, he was made a midshipman in 1816, and was promoted to lieutenant only two years later.

In 1825 he was appointed as an assistant surveyor to H.M.S. *Blossom* under Captain F. W. Beechey, serving for three years. He attained the rank of commander on March 16, 1829. During the following three years and four months he commanded the *Aetna*, which was engaged in charting portions of the western and northern coasts of Africa. He went on to survey in the British Isles, principally in the Irish Sea. In November 1836, he was appointed to replace the invalided Captain Beechey on the *Sulphur*, surveying on the west coasts of North and South America.

Before he returned to England in July 1842, he had been detached from his normal role of surveying, and required to assist in naval warfare on the Canton River. His homecoming followed an absence of nearly seven years.

Already holding post rank in 1841, when he was decorated as a Companion of the Bath (C.B.) he was knighted in January 1843. During the same year he published his account of the voyage of the *Sulphur*. For five years, until 1847, he was engaged in survey work in the Pacific. In 1852 he was appointed to command an expedition to the Arctic in search of Sir John Franklin, the Arctic explorer who disappeared while in search of the Northwest Passage. It was an unfortunate choice, according to the outspoken writer of the *Dictionary of National Biography*:

Belcher, though an able and experienced surveyor, had neither the temper nor the tact necessary for a commanding officer under circumstances of peculiar difficulty. Perhaps no officer of equal ability has ever succeeded in inspiring so much personal dislike . . . his expedition is distinguished from all other Arctic expeditions as the one in which the commanding officer showed an undue haste to abandon his ships when in difficulties, and in which one of the ships so abandoned rescued herself from the ice, and was picked up floating freely in the open Atlantic.

Although only in his mid-fifties at the conclusion of this controversial voyage, Belcher was never again employed in the navy, although he was given the customary promotions in order of seniority, becoming an admiral in 1877.

His ill temper and callous treatment of his subordinates were manifest on repeated occasions. Concerning an arduous five weeks spent surveying the Sacramento River, the *Sulphur*'s young Midshipman Simpkinson was critical:

Detached service in boats is at the best a most trying and harassing occupation without being made more so by the bad temper and caprice of the officer commanding . . . all the little enjoyments and indulgences which people expect on such service [which serve to] break the monotony of surveying . . . were denied them. Even the privilege of shooting at the passing flocks of ducks and geese Captain B. reserved for himself alone, and actually issued an order that no one was to fire except by his express permission.[1]

While in the Fiji Islands in 1840, Belcher sent an officer to Wilkes' nearby *Vincennes* "for the purpose of obtaining Pintles for their Rudder which they had broken by getting ashore on a coral reef." Wilkes sent a boat on nearly a 200-mile round-trip, in order to secure the right size from the *Starling*. Despite the favor, Belcher's subsequent actions failed to "evince any thanks for the benefit conferred & was extremely reticent on all points of the surveys he had made . . . I asked to get comparisons with his magnetic needles but he showed great disinclination to compare results."[2]

On the homeward voyage, Wilkes once more encountered Belcher, this time at the Cape of Good Hope. He found him "rather cool and distant . . . had he treated us as liberally as we did him, we should not have lost the *Peacock* on the Columbia River Bar as he had his charts then made, but he did not offer any apology or make mention of the obligations he was under to us for the supply of his rudder and which enabled him to pursue his voyage."[3]

According to a British source, after the end of his naval service Belcher spent the rest of his life in "literary and scientific amusements." In addition to the narrative of the *Sulphur*'s voyage, he produced four other books. These included his self-exonerating version of his search for Franklin, with the "somewhat extravagant title" of *The Last of the Arctic Voyages*, in two volumes; also an "exceedingly stupid one, *Horatio Howard Brenton, a Naval Novel*, in three volumes."[4] On the positive side of his literary achievements, it should be noted that his 1835 *Treatise on Naval Surveying* was "long a standard work on the subject."

He died on March 18, 1877, at the advanced age (for the time) of seventy-eight. One of his fellow surveyors, Captain Richards of H.M.S. *Plumper*, who presumably had never had the experience of serving under Belcher, gave his name in 1859 to a 1,600 foot mountain on Saltspring Island, near Victoria, British Columbia. This action may have been in recognition of his excellent textbook on the difficult and demanding art of marine surveying.

Belcher Point, thirteen miles northeast of Wainwright on the Chukchi Sea coast, was named in September 1826 by Captain Beechey. Some 140 years later, the author of the *Dictionary of Alaska Place Names*, a rather matter-of-fact government publication, felt it necessary to add to the data above, "The following year he was responsible for the loss of the *Blossom*'s barge and the lives of three of Beechey's men off Choris Peninsula."

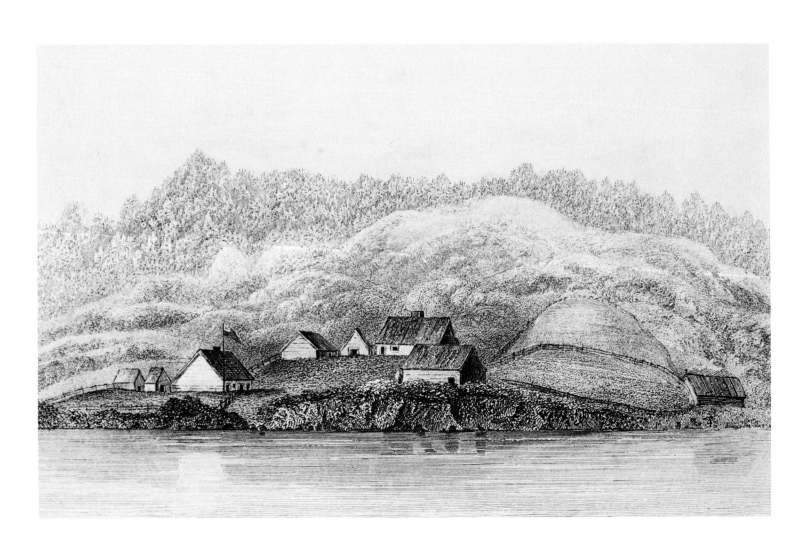

"Fort George, Astoria," 1839

Engraving of a drawing attributed to Edward Belcher, in his *Narrative*, 1:facing p. 289; courtesy Pacific Northwest Collection, UW Libraries.

"Off this fort, the well-known 'Fort Astoria' of Washington Irving, we anchored for the night. It has dwindled considerably since the Hudson's Bay Company took charge, who removed their chief establishment to Fort Vancouver, and allowed it to run to utter ruin. Not a vestige [of the fort] remains. Two or three sheds for the Canadians, about six or eight in number, and a pine stick with a red ensign, now represented Fort George. Not a gun or warlike appearance of any kind remains. One would rather take it for the commencement of a village than any noted fort. The scenery is similar to that of all the northern coast—wooded to the water's edge, and differing little excepting in the varities of pine. The outline is pleasing, but no field for the painter, there being no contrast of tints, and too stiff an outline" (Belcher, *Narrative*, 1:289).

This area is the location of today's city of Astoria, Washington.

"*Indian Burial Place, Columbia River,*" 1839

Watercolor sketch attributed to Edward Belcher; courtesy Special Collections Division, University of British Columbia Library.

"*It is the custom of these tribes to bury each individual in a canoe; and according to his wealth so are they laden with his worldly goods; care being taken to render the greater part of the utensils, as copper kettles, &c., useless, by driving an iron bar through the bottom. The bodies are wrapped closely in mats. . . . Great secrecy is observed in all their burial ceremonies, partly from fear of Europeans; and as among themselves they will instantly punish by death any violation of the tomb, or wage war if perpetrated by another tribe, so are they inveterate, and tenaciously bent on revenge, should they discover that any act of the kind has been perpetrated by a white man. It is on record, that part of the crew of a vessel, on her return to this port, suffered because a person who belonged to her (but not then in her) was known to have taken a skull; which, from the process pursued in flattening, has become an object of curiosity*" (Belcher, Narrative, 1:292-93.

Francis Guillemard Simpkinson

Born in 1819, Francis Simpkinson was eighteen when he first served as a midshipman under Captain Edward Belcher on H.M.S. *Sulphur* in 1837. After three years, he was fortunate in being transferred from the service of the notably disagreeable Belcher, to the *Rainbow* under his uncle, Sir John Franklin. Later he became one of the illustrious Alexander von Humboldt's lieutenants, two having been appointed by each of various nations for the investigation of magnetic currents, by taking synchronous pendulum observations in different parts of the world. From 1844 to 1849 he was naval officer in charge of Hobart Observatory in today's Tasmania.[1]

After some twenty years, having attained the rank of lieutenant, he left the navy and married in 1858. The following year, he assumed his grandmother's name of deWesselow, possibly in anticipation of entering a higher strata in Cannes society. For the last forty years of his life he lived with his wife in Cannes, where they became keenly interested in art and music. He died in London in 1906 at the age of eighty-seven.

Simpkinson was a close observer of the natives of the Northwest Coast, but like many others, was disgusted with their lack of cleanliness and "revolting customs." He was enthralled, however, with the fine workmanship and handsome appearance of their cloaks, hats, and other items of their ceremonial costumes.

He did not hesitate to criticize Belcher in the pages of his journal (see p. 132). When the *Sulphur* narrowly escaped being wrecked on the Alaskan coast, because Belcher refused to believe the officer of the watch when land was reported ahead, Simpkinson recorded: "I cannot help thinking that standing in after dark for an unknown coast is certainly a rash act."

Simpkinson was an accomplished artist, but how many of his drawings on the *Sulphur* voyage formed the basis for Belcher's illustrations may never be known, since Belcher allowed no officer's name to be credited to a specific drawing.

Chief Macquena, 1837

Engraving of a drawing attributed to Francis Guillemard Simpkinson, in Belcher, *Narrative*, 1:108; courtesy Pacific Northwest Collection, UW Libraries.

"Macquena, the only chief we have seen at this place [Friendly Cove], is constantly in the habit of visiting the ship with his family. He is the only person that is admitted on board and is really a handsome man having a remarkably high forehead, with open manly features and none of those treacherous, fierce, demoniacal looks of most of our recent acquaintances. I attempted to take his portrait which he was so gracious as to allow me to, but what from his extreme restlessness combined with my own inability to do any justice to a handsome face, I am afraid my production bears but little resemblance" (from Simpkinson's journal in Pierce and Winslow, *Sulphur*, p. 110).

This is not the Maquinna who was chief at Nootka from at least 1788 to 1818.

The French Voyages

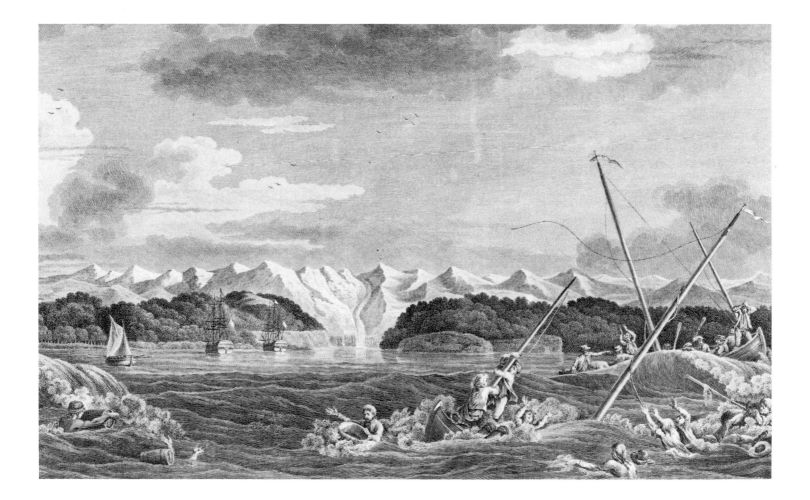

"Wreck of the boating party in which twenty-one men perished," Lituya Bay, 1786

Engraving based on drawings and accounts from the La Pérouse expedition, in La Pérouse, *Voyage*, English edition courtesy Pacific Northwest Collection, University of Washington Libraries. (For an account of the wreck, see p. 139.)

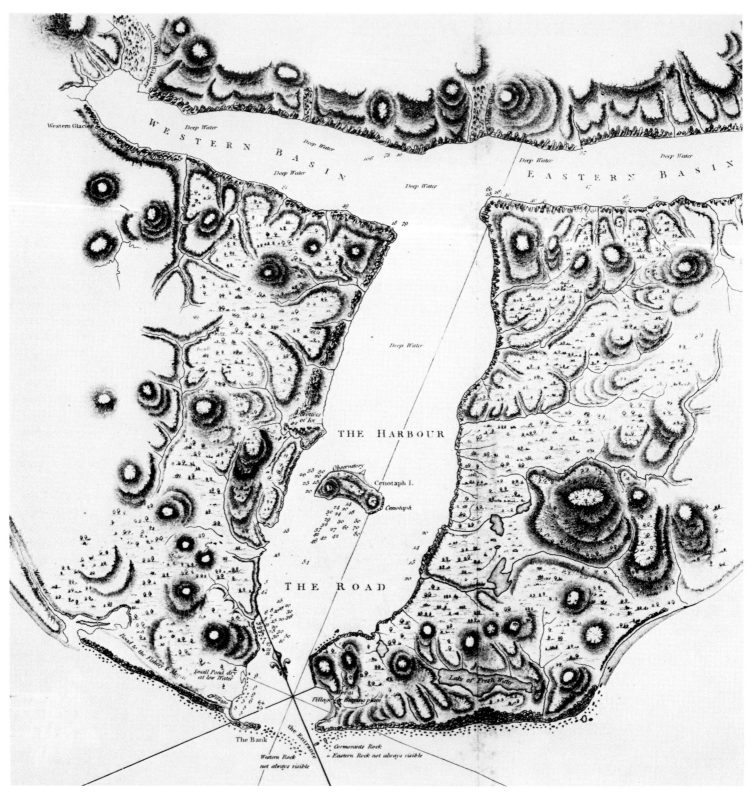

La Pérouse's chart of Port des Français, 1786. Courtesy Pacific Northwest Collection, University of Washington Libraries

La Pérouse and the *Boussole* and *Astrolabe*, 1785–88

"Two ships came into the bay. The people did not know what they were, but believed them to be great black birds with far reaching white wings, and, as their bird creator, Yehlh, often assumed the form of a raven, they thought that in this guise he had returned to earth, so in their fright they fled to the forest and hid." (Meeting of La Pérouse and the Tlingit at Lituya Bay in Emmons, *Native Account*, p. 294)

Following the establishment of peace with England, King Louis XVI ordered preparations for a scientific expedition to circumnavigate the world, a voyage designed to help France "assume its responsibility as a first class naval power and more especially as one dedicated to the advancement of science." Other objectives were to "discover new lands and to establish commercial relations with them; to collect precise data on whaling [and] the fur trade . . . to make a careful reconnaissance of the northwest coast of North America, Japanese waters, the Solomon Islands, and the southwest coast of Australia." Detailed instructions were issued under the close scrutiny of the king, those connected with scientific research being especially elaborate.[1]

Jean François Galaup de la Pérouse, about forty years of age, was chosen as leader. Two transports, converted to armed frigates, were extensively fitted out at Brest. The *Boussole*, under the command of La Pérouse, had a length of 127 *pieds* (about 137 feet). The *Astrolabe* was placed under Paul-Antoine de Langle, who had been second-in-command under La Pérouse during the latter's leadership of certain naval operations against the British during the American Revolutionary War.[2]

The expedition left Brest on August 1, 1785. After stops at Chile, Easter Island, and the Hawaiian Islands, it arrived on the Northwest Coast on June 26, 1786, anchoring off Yakutat Bay, Alaska. On July 3, La Pérouse entered what is today known as Lituya Bay, naming it "Port des Francais," thus establishing the first French presence on the Northwest Coast of America. While surveying near the entrance passage, two of the boats, contrary to written orders, ventured too close to the channel at the time of the current's maximum velocity. Caught in the tide rips, twenty-one men perished. No bodies were recovered, but a memorial was erected on an island in the middle of the bay.[3]

Proceeding southward, La Pérouse passed the Queen Charlotte Islands without anchoring, then on past Nootka Sound and the Strait of Juan de Fuca, both shrouded in fog. He arrived at the Spanish settlement at Monterey on September 14 for a stay of ten days. During the ensuing fifteen months, he continued his mission across the Pacific to the Hawaiian Islands, to Macao on the Chinese coast, northward to Kamchatka, then south, stopping at the Samoan Islands in December 1787 to obtain water and provisions. Here misfortune and death struck another grievous blow. De Langle, naturalist Lamanon, and eight others were brutally massacred by the natives, as four boats of a watering party of sixty-one men were stranded in a shallow bay. De Langle had withheld the use of firearms, hoping to escape "without shedding blood."[4]

The vessels continued on to Botany Bay, arriving in late January 1788. Departing there about the middle of February, the expedition disappeared at sea and was never heard from again. Although a search was made by two ships sent by the French government in late 1791, no trace was found. It was later determined that the rescue ships must have sailed close by the scene of the disaster, where some survivors may still have been alive.

In 1826 remains of the ships were found near the island of Vanikora in the New Hebrides, where they had apparently been driven aground by a typhoon. According to the natives, there had indeed been survivors, some of whom built a small vessel from the wreckage. It was sailed away to obtain help, but also disappeared without a trace.[5]

Lieutenant de frégate Blondela

The second of the two ships on the La Pérouse expedition was the *Astrolabe*, under the command of Comte de Langle. One of his talented young ensigns, Blondela, produced some of the most interesting drawings done on the voyage. Of the twenty-eight engravings that illustrate the La Pérouse journal, made from drawings actually executed during the expedition, fifteen were from Blondela's works, two more than those based on the productions of the official artist, Gaspard Duché de Vancy.*

Blondela was taken into naval service as a volunteer on March 2, 1777. After four years' service as an *officier auxiliaire*, he was promoted to *lieutenant de frégate* at Brest. According to official French naval records, he served in squadrons sent to engage the British on the eastern coast of North America for a total of nearly five and a half years, between 1777 and 1782. During this time he participated in nine naval actions on five different ships.[1]

Blondela was involved in the most significant of those actions taken by the French navy in support of the American Revolution. He was one of ten auxilliary officers aboard the *Auguste* from July 26, 1781 to May 10, 1782. This vessel was one of twenty-four ships of the line under the overall command of Admiral de Grasse, which blockaded Chesapeake Bay on August 30, 1781, to prevent a British squadron from entering the bay and evacuating Cornwallis and his force of eight thousand men, bottled up at Yorktown by Washington and Lafayette.[2]

Six days later de Grasse defeated a British fleet off the mouth of the Chesapeake River. The blockade was successfully maintained until the surrender of Cornwallis on October 19, assuring England's final loss of its American colonies.

In April 1782 Blondela was still with the French fleet when it suffered a devastating defeat by the British in the West Indies. One of the twenty-five French vessels which escaped was the *Auguste* with Blondela aboard.

In May he was transferred to the *Palmier*, leaving it after six months, apparently for shore duty. Naval records indicate a two-year lapse before he returned to sea on the cutter *Levrette* in October 1784. He transferred to La Pérouse's *Astrolabe* on July 11, 1785, only three weeks prior to the departure of the expedition. It may be assumed that Blondela volunteered, perhaps in part because he admired La Pérouse, who had commanded a number of successful actions on the American and Canadian coast. It was a decision which was to cost Blondela his life.

*Research has not revealed Blondela's first name. He invariably signed his drawings "Blondela Lieut' de frégate." French naval records refer merely to "lieutenant de frégate Blondela."

On May 1, 1786, nine months after leaving France and a few days after the *Astrolabe* and *Boussole* left Easter Island, he was promoted to sub-lieutenant. A final promotion to captain was received on July 13, 1786.[3]

In a letter to Comte de Fleurieu, Minister of the Marine, dated January 3, 1787 at Macao, La Pérouse wrote: "I have the honour, Sir, to send you two drawings by Mr. de Blondela, which are not inferior to any of the four by Mr. Duche [the official artist]." (Apparently all of these were views of Easter Island.) De Langle also wrote Fleurieu about the same time: "Mr. de Blondela, also, is an excellent naval officer, and a man of exemplary prudence and resolution. He employs his leisure in drawing plans of the different harbours, and in executing designs equally pleasing and natural." La Pérouse joined in praise for Blondela, writing on September 7 from Avatcha: "With the charts . . . I transmit to you some particular plans drawn by Mr. Blondela . . . who applies himself with a degree of assiduity, and executes with an intelligence, order and neatness, that are deserving of the highest encomiums."[4]

In the same dispatch he enclosed drawings by Blondela: "a view of the harbour of St. Peter and St. Paul [in Kamchatka] which is taken from a different point of sight from that inserted in Cook's third voyage: and also a series of drawings of the different vessels used at sea by the various people we have visited. This collection cannot be but interesting, and certainly merits the honour of being engraved." These consisted of a group of ten drawings, fortunately reaching France safely, which do appear in the published journal.

Early in the voyage, there was concern about his health. De Lamanon, meteorologist and mineralogist on the *Boussole*, wrote to the secretary of the Academy of Sciences: "We have had on board neither of the vessels a single individual sick, Mr. Blondela excepted, who is subject to complaints of the breast."[5]

It is entirely possible that the resolute Blondela was one of the thirty men who escaped the *Astrolabe* as she sank on a New Hebrides reef, and joined the survivors of the *Boussole* on the island of Vanikora.[6] If his health permitted, his talents would have been of signal assistance in the building and navigating of a small vessel, on which they left the island after a few months, only to perish on an unknown shore or in a remote sea.

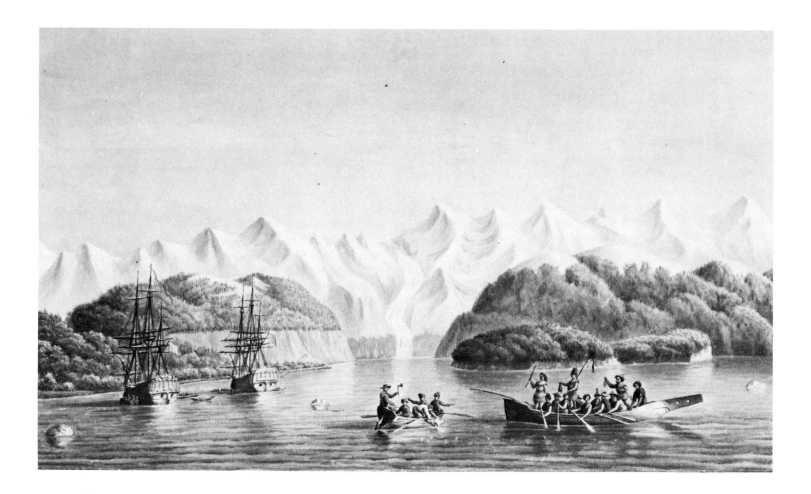

"View of the interior of port des François" (Lituya Bay), 1786

Drawing by Blondela; courtesy Service Historique de la Marine, Vincennes.

The French officer in the ship's boat is holding up a trade hatchet, offering it either as a gift or for trade; while the Tlingits are apparently making "signs of friendship, by displaying and waving white mantles, and different skins" (La Pérouse, Voyage, 1:365). Soon afterwards, the ships changed their anchorage to a more protected location, behind the island in the right background. This sketch was not reproduced in the La Pérouse atlas.

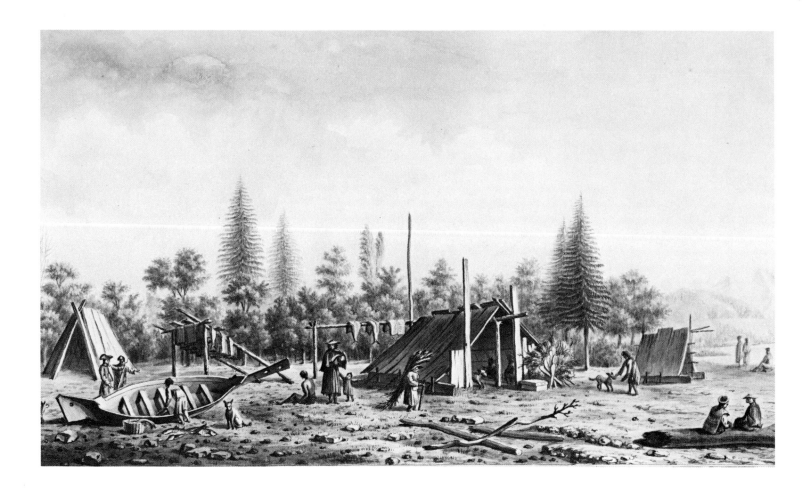

"View of native establishments at port des François during fishing season," 1786

Drawing by Blondela; courtesy Service Historique de la Marine, Vincennes.

An engraving from this drawing is reproduced in La Pérouse's atlas to his Voyage. *The fish drying on the racks are probably halibut, judging from their size. Canoe paddles are leaning against a pile of brush at the right of the main shelter. The bow of the canoe appears to be out of a parallel line with the stern, although the outline of the canoe is correct. Professor Bill Holm, by making an overlay drawing, has proven that the lack of shading on the bow creates an illusion, which turns the broad low fin to the wrong angle.*

Frame of a skin-covered "canoe" at Lituya Bay, 1786

Engraving of a drawing by Blondela; courtesy Service Historique de la Marine, Vincennes.

"The frame, which was well made, had a covering of seal-skins . . . sewed together with such nicety, that the best workmen in Europe would find it difficult to imitate" (La Pérouse, Voyage, *1:391). The covering of the frame is in the foreground.*

 La Pérouse learned from the Tlingits that seven such craft had been wrecked at the harbor entrance. Because of their similarity to the baidaras of the Eskimos, he thought it possible that "the Esquimaux in the neighborhood of the islands of Schumagin, and of the peninsula explored by Cook" traded with the Tlingits (ibid., 1:407).

Canoe at Lituya Bay, 1786

Engraving of a drawing by Blondela; courtesy Service Historique de la Marine, Vincennes.

La Pérouse was not impressed with the workmanship displayed in the local canoes: "[the inhabitants] are very unskilful in the construction of their canoes, which are formed of a trunk of a tree hollowed out, and heightened on each side by a plank" (La Pérouse, Voyage, *1:406). The man in the stern is holding a pole from which is suspended a small fur or bird feathers, apparently as a sign of peace and a desire to trade.*

Gaspard Duché de Vancy

For the La Pérouse expedition, Gaspard Duché was selected as the "Draughtsman of landscapes and figures," according to the muster list of the *Boussole*. Recognized art biographical references in France and Germany contain only sparse data on his life, but more on his paintings, drawings, engravings, and exhibitions.

He was reared in Vienna, where he apparently studied art. One of his views of the Place Dauphine in Paris was exhibited in the Salon of Young Artists in 1781, which may indicate that he was still relatively young when he left France with the expedition in 1785. At an unknown date he painted a portrait of Marie Antoinette, which, if executed from life, may indicate that he had an influential friend in the French Court.

In 1784 Duché resided in London, where his skill was recognized by the prestigious Royal Academy, which exhibited five pictures, including two architectural views of Naples and Rome. He also did portraits of Stanislas, the puppet king of Poland, and Vincent Lunardi, secretary of the Kingdom of Naples, both dated 1784. For years after his death his work was known only by a single watercolor drawing, dated 1782, in a private collection. After the posthumous issue of La Pérouse's journal with its excellent engravings, his work became better known.

Official instructions to the La Pérouse artists were much more detailed than those given to Cook's. Not only were coastal profiles to be depicted, but all unusual happenings. With the assistance of the two natural history draftsmen, Duché was to "prepare portraits of the natives of the different parts, their dresses, ceremonies, games, buildings, boats and vessels, and all the productions of the sea and land . . . if he shall think that drawings will render the descriptions more intelligible."[1]

La Pérouse was highly complimentary of Duché's drawings. While at Macao, in a letter transmitting four of Duché's pictures to Paris, he wrote that "the dresses of the natives are depicted . . . with the greatest fidelity; and his view of Easter Island gives an idea of its monuments, that is much more accurate than the engravings in Cook from the designs of Mr. Hodges." In another letter, from Petropavlovsk, he wrote: "You will find, among the plans, nine designs from the hand of Mr. Duché, which are strikingly accurate."[2]

The existence of any drawings from the expedition is due to La Pérouse's diligence in periodically forwarding to Paris journals, maps, and drawings. He did this from Macao, Kamchatka, and finally, Botany Bay. As noted elsewhere, the two vessels, *Boussole* and *Astrolabe*, left Botany Bay in February 1788, and were never heard from again.

One may only speculate as to the quantity of graphic material produced on the Northwest Coast by Duché and Blondela. The production of the former may well have been large. Once again from Macao, in one of his frequent reports to the Minister of the Marine, La Pérouse wrote, enclosing three drawings; "they afford a small specimen only of his diligence, twenty others at least remaining in his port-folio."[3]

The list of original drawings done on the Northwest Coast during the La Pérouse expedition, and lodged at the Service Historique de la Marine in Vincennes, total eight, of which four are by Blondela, three by Duché, and one of a bird by J. R. Prevost, one of the two naturalists.[4] With two exceptions, they all bear numbers near the upper lefthand corner, written in the same hand. After allowing for the eight known drawings, and those which are unnumbered, it appears that twelve are unaccounted for. Perhaps many of the twelve were done at Port des Francais (Lituya Bay), where the expedition spent three weeks. One is acknowledged to be missing in a footnote by the editor of the official narrative. Another drawing, of a salmon weir across a stream, is described in the text: "Mr. Duché de Vancy made a drawing, which will explain the particulars of this fishery."[5]

The greater part of the drawings done by the expedition artists undoubtedly perished in the wreck of the two vessels at Vanikoro. As to those which were returned to France, how many disappeared en route in the turmoil of the French Revolution may never be known.

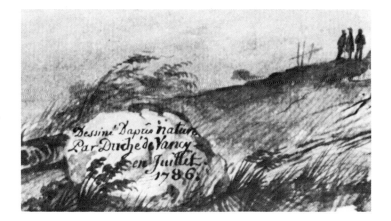

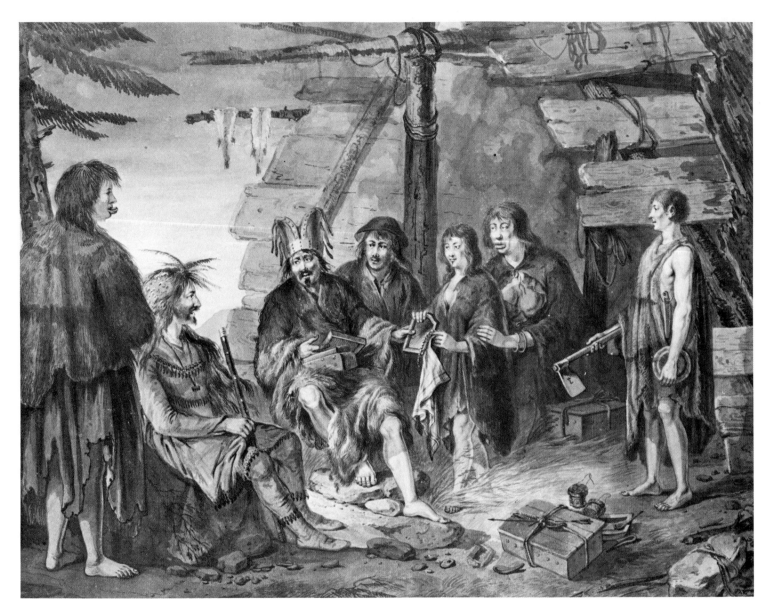

"Native costumes at Port des Français," 1786

Drawing by Gaspard Duché de Vancy; courtesy Service Historique de la Marine, Vincennes.

The Tlingit chief is exhibiting a trade mirror, probably a gift. This may be the chief to whom La Pérouse initially gave "several presents, which made him so very troublesome, that he daily spent five or six hours on board; and I was obliged to repeat them very frequently" (La Pérouse, Voyage, *1:370).*

The chief's elaborate headdress is not a figment of the artist's imagination, as it may be seen again in the background of the drawing of the woman with labret (p. 148). The man seated on the left, holding a trade musket, is smiling at his reflection in the mirror. His fringed, tanned skin costume is an article of trade with Indians of the interior. He has eagle feathers plaited in his hair.

The man at right wearing a dagger is holding a trade ax embossed with a French emblem, and a pewter plate. "We at length prevailed on them to take pewter pots and plates, yet these had only a transient success, iron prevailing over everything" (ibid., 1:369).

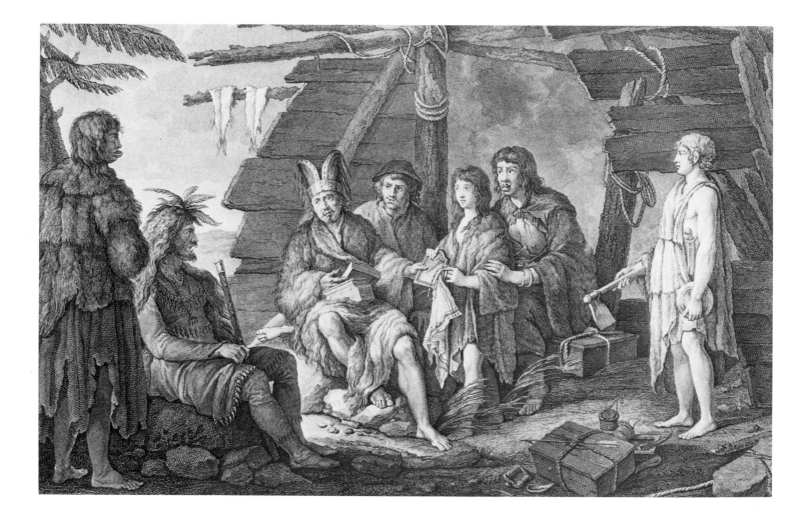

Native costumes at Port des Français, 1786

Engraving of a drawing by Gaspard Duché de Vancy; courtesy Service Historique de la Marine, Vincennes.

It is both interesting and amusing to compare this engraving with the accompanying original drawing. The engraver has taken it upon himself to change the mood of this little gathering by altering the facial expressions depicted by the artist. The seated Indian, who was amused at seeing his face reflected in the mirror, is now aghast at the miraculous image, while the others show concern and fear at this evidence of the white man's magic. The Tlingit man, at right, has been transformed from an intrigued spectator into a statuesque Greek athlete holding a discus. Inexplicably, the engraver has inserted a human foot protruding from an area just back of the chief, at an angle hard to conceive as connected with the man seated behind him.

This print shows the engraving in reverse, in order to compare it more easily with the original drawing.

"Inhabitants of Port des Français," 1786

Drawing by Gaspard Duché de Vancy; courtesy Service Historique de la Marine, Vincennes.

"[These women] have a custom, which renders them hideous . . . all without exception have the lower lip slit close to the gum the whole width of the mouth, and wear in it a kind of wooden bowl without handles [labret], which rests against the gum, and which the slit lip serves as a collar to confine, so that the lower part of the mouth projects two or three inches. The young girls wear only a needle in the lower lip: the married women alone have a right to the bowl. We sometimes prevailed on them to lay aside this ornament; but it was with difficulty; and they made the same gestures, and testified the same embarrassment, as an European woman on discovering her bosom" (La Pérouse, Voyage, 1:402–3).

The same woman is also drawn in profile, so as to better display the labret. This drawing was reproduced as an engraving in the La Pérouse atlas.

The Spanish Voyages

Mount St. Elias and the corvettes Descubierta *and* Atrevida, *1791*

Drawing attributed to Tomás de Suría; courtesy Oregon Historical Society, and Museo de América, Madrid.

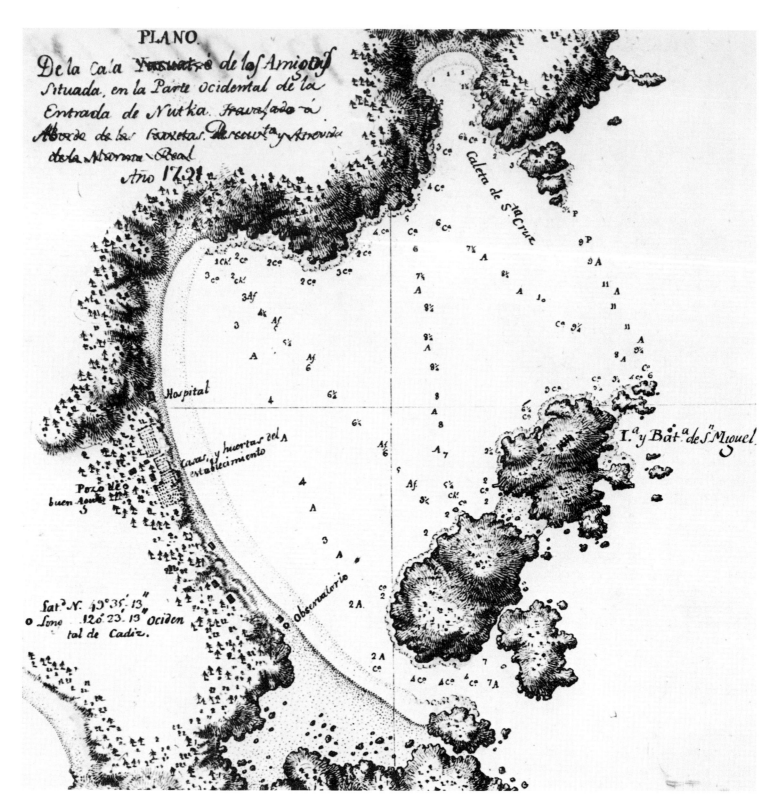

Chart of Friendly Cove, 1791, Malaspina Expedition. Photograph by Arthur Taylor; courtesy Museum of New Mexico

Alejandro Malaspina and the *Descubierta* and *Atrevida*, 1789–94

After the establishment of peace between England and Spain in 1783, Spain sponsored a series of explorations designed to improve its hydrographic and land maps in several parts of the world. To accomplish this for the west coasts of North and South America, and in addition to certain other objectives, Alejandro Malaspina and José Bustamente y Guerra were selected as co-captains to head an ambitious scientific voyage around the world.[1]

Two 120-foot corvettes, the flagship *Descubierta* (*Discovery*), under the command of thirty-five-year-old Malaspina as the senior captain, and the *Atrevida* (*Daring*), were built especially for the expedition. Each ship had a complement of eighty-six men and sixteen officers, all carefully selected. While perhaps not directly furthering the objectives of the voyage, a harpsicord was provided for the main cabin of the flagship. Large stores of sauerkraut, bacon, vinegar, wine, and grog were included to combat scurvy. No expense was spared in any aspect of preparation for the voyage, as it was hoped that its achievements would surpass those of the Cook voyages.[2]

Leaving Cádiz July 30, 1789, the expedition spent two years on the east and west coasts of South America and Mexico. At Acapulco, new orders reached Malaspina from the Spanish court, which altered plans for the rest of the voyage. The crown was persuaded that a search should be made for the "Strait of Anian" (the Northwest Passage), described in an account of an apocryphal voyage which supposedly took place in 1588. Malaspina also gave credence to the claim.[3]

With two boats and supplies for two weeks, Malaspina explored the area, soon determining that no passage across the continent existed at the latitude noted by José Maldonado. He recorded his disillusionment by naming the bay "Bahia del Desengaño" (Disenchantment Bay). Some exploring activities were fruitful, however, producing surveys and plans of the area, scientific experiments, and magnificent drawings by the artists. A number of potentially violent encounters with the Indians were averted by the forbearance of the Spaniards.[4]

After leaving Yakutat Bay, the expedition sailed to Prince William and Bucareli sounds, then proceeded to Nootka, arriving August 12 for a stay of two weeks. Immediately the scientists set up their observatory tents ashore, and the crews began renewing depleted supplies of water and firewood. Malaspina then turned his attention to the uneasy political relations between the Spanish and several leading local chiefs. He sent an invitation to each leader, eventually locating Maquinna, chief of the Nootkans, at his village at the head of Tahsis Inlet. Unfriendly at first, Maquinna was reassured by the sociable demeanor of the Spaniards, and returned to Friendly Cove to receive gifts, including sails for his canoes and panes of window glass.[5]

The expedition returned to Cádiz on September 21, 1794, more than five years after its departure. Malaspina soon became involved in political intrigue with the Spanish queen against Godoy, the powerful prime minister, and expressed open criticism of Spain's colonial policies. These indiscretions resulted in eight years' imprisonment, followed by banishment. As a consequence, it was not until 1885 that the importance of the voyage overcame the reluctance of the authorities, permitting the publication of Malaspina's journal in much reduced format.[6]

Felipe Bauzá y Cañas

Felipe Bauzá, a native of Barcelona, was born in 1769. He occupied one of the key staff positions on Malaspina's expedition of 1789, serving as chief of charts and maps. His background and training for such a responsibility were excellent. He had served as a pilot's mate, and had also worked under cartographer Vicente Tofiño de San Miguel in preparing the Spanish *Atlas Maritimo*.[1]

Later he became a drawing instructor in the midshipmen's academy of the Navy Department at Cádiz, with the imposing title, at age eighteen, of "Professor of Fortifications and Military Drawing." Two years later he was made a lieutenant.[2]

After the voyage, Bauzá returned to Spain. In 1797 he was made deputy chief of the newly created Direccion Hidrografia, a national depository of maritime historical material. At the time of Napoleon's invasion of Spain, fearing for the safety of priceless records, Bauzá loaded the hydrographic archives on carts, taking them to safety in Cádiz. In 1815 he was made director of the institution, and worked on two major atlases, the *Atlas of North America* and the *Atlas of South America*. As a member of the Royal Academy of History, he had, a few years earlier, presented a treatise on the geography of South America.[3]

Bauzá may have been influenced by Malaspina's liberal political and social ideals, prior to and while serving as a deputy from Mallorca to the Spanish courts. In any event, his strong beliefs impelled him to vote against absolute monarchy at a session in 1822, which in effect was a vote for his own exile. He moved to England; Fernando VII condemned him to death in absentia.[4]

In London he continued his work in cartography and geography, and was honored by the crowned heads of England and Russia, the Royal Geographic Society, and learned societies in Lisbon and Turin.[5] He died in London in 1833, at the age of sixty-four.

Fortunately for history, Bauzá had sufficient perception, perhaps tinged with an acquisitive instinct, to build up a substantial private collection of drawings and other material from the expedition. After his death this came into private hands, and eventually was acquired by the Spanish government and lodged in the Ministry of Education at Madrid.[6]

Coastal profiles, 1791

Drawing by Felipe Bauzá y Cañas; courtesy Museum of New Mexico, and Museo de America, Madrid.

The upper view shows the entrance to Nootka Sound. The letter A marks the location of the Spanish fort at the entrance to Friendly Cove. A conspicuous landmark from seaward is the remarkable steeple-shaped Conuma Peak (4,889 feet), marked by a B.

The lower view is of "Cabo Frondoso," which was named Woody Point by Cook in 1778, and is now called Cape Cook (Wagner, Cartography, 2:456). It is about seventy miles northwest of Nootka Sound. The letter A marks Solander Island, one mile offshore.

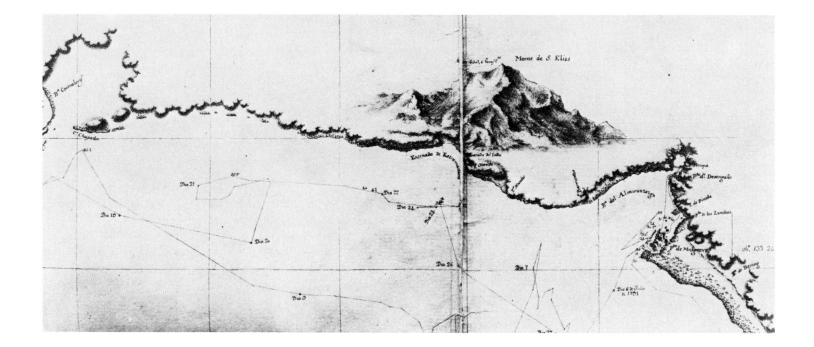

Detail of chart and Mount St. Elias, 1791

Chart by Felipe Bauzá y Cañas; courtesy Oregon Historical Society, and Museo Naval, Madrid.

The bay at the base of Mt. St. Elias is marked "Enseneda de Estremadura" (Icy Bay). At the upper right of the chart appears the name "Bª del Almirantazo" (Yakutat Bay?). Port Mulgrave, lower right, was the site of a six-day stay, during which the expedition had a narrow escape from armed conflict with the Tlingit Indians.

Tomás de Suría

This day the commander gave an order that at midnight the two longboats should set sail and make a reconnaissance . . . in each one were placed two swivel guns, the corresponding ammunition and provisions . . . I begged the commander to distinguish me by appointing me to such a glorious small expedition. He granted my request, providing me with a gun, pistols, and ammunition as if I were a soldier . . . with shouts and acclamations we departed from the corvettes. (From journal of Tomás de Suría at Nootka Sound in 1791)[1]

Tomás de Suría was born in 1761 in either Madrid or Valencia. At an unknown age he became a student at the Royal Art Academy of San Fernando in Madrid, under Jeronimo Antonio Gil. When the latter decided to go to Mexico to live, Suría and a fellow student were invited to accompany him. When Malaspina found it necessary to temporarily fill vacancies for two artists for his voyage to the Northwest Coast in 1791, Suría's name was suggested and readily accepted.[2]

Suría was able to arrange a leave of absence from the Mexican mint, where he was an engraver. A similar leave from his wife and mother-in-law was not so readily obtained, since they were so violently opposed to his leaving that they protested in person to the viceroy. The opposition could not have been based on financial anxiety, as Suría received a substantial salary increase, as well as expense allowances, which optimistically included transportation costs from the north Atlantic coast back to Mexico after the expedition had sailed through the mythical Strait of Anian.

Undeterred by marital protests, the venturesome thirty-year-old artist immediately left for Acapulco on horseback to join Malaspina, carrying a large supply of his own art materials. At the outset he began to keep a journal, the initial entry being a detailed record of the distances between cities and towns he touched on his journey, to a total of "110 Spanish leagues" to Acapulco.[3]

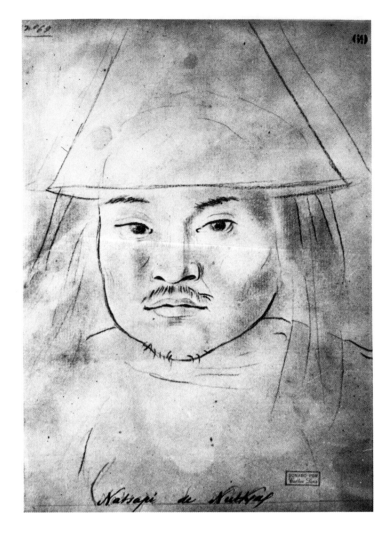

"Natzapi de Nutka," 1791

Drawing by Tomás de Suría; courtesy Oregon Historical Society, and Museo de America, Madrid.

Malaspina "had the good fortune to make the acquaintance of the brothers Manikius and Natzapi, brothers-in-law to Macuina . . . they will surely be the reformers of this nation, if the Europeans will cooperate in this useful reform" (Colson, Malaspina Voyage, 2:Appendix, 216). During a two-day visit by these "young men of singular talent, understanding and affability, they gave us many ideas, so clear and so strange, on their religion, origin, laws, customs, system of government, commerce and interior geography that it appears to us an illusion that we should understand each other so quickly" (ibid., 1:285–86).

As the ships reached northern latitudes, Suría recorded "the cold is increasing but with it comes the desire for eating and for drinking good wine." On the Alaska coast, when the range of mountains that include Mt. Fairweather (15,300 feet) came into view, Suría was exultant: "it causes the greatest wonder and admiration to see them all covered with the purest snow from the foot to the summit, and the eyes do not get tired of looking at them."[4]

Entering Port Mulgrave, Suría was enthralled with his first view of the Tlingit Indians, "because such strange and marvelous subjects presented themselves to our sight . . . they were dressed in skins of various colors, well tanned . . . it seems that their idea of gala dress is to make themselves look as horrible as possible." After the observatory tent was erected ashore, "the Indians continued very sociable and . . . gave us some rich, fresh salmon, at the rate of one for a button . . . the most delicate thing which can be imagined. We could never satisfy ourselves with it notwithstanding we ate an abundance."

Taken ashore to make drawings in the chief's house, Suría found himself alone and in some danger, the officers who accompanied him having moved outside:

I had scarcely commenced to work when with a great cry the cacique spoke to me in his language in an imperious tone and a threat that I should suspend my work. . . . I paid little attention to him when the third time there was a grand chorus of shrieks by all the Indians. I came to myself and suspended my work which was well started. I began to shout for my own people, but when I turned my face I did not see a single one. They formed a circle around me and danced around me knives in hand singing a frightful song, which seemed like the bellowing of bulls . . . in such a situation I feigned ignorance and shouted louder making the same contortions and gestures. They were very much pleased at this and I was able . . . to gain their good will with a figure which I sketched for them. . . . they marveled very much at this . . . so they quieted down . . . giving me fish to eat.[5]

After returning to Mexico City, Suría worked for eight months on his drawings produced on the voyage, then resumed his position at the mint. Continuing his artistic career, he achieved national recognition creating religious allegories, medallions, and portraits. He also taught, and held some minor government posts. His last known drawing was "The Resurrection of Lazarus," which was executed in 1834 when his eyesight was fading rapidly, possibly as a result of the strain of years of close work at the mint. He was then still resident in Mexico City at the age of seventy-three.[6]

Suría's drawings were a significant contribution to the expedition, as recorded by Malaspina: "Finally our collections for the Royal Museum have been numerous and very interesting, inasmuch as Don Tomás Suría has depicted with the greatest fidelity to nature all that merits the help of the engraver's art, so as to secure better understanding in the historical narrative of this voyage."[7]

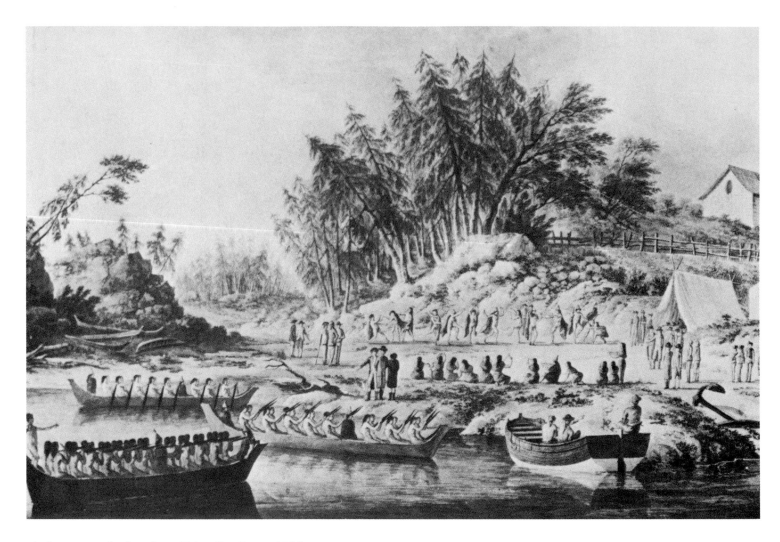

A dance on the beach at Friendly Cove, 1791

"Improved" drawing attributed to Tomás de Suría; courtesy Pacific Northwest Collection, UW Libraries, and Museo Naval, Madrid.

"The noble Tlupanamibo was lodged on the beach at the establishment where at certain hours of the day he sang for us in company with his oarsmen about the glories of his nation and his ancestors" (Wagner, Suria Journal, *p. 277*).

Malaspina described one such dance: "he [Tlupananuc, or Tlupanamibo] finally came to visit us in this state canoe manned by some thirty paddlers whose chanting, dexterity and evolutions surprised us in their first turns around the corvettes, there followed various dances, executed by the same paddlers, first on board and then on the beach close to the observatory" (Colson, Malaspina Voyage, *2:284).*

An observatory tent is at the extreme right, next to it a canvas tent, below are several large barrels, and a ship's anchor has a fluke buried in the sand to make a more secure moorage. The shape of the bows and sterns of the canoes have been somewhat distorted by the "finisher artist," but the attitude of the canoe paddlers is reasonably accurate, as they keep time to their songs by thumping paddles on the canoe sides, then thrusting them aloft in unison. Each canoe has a fur-clad chief seated in the middle. Several groups of Spanish officers and adjuncts are watching the performance. The fanciful posturing of the dancers is probably drawn entirely from the imagination of the "finisher."

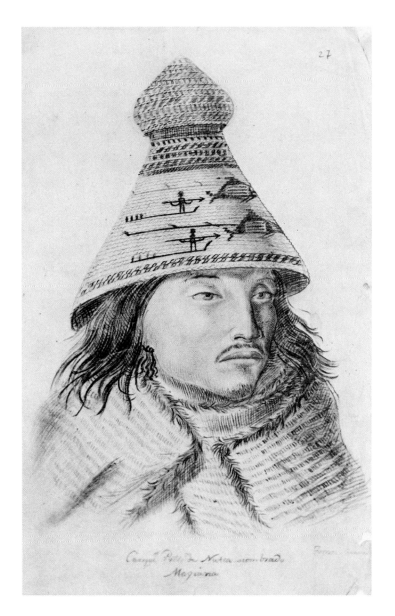

Maquinna, 1791

Drawing by Tomás de Suría; courtesy Museum of New Mexico, and Museo Naval, Madrid.

It is strange that so few descriptions exist of the person of this great chief, whose village of Yuquot and protected harbor of Friendly Cove were the center of events of international importance.

Meares in 1788 recorded one of the earliest impressions of Maquinna, when a number of war canoes entered the cove: "in most of these boats there were eight rowers on a side . . . the chief occupied a place in the middle, and was also distinguished by a high cap, pointed at the crown Maquilla . . . appeared to be about thirty years, of a middle size, but extremely well made, and possessing a countenance that was formed to interest all who saw him" (Voyages, pp. 112–13).

Cardero, perhaps depending on a sketch for the physical description, observed only that "Macuina was endowed with remarkable ability and quickness of intelligence" (A Spanish Voyage, p. 17). Vancouver noted, as justification for the initial refusal of boarding privileges on the Discovery by the officer on watch, that "there was not in his appearance the smallest indication of his superior rank" (Voyage, 1:385).

According to Malaspina, "the person of this Chief does not accord with his dignity, he is short and attenuated, though of a nervous constitution and heavily muscled. He attributes his present emaciation to the scarcity of food which compelled him to abandon the Port of Yucuat and he spoke, not without sorrow and pride, to the Commander of the Atrevida of the happy time when single handed, he would approach and harpoon a whale, enjoying then a health and strength above the common" (Colson, Malaspina Voyage, 3:218).

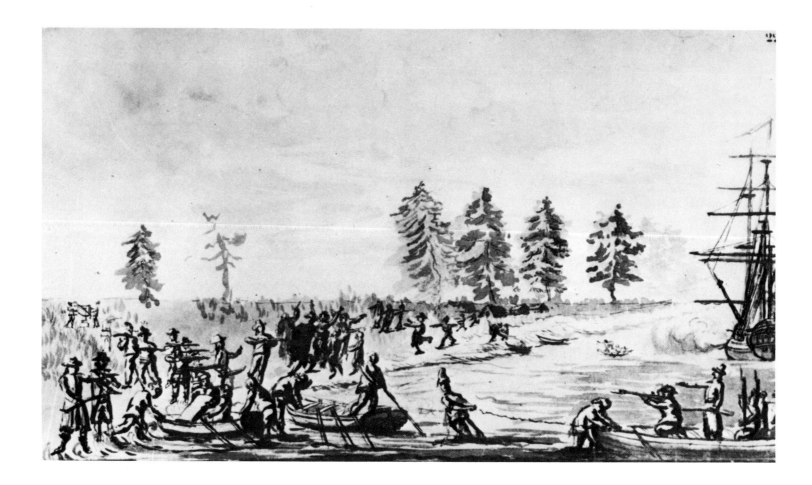

Disagreement with the Indians, 1791

Drawing attributed to Tomás de Suría; courtesy Museum of New Mexico, and Museo de America, Madrid.

While at Port Mulgrave, Juan Vernaci was detached with "the quarter-circle, clock number 351, a Pilots mate and two armed soldiers, to wait for clear moments . . . to make fresh observations for the checking of the marine clocks." Soon the natives "began to gather there in great numbers, pretending to touch one or other instrument and finally surrounding the soldiers . . . asking them for their muskets, not without some show of insolence."

Reinforcements were sent ashore, and the ankau [chief], already aboard the Atrevida, *was detained as hostage. Conflict seemed imminent, in spite of the ankau shouting to his people to retire. The Spanish officers, "expressing always the most pacific and conciliatory intentions," gave the order to box the instruments and carry them to the boat. "The natives somewhat resisted the retirement, manifesting in their faces and postures a desire to use their knives."*

The Atrevida *was requested to "make a discharge of artillery without ball, while we withdrew in good order to the shore. Our care was directed less to our own security than to seeing that none of the natives were killed by our muskets and bayonets . . . afterwards considered ourselves extremely happy to have been able to avoid the effusion of blood" (Colson,* Malaspina Voyage, *2:242–44).*

Vernaci and a helper are seen in the far left distance with some of the instruments, while in the foreground a sailor is placing a box in the ship's boat.

Galiano and Valdés and the *Sutil* and *Mexicana*, 1792

At the suggestion of Malaspina, in 1791 Viceroy Revillagigedo of Mexico gave orders to two of Malaspina's most trusted officers, Dionisio Alcalá Galiano and Cayetano Valdés, to proceed to Acapulco to fit out two newly built schooners, the *Sutil* and the *Mexicana*, for exploration and survey of the continental shore at the east end of the Strait of Juan de Fuca, and thence northward.[1]

Galiano was commander of the expedition on the *Sutil*, Valdés was captain of the *Mexicana*. The schooners were identical in size, each being just over fifty feet long, with nearly a fourteen-foot beam, drawing six feet two inches, equipped with limited armament, provisions, and water sufficient for one hundred days, and attractive trade goods to be used as presents for the Indians. The crew of each ship numbered seventeen, plus two officers, with the addition of José Cardero on the *Mexicana*, who served as the artist and journalist.

Owing to various delays, departure did not take place until March 8, 1792. The inferior sailing qualities of the schooners were soon apparent, once at sea. In addition, on April 14, the mainmast of the *Mexicana* broke a few feet above the deck. After jury-rigging a sail, which allowed progress at a reduced rate, they reached Friendly Cove, the Spanish base at Nootka, on May 13. They were greeted by Chief Maquinna, accompanied by his retainers in a large canoe.[2]

After repairs, the schooners sailed to Nuñez Gaona (Neah Bay), where the captains entertained Chief Tetacu (Tatoosh). When the eastern voyage was resumed, Tetacu was aboard as a willing guest during the short cruise to his village further up the strait. (Cardero's journal account of this incident [pp. 32–36] indicates that Tetacu was the principal chief of two villages, one at Neah Bay and the second at Esquimault.)

On June 13, the schooners encountered Vancouver's *Chatham* with Lieutenant Broughton in command. After presenting his compliments and an offer of assistance, Broughton informed them that palatable water was difficult to locate in these regions, and that a plentiful supply was available at his present anchorage. The winds not being favorable for following Broughton, the schooners proceeded northward, anchoring at Descanso Bay on Gabriola Island. Moving eastward again, on June 20, Galiano and Valdés met Vancouver in person at the anchorage near Point Grey. Vancouver then made his historic offer to couple forces and engage in joint surveys. The Spanish captains were not entirely pleased with the offer because of the difficulty of keeping pace with the larger British vessels. Due to the generosity of the invitation, however, and the fact that the viceroy had suggested a joint effort, they accepted.[3]

The cooperative effort soon proved unsatisfactory. Although the Spanish captains were willing to, and in fact did on occasion, accept the British surveys, Vancouver explained that he could not reciprocate. While he stated that he had full confidence in the Spanish work, his orders expressly required him to view the areas surveyed. Accordingly, on July 12 the two parties separated on good terms, after exchanging copies of each others' charts produced in the region. Vancouver gave them a friendly warning that the smaller channels, which the Spaniards intended to follow northwestward, would prove dangerous.[4]

Four months after first departing from Friendly Cove on the survey, the schooners returned, only to depart for Acapulco the same day at midnight.

The first circumnavigation of Vancouver Island may fairly be credited to the two Spanish captains, although it has generally been given to Vancouver. Also to their credit, their charts have proved to be more accurate of the inlets indenting the mainland of British Columbia, an area which Vancouver claimed he was instructed to examine carefully.[5]

José Cardero

When the Malaspina expedition left Cádiz in 1789, one of the vessels carried as a cabinboy for its officers a twenty-one-year-old native of the Andalusian town of Ecija. José Cardero was small of stature, with an appealing personality which won him the nickname "Pepe."

He must have had a number of years of previous nautical experience, since he received a promotion to first boatswain. In addition, with another of the same rank, he was commended by Malaspina, who secured for them a "small increase in monthly salary to show that His Majesty was aware of their good services," bringing Cardero's pay to twenty pesos monthly. Malaspina's letter recommending the action indicated that special recognition was due because of the conduct, subordination, and intelligence of the two men.[1]

It is not known at what stage in the voyage Cardero's artistic ability began to attract the attention of his superiors. Most certainly his drawing would not have been allowed to interfere with his duties; although, by the time the expedition was at Guayaquil (now Ecuador), he was allowed to produce abundantly as a volunteer artist.

When the vessels had reached the Alaska coast, Cardero had drawn a series of sixty-four zoological illustrations, nearly all in color. In addition, he drew a number of general views, coastal profiles, and natives. Historian Donald Cutter notes that "some of these leave something to be desired aesthetically, but historically almost all . . . [are] superior to that of his highly trained associate, Tomás de Suría. Either through lack of confidence or by personal preference, Cardero drew with less artistic license and far greater detailed precision" than the other artists.[2]

After returning to Acapulco in 1792, Cardero was soon assigned to a shorter, more specialized expedition recommended by Malaspina, to examine the channels and islands to the east and north of Vancouver Island. He had already won the confidence of two of the officers on the previous voyage—Galiano and Valdés—appointed by Malaspina to head the new exploration. They prevailed upon Malaspina to replace a previously appointed pilot-cartographer with the youthful Cardero.[3]

They were also able to secure an increase in his salary to sixty pesos monthly, based on his manifold responsibilities as artist, cartographer, and scribe, as well as journalist. According to Cutter, Cardero was actually the author of the anonymous account of the voyage, *Relación del viage hecho por las Goletas Sutil y Mexicana.*

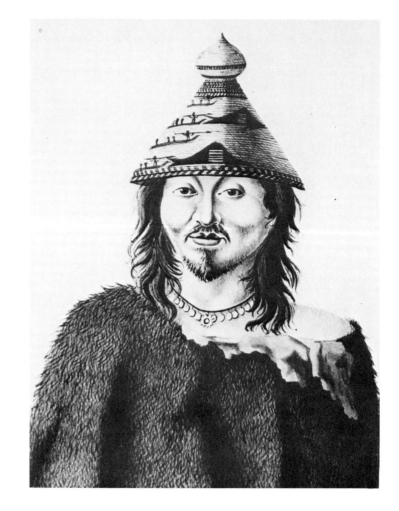

Chief Tetacus (Tetaku), 1792

Drawing by José Cardero; courtesy Oregon Historical Society, and Museo de America, Madrid.

"Tetacus, one of the principal chiefs . . . was one of those most attached to the Spaniards" ([Cardero], A Spanish Voyage, *p. 28). Cardero states in his journal that Tetaku was the principal chief of two villages, one at Neah Bay and the second at the harbor of Córdoba (Ibid., pp. 16–19, 36). The latter is today's Esquimalt Harbour on Vancouver Island (Wagner, Cartography, p. 444).*

The chief's hat seems accurately depicted by the artist assigned to "improve" the drawing, except for the placement of the canoes, two of which should be spaced to the right. The hat, however, is a coastal type not made inland as far as Córdoba, and was presumably acquired either as a gift or by trade. The pendant on his necklace may be a European token. He is wearing a sea otter fur cape (Bill Holm, personal communication).

An inscription with the drawing reads "Chief of the entrance of Juan de Fuca, Tetaku."

His artistic output improved in quality during the second voyage, with approximately twenty-five drawings of natives, general scenes, and coastal profiles, including one of the entrance to the Columbia River. As to the journal, it shows an excellent command of syntax (although some of this may be due to the translator), an occasional tendency toward poetic rhapsody, and observations with conclusions not always based on sound evidence.

He was deeply moved by the beauty and grandeur of the deep inlets which they explored, and admired the ability of the Indians to cope with their environment:

The diversity of trees and shrubs . . . the loveliness of the flowers . . . the variety of animals and birds . . . the observer is afforded many occasions for admiring the works of nature and for delighting his senses as he contemplates the majestic outlines of the mountains, covered with pines and capped with snow . . . when any men are met . . . the observer will see that, denied those advantages which are believed to be indispensable for life, these men are yet very intelligent, strong and cheerful, and that, without the aid which is supplied by the study and perfection of the arts, they still know how to provide themselves with the necessary sustenance, to supply their wants and to defend themselves against their enemies.[4]

When the two schooners arrived at Nootka for a short stay before returning to Acapulco, Cardero met the botanist Moziño, who had accompanied Bodega y Quadra. He accepted as valid, and incorporated in his journal, Moziño's observations concerning the resident natives, with a notable exception. Had he stayed longer, Moziño might have corrected Cardero's mistaken belief that because "the inhabitants of Nootka have heads which end in a point; they are undoubtedly born so . . . not to be attributed to the fact . . . that their heads are moulded with strong bandages [as children in cradles]" (p. 98).

Cardero illogically speculated that the reason "the women do not mortify their flesh by cutting it," or "pull their ears out of shape by the weight of metal ornaments, as do the men," might be attributed to the possibility that "the women of Nootka are surer of being able to attract the attention of their men, an idea to which colour is lent by the fact that the number of women is very small in proportion" (p. 100).

After the voyage, Cardero finished work on his drawings, and completed the journals of the voyage. Later, aboard the Royal Navy vessel *Minerva* leaving Vera Cruz in April 1793, he accompanied his commander Cayetano Valdés in a return to Spain. There, in recognition of his work during the expedition, he was assigned a rank approximating that of a lieutenant, in the supply corps at Cádiz.[5]

No evidence had been found of further activity as a professional artist. His name was listed regularly in the *Estado General de la Armada* from 1797 until 1808, when the accompanying title was changed to "second official." In 1811 his name no longer appeared, which could be due to political intrigue, death, or retirement. His age at that time would have been about forty-three.[6]

Cardero's contribution to the knowledge of the Northwest Coast deserves more recognition than it has been given. It is gratifying to note that two living memorials to the former cabin-boy still exist in the remote fiords of British Columbia, so much admired by Cardero. His captains assigned his name to "Cordero" Channel, a beautiful mountain-girded waterway north of Stuart Island, a place where the *Mexicana* nearly met disaster in the strong currents. The name survives on modern charts, as a result of farseeing policies established in 1831 by Francis Beaufort, hydrographer of the British Admiralty, who held that "the name stamped upon a place by the first discoverer should be held sacred."[7]

Even more heartening, Captain Parry of H.M.S. *Egeria*, engaged in a resurvey in 1905, gave the name "Cordero" to a point of Valdes Island which borders Gabriola Passage in the Gulf Islands, honoring Cardero after 113 years of British domination in the waters he had sailed. Perhaps Parry's action was an unconscious response to the amiable personality of the diminutive artist reaching through the years.

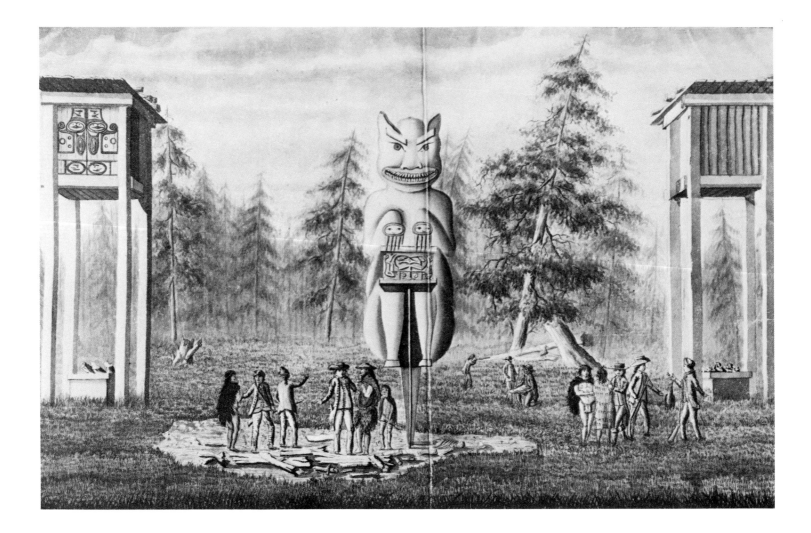

Burial place of the family of the An-Kau of Port Mulgrave, 1791

Drawing by José Cardero; courtesy Museum of New Mexico, and Museo Naval, Madrid.

"The depository of the dead of the [Ankau's] family . . . which was sketched with much accuracy by the painter Cardero, should particularly fix our attention. We do not know whether the colossal monster which occupies the foreground is an idol or merely a frightful record of the destructive nature of death, but the fact that in its vicinity are various pyres on which bodies have been cremated inclines us to the first idea. In a casket which lay beneath its claws or hands was a bowl-shaped basket, a European hat, an otter skin and a piece of board. The height of the monster was no less than ten and half feet (French). The whole was of pine wood and the ornaments on the casket were of shells embedded in the same wood. The colouring was of red ochre with the exception of the teeth, the claws and the upper part of the head which were painted black and white. In the upper chambers of the two sepulchral deposits were two baskets one greater than the other, the contents of which we were unable to ascertain. The lower chamber . . . contained a basket with some calcined bones. . . . The monster faced Eastward, his name . . . was Iukitchetch" (Colson, Malaspina Voyage, 2:Appendix, 208–9).

 This forthright representation by Cardero should be compared with the "improved' drawing by Brambila (see p. 163) adapted with considerable variation (Cutter, "Early Spanish Artists," p. 157).

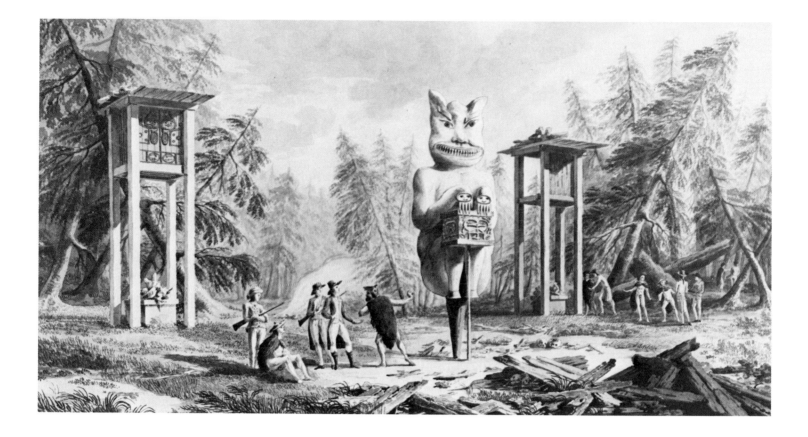

"Burial place of the family of An-Kau"

Drawing by Fernando Brambila based on José Cardero's sketch; courtesy Museum of New Mexico, and Museo Naval, Madrid.

The artist assigned to "improve" this drawing was the Italian Brambila (Cutter, "Early Spanish Artists," p. 157). It should be compared with the original Cardero drawing of the same scene (facing page).

While the massive mortuary structures, burial chests, and the great central figure are depicted with reasonable fidelity, Brambila rearranged and redrew the human figures for greater dramatic and romantic interest. The small Indian boy holding his bow, closely accompanying his father, has vanished. The casual outdoor clothing of the officer talking to the father, has been exchanged for elegant wear appropriate to European boulevards. The central figure with his back to the viewer, who is perhaps a noncommissioned officer, has likewise been reclothed, and turned around. Many changes have been made in the group of men at the right.

In the foreground Brambila has introduced a number of skulls for somber emphasis. A blazing fire has been added in the background, presumably in the process of cremation. An absurd number of wind-damaged trees have also been inserted. An engraving was made from this "reconstructed" version for the published journal.

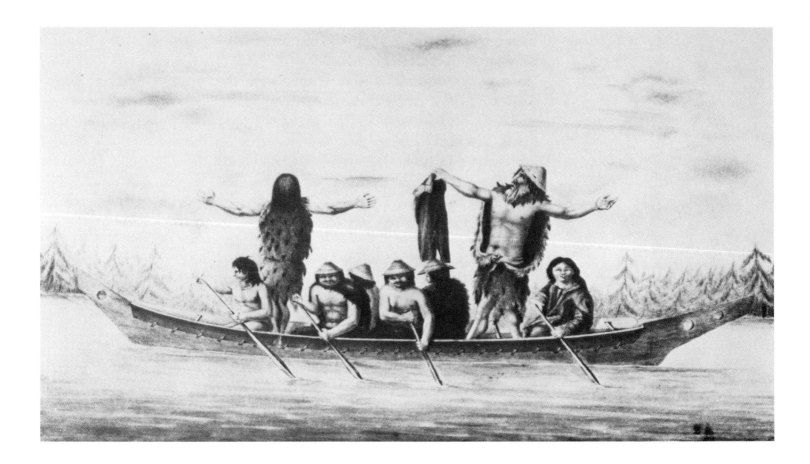

Return of the stolen trousers, 1791

Drawing by José Cardero; courtesy Museum of New Mexico, and Museo de America, Madrid.

After peaceably resolving the threat of armed conflict with the natives at Port Mulgrave, the Spaniards released the chief, who had offered "to return a pair of trousers, dexterously stolen from a sailor on the first day of the wood-cutting . . . he shortly returned, intoning the hymn of peace and solemnly carrying the stolen trousers aloft, ratified the peace, soliciting on our part the usual signs and singing at the rail while his people repeated them from the beach" (Colson, Malaspina Voyage, *1:244).*

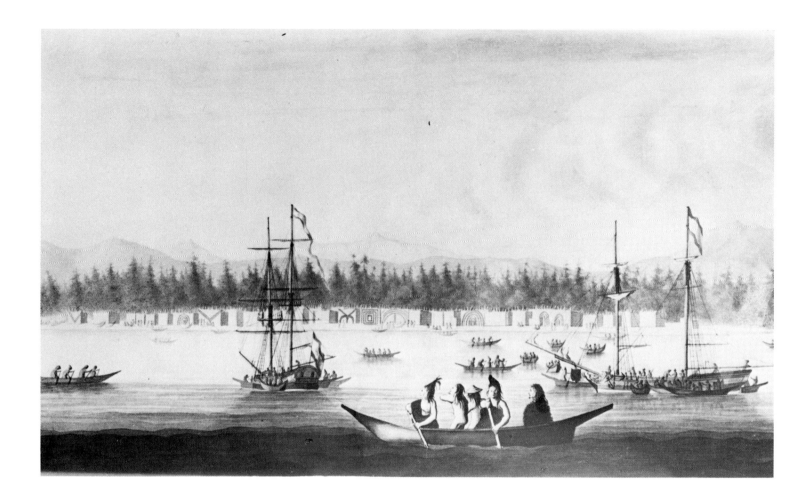

Native Village of Maguaa, c. 1792

Drawing by José Cardero; courtesy Oregon Historical Society, and Museo de America, Madrid.

One can only speculate as to the exact location of this extensive village. It would have been located at the north end of Vancouver Island, somewhere between the mouth of the Nimpkish River and Port Hardy, and on the south side of Queen Charlotte Strait (Bill Holm, personal communication). The vessels appear to be the schooners Sutil *and* Mexicana, *and the expedition was recorded as anchoring "near the famous settlements of Quacos and Majoa; many canoes came out . . . [one holding] the tais of Majoa, who proclaimed himself to be so, presenting a skin to the commander of each ship" ([Cardero],* A Spanish Voyage, *p. 83).*

The canoe in the foreground has a chief sitting in the stern, probably the "tais" in person. He may have been giving the explorers his own name, "Maguaa" or "Majoa," as recorded by the Spanish, which in the Kwakiutl language means "potlatch giver." It was Spanish practice to name Indian villages after the principal chief (Bill Holm, personal communication).

165 The *Sutil* and *Mexicana*

Bodega y Quadra and the Nootka Convention, 1792

Bodega y Quadra's expedition was not made primarily for exploration, but was a diplomatic mission to negotiate a settlement of differences with England over British "rights" at Nootka Sound, under the terms of the Nootka Convention. Bodega was considered uniquely qualified for the task, having a total of eighteen years' experience on the West Coast, and currently serving as commandant of the important naval base at San Blas.[1]

He sailed from San Blas on February 29 aboard the giant frigate *Santa Gertrudis*, commanded by Alonso de Torres. Also under Bodega's direction were six other vessels, although not sailing as a fleet. Some of these were assigned to exploration, others to carry supplies to Nootka from Monterey and San Blas. Also aboard was the naturalist José Moziño, with his artist assistant, Atanasio Echeverría. The *Santa Gertrudis* arrived at Nootka in late April.[2]

Revillagigedo had instructed Bodega to "relinquish and surrender to the English everything which they can prove in any way belongs to them . . . sanctioning that which is not injurious to our rights." He was to "seek complete harmony and the most cordial relationship with the Commander, the officers, and the crew of the ships of His Britannic Majesty."[3]

Vancouver arrived at Friendly Cove on August 28. After an exchange of formalities, negotiations began with dispatch. During the weeks following, it soon became evident that the directives by which each commander was bound were so far from being parallel as to preclude agreement. Both asked for instructions from their governments. Bodega returned to Mexico, and Vancouver to his survey of the coast. Neither was to participate in the final act of accord that was eventually reached and implemented in 1795.

Those who came in contact with Bodega remembered him with admiration, some even with affection. A typical example of such regard was recorded by John Hoskins of the *Columbia*: "this Governor is really a Gentleman, a friend to all the human race, a father to the natives, who all love him and a good friend to the Americans in general."[4]

Atanásio Echeverría y Godoy

When the Bodega y Quadra expedition was ordered by the viceroy of Mexico to proceed to Nootka Sound in 1792, José Moziño was appointed as naturalist and assigned two assistants. One of these was "Don Atanasio Echeverría, one of the best artists of our botanical expedition in New Spain," according to Moziño, who had grown to appreciate his talent during the Royal Scientific Expedition of New Spain's botanical campaign to the north of Mexico City.[1]

Echeverría was then in his mid-twenties and a member of the Academy of San Carlos. Like Moziño, he had been born in Mexico, which may have helped form a special bond between the two. During the more than four-month stay at Nootka, Echeverría made over twenty sketches, all presumably in the vicinity of Friendly Cove. In addition to botanical and zoological drawings, he produced sketches of general views, natives, and their customs. All of these seemed to be preliminary studies, which he intended to refine at a later date.[2]

The caliber of his work attracted the attention of two contemporary observers. One of these was Archibald Menzies, naturalist and surgeon with Vancouver, who met him at Friendly Cove: "an excellent draughtsman Sr Escheverea a Native of Mexico, who as a Natural History Painter had great merit." Moziño and Echeverría told Menzies that in Mexico they had been "collecting Materials for a Flora Mexicana," Menzies adding that "with the assistance of so good an Artist it must be a valuable acquisition."[3]

The brilliant naturalist Alexander von Humboldt gave particular praise: the "distinguished doctor, Jose Moziño," and "Senor Echeverria, painter of plants and animals and whose works can compete with the most perfect which Europe has produced of this class [of artist], were both born in New Spain and both occupy a very distinguished place among learned persons and artists without having left their native country."[4]

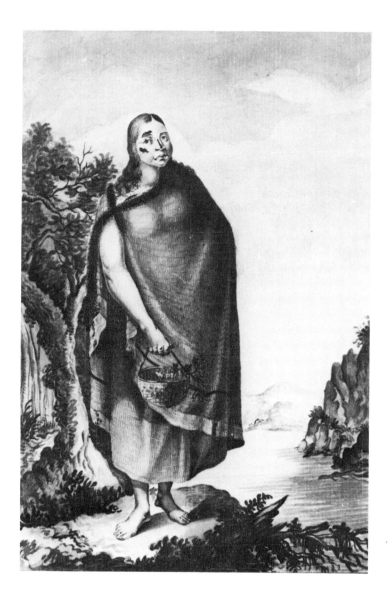

In September 1792, Echeverría accompanied Moziño and Bodega y Quadra to California. After a stay in Monterey, they returned to Mexico City to resume their association with the Royal Scientific Expedition. Echeverría was instructed to turn over his sketches to artists at the Academy of San Carlos for completion. The fourteen artists involved in the "refinishing" project included José Cardero and Tomás de Suría, both with experience on the Northwest Coast.

During the spring of 1793, Echeverría rejoined Moziño to explore the active volcano of San Andrés de Tuxtla. Little is known of his activities during the ensuing ten years. In 1802 he returned to Spain after service in Cuba. Two years later he was appointed as second director of painting at the Academy of San Carlos in Mexico City. Through influence at court, he was able to draw a salary immediately, even before returning to Mexico.[5]

It is not clear whether Echeverría ever journeyed to his homeland to take up his new assignment. He was said to have continued in Madrid until 1808, when the Napoleonic invasion of Spain impelled him to take his family to Seville. It is known that he was in southern Spain in 1811. Thereafter, as with his original field sketches, he seems to have faded from view. He would then have been in his mid-forties.

Wife of a Nootka chief, 1792

"Improved" version of a drawing by Atanásio Echeverría; courtesy of Iris H. W. Engstrand, and Ministerio de Asuntos Exteriores, Madrid.

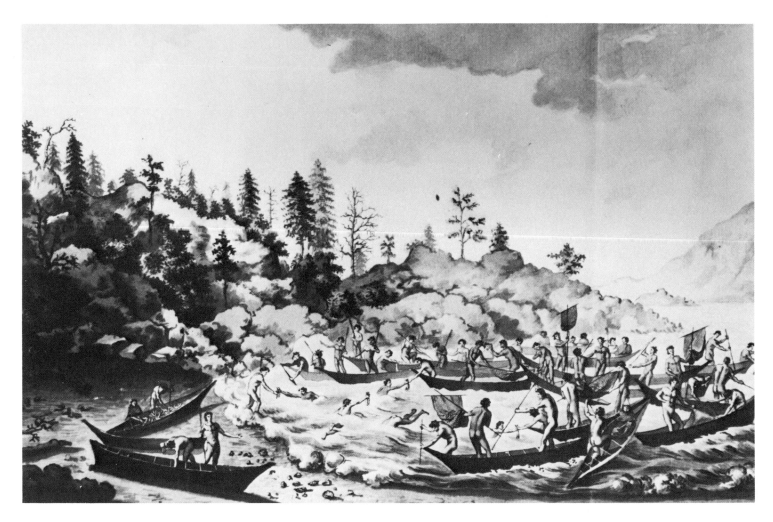

"Sardine" fishing at Nootka, 1792

"Improved" version of drawing by Atanásio Echeverría; courtesy Iris H. W. Engstrand, and Ministerio de
Asuntos Exteriores, Madrid.

*"Sardines are the fish found in greatest abundance, and their catch offers the most entertaining spectacle. A
great many canoes join together. . . . [The fishermen] vibrate long, thick poles underneath the water to
frighten the fish and, gradually drawing their canoes closer together, each time form a smaller circle until
they have corralled the fish in a very small cove, from which they pull them out quickly and in great numbers
with nets, little baskets, and rakes. They even gather them in their hands from the places where they are
most thickly collected. At the conclusion . . . the* tais *. . . distributes a considerable portion to each village
(Moziño,* Noticias de Nutka, *p. 47).*

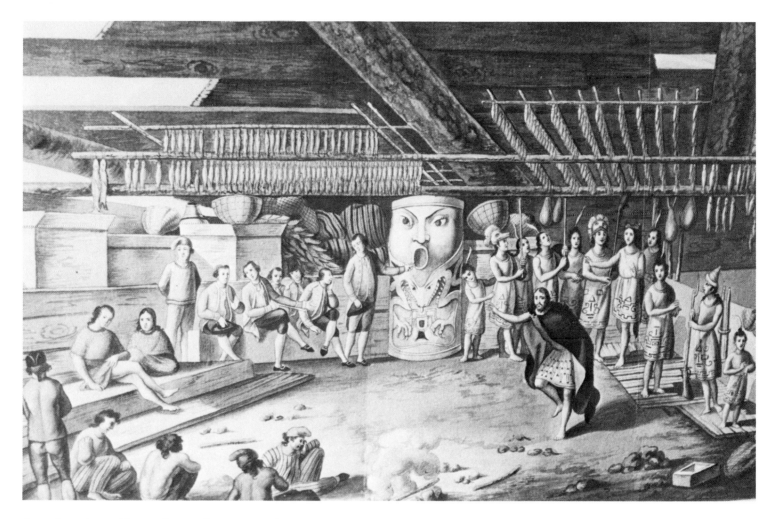

Interior view of Maquinna's house at Tahsis, 1792

"Improved" version of drawing by Atanásio Echeverría; courtesy Iris H. W. Engstrand, and Ministerio de Asuntos Exteriores, Madrid.

As described by Menzies in a detailed account, Bodega y Quadra proposed to Vancouver that they visit Maquinna at the head of Tahsis Inlet, some twenty miles distant, to assist in establishing a friendly relationship with the British. In a large party in four boats, "we therefore proceeded . . . with drums beating & Fifes playing to the no small entertainment of the Natives."

After a night's encampment, "Maquinna together with his Brother & Attendants received us on the Beach, & we were conducted to the Chief's House which was large & spacious." During the opening ceremonies and exchange of gifts, there "assembled at the Chiefs door . . . a group of the most grotesque figures that can possibly be imagined, dressed, armed, & masked in imitation of various characters of different Countries." During the dancing, Maquinna "stole away . . . masked himself behind the group & enterd the Area capering & dancing with great agility, which he performd much to the satisfaction of the whole group." Vancouver responded by getting "some of the Sailors to dance a Reel or two to the Fife."

Afterwards, the Europeans and Indian nobility feasted on food that "was profusely provided by S^r Quadra who had brought . . . not only his Steward Cooks & Culinary Utensils but even his Plate, *so that our dinner was served up in a manner that made us forget we were in such a remote corner, under the humble roof of a Nootka Chief" (Newcombe,* Menzies' *Journal, pp. 115–16, 118–20).*

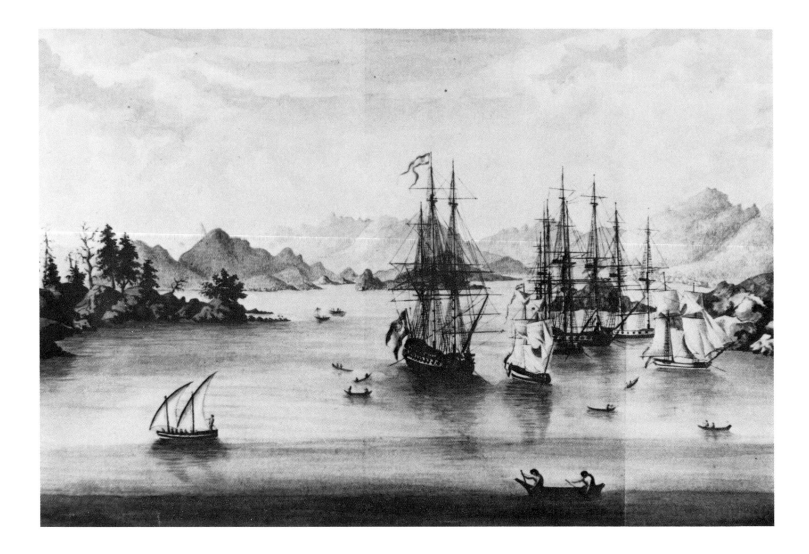

Ships in the harbor of Friendly Cove, 1792

"Improved" version of drawing by Atanásio Echeverría; courtesy Iris H. W. Engstrand, and Ministerio de Asuntos Exteriores, Madrid.

While there are only six sailing ships anchored in this scene, the harbor had room for more. On September 22 Menzies observed "ten Vessels riding at Anchor in this small Cove, besides two small ones building on shore . . . & this perhaps was the greatest number of Vessels hitherto collected together in this Sound at any one period, but the number which visited this Coast in the course of the Summer has been far greater" (Newcombe, Menzies' Journal, p. 124).

Such a number of ships could create a problem for the earlier arrivals: "we began to unmoor, but this was a business not easily effected, our Cables being so much overlaid by those of other Vessels who had come later into the Cove, & who had been carrying out Anchors in all directions to secure themselves in the late boisterous weather" (ibid., p. 130).

The American Voyages

"Shaste Peak," 1841

Engraving of a drawing by A. T. Agate, in Wilkes, *Narrative*, 5:facing page 240; courtesy Pacific Northwest Collection, University of Washington Libraries.

Wilkes' chart of the San Juan Islands, 1841. Courtesy National Oceanic and Atmospheric Administration

The *Columbia* and *Washington* under Gray and Kendrick, 1787–93

We purchased while here about 1500 beaver [sea otter] . . . to the purpose of cloathing, but it afterwards happened that skins which did not cost the purchaser sixpence sterling sold in China for 100 dollars. (From John Ledyard's Journal of Captain Cook's Last Voyage, *concerning Nootka Sound in 1778, p. 70)*

Following the return of the Cook expedition to England, the American-born John Ledyard, who had been a marine sergeant on the *Resolution*, returned to his birthplace shortly after the end of the American war of independence. He then engaged in idealistic but fruitless attempts to interest Boston merchants in financing a fur-trading expedition to the Northwest Coast and China.[1]

Several years later, when the British Admiralty in 1784 permitted publication of the Cook journal, which corroborated Ledyard's enthusiastic claims, a group of six Boston, Salem, and New York merchants met and subscribed the considerable sum of $50,000 to equip an expedition to tap the newly discovered riches of the Northwest Coast. Two vessels were soon outfitted under the general command of Captain John Kendrick on the 220-ton *Columbia*, with Robert Gray as captain of the smaller *Washington*, a sloop of 90 tons.[2]

In September 1788, the ships arrived in Nootka Sound, where they wintered. Inexplicably, Kendrick kept the *Columbia* inactive at Nootka Sound for the next ten months, moving only at the end to Clayoquot Sound. The *Washington* however, traded extensively along the coast with considerable success.

Prior to leaving for China on July 30, Gray and Kendrick, for reasons not yet revealed by history, agreed to exchange vessels. Gray departed for China to dispose of the furs, as did later the *Washington*. After the China transactions, Kendrick returned with the *Washington* to the Northwest Coast.

The *Columbia* made a triumphant return to Boston on August 10, 1790, completing the first American circumnavigation of the world. Her arrival was celebrated with "salvos of artillery . . . and repeated cheers from a great concourse of citizens."[3] That evening Gray was honored by Governor Hancock at a dinner.

From a purely financial standpoint, the voyage was disappointing, perhaps in considerable part due to the prolonged inactivity of the *Columbia*. Two of the original partners dropped out, selling their interests to those remaining, who promptly financed a second expedition. Seven weeks later, on September 28, 1790, the *Columbia* was again on her way under Gray, arriving at Clayoquot Sound on June 4, 1791. Trading was soon actively resumed as she sailed up and down the coast.[4] On August 12, tragically, Caswell, the second mate, and two others were killed by the Indians. Young John Boit, fifth mate, who was only sixteen at the beginning of the first voyage, wrote movingly of the funeral:

At 10 Left the Ship with three boats . . . the Ship firing minute guns . . . at 11 Capt. Gray landed in a small boat, and after performing divine service, we inter'd the remains of our departed, and much beloved, freind, with all the solemnity we was capable off The place was gloomy, and nothing was to be heard but the bustling of an aged oak whose lofty branches hung wavering o'er the grave, together with the meandering brook, the Cries of the Eagle, and the weeping of his freinds added solemnity to the scene. So ends.

At Clayoquot, Gray found Kendrick and the *Washington*, back from China. The two then established a lightly fortified base for the winter. For easier handling in trading, the forty-five ton *Adventure* was built, using stem and stern posts brought from Boston, and planks sawn from local trees. Boit admired the launching: "One of the prettiest vessels I ever saw . . . with a handsome figure head . . . and other ways touch'd off in high stile."

While Gray was not noted for his cruelty, on one occasion he displayed great antagonism in a retaliatory action against one band of Indians, whose village was temporarily deserted. Wrote Boit:

I am sorry to be under the nessescity of remarking that this day I was *sent*, with three boats all well man'd and arm'd, to destroy the Village of Opitsatah it was a Command I was no ways tenacious off, and am greived to think Capt. Gray shou'd let his passions go so far. *This* village was about a half a mile in Diameter, and Contained upwards off 200 Houses, generally well built for Indians ev'ry door that you enter'd was in resemblance to an human and Beasts head, the passage being through the mouth, besides which there was much more rude carved work about the dwellings some of which was by no means *innelegant*. This fine Village, the Work of Ages, was in a short time totally destroy'd [5]

The voyage resulted in two important discoveries. The first was the large bay of Gray's Harbor, the second, the Columbia River, documentary evidence of which was later to play a significant part in the reluctant decision of the British not to further dispute the claim of the United States to Oregon.[6]

After selling the *Adventure* sloop to Spanish ownership at Nootka Sound, Gray sailed to China, thence to Boston, arriving on July 25, 1793, to a rousing welcome by his jubilant countrymen. The return was duly noted in the shipping news of a Boston newspaper, the *Columbian Centinel* of July 27: "Last evening arrived in this port, the Ship Columbia, Captain Gray, from China, which she left the 9th February . . . the Columbia, when passing the Castle, saluted the flag of the United States; which salute was immediately returned; and on coming to anchor, she gave the tower's salute of thirteen guns, which was returned by a welcome huzza."

George Davidson

A young housepainter and occasional artist named George Davidson may have been among the townspeople of Boston on a hot August afternoon in 1790, gathered to see Captain Robert Gray disembark from the *Columbia*. The ship had just returned from a three-year voyage to examine the feasibility of fur trade on the Northwest Coast. As Gray marched with his men up State Street from Long Wharf, most eyes were focused on his companion, a native of Hawaii named Attoi, wearing "a helmet of feathers, which glittered in the sunlight, and an exquisite cloak of the same yellow and scarlet plumage."[1]

Davidson must have been profoundly affected by local discussion of the romance and dangers of the trip, for he applied for enrollment on the next voyage. Gray, at the same time, may have been looking for a robust young man with drawing ability, in addition to such primary skills as tending to the ship's need for paint.

In any event, when the *Columbia* left Boston harbor on the twenty-eighth of the following month, her muster list, under the heading "Ship Collumbia ofisers and Crew," included "gorg Daiveson painter." After a voyage of about eight months, the *Columbia* made a landfall at Clayoquot Sound, on the rugged west coast of Vancouver Island. After trading along the coast northward, she was overtaken by a severe storm in Clarence Strait, in what is now southeastern Alaska.

Gray seems to have had more than the usual share of violent encounters with the Indians. Two of these became the subject of paintings by Davidson, including an exciting night skirmish. How many more incidents he recorded in drawings may never be known. I am almost certain that unknown drawings do exist, given such graphic material as the complete destruction, at Gray's orders, of the large Indian village of Opitsatah, and the ship's striking a rock in Milbanke Sound.[2]

Departing the coast in early October 1792, Gray proceeded to Whampoa, China, to sell furs, and thence to Boston, arriving in late July of 1793.[3] It is not known whether Davidson returned to his former prosaic occupation after the voyage. It is apparent that he made many copies of his drawings of the trip—watercolors, drawings, crayon renditions, some even on glass—for friends. It is likely that some were also made to sell.

One set of drawings was acquired, presumably as a gift, by a shipmate, Benjamin Popkins, the ship's armorer. Another set was given to Samuel Yendell, the ship's carpenter. According to remarks at a meeting of the Massachusetts Historical Society in 1892, "These Chinese marks upon some of the old frames would indicate that they were made perhaps while the ship was in port near Canton." Captain Gray also obtained a set, part of which was exhibited at a meeting of the Society in January 1871.[4]

George Davidson, c. 1798

Portrait by an unknown artist, undated; courtesy Concord Antiquarian Museum, Massachusetts.

Factual material about Davidson's life is meager and difficult to locate. Genealogical records published in 1879 indicate that he was the son of Alexander Davidson and was born in Boston on July 25, 1768. He married Mary Clark, of Boston, seven years his junior, on April 27, 1794.[5] Their daughter, Mary-Ann G., was born about eleven months later and a son, George, was born in 1798. George, Jr., eventually became a printer and publisher, but died at the age of thirty-nine. He may have written about his father's adventures, but my search has located no record that he did so, or even the name of his printing establishment.

Other recorded facts of Davidson's life, few though they are, lead one to the conclusion that he turned to seafaring for a livelihood, having acquired a liking for it as a result of his experiences on the *Columbia*. His next stint at sea did not begin until a year or so after the return of the *Columbia*, and after the birth of his first child. Shore life must soon have begun to pall, after the danger and excitement of the wild Northwest Coast.

He eventually rose to become captain of the *Rover*. An undated portrait of him by an unknown artist may have been executed shortly before he left on his final voyage. It shows a prosperous, well-dressed individual, with a sailing ship (perhaps the *Rover*) in the background. Historian F. W. Howay notes that the *Rover* was owned by Dorr and Sons of Boston, was commanded by a Captain Davidson, clearing for the Northwest Coast in 1799, "but is said to have been lost at sea. No further details have been found, unless she is the 'American ship [which] was lost in June, 1801, on the N. W. Coast, and it is feared the crew were cut off by the natives.'" (Howay's quote is from the files of the *Columbian Centinel* (Boston), which had a regrettable practice of omitting the first names of all ship's captains in its shipping news.)

A sequel to Howay's *List of Trading Vessels* contains a further note about the *Rover*, from the files of the *New England Palladium* of October 9, 1801: "We understand that there is no doubt that the schooner *Rover*, Davidson, of this port, foundered on her passage from the Sandwich Islands to Canton."[6]

William Sturgis corroborates this in the appendix to his journal of 1798–1800: "The schooner *Rover*–Captain Davidson, belonging to Miss Dorry of Boston, left the Sandwich Islands with 2,000 skins on board and was never heard of afterward, it was conjectured she foundered in a Typhoon in which the *Jenny* lost her mizen mast."[7]

Davidson's will gave his wife "the use and improvement of all my real estate so long as she remains my widow." If she were to remarry (and she did), two thirds of the real estate was to go to his two children. Daniel Ballard, a ship's carpenter, and William Rogers, a mariner, acted as trustees until the beneficiaries came of age.[8]

George Davidson Del. Pinx.

Building of the sloop Adventure, 1792

Drawing by George Davidson; courtesy Frick Art Reference Library, reproduced by permission of the owner, Dr. Gray H. Twombly

In September 1791, Captain Gray established winter quarters in Clayquot Sound. As first officer, Robert Haswell was directly in charge of activities: "I landed with a party and struck the first blow towards building a log house and clearing a place for the vessel . . . few of the trees were less than two fathoms round and many of them four." Construction began on the Adventure: *"the two whipsaws kept constantly at work sawing plank, for it was our misfortune to find those of oak we had brought from Boston . . . so rotten as to render them quite unserviceable" (Howay,* Columbia Voyages, *pp. 303–5).*

In this scene, the Columbia, *with topmasts removed, is at anchor. A boat is pulling out to her, laden with watercasks or perhaps firewood. The log house is "well armed, two cannon mounted outside and one inside of the house through a port, and in every direction loopholes for our small arms and pistols" (Ibid., p. 305).*

The foreground shows what is probably a self-portrait of Davidson, exhibiting to Captain Gray, with some pride, his drawing of the scene.

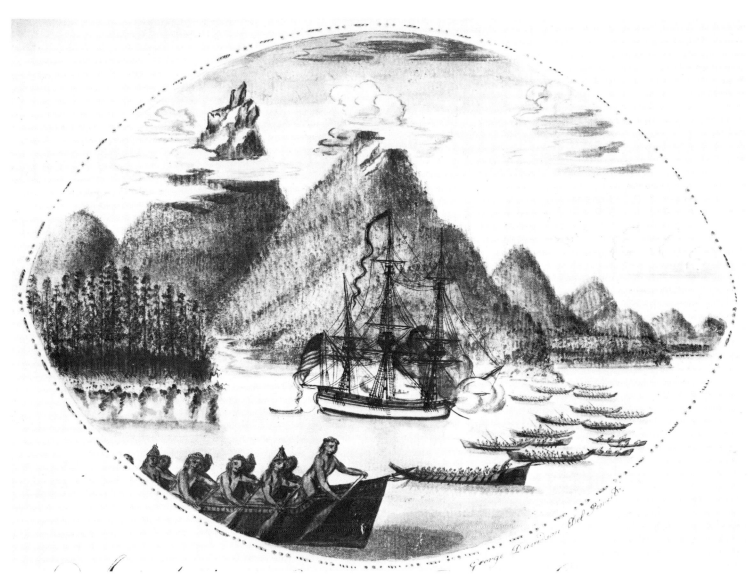

"Attackted at Juan De Fuca Straits," 1792

Drawing by George Davidson; courtesy Oregon Historical Society.

"About Noon, 20 large War Canoes hove in sight, with above 30 Men in each, and we soon discern'd with our Glasses that they was all arm'd, with Spears and Arrows. The friendly Indians that was trading along side, told us these people had come to fight, and belong'd to the tribe we had fir'd at two days before, when attack'd upon the beach. Capt. Gray . . . order'd them . . . to keep off, and not but one canoe come along side at a time. . . . We soon discover'd that the main body of canoes was paddling towards us, singing a War Song. We fir'd a cannon and some Muskets over their heads. At this they mov'd off about 100 yds."

 One small canoe, carrying a Chief *"kept constantly plying between the Ship and the main body of the Canoes, counting our men, and talking earnestly to the* Natives *along side, encouraging them to begin the attack. . . . Capt. Gray told him to come near the Ship no more, but he still persisted, and was shot dead for his temerity. Also the chief Warrior, of the Canoe along side, was shot, for throwing his Spear into the Ship. They then made a precipitate retreat"* (from Boit's journal, in Howay, Columbia Voyages, p. 404).

 The attack actually took place in Queen Charlotte Sound.

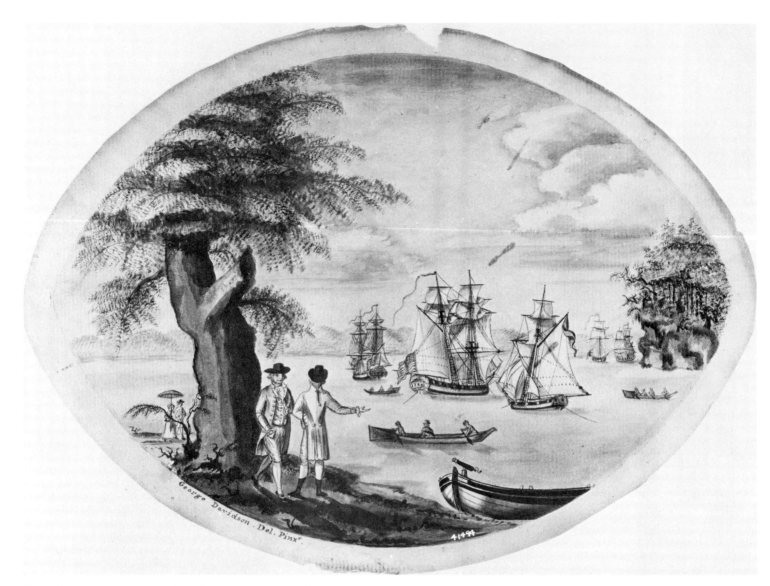

Imaginary scene, sometime between 1792 and 1800

Drawing by George Davidson; courtesy Frick Art Reference Library; reproduced by permission of the owner, Dr. Gray H. Twombly.

The locale of this finely executed drawing is surely on the Northwest Coast, since it displays three Indian canoes with native paddlers. It has been variously interpreted, but I believe it to be an imaginary scene, drawn partly from memory and partly from fantasy.

It could be based on a relaxed encounter between Gray (in foreground) and officers of several ships at Friendly Cove, one of whose captains was accompanied by his wife. Women seldom sailed on voyages to the Northwest Coast, but the voyage of Charles Barkley in the Imperial Eagle *is one known exception. The sloop in the right foreground could be the* Washington *or the* Adventure, *the ship at the far left, the* Columbia, *with her mizzenmast hidden by the flag.*

All the ships are improbably under sail, even the two in the foreground which are securely moored fore and aft. The second ship from the far right seems to display a British flag. The headland at the right may represent the rocky island at the entrance of Friendly Cove, fortified by the Spanish in 1789.

Robert Haswell

To Robert Haswell, only a few days short of his nineteenth birthday at the beginning of Gray's first voyage, we owe the only available written account of the earliest Boston venture in the maritime fur trade on the Northwest Coast.[1]

He was born November 24, 1768, probably in Nantasket, Massachusetts. His father was a lieutenant in the British Navy. When the American rebellion burst into flame, Haswell was only six years old. The family was interned, and eventually sent to Halifax, Nova Scotia. Later they returned to England, settling in Yorkshire.

While little is known of his life in the intervening years, it may be assumed that he followed the sea, for when the *Columbia* and the *Washington* left Boston on September 30, 1787, Haswell was third mate on the *Columbia* under Captain John Kendrick. Before clearing the coast, the wind dropped, and the two ships anchored in "Nantaskit roads," where "the evening was spent in murth and glee the highest flow of spirits animating the whole Company . . . our Friends parted not with us untill late in the evening."

The spirit of amity had faded away by the time the vessels reached the Cape Verde Islands, less than two months after leaving Boston. A mutual dislike had quickly developed between Kendrick and Haswell, reaching a bitter fruition near the Falkland Islands. Haswell had been critical of the lack of discipline; "little work was done the people encouraged to dissobey the Command of there Offisers and [were] continualy intoxicated with Licure delivered them by Capt. K. orders."

When Haswell used force against a seaman who refused to obey an order passed down by Kendrick, the man "used such scurilous language that at length I was provoaked to strike him a blow with my fist that instantly covoured him with bludd." Attracted by the commotion, Kendrick "no sooner saw me than with Language too horrid to be repeeted he ordered me off the Quarter deack and had the amazing assurance even to strick me several times untill prevented by my holding him."

A few days later, Captain Kendrick apologized; Haswell accepted, but "requested that I might not be continued any longer onboard the Ship but go onboard the Sloop." Within a few days he was made the second officer of the sloop *Washington*. Haswell was elated at the change:

I was fully convinced that I should enjoy myself much better and Live far happier have a greater oppertunity of seeing the Coast on which we were to persue discoveries and Commerse with the Natives and by those meens impruve myself in Knoledge which it would be imposable to attain with such a man as Cap. K. whose naturel timidity of runing in with the land would fully prevent the gaining Knoledge which can be attained by no other meens than pursevearing in with the Land.

Robert Haswell, c. 1800

Pastel portrait attributed to James Sharples, date unknown; courtesy Massachusetts Historical Society.

It was fortunate for Haswell that his disagreement with Kendrick occurred, since, once at Nootka Sound, only the *Washington* moved up and down the coast, trading with the Indians for furs. For reasons unknown, the *Columbia* under Kendrick swung idly at anchor in Friendly Cove during the next ten months.

When the *Columbia* left Boston on September 28, 1790, on her second voyage, Haswell was aboard as first officer under Gray. At winter quarters in Clayoquot Sound, the sloop *Adventure* was built, and Haswell placed in command. After a successful trading season, she was sold to the Spanish commander Bodega y Quadra, for "seventy five sea-otter skins of a superior quality." The *Columbia* then sailed to China to dispose of her cargo, returning to Boston on July 25, 1793.[2]

After this adventurous period of nearly six years, Haswell continued to follow the sea. Only three months after his return, he left for a voyage of twenty-seven months to the East Indies, as captain of the new ship *Hannah*, then to England where he visited his parents, thence to Boston.

Shortly thereafter in a revealing letter to his half sister, he displayed a weariness of the sea:

I think I shall tarry ashore this winter, and in the spring seek my fortune again. I hope in a few years . . . to purchase a small farm, and then sit down in homely ease and enjoy the few years that may be left. For the sea, my love, has almost worn me out, but I have rashly taken steps of adventure . . . which sets me in the first rank of my profession yet it has impaired my constitution beyond measure and has not been productive of the gain that should be expected from such hazardous enterprises."[3]

After a voyage to Batavia as master of the ship *John Jay* of Boston, Haswell married Mary Cordis on October 10, 1798; the union produced two daughters. On March 4, 1799, he entered the United States Navy as a lieutenant, serving for more than two years.[4]

Haswell saw active service as first lieutenant of the *Boston*, a twenty-eight-gun frigate built by public subscription, and launched in May 1799 for duty in the West Indies, guarding American shipping against French privateers. While far out in the Atlantic on October 12, 1800, nearly a thousand miles east of the Virgin Islands, the *Boston* intercepted and captured the small French frigate *Le Berceau*, losing seven men killed and eight wounded, after an action of an hour and forty minutes.[5] One of the wounded was Haswell's younger brother, a midshipman. Haswell was given command of the prize, and after both vessels reached Boston, received $286.13 as his share of the prize money.

Leaving the navy at age thirty-two, he became master of the ship *Louisa* of Boston, leaving August 5, 1801, for the Northwest Coast. She and all her crew disappeared at sea without trace.

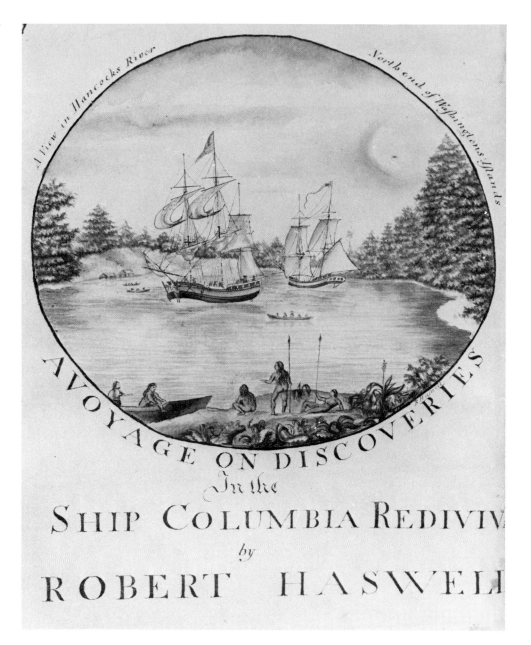

"A View in Hancocks River," 1791

Drawing by Robert Haswell in his journal of the second voyage of the *Columbia*; courtesy Massachusetts Historical Society.

The "river" is actually Masset Sound on Graham Island, in the northern part of the Queen Charlotte Islands, which were originally named "Washington's Islands" by Gray.

"The banks of the river present the most delightful green fields behind which are finely placed most stately trees which appeared to be free from underwood. The huts of the natives, the framings of the deserted ones etca. scattered about the banks all serve to heighten the scene and render it one of the most pleasing romantic places I have yet seen" (Hoskins's narrative in Howay, Columbia Voyages, *p. 229).*

The Columbia *is at left; at right is the* Hancock, *commanded by Samuel Crowell.*

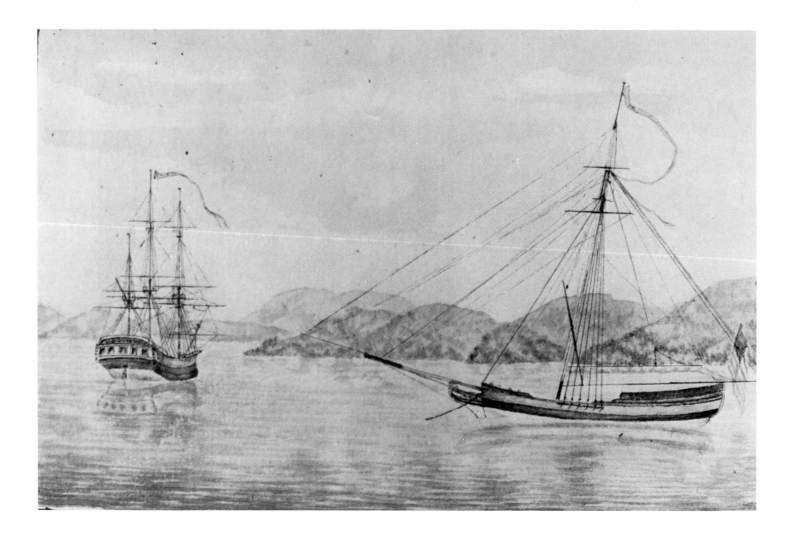

The Columbia *and the* Washington *at anchor, c. 1788*

Drawing by Robert Haswell; courtesy Massachusetts Historical Society.

The locale of this view is unknown, but could be somewhere on the Northwest Coast, or in the Cape Verde Islands where the ships spent about a month. They were separated on April 1, 1788, during a gale off Cape Horn, and did not meet again until Nootka Sound was reached.

The drawing shows the Washington *still rigged as a sloop. At Canton in 1790, Kendrick had her re-rigged as a brig (Howay,* Columbia Voyages, *p. 379).*

Joseph Ingraham and the Brigantine *Hope*, 1790–93

While the trading vessel *Astrea* from Boston was anchored near Canton at Whampoa Bay, her supercargo, young Thomas Handasyd Perkins, struck up an acquaintance with Joseph Ingraham, the twenty-seven-year-old first mate of the *Columbia*, which had recently arrived from the Northwest Coast with a cargo of furs. Impressed by the possibilities for profit in the fur trade, Perkins on his return to Boston equipped his brigantine *Hope* for the Northwest Coast, signing on Ingraham as its master.[1]

The seventy-two-ton *Hope*, with "a healthy crew consisting of sixteen young men all in spirits," left Boston on September 16, 1790. Doubling Cape Horn without difficulty, she arrived at the Marquesas Islands on April 15, 1791. Supplies and water were replenished, although with considerable difficulty because of the "troublesome and mischievous" natives.[2]

On May 29 Ingraham left the Hawaiian Islands after a stay of a few days, during which an attack by the natives was repulsed. On June 29 he entered a protected cove in the Queen Charlotte Islands for repairs, brought about, as he admitted in his journal, because the *Hope* had "leak'd considerably for some time past and very fowl which retarded her sailing much" (p. 80).

On July 10 trading commenced at Cloak Bay with disappointing results. The Haida chief, Cow, showed indifference to Ingraham's trade articles, indicating that his people already had plenty from earlier traders. To revive their interest, Ingraham had his blacksmith make "iron collars of 3 Iron rods about the size of a mans finger," which he found "would purchase 3 of their best skins" (pp. 87–88, 90).

From the deck of the *Hope* Ingraham saw something which aroused his curiosity: "I went in the boat accompanied by Cow to view 2 pillars which were situated in the front of a village . . . they were about 40 feet in height carved in a very curious manner indeed—representing men, Toads, & the whole of which I thot did great credit to the naturale genius of these people" (p. 88).

After the night of August 4, "when it blew a perfect Hurricane so that we could scarce bear our double reef'd mainsail," the *Hope* stood in for a harbor, where she was boarded by Chief "Cummashawa" (at the village of Skedans on Cumshewa Inlet in the northern Queen Charlotte Islands). Active trading con-

tinued all day Sunday, to Ingraham's regret, as "it was ever my practice to refrain from all work whatever on Sunday."[8]

By September 2, Ingraham had acquired a cargo, and cleared for Hawaii and China. In spite of the port of Canton being closed because China was at war with Russia, he managed to dispose of the skins.

Again at Hope Bay in 1792, the following year, Ingraham found that values had changed: "the things which they esteem'd highly when I was here before was now of little value." Leather for war armor and abalone shell were in demand. Trading southward, the *Hope* entered Friendly Cove, where Ingraham was taken on a tour of the Spanish settlement, and was favorably impressed.

Ingraham departed for the Hawaiian Islands on October 12, arriving on November 6. At this point his journal abruptly ends. It is believed that the *Hope* probably arrived at China in January 1793, disposed of her furs, and returned to Boston during the summer.

Joseph Ingraham

One of the most literate journals of any American fur trader on the Northwest Coast was that kept by Joseph Ingraham, who embellished it with charming drawings of native people, birds, and fishes, in addition to interesting charts adorned with the pleasing details of ships, towns, and native dwellings.

Ingraham was born in Boston in 1762, and was baptized on April 4 in New Brick Church. Little information exists as to his schooling, but the contents of his journal gives the impression that he was reared in an enlightened environment. It may be that he was in naval service during the Revolutionary War. According to historian F. W. Howay, after the war "it appears from his manuscript journal that he voyaged to Asiatic waters." At the age of twenty-three, he married Jane Salter of Boston, the union producing three sons.

When a group of Boston merchants sent the ship *Columbia* on her first voyage to the Northwest Coast on September 30, 1787, Ingraham was aboard as second mate, a rank which he held only briefly. At the Cape Verde Islands, the younger third mate, Robert Haswell, relates "much discord . . . has subsisted in our Ship . . . and they now prevailed to a more violent degree . . . Captain Kendrick ordered Mr. Woodruff to consider himself no longer as Chief Officer and confured the Situation on Mr. Jo[sep]h Ingraham."[1] Ingraham was known to have kept a journal (presumably illustrated) of this voyage, but its whereabouts are unknown.

After the *Columbia* returned to Boston in August 1790, Ingraham was offered the command of the brigantine *Hope* for a trading voyage to the Northwest Coast. His journal reveals his motive in accepting:

I was under some apprehensions as to the safety of the *Hope* being only 70 Tons burthen & slightly built. However I conceived it the only time to make Hay while the sun shone. The trade to China from the NW being lucrative and in its Infancy it was not to be long neglected . . . Notwithstanding the Ill success of the first Attempt [of the *Columbia*] . . . I was determined to be among the first that Embark'd . . . altho I had been on shore but 5 weeks.[2]

When the *Hope* was outward bound, at the Cape Verde Islands, an incident revealed Ingraham's humanitarian instinct. Boarding a large vessel from Liverpool "bound to the continent of Africa for slaves," he asked the captain to accept some mail for America. Ingraham recorded in his journal:

He was an old Gent[n] very polite and Hospitable, he insisted on my remaining to sup with him . . . their business to the continent was to procure 500 slaves for the West India market Supper being over the first toast was "The Land of Liberty" I could scarce conceal my feelings at hearing such a toast given on board a Ship bound to enslave 500 poor wretches. However perhaps they posses'd Ideas convenient to their business which I have often witness'd in the West Indies Namely that Negroes were a lower order of Human beings born to be slaves how far this may be true I cannot take upon me to say but leave it as a matter of Speculation to be solv'd by men of more extensive knoledge that I can pretend to and who have had more leisure to study and consider why the Almighty created men black or white [pp. 5–6].

Continuing to the Marquesas, Ingraham discovered a chain of six islands to the north, which had been overlooked by previous voyagers. Taking possession of them for the United States, he named the group the Washington Islands. According to Robert Greenhow in 1840, the name was retained "by all geographers except the British." The name has since disappeared, and the group is now considered part of the Marquesas, a French possession.[3]

In the Hawaiian Islands, Ingraham's concern for human life was again revealed, during a complicated incident arising from a stolen musket. About thirty canoes with nearly three hundred men appeared to be attacking the *Hope*, and were repelled with musket and swivel fire. Later, in sad introspection, Ingraham wrote: "I hope I think as much of the life of a savage as any man existing and God forbid my conscience should ever be charged with taking the life of anyone wantonly however uncivilzed what I have done in this case my reason dictated at the moment having no time for reflection" (pp. 75–76).

After two disastrous seasons on the Northwest Coast, Ingraham returned to Boston in 1793, the voyage having lost more than $40,000.

Nothing is known of his life in the ensuing five years. Presumably it would have been difficult to obtain command of another fur-trading voyage, due to the failure of the *Hope*'s venture. He is known to have written the Secretary of the Navy in December 1797, soliciting an appointment as first lieutenant of the *Constitution* "to enable me to maintain an amiable wife and family which a series of misfortunes has prevented me from doing as I would wish."[4]

A year and a half later, on June 14, 1799, he was commissioned a lieutenant, and later assigned to the ill-fated brig *Pickering*. Cruising in the West Indies, at the period of the United States' "quasi war" with France, the *Pickering* captured four French privateers, which should have gained rewards in prize money for the impecunious Ingraham. Returning to Boston, she departed for Newcastle, Delaware, leaving there on August 20, 1800 to join the West Indies squadron of Commodore Thomas Truxton. Neither the *Pickering* nor any of her company was ever seen again, apparently victims of a savage gale that September. Ingraham was then thirty-eight.

Ingraham is to be admired for his record of fair dealing with the Indians, in sharp contrast to the grasping and frequently vicious practices reported of some. Although he was severely criticized by the owner of the *Hope* and its supercargo, the great Spanish captain Bodega y Quadra, who came to know him at Nootka, called him "a vigorous young man, a great coast pilot, very talented."[5]

His name was given in 1879 to Ingraham Bay on Prince of Wales Island on the Alaska coast, in recognition of his "unpublished hydrographic notes of this region . . . used in compiling the Coast Pilot of 1883."

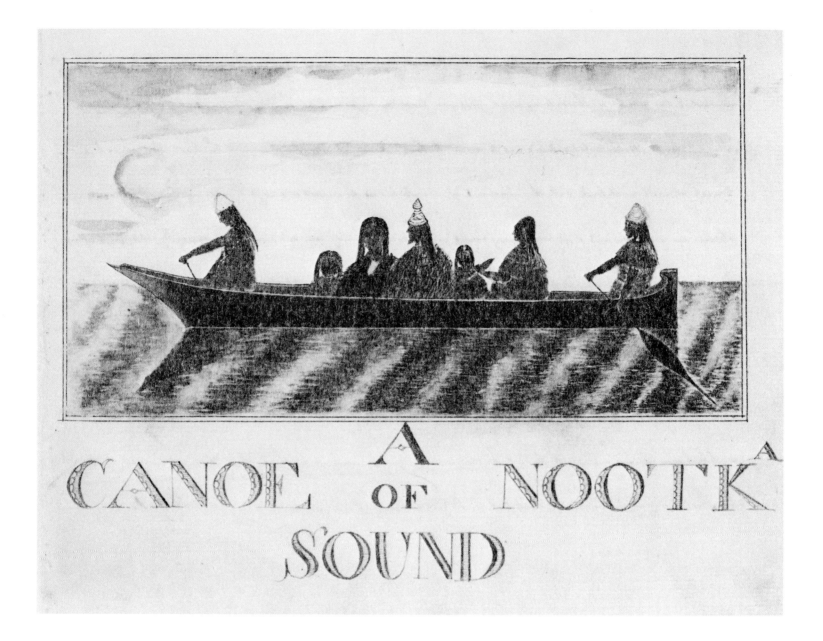

"A Canoe of Nootka Sound," 1792

Drawing by Joseph Ingraham, in his "Journal," p. 205; courtesy Library of Congress.

"On the following leaves I shall lay down a Chart of the NW coast in the most accurate manner I am able
. . . I shall likewise present a drawing of a Canoe of Nootka Sound" (Ingraham, "Journal," p. 205).
 The drawing of the canoe is faithfully rendered, as is that of the paddle. A chief is seated in the middle,
apparently with his two wives and two children. He seems to wear a small beard. The woman at the right
has the typical flattened head of the region.

The Hope *and* Princesa *off Nuñez Gaona (Neah Bay), 1792*

Drawing by Joseph Ingraham in his "Journal"; courtesy Pacific Northwest Collection, UW Libraries.

The nine crosses on the beach were erected at the Spanish fort at Nuñez Gaona by order of its commandant, Salvador Fidalgo. They were probably intended to serve as a constant reminder to the local Indians of the terrible vengeance taken by Fidalgo after the murder of his first officer, a personal friend.

Officer Antonio Serantes had gone ashore to hunt alone in the forest. His mutilated body was later found by a search party. In the course of inquiring about the missing man, Fidalgo was told by an Indian that Serantes had been slain by order of Chief Tatoosh. Reacting violently to the news, he ordered a cannon fired on two canoes then peacefully approaching the ship. According to Ingraham, eight Indian men were killed in the incident. (Native tradition tells that Serantes was killed by an enraged suitor, because of his advances to an Indian woman.)

Ingraham's view is taken from the southeast. The long, low island in the distance is present Waadah Island. The harbor proper is seen at left. The three small buildings on the shore are likely part of the fortified area. The vessels are Fidalgo's Princesa *(left) and Ingraham's* Hope. *The fort was abandoned after six months because of its unprotected anchorage.*

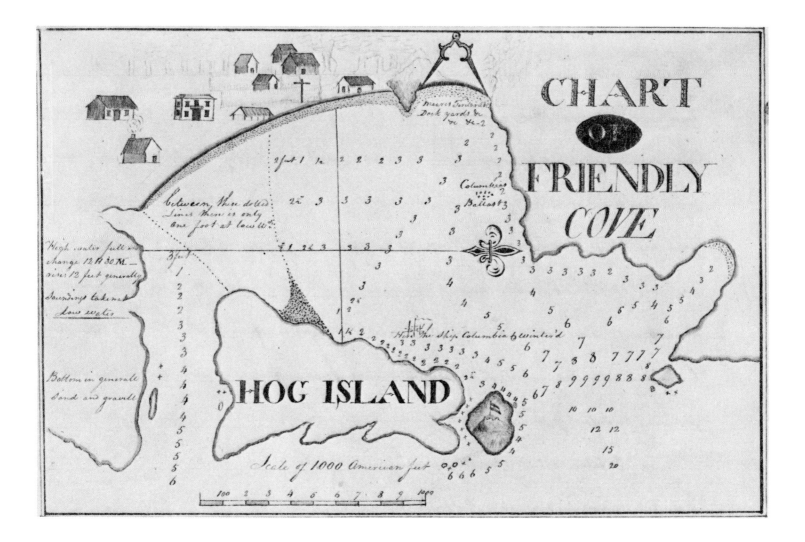

"Chart of Friendly Cove," 1792

Drawing by Joseph Ingraham; courtesy Library of Congress.

Ingraham shows only nine of the sixteen buildings and fort actually at the Spanish settlement. The commandant's two-story house is at the upper left. The area marked by the calipers is titled "Meares Teritorus Dock yards & & &." A flag marks the location of the Spanish fort.

Ingraham was impressed during a tour with "Capn. Arrow [Huro] to view the place which from being a wilderness was now become a garden producing every kind of vegetable. The village consists of 16 Houses the one the Commodore and his Officers occupied tho by no means handsome was convenient. They had severall Store Houses-Bake Houses a Hospital etc. Cattle Sheep and Hogs they had and poultry in abundance-in Short it seem'd a pity to disturb people in so fair a way to establish a good settlement and who to me seem'd above any best calculated for such purpose" (Ingraham, "Journal," p. 197).

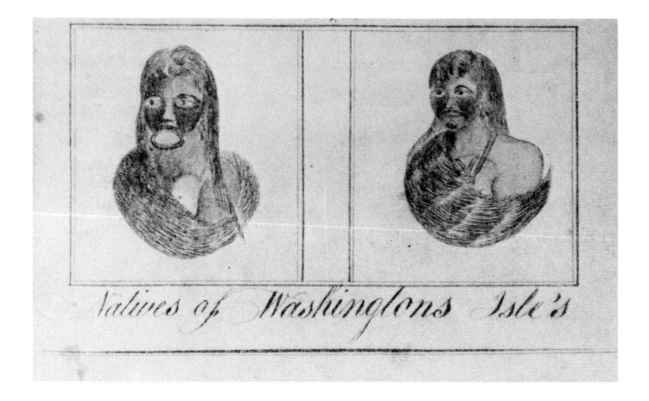

"Natives of Washingtons Isle's" (Queen Charlotte Islands), 1791

Drawing by Joseph Ingraham in his "Journal," p. 96; courtesy Pacific Northwest Collection, UW Libraries.

"Most of the women have a piece of wood in their under Lip which resembles a small shelf when the mouth is Shut or may be lap't up against the tip of the nose which may occasionally serve to keep the wind out of their mouths . . . upon the whole it seems as strange a fancy as was ever adapted by [the] human spicies" (Ingraham, "Journal," p. 87).

The Haida Indians inhabited the Queen Charlotte Islands.

Voyages of Seaman John Bartlett, 1790–93

John Bartlett's journal, kept for a period of three years and three months from 1790 to 1793, was written in a clear, firm hand, and illustrated with a number of rather crude drawings. His concept of spelling was fluid, requiring a reader with a creative imagination to aid in recognition. His journal was "translated" into intelligible language more than fifty years ago, but lost much of its flavor and accuracy in the process.[1]

Bartlett left Nantasket Roads, outside Boston, on March 29, 1790 "unbord the Ship Massachusetts . . . bound to Canton in Chinia," arriving at the Whampoa anchorage on October 12. After unloading the cargo, the ship was sold by the owners. Bartlett and eight others of the crew signed "unbord od the snow gustavous [*Gustavus III*] Thomas Barnet Comander bound to the North west Coast of America."[2]

On March 5 of the following year, the *Gustavus* "made the N-west Coust of America a Tedious passage of 70 days attended with gales of winds and Darty weather." Captain Barnett, who had been to the region previously, traded up and down the coast, accumulating a total of 1,869 "skins."

Some of the contacts with the Indians created uneasiness among the crew, while on other occasions violence was narrowly avoided. On April 26 at Cloak Bay in the Queen Charlotte Islands, Bartlett recorded in his journal:

This Day tradeing with the Natives on the qurter Deack a large Canoe came a long side haveing a great Number of Spears bow and Arrows the men begun to flock unbord in great Numbers and Send thar wemen unshore which Shoude a very bad Dissine [design] thay wos Seen to put In thear Shilds and hand up thear Turgets & Pass thear knives frome one to the other on the qurter Deack thare beeing About 150 of the Natives thare at a time Seaing of this we mand our tops with Blunderbusses and the Remainer of our men with Small Armes Chals Treadwell and my self wos unshore at the time of the fray with the Natives unbord the wemen Surrounded us unshore Singing thear war Song we bouth tuck up our Pistols & cockt them Resolved to Sell our lives as Dear Posable af thay Melisted us The Norse [noise] unbord begen to Abate the Natives would Not trade Any More Except we would Disarm our men we did so all was qurte [quiet] thar armed canoes whent away trade went Brisker then Ever [pp. 18–19].

Cover of John Bartlett's journal, 1790

Cover design of Bartlett's journal at Peabody Museum, Salem, Mass.; courtesy Special Collections Division, University of British Columbia Library.

Bartlett and his mates had a continuing complaint about the captain's parsimonious attitude toward their food rations, resulting in at least twelve journal entries during the nearly five months on the Northwest Coast. On July 3 the crew's dissatisfaction erupted:

All Hands went on the qurter Deack and tould the Capt^n that they Could Not live on thare alowance of Bread it Beeing out three Days Befeore Next Alowance is Served out . . . we tould the Capt^n it would Not Do for him and his Offersers which wos Eleven in Number with thear Servents to have as much Provisions as thay Could Eat and 15 Hands Before the mast upon a Very Short Allowance he had much to Doue too git the People to thear Dutey Again." [The following day being Independence Day, the captain made a peace offering], a Allowance of grog Extroy the Mates gave a half Gall^n of Rack [pp. 35–36].

On July 27 the *Gustavus* left for Hawaii, "we Leave With Pleashure the *North West Coust of America*." The crew was on short rations all the way, "the Boatswain Pipes to Dinner and turns the hands out Again as Usual weathear we have any thing or Not to Eate" (pp. 42, 43). The ship arrived at the island of Hawaii on August 22.

Barnett traded with the natives, "bought a great Numb^r of Hogs Potatoes & Bread Fruit & Grass Lines and Tapper [tapa] . . . upwards of one hundred Girls unbord at a Time But No Men Excepting one at a time . . . at Night Every man tuck his Girl the Remainer jumpt over Bord to Swim upwards of three mile for the shore" (pp. 45–46).

A few days after leaving the islands, a great storm arose, continuing for five days. Hatches were stove in by the seas, the ship became waterlogged, pumps failed, three men were lost overboard, and the mainmast had to be cut away after the *Gustavus* broached in a huge wave. When the storm died, a jury mast and sail were rigged, enabling the ship to reach Macao in late October.

Here the captain sent the men ashore, preventing them from removing the furs they personally owned, lest they smuggle them ashore for an illegal but highly profitable sale. Bartlett was "Resolved to Luse my Life Or to Gain what I So Dearly Earnt," and enlisted the aid of a friend who also owned furs, to board the ship at night. The plan was successful despite armed guards; "I got Clear off with My Skins which wos 17 in Numb^r Next Day I Sould them at *Macao* for 6 hundord Dollars So thare is an End to My N-West Voyage" (pp. 54–56).

Nothing is known of Bartlett's earlier life, other than his having been born in Boston. During his later career, he shipped on a number of vessels bound to various parts of the world, including a whaling voyage in Mozambique Channel. His journal abruptly ended in June 1793, but two letters, which appear at the end, indicate that he had been impressed into service on a British naval vessel under Captain Lord Charles Fitzgerald, and had been attempting to secure his release on the grounds of ill health. In one of the letters, obviously written for him, he was "fully determined never to take up arms for any but my own Country, let the consequences be what it will."[3]

Haida totem pole, 1791

Drawing by John Bartlett in his journal, "Remarks," at Peabody Museum, Salem, Mass. p. 34; courtesy Special Collections Division, University of British Columbia Library.

"The Dore of it is made like a man[s] head the Passage in to the House is in Betwen his teath and was Boult be fore thay nkowd the youse of Iron" (Bartlett, "Remarks," p. 34).

This is the earliest known drawing of a Haida pole. It was a frontal pole about forty feet high, located at the village of Dadens on Langara Island in the Queen Charlotte Islands (Duff, "Contributions," p. 88).

The Trading Sloop *Union*, 1794–96

The *Union* left Newport, Rhode Island, on August 28, 1794, bound for the "N.W. Coast of America, China, Isle of France [Mauritius] & back to Boston." According to the ship's log, she had "taken on board Stores & Provisions for Three Years, likewise a Cargo consisting of Sheet Copper, Bar Iron, Blue Cloth, Blankets, Trinkets of various kinds etc. etc. All which articles where suitable for traffick with the NW Indians, for firs propper for the Canton markett."[1]

The *Union* was almost new, sixty-five feet long, with nearly a twenty-foot beam, drawing only eight feet five inches. She carried a crew of twenty-two, and armament consisting of "ten Carriage Guns & Eight Swivells on the rails." Captain John Boit seems to have run a fairly taut ship: "the regulations of the sloop is strict as respects cleanliness & no hash is allowed to be eat by the people" (pp. 3, 5).

Nearly eight months after leaving Newport, the *Union* anchored in Nasparti Inlet on the west coast of Vancouver Island. The natives were peaceful, although three years previously the *Columbia* had repelled a night attack. After trading along the coast for a month, the *Union* anchored at Anthony Island in the Queen Charlotte Islands, where Boit "kept a strong watch with boarding net up as that is the identical spot where the indians try'd to cut off Capt. Kendrick" (p. 40–41). The following morning more than one thousand Indians in war canoes began an attack, supported by the eight chiefs who earlier had been permitted to board for trading. Boit killed the principal chief with a bayonet as he struggled with the second mate. Bloodily repulsing the assault, Boit held the remaining chiefs overnight as hostages, releasing them without penalty the following day. Trading was then cautiously resumed (pp. 49–50).

On July 11, the *Union* "set all sail & bore away for Columbia's river. All hands employ'd gett'g the Muskets in good order." Boit, recalling the excellent trading during the *Columbia*'s stay in the river in 1792, was severely disappointed at his inability to enter the river, due to unfavorable weather over a three-week period. "Had I been fortunate enough to have accomplished it many capitall sea otter skins would have been procured. Came very near losing the sloop several times on the bars" (p. 55).

Departing the west coast on September 12, the *Union* headed for Hawaii for provisions. Boit commented that "the females were quite amorous" (p. 70). After selling his cargo of furs at Canton, Boit invested the proceeds mainly in nankeen, a coarse cloth, and then began the homeward voyage on January 12, 1796, stopping at Mauritius for a cargo of coffee and pepper.

The Cape of Good Hope was rounded in a heavy gale, the *Union* suffering moderate damage from a large sea, which, among other injuries, "washed away the Boats Oars & masts & one hen Coop." When only two days away from Boston, the *Union* was fired upon by a British frigate and ordered to drop all sail. Boit was infuriated: "finding they could not make a prize of the sloop, suffer'd us to pass after treating me in a rough, ungentleman like manner. Bad luck to him!" (pp. 108, 117–18).

On July 8, "anchor'd abreast the town. Saluted the town was return'd with their welcome huzza." Boston's *Columbian Centinel* was unimpressed, only noting under Nautical Intelligence: "Arrived since our last . . . sloop Union, Boit, Canton."[2]

John Boit

John Boit was born in Boston October 15, 1774, during the growing ferment which shortly was to result in the outbreak of the Revolutionary War. The extent of his education is unknown, but judging from his writings, it was diverse. His logbooks and journals include literary quotations and even some of his own poetry. It is assumed that he attended the Boston Latin School.

Boit's father, an importer, was a father-in-law of Crowell Hatch, a sea captain and ship broker who was among the group financing the two voyages of the *Columbia* to the Northwest Coast. It was this connection which resulted in the sixteen-year-old Boit's appointment as fifth mate on the second voyage of the *Columbia*, under Captain Robert Gray.* (To his credit, it should be emphasized that he had pleaded for enrollment as a seaman.)

*As a result of my successful appeal to the British Columbia government to restore the name of Columbia's Cove, bestowed by Captain Robert Gray, the Hydrographic Service has named a dangerous reef off its entrance "Boit Rock."

Boit kept a journal on the voyage, fortunately for history since most of the official log was destroyed. After the *Columbia* returned to Boston in 1793, he was accepted as mate on the *Eliza*, voyaging to Dublin and returning in April 1794.[1]

The success of the *Columbia* in the fur trade probably led Hatch to agree to Boit's urging that a syndicate be formed to purchase the sloop *Union* for trading on the Northwest Coast, with Boit as its captain. He was then only nineteen years old.

Boit's achievement on the two-year voyage has been lauded by historian Frederic W. Howay in *Voyages of the* Columbia *to the Northwest Coast*: "The fact that he, a mere boy in his teens, was entrusted with the command of this vessel to sail to the Northwest Coast, engage in the maritime trade there, proceed thence to China to exchange the sea-otter skins for Oriental goods, and finally return to Boston speaks volumes for his complete mastery of his profession, his management of men, and his general ability" (p. xxiii).

John Boit, c. 1800

Courtesy of C. Jared Ingersoll, from original in his collection.

After a month ashore, Boit was commissioned to deliver the *George*, a captured English shore ship which he was to sell at Mauritius. The ship was unseaworthy, almost sinking in a gale. Boit recorded in the log, "God send that I may never sail in the like of her again."

Two years later, in 1799, he married Eleanor Jones, of whom he had written as a finale in his log of the sloop *Hiram*: "In pursuit of Miss E. J. In her smiles to be happy. Fortune de Ger [guerre]." (She may have been in mind when he inscribed on the first page of his *Union* log, "Adieu to the pretty girls of Newport.")

In 1801, he began the first of three voyages in command of a larger vessel, the 600-ton *Mount Hope*. Following the end of the third voyage in 1806, his activities are unknown until 1813, when he was engaged as a merchant in Boston. In 1816 he entered the import business with Joseph Bray as a partner.

It was not until 1822, after sixteen years of life ashore, that he again heeded the siren song of the ocean. In that year he commanded the Boston brig *Sally Ann*, voyaging to Havana. In 1824 he was master of the brig *Barbara*, with the same destination; two years later London records listed him as captain of the *Mercury*. In 1828 the Boston directory recorded his name as a mariner; he died on March 10, 1829, fifty-five years of age, father of seven children.

Further clues to Boit's character may be found in his *Union* log. While in the Queen Charlotte Islands an Indian attack was repelled in a bloody battle (see p. 192). When the natives later offered furs to ransom them, Boit "order'd the irons off them & got the poor devils up and not with standing the treatment I paid full price for the skins."

While in the Hawaiian Islands, Boit again showed his humanity, this time toward a sailor who tried to desert the *Union* for the lush temptations nearby: "John Barton, was one of those kind of people, that sometimes come into this transitory world merely by chance . . . I only had recourse to threats, not having the heart to flog the poor illitterate devil, although he so richly deserv'd correction" (p. 78). He could be exacting, as well as humane: "the Chinese stole both boats from along side owing to ye [the] Negligence of the watch . . . made the watch pay the expense [of recovery], which amounted to 30 doll'r" (pp. 90–91).

Boit recorded in his commonplace book a quotation concerning good character, which well might have been used as an epitaph.

I live in terms of good neighbourhood with all about me . . . I slander no one, nor do I allow backbiters to come near me; my eyes pry not into the actions of other men. . . . I go to church ev'ry Sunday, and the poor man partakes of my substance; I make no ostentation of the good I do. . . . As far as I have an opportunity, I am a reconciler of differences among my neighbors.[2]

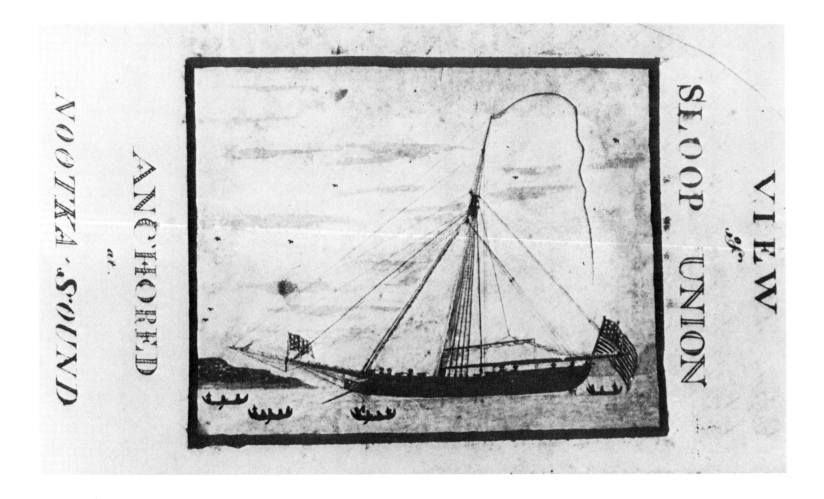

"View of Sloop Union *Anchored at Nootka Sound," 1795*

Watercolor drawing by John Boit in his log of the *Union*; courtesy Massachusetts Historical Society.

"Merquinna the Cheif of the sound came on board & brought a fine lot of Furs which I purchas'd, the Cheif was very sick. A Vast many Canoes, with Green peas & Beans, Cabbges etc. which they collected from ye remains of the Spanish gardens" (Hayes, Log of the Union, *p. 61).*

* Boit anticipated the coming departure of the* Union *for Boston by flying her homeward-bound pennant, although she would not leave the Northwest Coast for another twenty-five days.*

The United States Exploring Expedition, 1836–42

In the early part of the nineteenth century, some of the national legislators of the still youthful United States began to entertain thoughts of an official voyage of exploration around the world, similar to those of Cook and Vancouver. There were obvious merits in such a plan. American interest in the western coast of the continent had steadily increased since the discoveries of the Lewis and Clark expedition of 1803 to 1806, American whaling ships were visiting the region in considerable numbers, and, perhaps as persuasive, there was a growing consciousness that a successful scientific voyage would be proof to the world that the United States had joined the ranks of older nations in contributing to world knowledge.

Although the House of Representatives had passed a resolution in 1828 favoring such a voyage, it was not until 1836 that an appropriation bill was passed by Congress for the purpose.[1]

The command of the expedition was initially placed with Captain Thomas ap Catesby Jones, who soon became overwhelmed with organizational, financial, and equipment difficulties. This last included the shocking realization that four ships, expressly built at his insistence for the expedition with extra strength to withstand conditions in the Antarctic, when launched proved inadequate in sailing qualities and unable to claw off a lee shore, a capability essential in such a voyage.[2]

Jones soon resigned because of illness, and was succeeded by Lieutenant Charles Wilkes, whose only qualification in some eyes was his reputation for being the best qualified surveyor in the Navy. His appointment was opposed by a few officers who had higher ranking.

After many delays, the expedition left Hampton Roads, Virginia, on August 18, 1838, with six vessels: the 780-ton *Vincennes*, the 650-ton *Peacock*, the 230-ton *Porpoise*, two sturdy former New York pilot boats, *Sea Gull* and *Flying Fish*, and the slow-sailing *Relief*.

Following a forty-seven day stay at Rio de Janeiro for repairs to the *Peacock*, Cape Horn was weathered without incident. The ships anchored at Orange Harbor on Feburary 17, 1839, a few miles north of the cape. Here preparations were made for the first of two voyages to the Antarctic. Four vessels in groups of two left February 25, for varying periods up to about eight weeks.

Little of value was accomplished, or perhaps even expected, but exposure to antarctic conditions brought valuable experience, although some vessels came very close to being lost in the process.[3]

Arriving at Tahiti on September 10, the flotilla went on to survey the Samoan Islands in October and November, then proceeded to Sydney on November 29. During January and February 1840, explorations were made in antarctic regions.

This second venture met with some degree of success, although the principal discovery later created a controversy. Subsequent analysis of Wilkes' chart from 148° east longitude to about 105°, a distance of over one thousand miles, has proven it to be remarkably accurate. The foremost achievement was to establish that the area surveyed was indeed a continent and not a chain of islands. Recognition of this accomplishment is shown by this portion of the Antarctic being named "Wilkes Land."[4]

The Fiji Islands were surveyed from May to August. The fleet wintered at Hawaii, where the peak of Mauna Loa was gained with considerable hardship. Significant observations on Hawaiian volcanoes were made by James D. Dana, the expedition geologist and zoologist.[5]

Landfall on the Northwest Coast by Wilkes in the *Vincennes*, accompanied by the *Porpoise*, was made at the Columbia River on April 28, 1841. Heavy surf prevented entrance into the river, so Wilkes proceeded northward, nearly losing both vessels on the way to a strong set of current upon the coast. His *Narrative* recalls: "Neither of the vessels now had much water under their keels, and both were in imminent danger . . . the difficulty of our position was enhanced by the heavy seas we had to encounter, into which the vessels plunged so heavily as to endanger our spars . . . this was one of the many hair-breadth escapes from wreck, incident to this cruise" (4:295).

Detailed surveys were made as far north as the Fraser River. A base was established at Fort Nisqually, from which overland parties began extensive surveys and exploration, to the east as far as Fort Colville, and south to San Francisco.

Originally, a party from the *Peacock* was to go up the Columbia River to the headwaters of the Yellowstone. Her wreck on a bar at the entrance forced changes in this plan: "Mr. [Joseph] Drayton was therefore detached to make this jaunt," upon the Columbia as far as Fort Walla Walla, wrote Wilkes. (Drayton was one of two official artists, the other being Alfred Agate.)

Other ambitious undertakings had to be relinquished. Wilkes had planned a northward expedition:

Orders were also prepared for the Porpoise to proceed to Port Townsend; thence to Fraser's river, visiting Fort Langley and then through Johnson's [Johnstone] Straits, and round the north end of Vancouver's Island, to Nootka Sound . . . all my plans for the employment of the squadron were now at once to be changed; for it became necessary for me to proceed without delay to afford relief to our shipwrecked companions. I therefore immediately sent orders to the Porpoise, countermanding her previous instructions, and ordering her to repair forthwith to join the Vincennes at New Dungness [4:484].

Wilkes departed from the Columbia River in the *Vincennes* on October 11, thence to San Francisco; Manila on January 13, 1842; Singapore, Cape of Good Hope, and, finally New York City on June 10.[6] The voyage had lasted three years and ten months.

The very real and worthwhile achievements of the expedition were obscured by its disturbing aspects, such as the return with some officers under arrest, rumors of disruptive and tyrannical leadership, and the series of courts-martial which followed. Its charts and reports on the value of Puget Sound and San Francisco Bay, and the detailed descriptions of the interior regions, had much to do with an acceleration of the nation's growing belief in the principle of "manifest destiny."[7]

Alfred T. Agate

I had under my command a young artist [Agate] of great promise . . . a most aimiable person but of very Great delicacy of constitution. His talents in landscape were of a high order and [he was] duly appreciated by all my officers for his kind and gentle temper. (Wilkes, Autobiography, pp. 225–26)

According to Charles Wilkes, he and Alfred Agate had studied under the same art instructor, "Mr. J. Ruben Smith, a drawing master who had a large class of pupils, . . . [and] was a great oddity in his way . . . he was short of Stature and rough in manner, dressed artistically—that is almost always in dishabille and his bushy grey locks were dysheveld or uncombed. At the Same time he had all the enthusiasm of and admiration for his profession. His ideas of perspective were very good and in his teachings he used a machine on which he set great Store."[1]

It may have been here that Agate learned the use of the camera lucida, a portable instrument favored by Joseph Drayton, the other official artist, and by Titian R. Peale, another naturalist of the expedition, as well as other artists of the period. It was an optical instrument consisting of a four-sided prism of glass with carefully measured angles, enabling the viewer to project a scene or object on a sheet of paper, on which it could then be traced. The device was of much help in producing drawings in which accuracy was important.

Agate was initially assigned to the storeship *Relief*, but joined the *Peacock* at Calloa, transferring to the flagship *Vincennes* at San Francisco. His skills were in frequent demand by Wilkes, and he was involved in occasionally hazardous shore duty.

Arriving in the Fiji Islands in early May 1840, Wilkes learned of a massacre six years earlier of the mate and eight seamen from the American brig *Charles Doggett*, planned by Vendovi, a principal chief at Rewa. Wilkes decided to take him prisoner and bring him to trial as an example, in order to protect future traders and whalers. Before Vendovi was located, Agate, while wandering about the town,

. . . was met by a [native] priest, who came to him and signified by signs he wished him to sketch something, and at the same time pointing to a house. Mr. Agate followed him in. There were a large number of retainers present . . . shortly after his entrance a man . . . said he wished his likeness taken. . . . A day or two later he proved to be the notorious Vendovi, brother to the king . . . from his head-dress our gentlemen recognized him as the individual who had been their guide in one of the short excursions.[2]

Agate's drawing skill was frequently mentioned by Wilkes and others. In the Fiji Islands, Wilkes referred to him when he "took a most capital likeness of the wife of the chief of this village . . . her head and sidelocks were nearly of a scarlet colour; her necklace was composed of a whale's tooth, shells, and a few beads; the corners of her mouth were tattooed in circles of a blue-black colour."[3] Expedition naturalist James Dana wrote Asa Gray from the Fiji Islands in June 1840: "Agate is very busy, sketching and taking portraits when not engaged in making botanical drawings. He has an admirable series of portraits. Unlike those of the French voyages, they may be trusted as not only characteristic, but accurate likenesses of the individuals."[4]

On the Northwest Coast, after extensive use of Agate on various excursions, Wilkes assigned him to accompany the overland expedition under Lieutenant Emmons, from the Columbia River to San Francisco. This journey had an especially deleterious effect on his health. The rendezvous and assembly point for the journey was on the lower Willamette River, where "Messrs. Emmons, Peale, Rich, and Agate, all had attacks of ague and fever, and the two last-named gentlemen suffered much from this disease. Dr. Whittle ascribed these attacks to the length of time, nearly five weeks, during which they had been encamped on the Willamette, and particularly to the position of the camp, immediately on the banks of the river, where it was subject to the damp and fogs."[5]

Leaving the camp on September 5, they reached the Elk River eleven days later, fourteen miles from Fort Umpqua. Emmons and Agate, with a guide, reached the bank of the river opposite the fort, and were ferried across in canoes. According to the person in charge at the fort, "an unusual number of Indians of the Umpqua tribe had collected . . . [and] had shown a strong disposition to attack and burn the fort." News of their journey had been "passed on to all the tribes, who were collecting in vast numbers to oppose their passage, having sworn vengeance against all the whites." The officer warned them to cross the river at a place well away from the usual route, and said "that he was sure they would all be killed" because their party was so small.

Farther south, they were visited by a peaceful group of "Shaste" Indians, and traded with them for samples of their bows and arrows. In sketching some of them, Agate had

much difficulty in getting them to stand still for the purpose of having their portraits taken, and gave them a miniature of his mother to look at, hoping it would allay their fears, but it had a contrary effect, as they now believed that he desired to put some enchantment upon them, and

thought that he was the medicineman of the party. The officers prevailed on the Indians to exhibit their skill in archery, and found one of them could hit a button three times out of five at a distance of twenty yards.[6]

Agate's life was shortened by the hardships of this journey and of the voyage. According to historian David Tyler in his account of the Wilkes Expedition, "he died of consumption in 1844 and this set back the preparation of drawings [for publication]. His death was felt as a personal loss by members of the Expedition who greatly respected him as a man as well as an artist." The botanist Asa Gray established a memorial: "As the Ancients garlanded the graves of their deceased friends with violets, so I dedicate this new genus of Violacea to the memory of Alfred T. Agate, the Botanical Artist of the Expedition, who died in Washington shortly after its return (Agatea)."[7]

Wilkes named at least two features after the gifted young artist—Agate Passage at the north end of Bainbridge Island, near Seattle, and Agate Island in the Fiji Islands.

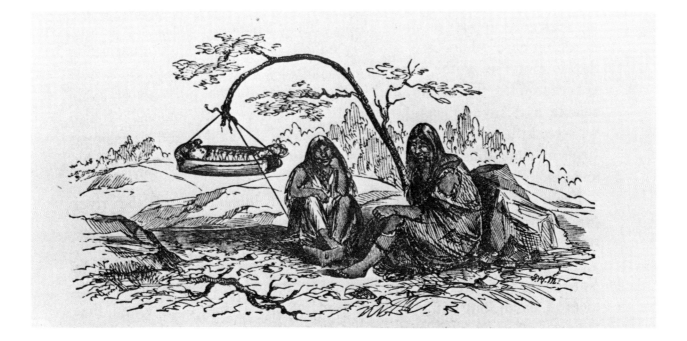

"Indian Mode of Rocking Cradle," 1841

Woodcut engraving of a drawing by Alfred Agate, in Wilkes, *Narrative*, 4:338; courtesy Pacific Northwest Collection, UW Libraries.

The cradle is suspended from a sapling, from which a line is attached to the mother's toe. The cradle is rocked by movement of her foot. The drawing was probably done in the vicinity of the Willamette River, where "during the time of their stay, Mr. Agate made many sketches" (Wilkes, Narrative, *5:219).*

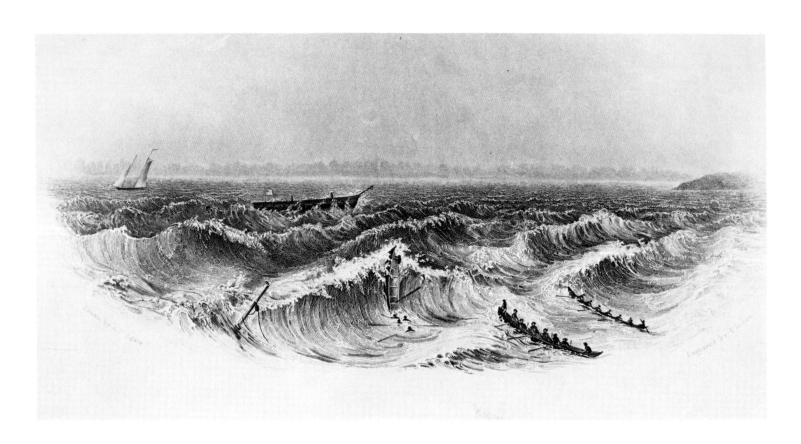

"Wreck of the Peacock," 1841

Engraving of a drawing by Alfred Agate, in Wilkes, *Narrative*, 4:facing p. 493; courtesy Pacific Northwest Collection, UW Libraries.

Agate's drawing of this scene was made on July 19, on the day following the grounding of the Peacock *at the mouth of the Columbia River. Her masts had been cut away because she was striking the bar so heavily in enormous breakers, that Captain Hudson feared she might fall over on her beam. In the heavy seas the ship's boats attempted to make an additional trip to rescue those remaining on the wreck.*

Suddenly one boat "was thrown end over end, and with her crew engulfed. Lieutenant De Haven was fortunately close at hand, and succeeded in saving those on board, all of whom were injured, one of them severely, by the breaking of his hip bone." The boats were ordered to return to shore and wait for slack water. Later, all were rescued (Wilkes, Narrative, *4:493).*

The vessel cruising in the distance, beyond the shoal, is probably the expedition's Flying Fish.

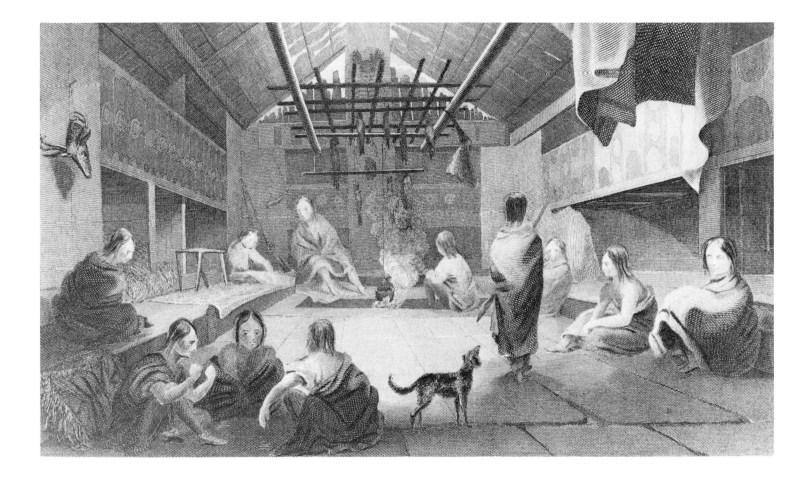

"Chinook Lodge, 1841

Engraving of a drawing by Alfred Agate in Wilkes, *Narrative*, 4:facing p.341; courtesy Pacific Northwest Collection, UW Libraries.

This lodge was probably located on the lower Columbia River. The three Chinooks in the left foreground are playing a gambling game, the one with upraised fists is hiding marked and unmarked sticks or discs, which the others must guess.

The housepost at the far end of the lodge has a carved or painted design at the top, while painted designs appear along the sides of the loft, along both sides and the rear of the lodge. Various kinds of fish and game, and perhaps a haunch of venison, hang in the smoke over the fire, by which a cooking pot rests. The Indian under scrutiny by the suspicious dog is holding a trade musket. Another trade musket with powder horn stands in the corner, at left.

All of the individuals portrayed exhibit the characteristic sloping forehead of the region, created by a padded headboard in the cradle, bound at an angle against the infant's head.

"Indian Burial Place, Oregon," 1841

Engraving of a drawing by Alfred Agate, in Wilkes, *Narrative*, 5:219; courtesy Pacific Northwest Collection, UW Libraries.

"The graves are covered with boards, in order to prevent the wolves from disinterring the bodies. The emblem of a squaw's grave is generally a cammass-root digger, made of a deer's horns, and fastened on the end of a stick" (Wilkes, Narrative, *5:219).*

 Such a camas-root digger described appears in the right foreground. In accordance with traditional practice, the departed's baskets, including those used for cooking, have been upended on poles around the grave. This sketch was likely made in the vicinity of the Willamette River, during the nearly five-week stay of the Wilkes overland expedition, prior to leaving for San Francisco.

 Wilkes recorded that "the Calipooyas tribe residing south of the [Columbia] and along the Willamette Valley bury their dead ornamenting the grave with poles, or with an affixed calabash, pots, pans & " (Diary, *p. 47).*

James D. Dana

Born in Utica, New York, on February 12, 1813, James Dana was the eldest of ten children. He entered Yale College in 1830 as a sophomore, and was graduated in 1833. Seeking congenial employment, Dana turned to the navy, which, lacking a naval academy, engaged schoolmasters to tutor midshipmen aboard naval vessels. Dana applied for a position by letter on one of the "national vessels destined to the Mediterranean . . . a station which I seek with much earnestness." On August 14, 1833, he was aboard the *Delaware* as an instructor of mathematics, and later was transferred to the frigate *United States*.[1]

While at Smyrna in July 1834, Dana climbed Mount Vesuvius, which was then in a state of mild activity. He was so strongly impressed by the experience that he wrote a detailed description to his former teacher at Yale. Returning after a voyage of sixteen months, he was appointed as an assistant to Yale professor Benjamin Silliman, to work with mineralogical specimens in Silliman's chemical laboratory. From this he produced a scientific treatise, *The System of Mineralogy and Crystallography*, which received praise in learned journals abroad and at home. He was then just turned twenty-four.[2]

In January 1837, Dana was appointed a member of the scientific corps of the Wilkes expedition, as mineralogist and geologist. His salary was $2,500 annually, plus one ration daily while on duty. He was initially assigned to the *Peacock*, and described his quarters in a letter to a friend: "snugly stowed away . . . in a small stateroom six feet by seven and a half, where I am required to keep, in addition to my own private stores, which are not a little bulky, all the public stores pertaining to my department . . . yet I feel our prospects are fine."

The expedition had to make a prolonged stay at Rio de Janeiro for extensive repairs to one of its vessels, allowing time for Dana to investigate the physical and political surroundings. He reported on the status of the many Negroes in the city:

Although very many of them are slaves, they appear to be a grade higher than the negroes of our country. This is owing to the political privileges the free blacks enjoy. They are equally entitled with the whites to the offices under government, and are treated in every way as equals. There is nothing of that prejudice which color excites with us, and black and white are seen mingling together with only those distinctions of rank which must exist in every state of society. The consequence is that all the blacks, even the slaves, have more self-respect, and . . . seem to feel themselves to be men.[3]

In a long letter dated at the Fiji Islands in June 1840, Dana reported that he had prepared "some long manuscripts [with] about one hundred sketches of mountains, craters, basaltic causeways and caverns, faults and dikes, etc. . . . 175 species [of corals] with the animals of most of them. Among crustacea I have made collections and drawings when geology was not requiring my time. I count up now 400 species . . . in geology, I shall take the liberty of disputing some of Darwin's views."

Following the return of the expedition, Dana and the other scientists spent years completing their reports. In Dana's case, thirteen years were used to prepare his three reports: *Geology*, 756 pages, *Crustacea*, 2 volumes totaling 1,620 pages, and *Zoophytes*, 740 pages. All were accompanied by folio atlases of varying length. Many of the plates were from Dana's own drawings.

Charles Darwin was deeply impressed by the extent of Dana's findings. In a letter of September 17, 1853, he wrote, "The size of the work, and the necessary labor bestowed on it, are really surprising . . . if you had done nothing else whatever, it would have been a *magnum opus* for life . . . when I think this work [*Crustacea*] has followed your *Corals* and your *Geology*, I am really lost in astonishment at what you have done in mental labor . . . so much originality in all your works!"[4]

James Dwight Dana at thirty, 1843

Portrait by unidentified artist, in Gilman, *Life of Dana*, facing p. 142; courtesy Pacific Northwest Collection, UW Libraries.

Dana's earlier disagreement with Darwin's theory of evolution was mainly based on his unwillingness to depart from conventional religious doctrine; however, later in life, according to one historian, he became "a confessed evolutionist."[5]

In 1849 he was appointed professor of natural history at Yale. He received many honors for his scientific achievements and at age seventy-seven *Characteristics of Volcanoes* was published. He died in 1895 at eighty-two.

Among geographical features on the Northwest Coast named after Dana are the following: Dana Passage, at the south end of Puget Sound, named by Wilkes; Dana Peak, east of Sitka, named in 1887 by Lieutenant Commander C. M. Thomas USN; and Dana Inlet in the Queen Charlotte Islands, named by George M. Dawson of the Geological Survey of Canada in 1878.

"Granite needles—as seen below encampment Oct. 4," 1841

Drawing by James Dana in his notebook labeled "Oregon": courtesy Beinecke Library, Yale University.

The campsite was probably somewhat south of the Oregon–California border.

Joseph Drayton

His death was a great affliction to me and a great loss to the Expedition . . . his equilibrium of temper and kindness to all under his orders and direction secured their good will and respect. He never made any charges against any one and pursued his duties unremittingly. I never [had] a [more] sincere friend and one to whom I was greatly attached and shall ever remember for his upright principles, talent and kindness with which he treated all who were in any way associated with him. (From Charles Wilkes, *Autobiography*, p. 532)

Joseph Drayton was one of the two official artists of the expedition, at a salary of $2,000 annually, plus rations. He was a middle-aged widower with two grown sons, and had never been to sea. Wilkes found it necessary to reassure him: "the dangers of the sea he was unused to and in many cases of our peril he showed great timidity, but placed implicit confidence on any assurance I made him that there was no danger." According to Assistant Surgeon Whittle, Drayton expressed great concern about an island "which some charts put down not far ahead of us." Whittle excused his fears, as "even we *young bloods* do not always feel entirely easy."[1]

Wilkes reported that Drayton was "a good musician and had for some length of time in his spare hours taught it." A more recent writer says, "Drayton had brought along his violin and often entertained the men with concerts on the forecastle [of the *Vincennes*]."[2] While the source for this statement is not disclosed, it is a pleasing and believable image.

In spite of his "great timidity" at sea, Drayton performed much more than adequately on the voyage, despite Dana's concern expressed in a letter to a friend: "He is not in good health, but has frequent ailings which lay him up occasionally for six days or so; he smokes too many cigars and takes too much medicine to be well."[3]

After the *Vincennes* arrived on the Northwest Coast in April 1841, Drayton accompanied Wilkes on several field trips into the interior, including the Willamette Valley of Oregon. Subsequently, he was detailed to accompany Peter Odgen, chief factor of the northern district of the Hudson's Bay Company at Vancouver, up the Columbia River as far as Walla Walla.[4]

Wilkes recorded the journey in his *Narrative*, from Drayton's account. Odgen's brigade left the post on June 27, with "nine boats, rowed by sixty voyageurs, eight of whom have their Indian wives with them. The goods . . . for the northern posts are all done up carefully in bales of ninety pounds each, and consist of groceries, clothing, flour, powder, bullets, &." Each boat could carry "three tons weight, and have a crew of eight men, besides a padroon. The boatmen are Canadians, excepting about one-fourth, who are Iroquois Indians" (pp. 378–79).

Bands of Indians on shore followed the brigade up the river, occasionally being employed for half an hour's work at a price of "two leaves of tobacco . . . these Indians paint their faces with red and yellow clay." Drayton observed that their women seemed of "more consequence than is usual . . . some of them even took command over the men" (p. 388).

Leaving the brigade at Fort Walla Walla, Drayton visited the Whitman mission at Waiilatpu. After a trip into the Blue Mountains, he continued with his drawing and sketching. Assembling "the necessary data for the map of the river and the country surrounding this post," he returned to Vancouver. Wilkes was pleased: "The manner in which this task was executed was very satisfactory, and merits my warmest acknowledgments." His material was later incorporated into Wilkes' map of Oregon.

After the expedition had returned home, Wilkes was authorized to proceed with preparation for a definitive series of volumes on all aspects of the voyage. At Wilkes' request, Drayton was engaged as his chief assistant at a salary of $166 monthly. His responsibilities were described by the Joint Committee on the Library, in 1846:

Mr. Drayton is employed in preparing drawings in several departments of natural history . . . and in superintending the illustrations of the work generally. He has charge of all the copper plates, which he inspects before they are received, as he does the engravings taken from them. He is also charged with the coloring of all the illustrations, superintends the printing and binding of the books, and even the making of the paper on which the works, engravings, and charts are printed. In conjunction with Commander Wilkes, he makes the contracts for engraving the charts and drawings, providing for their execution by the various artists employed, under the strictest terms as respects cost, time, finish, style, &. Mr. Drayton is himself an excellent artist, and has as much experience as any one in employment of this sort, in which he has been constantly engaged by the most eminent publishers in the country for more than twenty years."[5]

Wilkes observed in his autobiography, "the whole work proceeded with alacrity and order under the charge of Mr. Drayton and will remain an enduring mark of his good taste and ability in its beauty and accuracy." When the work was far along toward completion in 1856, Drayton became ill and died late in the year, placing a heavy burden on Wilkes who had leaned heavily on his competence.[6]

Wilkes was not alone in his admiration of Drayton's capability. The naturalist Louis Agassiz, in a letter to Wilkes, wrote that his drawings were the most accurate ever made, while Dana, referring to the drawings in his volume *Crustacea*, wrote "the plates . . . owe much to the artistic skill and taste of Mr. Joseph Drayton . . . [who] contributed in many ways to the beauty of work."[7]

Drayton's name was immortalized in the field of phytology by botanist Asa Gray, who spent some years organizing and studying the expedition's botanical collection: "With much satisfaction I dedicate this genus (Draytonia Rubicunda) to Joseph Drayton Esq., the principal of the Scientific artists of the Expedition, of no small attainments in natural history especially in conchology, to whose pencil and superintendance the illustrations of the

whole invertebrate zoology of the Expedition owe their high perfection."[8]

Wilkes named at least two features after him: Drayton Passage near the head of Puget Sound, and Drayton Bay (now called Drayton Harbor), near the U.S.-Canadian boundary.

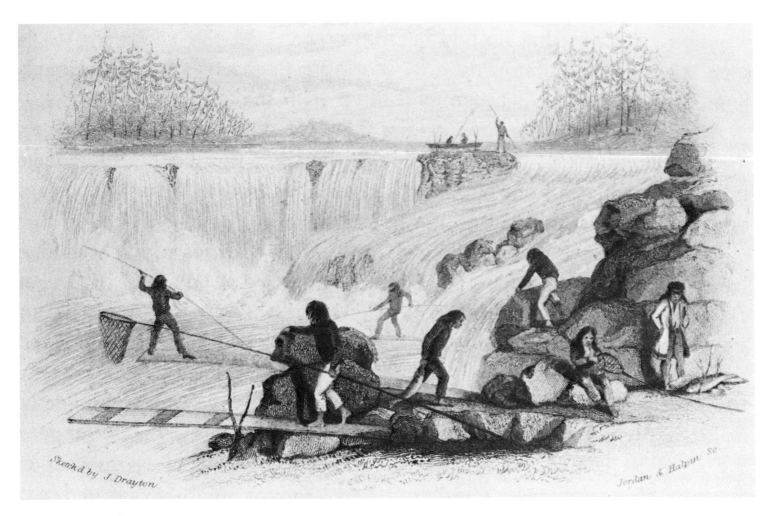

"Willamette Falls," 1841

Engraving of a sketch by Joseph Drayton, in Wilkes *Narrative*, 4:345; courtesy Pacific Northwest Collection, UW Libraries.

"At the time of our visit . . . the salmon-fishery was at its height. . . . I never saw so many fish collected together before; and the Indians are constantly employed in taking them. They rig out two stout poles, long enough to project over the boiling cauldron, and secure their larger ends to the rocks. On the outer end they make a platform for the fisherman to stand on, who is perched on it with a pole thirty feet long in hand, to which the net is fastened by a hoop four feet in diameter: the net is made to slide on the hoop, so as to close its mouth when the fish is taken. The mode of using the net is peculiar: they throw it into the foam as far up the stream as they can reach, and it being then quickly carried down, the fish who are running up in a contrary direction, are caught. Sometimes twenty large fish are taken by a single person in an hour. . . . Some of the Indians are in the habit of coming down in canoes to the brink of the falls, where they secure themselves by thrusting down poles . . . there they take many fish . . . esteemed to be of the best flavour. . . . [Few] expose themselves to the risk of fishing there" (Wilkes, Narrative, 4:345–46).

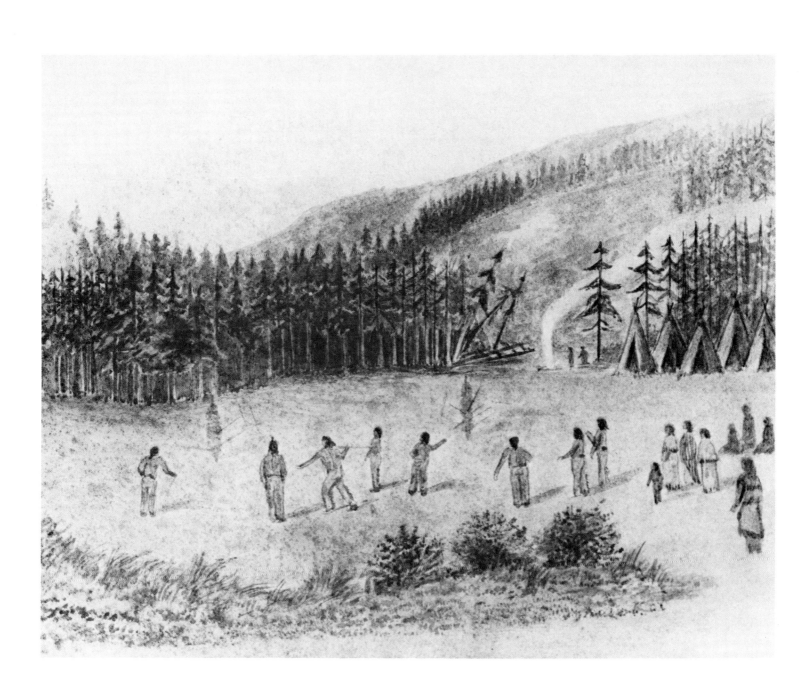

Indians playing the spear game, 1841

Pastel drawing attributed to Joseph Drayton; courtesy Oregon Historical Society.

Two targets are in use for the casting of spears in competition, while a group of Indian women watch at right. Near the trees is a group of teepees. Mount Hood is barely visible in the distance.

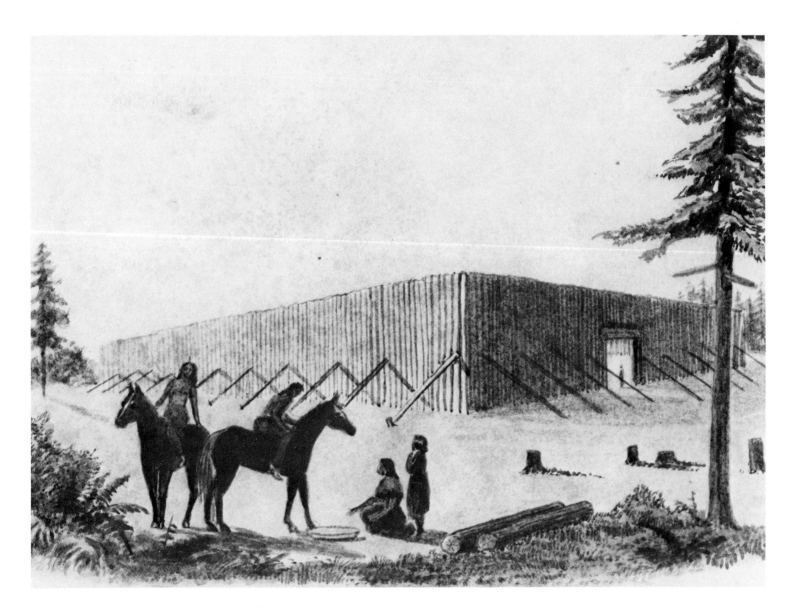

A stronghold of the Sachets, Whidbey Island, 1841

Pastel drawing attributed to Joseph Drayton; courtesy Oregon Historical Society.

"The next point visited and surveyed was Penn's Cove, between Whidby's Island and the main. This island contains many small villages . . . it is in possession of the Sachet tribe, who . . . are obliged to provide for their defence against the more northern tribes, by whom they are frequently attacked, for the purpose of carrying them off as slaves. For protection against these attacks they have large enclosures, four hundred feet long, and capable of containing many families, which are constructed of pickets made of thick planks, about thirty feet high. The pickets are firmly fixed into the ground, the spaces between them being only sufficient to point a musket through. The appearance of one of these enclosures is formidable, and they may be termed impregnable to any Indian force; for, in the opinion of the officers, it would have required artillery to make a breach in them. The interior of the enclosure is divided into lodges, and has all the aspects of a fortress. Upon the whole, the tribe[s] inhabiting Penn's Cove are more advanced than any others in civilization" (Wilkes, Narrative, 4:480–81).

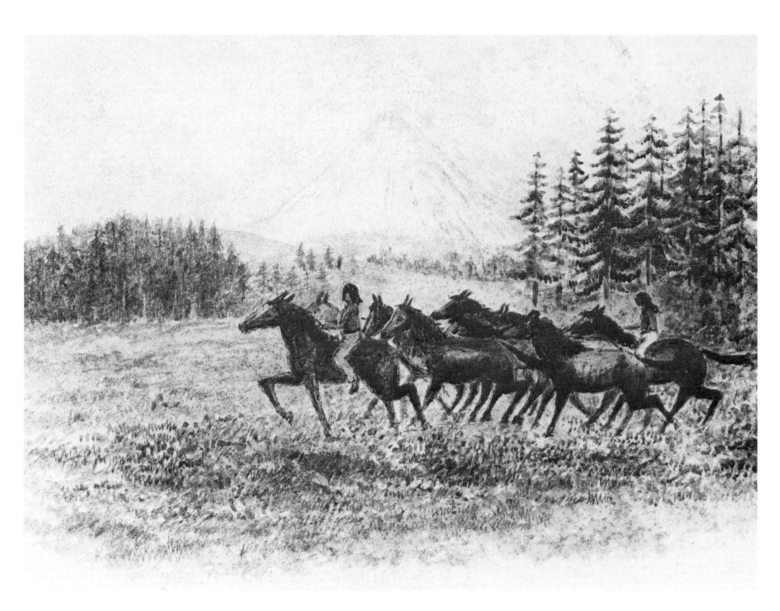

Indian horses near Mt. Hood, 1841

Pastel drawing attributed to Joseph Drayton; courtesy Oregon Historical Society.

"The Indians of this country are so much with their horses that one ought in giving their character to separate the two. On his horse he is a man but dismount him, and all his qualities vanish. . . . The management of their horses is truly surprising, and those that a foreigner or pale face would be unable to get off a walk they will mount and proceed with speed without the aid of spur or anything but a small switch. The usual bridle is simply a piece of rope fastened to the under jaw which seems all sufficient for the management of the most refactory horses. . . . They practice great cruelty in using their animals & a horse is seldom found that has not a raw back" (Wilkes, Diary, *pp. 21–22).*

Henry Eld

Henry Eld was born in New Haven, Connecticut, on June 2, 1814, and joined the United States Navy at age eighteen. Holding the rank of passed midshipman, he at first was enthusiastic at the prospect of serving as a member of the Wilkes expedition, but two years of seemingly endless delays and bickering had dampened his eagerness, as revealed in a letter to his father shortly before the departure: "A General Order was read to the officers & crew on preparation to sailing from Capt. Wilkes, which read as those . . . generally do. Subordination. Honoring our countrys expectations, patriotism, etc. All I can say [is] a very little of either is flowing in my veins at present . . . all the zeal that I ever felt for the service of my country had evaporated, gone, vanished inevitably."[1]

Eld had previously served under Wilkes on coastal survey duty, and had apparently earned some reasonable degree of confidence from his commander. During the expedition, he also gained the respect of one of the scientists, James Dana, who was skeptical of the officers' concern about the scientific goals of the expedition, as "they were careless in their manner of taking certain observations." In Dana's view, however, Eld was very accurate in such duties.[2]

When the expedition arrived at Tahiti in September 1839, Eld had little relief from his tasks of observing the transits of heavenly bodies, measurements of dip intensities, tidal changes, and the like, with recording necessary every hour. Nevertheless, he observed that "the transition from the irksome and monotonous life on shipboard to this enchanting spot we were at was delicious."

One of Eld's assignments while at Tahiti was to assist Dr. John L. Fox, an assistant surgeon, in his anthropological studies, which included the taking of measurements of the natives, who cooperated upon receiving presents of tobacco or a twenty-five cent piece. Eld recorded some of the scenes, especially with "the Girls who were a little timid in being handled in so wholesale a manner & I was much pleased at the modesty . . . [which] would have been an ornament to a civilized female. Many of the forms of both sexes were perfect symetry & would serve as models for an Apolo or a Venus."[3]

Henry Eld, c. 1846

Portrait in Western Americana Collection; courtesy Beinecke Library, Yale University.

While Eld was commissioned a lieutenant in 1843, it was not until January 1, 1846, that a new Navy regulation authorized lieutenants to wear two plain gold epaulets instead of one (Tily, Uniforms, p. 97). It would have been a natural action for Eld to have this portrait made, to exhibit the more appropriate and decorative badges of office.

Later, survey duties at the Samoan Islands with two boat crews involved hardship, with hours from dawn to dusk, continuously on guard against possible attack, often wading over coral reefs in waist-high water, occasionally in rain, sometimes in broiling sun, and attacked by mosquitoes.

Wilkes' frequent clashes with officers extended to Eld, who had been somewhat of a favorite because of prior service. When Eld accidently broke a level in the chart room, Wilkes wrote "I could better have spared his services than that of the level . . . I could almost cry over it."

After the expedition arrived on the Northwest Coast in 1841, Eld was placed in charge on July 17 of a party with two canoes, and ordered to proceed from Fort Nisqually to survey Gray's Harbor. Long, difficult portages were necessary to reach streams which would lead them to salt water. After the project was complete, Eld and his party tracked the canoes down the ocean beaches to Cape Disappointment, then portaged over the hill to Baker Bay on the Columbia.[4]

Wilkes was warm in his praise of their achievement: "I cannot refrain from expressing the satisfaction I felt at the manner in which the service was performed, and deem it my duty to make known to the country the commendable perserverance with which this party persisted in completing the duty assigned them; regardless of inconvenience, privation, and discomfort . . . I look back upon [it] with pride and pleasure."[5]

Several days later Eld left Astoria on the overland expedition to San Francisco under Lieutenant George F. Emmons, having worked till midnight the previous day to finish his charts of Gray's Harbor. On the second day after leaving the Umpqua River in Oregon, Eld lagged behind the party, having paused to make a sketch. A band of Indians arrived and attempted to force him to ride north, but he escaped by spurring his horse and breaking through.[6]

After the expedition's return in 1842, promotions were in order for some of the officers. Eld and George Colvocoresses, the two youngest passed-midshipmen, did not receive their warrants as lieutenants until February 1843.

After the distraction of the courts-martial (in which Eld was not involved as a principal), Wilkes was to give all his time and energy to the organization of the reports and collections of the expedition. He requested through channels the assignment of several of its personnel as assistants, including Eld, whom he especially needed. After some difficulty with naval red tape, involving the cancellation of orders for Eld to report for sea duty, Eld was reassigned to Wilkes in Washington.[7]

Due to the severe physical demands of the voyage, Eld's health had suffered, resulting in a severe attack of rheumatism in 1939, and recurrent attacks thereafter. According to a letter, a navy physician gave him relief by treating him with phosphate ammonia in sarsaparilla and burgandy pitch plaster.

By the summer of 1846, Eld had tired of shore duty and the continuous work on the numerous charts, and applied for sea duty in the war with Mexico. He left Washington with some regret, since he had become friendly with Wilkes' daughter, Janie. It was a fateful decision, as four years later he died of yellow fever, at age thirty-five.

Eld was one of two men credited by Wilkes as having first sighted the Antarctic continental land mass on January 16, 1840: "Two peaks, in particular, were very distinct, which I have named after these two officers."[8]

Eld's name was also twice given by Wilkes to geographical features on the Northwest Coast; one being Eld Inlet (locally called Mud Bay), at the southern end of Puget Sound, the other being Eld's Island in Gray's Harbor. The latter name has disappeared from modern charts. Wilkes also named Eld Island in the Fiji Islands.

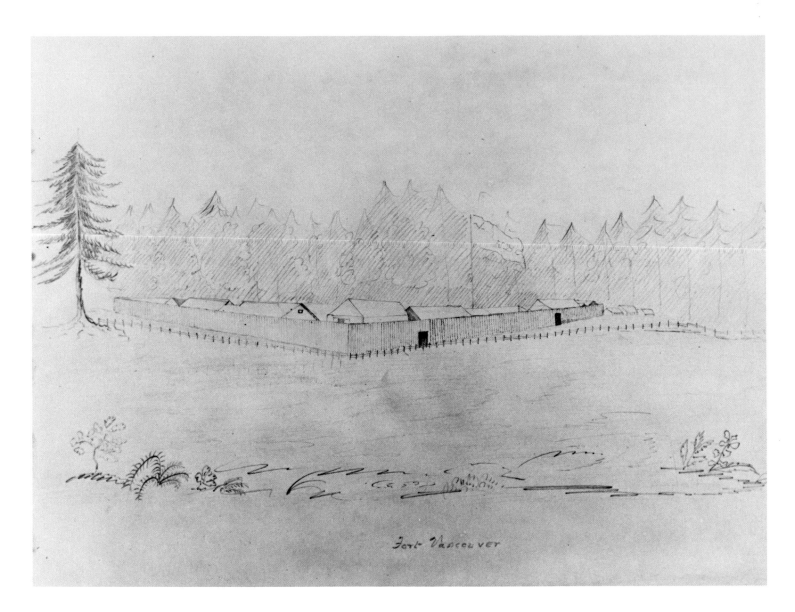

"Fort Vancouver," 1841

Drawing by Henry Eld; courtesy Beinecke Library, Yale University.

"The village consists of some 50 comfortable log houses placed in some order or rows and inhabited by the Company's servants, swarming with fine looking children, half breeds and pure Indians. The Fort consists of several good buildings including dwelling homes & magazines surrounded by a high palisade. In the establishment is an extensive bakery, coopers Blacksmith trade office for Indian purchases, shops for retail where any articles may be purchased. . . . I was introduced here to several of the Missionaries who for the most part make this their home & are extremely kindly and well entertained by the Company at no expense whatever there are usually some ½ dozen staying with their wives and there have been as many as a dozen" (Wilkes, Diary, pp. 37, 39).

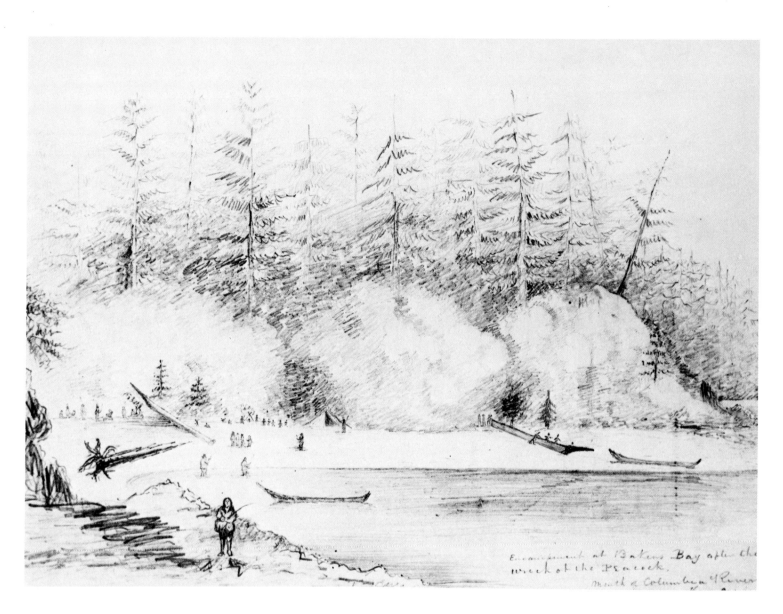

"Encampment at Bakers Bay after the wreck of the Peacock," Columbia River, 1841

Drawing by Henry Eld; courtesy Beinecke Library, Yale University.

"The remaining men were distributed among the boats, and embarked in good order, Captain Hudson being the last to leave the ship. After a pull of two miles, they landed in Baker's Bay. . . . The agent of the Hudson Bay Company . . . the missionaries . . . several residents, came promptly to the aid of the shipwrecked crew, with provisions, tents, cooking utensils, and clothing, all vying with each other in offering assistance" (Wilkes, Narrative, 4:494–95).

This sketch was made soon after the shipwreck, probably in a hurry, since perspective is lacking in some details, such as the length of the canoes and the relative size of some of the figures. No ship's boats are visible on the beach, as "some faint hopes were entertained that a portion of the property might still be saved from the wreck, as a relief in their state of utter destitution; and, in consequence, the boats were despatched the next morning at daybreak to the bar. But nothing was there to be seen of the Peacock, except the cap of her bowsprit"(Ibid.).

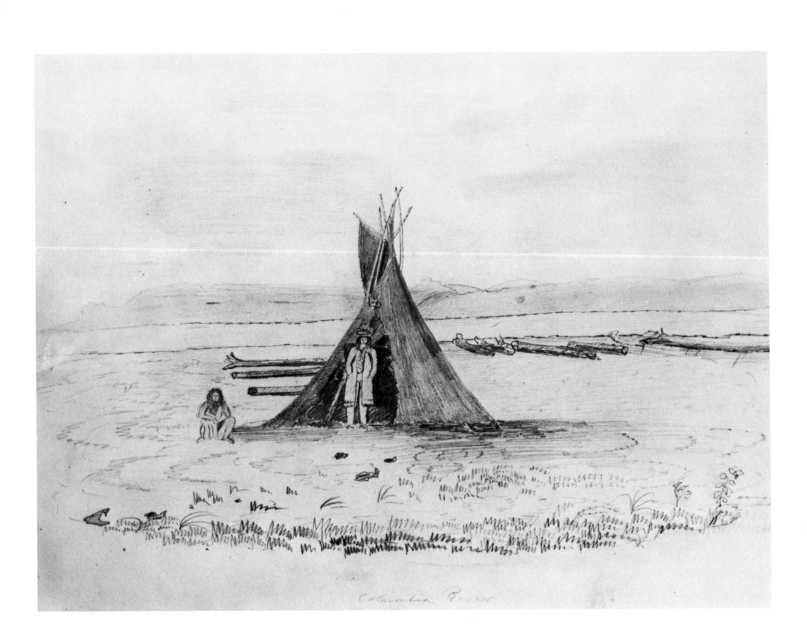

Indian teepee on the Columbia River, 1841

Drawing by Henry Eld; courtesy Beinecke Library, Yale University.

This is a Plains-type teepee, possibly of the Umatilla Indians, although the type was also in use in Plateau territory (Bill Holm, personal communication). The native standing in the entrance appears to be wearing European-style headgear and coat. Clothing was frequently a desirable object of trade with the Indians.

"A scene on the Columbia River," 1841

Drawing by Henry Eld; courtesy Beinecke Library, Yale University.

The Indian woman is broiling salmon before a fire. The man is holding a musket and wearing a nautical cap. The end of a mast is projecting over the bow of the canoe from the "spear groove," with the sail furled by rolling around the mast. The handles of three canoe paddles project near the bow. Mount Hood appears in the distance.

Charles F. B. Guillou

Although only twenty-five at the beginning of the Wilkes expedition in 1838, Charles Guillou already had acquired three medical degrees, and an enormous amount of self confidence.

He was born in Philadelphia in 1813, one of nineteen children of French parents who survived the slave uprising in Haiti, escaping to the United States. He received military training at Mt. Airy Classical and Military Lyceum in Germantown, and medical degrees from the University of Philadelphia Medical College, the Philadelphia Medical Institute, and the Therapeutic Institute of Philadelphia The latter specialized in "nautical diseases and naval therapeutics." Talented in languages, devoted to mathematics and science, he was skillful with tools, artist's equipment, and surgical instruments.

As were all officers of the expedition, Guillou was a volunteer. In his case, he was attracted by a family friend, Commodore Thomas ap Catesby Jones, who initially was in command. When Jones resigned and was replaced by the oversensitive yet dictatorial Wilkes, clashes with the officers became inevitable. The medical officers appear to have been particular targets for criticism.[1]

One of a number of conflicts between the mercurial doctor and his autocratic commander erupted at Sydney. Guillou had been ordered by Captain Ringgold to requisition medical supplies for the *Porpoise*, where he was assistant surgeon. According to Wilkes, he did so only "after much importuning . . . in so slovenly and ill ordered a Manner as showed an intention of not intending to perform it." Ringgold, after asking Guillou for corrections in the requisition "which he declined to do," referred the matter to Wilkes, who noticed that "he had required an Iron Mortar and pestle and gave no account of the one . . . already furnished . . . and under his care."[2]

Apparently Wilkes accused the doctor of deliberately damaging the original mortar, and ordered him to take a proper inventory, contrary to a naval regulation that permitted only full-ranking surgeons to do so. Guillou refused, and was suspended by Wilkes and transferred to the ill-fated *Peacock*, which placed him below three doctors, all junior to him in service.[3]

On another occasion early in the cruise, Guillou ignored naval regulations and irritated Wilkes by writing to the Navy Department requesting a promotion and extra pay, without forwarding his application through Wilkes. Both requests were denied. The navy informed Guillou that any such application required the endorsement of Wilkes, who described Guillou as "an irritable character and much wanting in common sense . . . [with] a great idea of his own importance and little of the usages & discipline of the Service, a novice in medicine but a very expert tailor."[4]

When the squadron arrived at Honolulu prior to sailing to Oregon, Wilkes issued orders for the inspection of all journals, pursuant to instructions of the secretary of the navy. Guillou submitted his journal, but first "deliberately tore the pages [of sketches] out of it & sent it to me in that delapidated State." Wilkes was "exceedingly amused at this ebulation of temper and had a hearty laugh over it, but it had to be noticed."[5]

An altercation ensued, resulting in Guillou "resolving to do no more duty as assistant Surgeon." He was allowed to occupy his quarters "as he had nowhere else to go, but I declined to notice him as belonging to the Squadron or under my orders . . . of all obstinate and headstrong individuals, I think he was the most so that I had ever met." Perhaps Wilkes had at last met his equal. Although under arrest, Guillou was permitted to continue his medical duties and assist the scientists in collecting and classifying biological specimens. When the *Peacock* was wrecked at the entrance of the Columbia River, he lost most of his personal effects, including his sketches and manuscripts, one of which was "under agreement of purchase."[6]

Charles F. B. Guillou, c. 1863

Daguerreotype of Guillou and his daughter; in collection of Emily Blackmore, reproduced by her permission.

At the conclusion of surveys on the Northwest Coast, the squadron sailed homeward via the Hawaiian Islands, where Guillou and Johnson, another officer under arrest, were set ashore at their own request, with orders to return home and report to the secretary of the navy as arrested officers. Fortunately, while at San Francisco, Guillou had received a letter from his brother authorizing him to draw a draft for necessary funds on arrival at Honolulu.[7]

The court-martial proceedings against a number of the officers took place in July and August of 1842. Guillou had filed seven charges against Wilkes, only one of which was upheld. Guillou was found guilty of "disobedience of orders, neglect of duty and disrespect to your commanding officer." He was sentenced to dismissal from naval service. But there was more: "Considering the privations and punishment . . . which constitute a severe atonement for the error of opinion, in no degree affecting your moral character . . . your uniformly good deportment . . . your attainments as a Physician, and your standing for honor and integrity—the President had been pleased to mitigate the sentence by commutation to suspension . . . for twelve months."[8]

After a hiatus of a year, he was chosen as assistant to naval doctor W. C. P. Barton, to organize the first Naval Bureau of Medicine and Surgery. Guillou was also promoted to serve on the *Columbus*, which was to take part in the Mexican war. On arrival, however, the easy conquest of California was found to be already complete.[9]

The *Columbus* also voyaged to China, then to Tokyo Bay. On the way cholera broke out in the crew, apparently from water casks refilled at Java. The disease affected the seamen more severely than the officers, who thought that the wine they drank at meals lessened their risk. At one time 120 men were ill, necessitating work by the officers and warrants in handling sail.

The *Columbus* returned to Norfolk on March 2, 1848. On October 9, Guillou was appointed to serve on the famous *Constitution*, part of the nation's Mediterranean Squadron, for three years. After a leave and foreign travel, he returned home to duty as surgeon of the Brooklyn Navy Yard. In 1852 he married, and in the next year resigned his commission to become head of the Marine Hospital in Honolulu. In 1866, King Kamehameha V sent him to Mexico as "Minister Plenipotentiary" to Emperor Maximilian. After an adventurous and dangerous trip by coach to the capital, enduring four robberies by bandits on the way, he and his wife and daughter eventually returned to the United States.[10]

Buying a farm near Petersburg, Virginia, he practiced medicine and raised tobacco and timber. Later he moved to New York and became a manufacturing pharmacist. He died in 1899 at the age of eighty-six.

Camp Peacock, Astoria, 1741

Sketch by Charles F. B. Guillou; in collection of Emily Blackmore, reproduced by her permission.

This view was drawn only four days after the shipwreck. Some of the officers found shelter in buildings of Fort George. The view shows the long lean-to and the great flag of the Peacock, *with a group of men in the open field.*

The Peacock*'s boats after the wreck, 1841*

Sketch by Charles F. B. Guillou; in collection of Emily Blackmore, reproduced by her permission.

"The launch and boats were . . . hoisted out, a few provisions put in them, and a part of the men and officers embarked, with as little delay as possible, and just as they stood, for fear of overloading the boats, and thus causing the loss of all. In these, Lieutenant Perry, with Purser Spieden, the sick, the naturalists, and the charts, books, and ship's papers, were sent off, to be landed in Baker's Bay" (Wilkes, Narrative, *4:492–93).*

"Fort George from George Point," 1841

Sketch by Charles F. B. Guillou; in collection of Emily Blackmore, reproduced by her permission.

In the middle is the settlement of Fort George, on the far right marked by the flag is Camp Peacock housing the crew. The vessel at the left displays a British flag.

"Bobville from Camp Peacock," 1841

Sketch by Charles F. B. Guillou; collection of Emily Blackmore, reproduced by her permission.

Bobville was named for Lieutenant Robert Johnson, who with Guillou, had been suspended from duty by Captain Wilkes. Johnson built a shelter for himself, held a housewarming, and, in jest, was elected "mayor" of the settlement of Fort George (Astoria). In the same spirit, the town was "renamed" Bobville in his honor. Johnson had been placed under arrest after exchanging angry words with Wilkes (Stanton, Great Expedition, *pp. 268–69).*

Charles Wilkes

Born in New York City on April 3, 1798, to a socially prominent and wealthy family, Wilkes in adolescence was considered "morbidly religious but . . . happily saved from overpiety by his ambition for a robust sea life and his frequenting of the wharves." His father had intended that he should be trained for a career in business and law, but after eighteen months of college preparatory school, Wilkes was even more attracted to the sea.[1]

He began taking lessons in navigation and nautical science, at the same time urging his father to secure for him an appointment as a midshipman. After he declined a well-salaried position in a bank, offered by an uncle, his father seemingly conceded defeat, and agreed to help find a berth in the merchant marine as a first step. The Navy Department had suggested this, since the period of service would be credited to him, and the waiting period curtailed.

The navy had no training school similar to the army's West Point established in 1802. Appointments as midshipmen were made from ages fourteen to seventeen. Mathematics and other needed skills were learned on ships possessing schoolteachers or chaplains, and by observation. The passing of an examination on seamanship and navigation earned the rank of passed-midshipman plus a salary increase from $400 to $750 annually.[2]

His father and uncle plotted with an acquaintance, the part-owner of the packet *Hibernia*, to provide what was intended as an overdose of life at sea. An incident in the English Channel unexpectedly favored young Wilkes. Captain Graham lacked an essential navigation chart and called Wilkes to his cabin to see if he could remember enough from his navigation school to supply pertinent data. Wilkes responded with a rough chart drawn from memory, enabling the *Hibernia* to land safely at Le Havre.

The captain, according to Wilkes, "was well satisfied when my task was completed & spoke more highly of the performance than was due." Wilkes also took observations: "the results being so readily & quickly obtained that Capt. Graham said he was bound to make me a good navigator & endeavored to take the credit of my expertness . . . although I was greatly afronted and provoked, I bore it patiently."[3]

Despite the captain's pleasure over this incident, he kept his pledge to help implant a profound distaste for a maritime career. The youthful Wilkes in turn recorded his concern: "what puzzled me was his continuing his growling and brutish conduct . . . and [permitting] his mates to 'haze' me about unnecessarily & to my great discomfort. Before the end of the voyage, some of the Older Sailors took to me and I was in a manner protected from the petty cruelties that were heaped upon me."

Captain Charles Wilkes, 1840s

Frontispiece engraving of a portrait by Thomas Scully, in Wilkes, *Narrative*, vol. 1; courtesy Pacific Northwest Collection, UW Libraries.

On his son's return, the father gave in to the inevitable, securing berths for him in other vessels, whose skippers agreed to give Wilkes special instruction, resulting in a letter of commendation from one. Shortly afterwards, his midshipman's warrant arrived directly with President Monroe, through the intervention of a family friend, the French minister at Washington.

It was not long before Wilkes was assigned to duty in the Mediterranean, where he served in 1819 and 1820, moving to the Pacific for the three following years. During this period, while on duty on the *Franklin* under Captain Charles Stewart at Valparaiso, he was recommended by Stewart for command of an American sealing vessel whose captain had died of fever. Since Hogan, the American consul, had the responsibility of locating a replacement, he gladly accepted Stewart's suggestion.

Wilkes was concerned at first: "I was almost appalled at taking charge of her, but Mr. Hogan encouraged me to go ahead and refit her." Hogan guided Wilkes in procedures, including drawing on the consul for previously approved expenditures. "He also fixed my pay at $80 per month, half the passage money, and the freight on Specie & [illegible] so that there should be no difficulty when I Delivered the Ship over to the Owner at Boston."[5] The bonus would be most welcome, in view of his hopes for marriage on his return.

The unusual assignment was fraught with problems for the young midshipman, untried in independent command. Among the challenges were the need to recruit a first and second mate and eighteen seamen, the last from waterfront dives, and the rounding of Cape Horn in the dead of winter. The initial problem of discipline was with a drunken steward who was discharged, but refused to quit the vessel. Wilkes gave orders to throw him overboard, which quickly established his authority with the crew (the steward was safely hauled aboard).

Six passengers embarked on the *O'Cain*, all experienced sea captains and older than Wilkes. He had been concerned that they would be critical of his command and, therefore,

inclined to interfere with the Navigation and crew, of whom some had been in their ships. I therefore told them that I was disposed to make their time on board as comfortable as laid in my power, but I should not permit any interference whatever on their part with the ship, my officers, or crew. That although very young, I well knew what I was able to do [while] not as long or experienced as they were, I felt equal to the duty . . . but I would broke no interference and if it was attempted, the Ship to them would become for the voyage a perfect h-ll. They all took it in good part.[6]

A fast passage was made to Boston, where the *O'Cain* had "long since been given up as lost and it was not only a surprise but a great gratification [to the owners]. Notwithstanding this . . . [they] did dispute many things . . . I expressed a desire that it . . . should be submitted to some accountant of standing and his decision abided by rather than have any dispute whatever." The owners agreed, and as a result Wilkes received "more than I anticipated." Altogether, including the proceeds of four bales of wool, his private venture, he received over $8,000.

During the ensuing six years Wilkes was engaged primarily in coastal surveys. He was named a lieutenant in 1826. Four years later, at age thirty-two, he was given a significant promotion to chief of the Bureau of Charts and Instruments, a forerunner of the Hydrographic Office and the Naval Observatory.

In 1837 the nation's ambitious plans to mount a great world girdling scientific and exploring expedition, was bogged down by delays, frustrations, and personalities, and had become a project in search of a leader, due to the resignation of the initial commander. Charles Wilkes was named in his place.

Aware of the prevalent opinion of his peers that he lacked sufficient experience at sea, Wilkes felt a pressing need to demonstrate his seamanship, as well as to enforce strict discipline to counter charges that the expedition was actually to be a pleasure cruise, since it had no military purpose.[7]

Shortly after leaving Hampton Roads on August 18, 1838, he took the first step to establish the dignity of a squadron commander of six vessels, by adopting the practice of dining alone in his cabin. Three weeks later, he strengthened his image as an exacting leader, mustering all hands on deck to observe the maximum punishment of a dozen lashes for a seaman who was found asleep while on lookout.

In the early days of the voyage, all of Wilkes' officers, many of the seamen, and most certainly Wilkes himself, must have been eagerly anticipating the discoveries and achievements yet to come. It was not long before this unity of hope and enthusiasm began to dissolve. Lieutenant Sinclair recalled their departure, "Full of ardour, unanimity and ambition . . . [we deplored the] want of encouragement and our unanimity censured as being improper." Another officer, later in the voyage, felt that "if he [Wilkes] expects to produce great results from this cruise, he must not use the beings under him, as if they were so many stones."

Dr. Whittle's feelings also changed toward Wilkes, "whom we all liked so much & who seemed disposed to behave so honourably and even kindly toward us . . . instead of behaving himself with that moderation and dignity which a man so much elevated above his rank must do to return any of the respect & love of his fellows. All his energies seem exerted to the exaltation of a few favorites, the persecution of the rest of his officers the very best & the most experienced in the Squadron."

Wilkes' reprimanding of officers in the hearing of others, and in one humiliating instance, through his trumpet enabling all to hear, struck at the essential human emotions of simple dignity and self-respect.

It was perhaps inevitable that at the end of the voyage, Wilkes' intolerance of most of his officers, and their cumulative resentment in turn, should have resulted in a series of courts-martial with charges and counter-charges. During the proceedings there was testimony favorable to Wilkes: "very prompt and energetic, and decided in his manner," was considered gentlemanly, even courteous, toward his officers; another officer knew nothing of his being "harsh, overbearing, and insulting personally," while another said that Wilkes averaged five hours daily for sleep, going without on occasion to the point of affecting his health. Captain Hudson said "Mr. Wilkes is of an excitable character, and he wishes every officer to move when he gives him an order . . . I have never seen him excited without cause."

None of the twenty-three cases resulted in punishment more serious than public reprimand and temporary suspension from duty without pay. In the opinion of one well-qualified contemporary observer, "the charges against the officers were trivial or arose from trivial circumstances . . . those against Wilkes himself were not much more serious . . . the whole affair did not justify a court-martial."

Wilkes was found not guilty, or the charges were not proven, except as to the illegal punishment of seamen (navy regulations forbade any punishment of more than twelve lashes except by verdict of a court-martial). He was sentenced to be publicly reprimanded, a severe punishment for a proud, sensitive officer who in fact had successfully carried out the nation's greatest exploring expedition up to that time.

During the ensuing years until 1861, he was chiefly engaged in preparing the first nineteen volumes of the expedition report for publication, out of twenty-eight planned. When the Civil War erupted, Wilkes was given command of the *San Jacinto*, and assigned to search for the confederate privateer *Sumter*.

He belatedly became a national hero and received the official commendation of Congress for intercepting the British mail packet *Trent*, and removing the Confederate commissioners, Mason and Slidell, who were bound for Europe. His action was later disavowed by President Lincoln, after strong protests by the British government.

Wilkes was commissioned a commodore in 1862, and placed in command of the "Potomac Flotilla," and later of a special "flying" squadron operating against blockade runners in the West Indies.

After retirement in 1864 he resumed the project, interrupted by the war, of publishing the remaining volumes of the expedition reports. A number of the originally scheduled volumes would remain unpublished, except for sections privately printed. Wilkes published many shorter articles and reports, in addition to three books relating to the voyage.

In 1866 he was promoted to rear-admiral on the retired list. He died in Washington on February 8, 1877, a few weeks short of his seventy-ninth birthday.

His contributions to future generations, as well as his own, were manifold. In the view of Commander F. W. Reichelderfer, writing in the *Proceedings of the American Philosophical Society*, "he was a pioneer in charting sailing routes and his observations still are represented in the averages shown on the Pilot Charts published monthly by the Hydrographic Office, charts which, during the days of sailing vessels, led to enormous savings in time of ocean passage and to great benefits to shipping of all nations."[8]

Daniel Henderson, while conducting research for his excellent Wilkes biography, located in the National Archives the official map drawn by Wilkes of the Oregon territory, as well as data about the "secret assignment" by the government which required him to advise it on conditions there and about routes into the country. In fulfilling this duty, he constructed the first accurate map of the area. Of this, Wilkes wrote, according to Henderson: "the portion colored in red has been nearly all carefully explored and its waters particularly surveyed and of the portion in blue authentic information has been received from intelligent persons who have examined particular parts of the country."[9]

Wilkes' detailed reports, accompanied by the map, had, in the opinion of historian William Denison Lyman, a profound influence on government officials, in bringing about a realization that the various parts of the Pacific Coast must be regarded as a whole, "that Puget Sound was an inherent and integral part of Oregon, and that the Columbia Basin was essential to the proper development of American commerce upon the Pacific."[10]

The time is long overdue for a realistic, fair public reappraisal of Wilkes' achievements. Writes Henderson in *Hidden Coasts*: "it is strange that there is no conspicious monument for this superb navigator, foremost scientist, pioneering explorer, distinguished coast surveyor, military strategist, and audacious commander of a Union war squadron . . . the Navy is obviously the place where this revaluation should begin" (p. 278).

"Tatouche chief," 1841

Woodcut engraving of a drawing by Charles Wilkes in his *Narrative*, 4:486; courtesy Pacific Northwest Collection, UW Libraries.

"The ship, on anchoring [near Neah Bay], was surrounded by many canoes of the Classet Indians . . .
George, the chief of the Tatouche tribe, as he terms himself, was on board all day. He speaks a few words of
English, and is a fine-looking man. It was difficult to make him or any of his people understand the use of a
man-of-war, the number of people on board, and the care that was taken to keep them from coming on board.
I succeeded in getting his likeness with the camera lucida, with which he was much pleased . . . on my
remarking a scar on the bridge of his nose . . . he told me it was the custom with them to cut the nose when
they had taken a whale, which they considered a great exploit. These Indians wore small pieces of an iridescent
mussel-shell, attached to the cartilage of their nose . . . generally kept in motion by their breathing"
(Wilkes, Narrative, 4:486–87).

"De Fuca's Pillar," 1841

Woodcut engraving of a sketch by Charles Wilkes in his *Narrative*, 4:496; courtesy Pacific Northwest Collection, UW Libraries.

"In leaving De Fuca's Straits I anxiously watched for De Fuca's Pillar, and soon obtained a sketch of it"
(Wilkes, Narrative, *4:488).*

"Salmon Fishery on Chickelis [Chehalis] River," 1841

Engraving of a drawing by Charles Wilkes in his *Narrative*, 4:313; courtesy Pacific Northwest Collection, UW Libraries.

"After a ride of twelve miles, we reached Chickeeles river, which empties itself into Gray's Harbour . . . we found the stream about two hundred yards wide in this place . . . on its banks there were a few lodges, containing about twenty Indians of the Nisqually tribe, who had come here to make preparations for the salmon-fishery. . . . They were a miserable-looking set, barely covered with pieces of dirty blankets and skins" (Wilkes, Narrative, 4:313).

Appendix

Selected major repositories of original drawings

Bancroft Library, University of California, Berkeley

Harry Humphrys
G. H. von Langsdorff
John Sykes

Beinecke Rare Book and Manuscript Library, Yale University

Louis Choris
Henry Eld

The British Library, London

John Webber

Central State Archive of the USSR Navy

M. D. Levashov
Luka Voronin

Columbia River Maritime Museum, Astoria

George Davidson

Hydrographic Department, Ministry of Defence, Taunton, England

F. W. Beechey
Harry Humphrys
John Sykes

Library of Congress, Washington, D.C.

Joseph Ingraham

Massachusetts Historical Society, Boston

John Boit (journal)
Robert Haswell (journal)

Paul Mellon Collection, Upperville, Virginia

Sigismund Bacstrom

Ministerio de Asuntos Exteriores, Madrid

Atanásio Echeverría

Museo de America, Madrid

José Cardero
Tomás de Suría

Museo Naval, Madrid

José Cardero
Tomás de Suría

National Library of Australia, Canberra

George Dixon
William Ellis
John Webber

National Maritime Museum, London

William Ellis

Oregon Historical Society, Portland

George Davidson
Joseph Drayton

Peabody Museum, Cambridge, Mass.

John Bartlett (journal)
John Webber

Public Record Office, London

Joseph Baker (journal)
Harry Humphrys
Zachary Mudge (log)

Service Historique de la Marine, Vincennes

Blondela
Duché de Vancy

State Library of New South Wales (Dixon Library), Sydney

Henry Roberts
John Webber

University of Alaska, Fairbanks

William Smyth

Special Collections Division, University of British Columbia Library, Vancouver

Edward Belcher

Scientific Research Museum of the U.S.S.R. Academy of Arts, Leningrad

Mikhail Tikhanov

Notes

Introduction

1. Vancouver, *Voyage*, l:xlv.
2. Jewitt, *Narrative*, p. 35.
3. Jackman, *Sturgis Journal*, pp. 56, 64–65.
4. Smith, *European Vision*, p. 9; Christ's Hospital, "Exhibition Catalogue," p. 15.
5. La Pérouse, *Voyage*, 1:102.
6. Sauer, *An Account*, pp. 35, 38.
7. Shur and Pierce, "Pavel Mikhailov," p. 360.
8. David, "A List," pp. vi, 7.
9. Cutter, "Early Spanish Artists," pp. 156–57.
10. Cutter, "Malaspina at Yakutat Bay," p. 48.
11. Tero, "Riobo's Narrative," pp. 81–88.
12. Wagner, *Cartography*, 1:172–236 passim.
13. Golder, *Guide*, p. 1.

The Russian Voyages

The Second Voyage of Vitus Bering

The primary source for this voyage is F. A. Golder, *Bering's Voyages*, vols. 1 and 2.
1. Golder, *Bering's Voyages*, 2:16.
2. Ibid., 1:333; 2:60.
3. Ibid., 2:23, 30.
4. Wagner, *Cartography*, 1:157.

Sofron Khitrov

1. Saltykov-Shchedrin Library to Marino Kraabel, January 3, 1980.
2. Golder, *Bering's Voyages*, 2:20.
3. Ibid., 2:151–52.
4. Waxell, *Expedition*, p. 129.
5. Golder, *Bering's Voyages*, 1:143, 273; Waxell, *Expedition*, p. 112.
6. Saltykov-Shchedrin Library to Kraabel.

Friedrich Plenisner

1. Stejneger, *Steller*, pp. 240, 510.
2. Steller's journal in Golder, *Bering's Voyages*, 2:148, 171–73.
3. Stejneger, *Steller*, pp. 386–87.
4. Ibid., p. 387.
5. Sauer, *An Account*, Appendix 5, p. 34.
6. Stejneger, *Steller*, pp. 388–89.

Sven Waxell

1. Waxell, *Expedition*, pp. 24–25.
2. Ibid., pp. 26–27.
3. Golder, *Bering's Voyages*, 1:32, 70–71; 2:18–19.
4. Waxell, *Expedition*, p. 27.

A Secret Voyage to the Aleutians

The primary source for this voyage is Glushankov's "The Aleutian Expedition of Krenitsyn and Levashov."
1. Glushankov, "Expedition," p. 205.
2. Ibid.
3. Ibid., pp. 206–7.

Petr Kuz'mich Krenitsyn

1. Glushankov, "Expedition," p. 205.
2. Coxe, *Russian Discoveries*, p. 266n.

Mikhail Dmitrievich Levashov

1. Glushankov, "Expedition," pp. 200–6.
2. Ibid., pp. 207, 209.

Joseph Billings and the Slava Rossjii

1. W. Cook, *Flood Tide*, pp. 114–15.
2. Sauer, *An Account*, Appendix, p. 29.
3. Bancroft, *Works*, 33:283–84, 295–96, 298.
4. Sarychev, *Voyage*, 1:79.
5. Beaglehole, *Cook Journals*, 3:1474.
6. Sarychev, *Voyage*, 2:35.
7. Bancroft, *Works*, 33:296–97.

Gavril Andreevich Sarychev

1. Golder, *Guide*, 1:135.
2. Sauer, *An Account*, p. 231.
3. Sarychev, *Voyage*, 1:63–64. Subsequent quotations are also taken from Sarychev's *Voyage*, 1:59–64; 2:26–27, 78.
4. *Entsik. slovar'*.

Luka Alekseevich Voronin

1. Sauer, *An Account*, p. 35.
2. *Khudoshniki Narodov USSR* (Artists of the Peoples of USSR), s.v. "Voronin, Luka Alekseevich."
3. Sauer, *An Account*, pp. 244–45.
4. Sarychev, *Voyage*, 2:80; *Khudoshniki Narodov USSR*.

The Voyages of James Shields

1. Vancouver, *Voyage*, 3:222.
2. Khlebnikov, *Baranov*, pp. 9–10.
3. Tikhmenev, *Russian-American Co.*, p. 33.
4. Khlebnikov, *Baranov*, p. 10, 14–17; Tikhmenev, *Russian-American Co.*, p. 33.
5. Tikhmenev, *Russian-American Co.*, p. 59.
6. Khlebnikov, *Baranov*, p. 32.
7. Golder, *Guide*, 1:118.

Krusenstern & Lisianskii in the *Nadezhda & Neva*

1. Nozikov, *Russian Voyages*, pp. 1–2; Majors, "Science and Exploration," p. 847.
2. Krusenstern, *Voyage of 1803–6*, 1:2–3.
3. Nozikov, *Russian Voyages*, p. 3.
4. Majors, "Science and Exploration," p. 847.
5. Nozikov, *Russian Voyages*, pp. 11–12; Majors, "Science and Exploration," p. 848.
6. Lisianskii, *Voyage*, p. 155.
7. Ibid., p. 162.

Georg Heinrich von Langsdorff

1. Langsdorff, *Voyages*, 1:vii.
2. Ibid., 1:vii–viii, ix.
3. Krusenstern, *Voyage of 1803–6*, 1:29.
4. Ibid., 2:101; Langsdorff, *Voyages*, 2:1–3.
5. Langsdorff, *Voyages*, 2:52, 57, 70–72.
6. Ibid., 2:225–26, 294.
7. Krusenstern, *Voyage of 1803–6*, 1:xxx–xxxi.
8. Barman, *Langsdorff in Brazil*, pp. 74–75, 87–91.
9. Ibid., pp. 95–96.

Yuri Fedorovich Lisianskii

1. Lisianskii, *Voyage*, pp. xvi–xvii.
2. Nozikov, *Russian Voyages*, p. 2.
3. Lisianskii, *Voyage*, pp. xvii–xviii.
4. Ibid., pp. xviii–xix, xx.
5. Ibid., pp. xx–xxi, 318.
6. Nozikov, *Russian Voyages*, pp. 74–75.
7. Lisianskii, *Voyage*, p. 317.

The Voyages of Ivan Filippovich Vasil'ev

1. Fedorova, *Russian Population*, p. 253.
2. Golovnin, *Kamchatka Voyage*, pp. 108–11, 301–5.
3. Fedorova, *Russian Population*, p. 253.
4. Ibid., pp. 347–48, n177.
5. Golovnin, *Kamchatka Voyage*, pp. 96–97, 98.
6. Fedorova, *Russian Population*, pp. 347–48.

Kotzebue and the *Rurik*

The primary source for this voyage is Kotzebue, *Voyage of Discovery in the South Sea, and to Behring's Straits*, vol. 1.
1. Kotzebue, *Voyage*, 1:6.
2. Ibid., 1:10–16, 18–19.
3. Ibid., 1:90–91, 206, 212, 217.

Louis Choris

1. *Entsik. slovar'*, s.v. "Khoris, Loggin Andreevich"; Mahr, *Rurik Visit*, p. 12.
2. Kotzebue, *Voyage*, 1:25.
3. Choris, *Voyage*, n.p., see "Liste," next to last page.
4. Mahr, *Rurik Visit*, pp. 12, 95.
5. Ibid., p. 103.
6. Kotzebue, *Voyage*, 1:230, 262.
7. *Entsik. slovar'*; *Russ. bio. slovar'*, s.v. "Khoris, Loggin Andreevich."

V. M. Golovnin and the *Kamchatka*

The primary source for this voyage is Golovnin, *Kamchatka Voyage*.
1. Golovnin, *Kamchatka Voyage*, p. 7.
2. Ibid., pp. 8, 9, 30, 32, note f.
3. Ibid., pp. 127, 130.

Mikhail Tikhanov

1. Golovnin, *Kamchatka Voyage*, pp. xxxii–xxxiii; Shur and Pierce, "Mikhail Tikhanov," p. 48n.
2. Golovnin, *Kamchatka Voyage*, p. xxxiii; Shur and Pierce, "Mikhail Tikhanov," p. 47.
3. Shur and Pierce, "Mikhail Tikhanov," p. 45.
4. Golovnin, *Kamchatka Voyage*, p. xxxiv.

The Voyages of Pavel Mikhailov

1. Shur and Pierce, "Pavel Mikhailov," pp. 360–61.
2. Ibid., pp. 362–63.

Litke and the *Seniavin*

1. Majors, "Science and Exploration," p. 864; Nozikov, *Russian Voyages*, pp. 99, 101, 102.
2. Nozikov, *Russian Voyages*, pp. 116, 118–19.
3. Ibid., pp. 135, 163.

Friedrich Heinrich von Kittlitz

The primary source on Kittlitz is his own *Twenty Four Views of Coasts and Islands of the Pacific*.
 1. Kittlitz, *Twenty-Four Views*, pp. 4, 6.

Aleksandr Filippovich Postels

 1. *Entsik, slovar'*, s.v. "Postels, Aleksandr Filippovich."
 2. Litke, *Voyage*, 1:xviii–xxi.
 3. Ibid., 2:208–9, 210, 213.
 4. *Entsik, slovar'*.

The British Voyages

James Cook's Last Voyage

 1. Beaglehole, *Cook Journals*, 3:ccxx–ccxxii.
 2. Ibid., 3:289, 293–94.
 3. Ibid., 3:367.
 4. Ibid., 3:371–72.
 5. Cook and King, *Voyage*, 3:38–39.
 6. Beaglehole, *Life*, p. 681.
 7. Beaglehole, *Cook Journals*, 3:697.

William Bligh

 1. Rawson, *Bligh*, pp. 6, 8, 14.
 2. Beaglehole, *Cook Journals*, 3:lxxviii.
 3. Gould, "Bligh's Notes," p. 371.
 4. Rawson, *Bligh*, pp. 22, 29.
 5. Beaglehole, *Life*, p. 692.
 6. Beaglehole, *Cook Journals*, 3:lxxviii.
 7. Rawson, *Bligh*, pp. 183, 186–87, 226.
 8. Beaglehole, *Cook Journals*, 3:27, 296n; Vancouver, *Voyage*, 3:163.

William Ellis

 1. Beaglehole, *Cook Journals*, 3:xxxiv.
 2. Ibid., 3:lxxxvi, 1473.
 3. Ibid., 3:1543.
 4. Howay, *Zimmerman*, p. 8; Beaglehole, *Cook Journals*, 3:ccxxiv.
 5. Howay, *Zimmerman*, pp. 7–9.
 6. Ibid., pp. 13–14.
 7. Ellis, *Authentic Narrative*, 1:205–6.
 8. *Gentlemen's Magazine*, 55 (pt. 2), p. 571 (July 1785).

Henry Roberts

 1. Beaglehole, *Cook Journals*, 3:498.
 2. Ibid., 3:551n.
 3. Ibid., 3:1560.
 4. Beaglehole, *Cook Journals*, 3:875.
 5. Naval Historical Branch, Ministry of Defence, London, to J. F. Henry, January 26, 1981.

John Webber

 1. Cole, "Webber," pp. 18–19, 20.
 2. Beaglehole, *Cook Journals*, 3:1459, 1507.
 3. Ibid., 3:1507.
 4. Cole, "Webber," pp. 20–21; Kaeppler, *Cook Voyage Artifacts*, p. 29.
 5. Cole, "Webber," p. 21–22.

Portlock and Dixon's Expedition of 1785–88

 1. Etches, *Authentic Statement*, pp. 2–3.
 2. Portlock, *Voyage*, pp. 63–64.
 3. Dixon, *Voyage*, pp. 234, 304.
 4. Ibid., p. 382.

George Dixon

 1. Beaglehole, *Cook Journals*, 3:1475.
 2. Portlock, *Voyage*, p. 5.
 3. Dixon, *Voyage*, pp. 235–36.
 4. Howay, *Dixon-Meares*, pp. 3, 27.
 5. Wagner, *Cartography*, 2:384.

James Hogan

The primary source for the biographical sketch is Portlock's *Voyage Round the World* (1789).
 1. Portlock, *Voyage*, p. 6. Subsequent quotations are cited in the text.

Joseph Woodcock

 1. Portlock, *Voyage*, p. 6
 2. Ibid., p. 7.
 3. Curtis, *History of Education*, p. 111; Smith, *European Vision*, p. 9.
 4. Ltr., Guildhall Library to J. F. Henry, June 5, 1979; Christ's Hospital to Henry, May 7, 1979.
 5. Portlock, *Voyage*, pp. 8, 22.
 6. Ibid., pp. 261, 269.
 7. Wagner, *Cartography*, 1:524.

John Meares and the *Nootka* and *Felice*

 1. W. Cook, *Flood Tide*, p. 137.
 2. Meares, *Voyages*, p. xii.
 3. Ibid., pp. xviii, xx, xxxvi.
 4. Meares, *Voyages*, pp. xxv, xxxv; Portlock, *Voyage*, pp. 233–34; Howay, *Dixon-Meares*, p. 11.
 5. Wagner, *Cartography*, 1:210.
 6. Meares, *Voyages*, p. 2.
 7. Wagner, *Cartography*, 1:210.
 8. Meares, *Voyages*, pp. 221–22; Wagner, *Cartography*, 1:210.
 9. W. Cook, *Flood Tide*, pp. 144–45.

John Meares

 1. *Dict. Nat. Bio.*, s.v. "Meares, John."
 2. Meares, *Voyages*, A,vi.
 3. W. Cook, *Flood Tide*, pp. 173–74, 179.
 4. Meares, *Voyages*, pp. lxi—lxiii.
 5. Howay, *Dixon-Meares*, p. 2.
 6. Ibid.
 7. W. Cook, *Flood Tide*, p. 535.

Vancouver and the *Discovery* and *Chatham*

1. Wagner, *Cartography*, 1:239.
2. Vancouver, *Voyage*, 1:xviii–xx. xxiii–xxiv.
3. Ibid., 1:385.
4. Vancouver, *Voyage*, 1:399–404; 3:29, 31–32, 56.
5. Ibid., 3:125, 272.
6. Anderson, *Life*, p. 213.
7. Ibid., p. 231; Heawood, *History*, p. 297.
8. Greenhow, *Memoir*, p. 139.

Joseph Baker

1. Vancouver, *Voyage*, 1:222.
2. Ibid., 2:101, 410.
3. Hewett, "Notes," 1:3.
4. Vancouver, *Voyage*, 3:486.

Thomas Heddington

1. Meany, *Vancouver*, p. 339.
2. M. Lewis, *The Navy*, p. 155.
3. O'Byrne, *Bio. Dictionary*, s.v., "Thomas Heddington."
4. Marshall, supplement, s.v. "Thomas Heddington, Esq."
5. Fuller, *Mutiny*, pp. 83–84.
6. Ltr., A. C. F. David to J. F. Henry, April 7, 1979.
7. Ltr., Naval Historical Library (London) to Henry, November 11, 1980.

Harry Humphrys

1. Meany, *Vancouver*, pp. 336–37; ltr., A. C. F. David to J. F. Henry, April 7, 1979.
2. Anderson, *Life*, pp. 199–200; ltr., A. C. F. David to Henry.
3. Ltr., A. C. F. David to Henry, April 7, 1979.
4. Newcombe, *Menzies Journal*, pp. 66–68.

Zachary Mudge

1. Godwin, *Vancouver*, p. 174.
2. Meany, *Vancouver*, p. 337.
3. Vancouver, *Voyage*, 2:328; *B.C. Pilot, Southern Portion*, p. 253.
4. Anderson, *Life*, pp. 112–13.
5. Broughton, *Voyage Providence*, p. 54.
6. Ibid., p. 206.
7. Meany, *Vancouver*, p. 227; *Dossiers of Ships*, s.v. "Zachary Mudge."

John Sykes

1. Anderson, *Life*, p. 196.
2. O'Byrne, *Bio. Dictionary*, s.v. "John Sykes"; Beaglehole, *Cook Journals*, 3:1458–59; M. Lewis, *The Navy*, p. 155.
3. Anderson, *Life*, pp. 38, 44; O'Byrne, *Bio. Dictionary*.
4. Meany, *Vancouver*, p. 336; O'Byrne, *Bio. Dictionary*.
5. Vancouver, *Voyage*, 2:358–62; Sykes, "A Log," August 16, 1793.
6. Anderson, *Life*, p. 214.
7. O'Byrne, *Bio. Dictionary*.
8. *Illustrated London News*, March 13, 1858, p. 271.

The Voyages of Sigismund Bacstrom

The primary source for these voyages is Douglas Cole, "Sigismund Bacstrom's Northwest Coast Drawings and an Account of His Curious Career."
1. Cole, "Bacstrom," p. 62. Subsequent quotations are found on pp. 62-68.
2. Beaglehole, *Endeavor Journal*, 1:69, 73n.

Frederick Beechey and H.M.S. *Blossom*

The primary source for this voyage is Beechey's *Narrative of a Voyage to the Pacific and Beering's Strait*, vols. 1 and 2.
1. Beechey, *Narrative*, 1:viii, xiii. Subsequent quotations are cited in the text.
2. Barrow, *Voyages*, 1:414–15, 433–35.

Frederick W. Beechey

1. O'Byrne, *Bio. Dictionary*, s.v. "Frederick William Beechey."
2. Ibid.
3. Gough, *To the Pacific*, p. 19.
4. Beechey, *Voyage*, p. 94; Gough, *To the Pacific*, p. 19.
5. Beechey, *Proceedings*.
6. Beechey, *Narrative*, 1:135.
7. Ibid., 1:403, 407–8.

William Smyth

1. Beechey, *Narrative*, 1:vii; Gough, *To The Pacific*, pp.44, 46.
2. Beechey, *Narrative*, 1:416, 442.
3. Ibid., 2:282–83.
4. M. Lewis, *The Navy*, pp. 69, 72.
5. Dawson, *Memoirs*, 2:77.
6. O'Byrne, *Bio. Dictionary*, s.v. "William Smyth"; Barrow, *Voyages*, pp. 488, 505.
7. Barrow, *Voyages*, p. 495.
8. Dawson, *Memoirs*, 2:77.

James Wolfe

1. Dawson, *Memoirs*, 2:58; Beechey, *Narrative*, 1:xv.
2. Withington, *Manuscripts*, pp. 308–9.
3. Beechey, *Narrative*, 1:198.
4. Wolfe, "Journal," p. 110.
5. Dawson, *Memoirs*, 2:58.

Edward Belcher and H.M.S. *Sulphur*

1. Belcher, *Narrative*, 1:2, 4, 72.
2. Pierce and Winslow, *Sulphur*, pp. 89–90; Belcher, *Narrative*, 1:100-2.
3. Pierce and Winslow, *Sulphur*, p. 107; Belcher, *Narrative*, 1:107, 132.
4. Belcher, *Narrative*, 1:xxii, xxiv.
5. Ibid., 1:283.
6. Pierce and Winslow, *Sulphur*, p. xi.

Edward Belcher

1. Pierce and Winslow, *Sulphur*, pp. 123–24.
2. Wilkes, *Autobiography*, pp. 462–63.
3. Ibid., p. 515.
4. *Dict. Nat. Bio.* (1885)

Francis Guillemard Simpkinson

The primary source for the biographical sketch is Pierce and Winslow, *H.M.S. Sulphur on the Northwest and California Coasts*.
 1. Pierce and Winslow, *Sulphur*, , pp. v–vii. For subsequent quotations, see pages 89–90 and 123–24.

The French Voyages

La Pérouse and the *Boussole* and *Astrolabe*

 1. Valentin, *Voyages La Pérouse*, pp. xvii–xviii.
 2. Ibid., p. xviii; ltr., Ministry of Culture to J. F. Henry, July 11, 1979.
 3. La Pérouse, *Voyage*, 1:367, 376–79, 387.
 4. Ibid., 1:427–28, 432; 2:133, 135–40.
 5. Valentin, *Voyages La Pérouse*, p. 136–39, 141.

Lieutenant de frégate Blondela

 1. Ltr., Ministry of Culture to J. F. Henry, May 23, 1979.
 2. Ministère etrangers, *Les combattants*, p. 138; Scott, *De Grasse à Yorktown*, p. 204; C. Lewis, *Sea Fighters*, pp. 204–8.
 3. La Pérouse, *Voyage*, 2:446.
 4. Ibid., 2:451, 462, 493.
 5. Ibid., 2:519.
 6. Dillon, *Fate of La Pérouse*, 2:403–4.

Gaspard Duché de Vancy

 1. Smith, *European Vision*, p. 102.
 2. La Pérouse, *Voyage*, 2:451, 493.
 3. Ibid., 2:452.
 4. *Catalogue general de la marine*, pp. 101–2.
 5. La Pérouse, *Voyage*, 1:389 and n.

The Spanish Voyages

Malaspina and the *Descubierta* and *Atrevida*

 1. Wagner, *Cartography*, 1:225.
 2. W. Cook, *Flood Tide*, p. 119.
 3. Wagner, *Cartography*, 1:226–27.
 4. Cutter, "Malaspina at Yakutat Bay," p. 48.
 5. W. Cook, *Flood Tide*, pp. 310–12.
 6. Ibid., pp. 318–19, 356, 563.

Felipe Bauzá y Cañas

 1. Vaughan et al., *Voyages*, p. 5.
 2. Cutter, "Early Spanish Artists," p. 152; Vaughan et al., *Voyages*, p. 5.
 3. Vaughan et al., *Voyages*, p. 6.
 4. Cutter, "Review," p. 154.
 5. Vaughan et al., *Voyages*, p. 6.
 6. Cutter, "Early Spanish Artists," p. 152.

Tomás de Suría

 1. Wagner, *Suria Journal*, p. 277.
 2. Cutter, *Malaspina in California*, p. 14.
 3. Cutter and de Iglesias, "Malaspina's Artists," p. 22; Wagner, *Suria Journal*, p. 241.
 4. Wagner, *Suria Journal*, pp. 245, 247.
 5. Ibid., p. 251.
 6. Cutter and de Iglesias, "Malaspina's Artists," p. 24; Cutter, "Early Spanish Artists," p. 155; Cutter, *Malaspina in California*, p. 15.
 7. Cutter, *Malaspina in California*, p. 15.

Galiano and Valdés and the *Sutil* and *Mexicana*

 1. Wagner, *Cartography*, 1:231.
 2. [Cardero], *A Spanish Voyage*, p. 9, 12 15.
 3. Ibid., pp. 43–44, 55–56; Wagner, *Spanish Explorations*, p. 51.
 4. [Cardero], *A Spanish Voyage*, pp. 61, 63.
 5. Wagner, *Spanish Explorations*, p. 55.

José Cardero

 1. Cutter, *Malaspina in California*, pp. 12, 13, 22n.
 2. Cutter and de Iglesias, "Malaspina's Artists," p. 26.
 3. Cutter, "Early Spanish Artists," pp. 153 and n.
 4. [Cardero], *A Spanish Voyage*, p. 57. Subsequent quotations are cited in the text.
 5. Cutter, "Early Spanish Artists," p. 155.
 6. Cutter, *Malaspina in California*, pp. 13–14, 22n.
 7. Wagner, *Cartography*, 2:382; Wood, *San Juan Island Names*, p. 22.

Bodega y Quadra and the Nootka Convention

 1. W. Cook, *Flood Tide*, pp. 70–71, 134.
 2. Ibid., pp. 332–33.
 3. *Official Spanish Documents*, trans. Daylton, pp. 48, 54.
 4. Howay, *Columbia Voyages*, p. 485.

Atanásio Echeverría y Godoy

 1. Moziño, *Noticias*, p. 83 and n.
 2. Cutter, "Early Spanish Artists," p. 156; Moziño, *Noticias*, p. xlix.
 3. Newcombe, *Menzies Journal*, p. 128.
 4. Moziño, *Noticias*, pp. xlix, xlviii.
 5. Ibid., pp. xlviii, lii.

The American Voyages

Columbia & Washington under Gray & Kendrick

1. Sparks, *Life of Ledyard*, pp. 131–37.
2. Howay, *Columbia Voyages*, p. vi.
3. Porter, "Ship Columbia," p. 479.
4. Howay, *Columbia Voyages*, p. ix.
5. Ibid., pp. 303–6, 390.
6. W. Cook, *Flood Tide*, p. 342.

George Davidson

1. Porter, "Ship Columbia," p. 479.
2. Howay, *Columbia Voyages*, pp. 338, 374, 390, 406, 447.
3. Ibid., pp. 356, 430.
4. Mrs. C. W. DuBois (a descendant of Popkins) to J. F. Henry, March 20, 1978; *Proceedings*, Mass. Hist. Soc., May 1892, p. 416n, and January 1871, p. 1.
5. Wyman, *Genealogies*, p. 277.
6. Howay, *Fur Trading Vessels*, pp. 168–69.
7. Jackman, *Sturgis Journal*, p. 116.
8. Probate Records, no. 5962, Middlesex County, Mass.

Robert Haswell

The primary sources on Haswell are Howay's *Voyages of the Columbia to the Northwest Coast*, pp. 4–14, and "Some Notes on Haswell."
1. Howay, *Columbia Voyages*, p. xviii.
2. Howay, "Haswell," pp. 595–97.
3. Ibid., pp. 597–98.
4. Callahan, *List*, p. 253.
5. Howay, "Haswell," p. 599.

Joseph Ingraham and the Brigantine *Hope*

The primary source for this voyage is Ingraham's "Journal of the Brigantine *Hope* from Boston to the North-west Coast of America."
1. Kaplanoff, *Ingraham's Journal*, p. xiii.
2. Ingraham, "Journal," p. 46. Subsequent quotations are cited in the text.

Joseph Ingraham

1. Howay, *Columbia Voyages*, p. 7.
2. Ingraham, "Journal," pp. 1–2. Subsequent quotations from the journal are cited in the text.
3. Greenhow, *Memoir*, p. 120.
4. Kaplanoff, *Ingraham's Journal*, p. 248.
5. Ibid., p. xxiv.

The Voyages of Seaman John Bartlett

The primary source for these voyages is Bartlett's "Remarks on Board the Ship Massachusetts," pp. 1–87.
1. Marine Research Society, *Sea, Ship, Sailor*, p. 289.
2. Bartlett, "Remarks," pp. 1, 5. Subsequent quotations are cited in the text.
3. Delano, *Narrative*, p. 29; Bartlett, "Remarks," pp. 57–87 passim.

The Trading Sloop *Union*

The primary source for this voyage is Hayes, *Log of the Union*.
1. Hayes, *Log of the Union*, p. 3. Subsequent quotations are cited in the text.
2. Howay, *Columbia Voyages*, p. xxiii.

John Boit

The primary sources on Boit are Howay, *Voyages of the Columbia to the Northwest Coast*, and Hayes, *Log of the Union*.
1. Howay, *Columbia Voyages*, pp. xxii, xxv; Hayes, *Log of the Union*, p. xxvi.
2. Howay, *Columbia Voyages*, p. xxv.

The United States Exploring Expedition

1. Tyler, *Wilkes*, p. 4.
2. Ibid., pp. 7, 11–13.
3. Wilkes, *Narrative*, 1:xv–xvi. Quotations from the *Narrative* are cited in the text.
4. Majors, "Science and Exploration," p. 882; Tyler, *Wilkes*, p. 153 and n.
5. Majors, "Science and Exploration," p. 883.
6. Ibid., p. 884.
7. Tyler, *Wilkes*, pp. 403–4.

Alfred Agate

1. Wilkes, *Autobiography*, pp. 225–26.
2. Wilkes, *Narrative*, 3:120.
3. Ibid., 3:256.
4. Gilman, *Life of Dana*, p. 122.
5. Wilkes, *Narrative*, 5:218.
6. Ibid., 5:224–26, 239.
7. Tyler, *Wilkes*, pp. 406, 414.

James Dana

The primary source on Dana is Gilman's *Life of Dana*.
1. Gilman, *Life of Dana*, pp. 13–14, 22.
2. Ibid., pp. 31–32, 41, 367.
3. Ibid., pp. 67–68.
4. Haskell, *U.S. Ex. Ex. Publications*, p. 80.
5. H. H. Bartlett, *Wilkes' Reports*, p. 658.

Joseph Drayton

1. Haskell, *U.S. Ex. Ex. Publications*, p. 4; Tyler, *Wilkes*, pp. 39, 188; Wilkes, *Autobiography*, pp. 532–33.
2. Wilkes, *Autobiography*, p. 542; Stanton, *Great Expedition*, p. 83.
3. Tyler, *Wilkes*, p. 184.
4. Wilkes, *Narrative*, 4:369.
5. Haskell, *U.S. Ex. Ex. Publications*, pp. 9, 17.
6. Wilkes, *Autobiography*, pp. 542–43, 598.
7. Tyler, *Wilkes*, p. 418; Haskell, *U.S. Ex. Ex. Publications*, p. 82.
8. Tyler, *Wilkes*, pp. 414–15.

Henry Eld

1. Withington, *Manuscripts*, pp. 71–72; Poesch, *Peale*, p. 69.
2. Tyler, *Wilkes*, pp. 34, 37.
3. Ibid., pp. 102, 104, 117.
4. Sperlin, *Brackenridge*, pp. 41-46.
5. Wilkes, *Narrative*, 5:134.
6. Tyler, *Wilkes*, pp. 312, 318.
7. Ibid., pp. 391–92.
8. Wilkes, *Narrative*, 2:293; 3:258.

Charles F. B. Guillou

1. Blackmore, *Guillou*, p. 3.
2. Wilkes, *Autobiography*, p. 440.
3. Blackmore, *Guillou*, p. 4; Tyler, *Wilkes*, p. 196n.
4. Wilkes, *Autobiography*, pp. 419–20.
5. Ibid., p. 481.
6. Blackmore, *Guillou*, pp. 4, 5.
7. Tyler, *Wilkes*, pp. 342–43; Blackmore, *Guillou*, p. 8.
8. Henderson, *Hidden Coasts*, pp. 210–11; Blackmore, *Guillou*, pp. 9–10.
9. Blackmore, *Guillou*, pp. 9–11.
10. Ibid., pp. 12–13, 18–19.

Charles Wilkes

1. Henderson, *Hidden Coasts*, p. 8.
2. Tyler, *Wilkes*, p. 8.
3. Henderson, *Hidden Coasts*, pp. 10–12; Wilkes, *Autobiography*, pp. 20–21.
4. Henderson, *Hidden Coasts*, pp. 12–13.
5. Wilkes, *Autobiography*, p. 192.
6. Ibid., p. 204.
7. Tyler, *Wilkes*, pp. 14, 18–19. See also pp. 34–35, 88, 379–85 for subsequent quotations.
8. Reichelderfer, "Contributions of Wilkes," pp. 583–600.
9. Henderson, *Hidden Coasts*, pp. 197–98.
10. Lyman, *Columbia River*, p. 165.

Bibliography

Anderson, Bern. *The Life and Voyages of Captain George Vancouver*. Seattle: University of Washington Press, 1960 (cited as *Life*).

Bancroft, Hubert H. *The Works of Hubert Howe Bancroft*. 39 vols. San Francisco: A. L. Bancroft and Co., 1886 (cited as *Works*).

Barman, Roderick J. "The Forgotten Journey: Georg Heinrich Langsdorff and the Russian Imperial Scientific Expedition to Brazil, 1821–1829." *Terrae Incognitae* 3:67–96 (1971) (cited as "Langsdorff in Brazil").

Barrow, John. *Voyages of Discovery and Research within the Arctic Regions*. London, 1846 (cited as *Voyages*).

Bartlett, Harley Harris. "The Reports of the Wilkes Expedition, and the Work of the Specialists in Science." *Proceedings of the American Philosophical Society* 82:601–705 (1940) (cited as "Wilkes Reports").

Bartlett, John. "Remarks on Board the Ship Massachusetts," March 19, 1790 to June 20, 1793. Peabody Museum, Salem, Mass. Typescript at Special Collections Division, University of British Columbia Library, Vancouver (cited as "Remarks").

Beaglehole, J. C., ed. *The Journals of Captain James Cook*. 3 vols. Cambridge: Cambridge University Press, 1955–1967 (cited as *Cook Journals*).

———, ed. *The Life of Captain James Cook*. Stanford: Stanford University Press, 1974 (cited as *Life*).

Beechey, Frederick W. *Narrative of a Voyage to the Pacific and Beering's Strait*, 2 vols. London, 1831; reprint ed. 1968 (cited as *Narrative*).

———. *Proceedings of the Expedition to Explore the Northern Coast of Africa. . . .* 1828 (cited as *Proceedings*).

———. *A Voyage of Discovery towards the North Pole, performed in His Majesty's ships Dorothea and Trent. . . .* London, 1843 (cited as *Voyage*).

Belcher, Edward. *Narrative of a Voyage Round the World. . . .* London, 1843 (cited as *Narrative*).

Birket-Smith, Kaj, and Frederica de Laguna. *The Eyak Indians of the Copper River Delta, Alaska*. Copenhagen: Levin & Munksgaard, 1938 (cited as *The Eyak Indians*).

Blackmore, Emily. *Oregon and California Drawings 1841 and 1847, by Charles F. B. Guillou*. San Francisco: Book Club of California, 1961 (cited as *Guillou*).

Bodega y Quadra, Juan Francisco de la. "Voyage to the Northwest Coast of America–1792." Trans. V. D. Webb. Typescript in Special Collections Division, University of British Columbia Library, n.d. (cited as "Voyage").

Broughton, William Robert. *A Voyage of Discovery to the North Pacific Ocean, Performed in His Majesty's Sloop Providence*. London, 1804, reprint ed. (cited as *Voyage Providence*).

Callahan, Edward William. *List of Officers of the Navy of the United States and of the Marine Corps from 1775 to 1900*. New York: L. R. Hamersley & Co., 1901 (cited as *List*).

Canadian Hydrographic Service. *British Columbia Pilot, Canadian Edition, Southern Portion*. Ottawa, 1933; reprint ed., 1965 (cited as *B.C. Pilot, Southern Portion*).

[Cardero, José]. *A Spanish Voyage to Vancouver and the North-west Coast of America*. Trans. Cecil Jane. London: Argonaut Press, 1930 (cited as *A Spanish Voyage*).

Catalogue general des manuscrits des bibliotheques publiques de France, tome bibliotheques de la marine (cited as *Catalogue general de la marine*).

Choris, Louis [Ludovik]. *Voyage pittoresque autour du monde*. Paris, 1822 (cited as *Voyage*).

Christ's Hospital, Dominion's Library. *Catalogue to Tercentenary Exhibition*. Horsham, Sussex, England, 1973 (cited as *Exhibition Catalogue*).

Cole, Douglas. "Sigismund Bacstrom's Northwest Coast Drawings and an Account of His Curious Career." *B.C. Studies* 46:61–85 (Summer 1980) (cited as "Bacstrom").

———. "John Webber, A Sketch of Captain James Cook's Artist." *British Columbia Historical News*, 13:1 (Fall 1979) (cited as "Webber").

Colson, Pedro de Novo y. "Politico-scientific voyage Round the World by the corvettes Descubierta and Atrevida . . . 1789–1794." Madrid, 1885. Trans. Carl Robinson. Typescript in Special Collections Division, University of British Columbia Library, 2 vols., 1934 (cited as "Malaspina Voyage").

Cook, James, and James King. *A Voyage to the Pacific Ocean Undertaken by Command of His Majesty, for making Discoveries in the Northern Hemisphere* [1776–78]. 4 vols. London, 1784 (cited as *Voyage*).

Cook, Warren. *Flood Tide of Empire*. New Haven: Yale University Press, 1973 (cited as *Flood Tide*).

Coxe, William. *Account of the Russian Discoveries between Asia and America*. London, 1780 (cited as *Russian Discoveries*).

Curtis, S. J. *History of Education in Great Britain*. London: University Tutorial Press, 1960 (cited as *History of Education*).

Cutter, Donald C. "Early Spanish Artists on the Northwest Coast." *Pacific Northwest Quarterly* 54:150–57 (cited as "Early Spanish Artists").

———, and Mercedes de Iglesias. "Malaspina's Artists," in *The Malaspina Expedition*. Santa Fe: Museum of New Mexico Press, 1977.

Cutter, Donald C. *Malaspina in California*. San Francisco: John Howell-Books, 1960.

———. "Malaspina at Yakutut Bay." *Alaska Journal*, 2:42–49 (Autumn 1972).

———. Review of Carril, Bonifacio del. *La expedición Malaspina . . . la Colección Bauzá, 1789–1794*. *Hispanic American Historical Review*, 43:153–54 (Feb. 1963) (cited as "Review").

Dana, James D. "Oregon." Notebook in Dana Scientific Papers, Beinecke Rare Book and Manuscript Library, Yale University.

David, A. C. F. "A List of Vancouver's Drawings." Mimeographed. Taunton, England, 1978–80 (cited as "A List").

———. "Drawings from Vancouver's Voyage Held in The Bancroft Library. . . ." Mimeographed. Taunton, England, 1980 (cited as "Drawings").

Dawson, L. S. *Memoirs of Hydrography*. 2 vols. Eastbourne, England, 1885 (cited as *Memoirs*).

Delano, Amasa. *A Narrative of Voyages and Travels*. . . . Boston, 1817. Reprint ed., London: Praeger Publishers, 1970 (cited as *Narrative*).

Dillon, P. *Narrative and Successful Result of a Voyage in the South Seas . . . to Ascertain the Actual Fate of La Pérouse's Expedition*. 2 vols. Reprint ed., London, 1829 (cited as *Fate of La Pérouse*).

Dixon, George. *A Voyage Round the World*. . . . London, 1789 (cited as *Voyage*).

Dossiers of Ships of the Royal Navy (cited as *Dossiers of Ships*).

Duff, Wilson. "Contributions of Marius Barbeau to West Coast Ethnology." *Anthropologica* 6 (1964):63–96 (cited as "Contributions").

Durham, Bill. *Indian Canoes of the Northwest Coast*. Seattle: Copper Canoe Press, 1960 (cited as *Indian Canoes*).

Ellis, W. *An Authentic Narrative of a Voyage performed by Captain Cook and Captain Clerke, . . .* 2 vols. Reprint ed., London, 1782 (cited as *Authentic Narrative*).

Emmons, G. T. "Native Account of the meeting between La Pérouse and the Tlingit." *American Anthropologist* 13:294–98 (April–June 1911) (cited as "Native Account").

Entsiklopedicheskii slovar' [*Encyclopedic dictionary*] (cited as *Entsik. slovar'*).

Etches, John. *An Authentic Statement of All the Facts Relative to Nootka Sound* London, 1790 (cited as *Authentic Statement*).

Fedorova, Svetlana G. *The Russian Population in Alaska* and *California, Late 18th Century–1867*. Trans. and ed. Richard A. Pierce and Alton S. Donnelly. Kingston, Ontario: Limestone Press, 1973 (cited as *Russian Population*).

Fuller, Edmund, ed. *Mutiny*. New York: Crown Publishing, Inc., 1953.

Gentlemen's Magazine, 55, pt. 2 (July 1785).

Gilman, Daniel C. *The Life of James Dwight Dana*. New York: Harper & Brothers, 1899 (cited as *Life of Dana*).

Glushankov, L. V. "The Aleutian expedition of Krenitsyn and Levashov." Trans. Mary Sadovski and Richard A. Pierce. *Alaska Journal* 3:204–10 (Autumn 1973) (cited as "Expedition").

Godwin, George. *Vancouver, A Life*. New York: D. Appleton & Co., 1931 (cited as *Vancouver*).

Golder, F. A. *Bering's Voyages*. 2 vols. New York: American Geographical Society, 1922–25.

———. *Guide to Materials for American History in Russian Archives*. 2 vols. Washington, D.C.: Carnegie Institution, 1917–37 (cited as *Guide*).

———. "Papers relating to the Russians in Alaska." 3 vols.

———. *Russian Expansion on the Pacific, 1641–1850*. Cleveland, Ohio: Arthur H. Clark Co., 1941 (cited as *Russian Expansion*).

Golovnin, V. M. *Around the World on the Kamchatka, 1817–1819*. Trans. Ella Lury Wiswell. Honolulu: Hawaiian Historical Society and University Press of Hawaii, 1979 (cited as *Kamchatka Voyage*).

Gough, Barry M., ed. *To the Pacific and Arctic with Beechey: The Journal of Lieutenant George Peard of H.M.S. Blossom 1825–1828*. Cambridge: Cambridge University Press, 1973 (cited as *To the Pacific*).

Gould, Rupert T. "Bligh's Notes on Cook's Last Voyage." *Mariner's Mirror*, 14:371–85 (October 1928) (cited as "Bligh's Notes").

Greenhow, Robert. *Memoir, Historical and Political, on the Northwest Coast of North America*. Washington, D.C., 1840 (cited as *Memoir*).

Haskell, Daniel C. *The United States Exploring Expedition, 1838–1842 and Its Publications, 1844–1874*. New York: New York Public Library, 1942 (cited as *U.S. Ex. Ex. Publications*).

Hayes, Edmund, ed. *Log of the Union*. Portland: Oregon Historical Society, 1981.

Heawood, Edward. *A History of Geographical Discovery in the Seventeenth and Eighteenth Century*. Cambridge: Cambridge University Press, 1912 (cited as *History*).

Henderson, David. *The Hidden Coasts*. New York: William Sloane Associates, 1953.

Henry, John F. "Bainbridge Peninsula?" *The Sea Chest, Journal of the Puget Sound Maritime Historical Society* 9:160–67 (June 1976).

———. "The Midshipman's Revenge; or, the Case of the Missing Islands," *Pacific Northwest Quarterly* 73:4 (October, 1982).

———. "Captain Cook's Artist Views the Nootka." *Pacific Search* 13 (Dec./Jan. 1978–79) (cited as "Cook's Artist").

Hewett, George Goodman. "Notes in Vancouver's Voyages." 1 vol. Typescript of c. 1798, fragmentary pencilled notes. Victoria, B.C.: Provincial Archives (cited as "Notes").

Howay, Frederic W., ed. *The Dixon-Meares Controversy*. Toronto: Ryerson Press, 1929 (cited as *Dixon-Meares*).

Howay, F. W., ed. *Voyages of the Columbia to the Northwest Coast*. Boston: Massachusetts Historical Society, 1941 (cited as *Columbia Voyages*).

———. *A List of Trading Vessels in the Maritime Fur Trade, 1785–1825*. Ed. Richard A. Pierce. Kingston, Ontario: Limestone Press, 1973 (cited as *Fur Trading Vessels*).

———, ed. *Zimmerman's Captain Cook*. Toronto: Ryerson Press, 1930 (cited as *Zimmerman*).

Howay, Frederic William. "Some Notes on Robert Haswell." *Proceedings of the Massachusetts Historical Society* 65 (1932–36) (cited as "Haswell").

Huish, Robert. *The Northwest Passage: A History of the Most Remarkable Voyages*. London, 1851 (cited as *Remarkable Voyages*).

Ingraham, Joseph. "Journal of the Voyage of the Brigantine Hope from Boston to the North-west Coast of America, 1790 to 1792." Washington, D.C.: Library of Congress (cited as "Journal").

Jackman, S. W., ed. *The Journal of William Sturgis*. Victoria, B.C.: Sono Nis Press, 1978 (cited as *Sturgis Journal*).

Jewitt, John R. *Narrative of the Adventures and Sufferings of John R. Jewitt.*, c. 1815. Reprint ed., Fairfield, Wash.: Ye Galleon Press, 1967 (cited as *Narrative*).

Jochelson, Waldemar. *History, Ethnology and Anthropology of the Aleut*. The Netherlands: Oosterhout N.B., 1966 (cited as *The Aleut*.)

Kaeppler, Adrienne L., ed. *Cook Voyage Artifacts in Leningrad, Berne, and Florence Museums.* Honolulu: Bishop Museum Press, 1978 (cited as *Cook Voyage Artifacts*).

Kaplanoff, Mark D., ed. *Joseph Ingraham's Journal of the Brigantine* Hope. Barre, Mass.: Imprint Society, 1971 (cited as *Ingraham's Journal*).

Kennedy, Gavin. *Bligh.* London: Gerald Duckworth & Co., Ltd., 1978.

Khlebnikov, K. T. *Baranov, Chief Manager of the Russian Colonies in America.* Trans. and ed. Colin Bearne and Richard A. Pierce. Kingston, Ontario: Limestone Press, c. 1973 (cited as *Baranov*).

Khudoshniki Narodov USSR [Artists of the Peoples of USSR].

Kittlitz, F. H. von. *Twenty-Four Views of Coasts and Islands of the Pacific.* Trans. and ed. Berthold Carl Seeman. London, 1861 (cited as *Twenty-Four Views*).

Kotzebue, Otto von. *Voyage of Discovery in the South Sea, and to Behring's Straits.* 3 vols. London, 1821 (cited as *Voyage*).

Krusenstern, A. J. von. *Voyage Round the World . . . 1803–1806.* 2 vols. London, 1813 (cited as *Voyage of 1803–6*).

Langsdorff, G. H. von. *Voyages and Travels in Various Parts of the World. . . .* 2 vols. London, 1813–14 (cited as *Voyages*).

La Pérouse, J. F. G. de. *A Voyage Round the World. . . .* 2 vols. Ed. M. L. A. Milet-Mureau. London, 1799 (cited as *Voyage*).

Ledyard, John. *Journal of Captain Cook's Last Voyage.* Ed. John Kenneth Munford. Corvallis: Oregon State University Press, 1963 (cited as *Journal*).

Lewis, Charles Lee. *Famous Old-World Sea Fighters.* Boston: Lothrop, Lee & Shepard Co., 1903 (cited as *Sea Fighters*).

Lewis, Michael. *The Navy in Transition, 1814–1864.* London: Hodder and Stoughton, Ltd., 1965 (cited as *The Navy*).

Lisiansky, Urey [Yuri Lisianskii]. *A Voyage Round the World. . . .* London, 1814 (cited as *Voyage*).

Lütke [Litke], Frederic von. *Voyage autour du monde.* 3 vols. Paris, 1835 (cited as *Voyage*).

Lyman, William Denison. *The Columbia River.* New York: G. P. Putnam's Sons, 1909.

Mahr, August C. *The Visit of the "Rurik" to San Francisco in 1816.* Stanford: Stanford University Press, 1932 (cited as *Rurik Visit*).

Majors, Harry M. "Science and Exploration on the Northwest Coast of North America, 1542–1841." Mimeographed. Seattle: University of Washington, 1969 (cited as "Science and Exploration").

Marine Research Society, comp. *The Sea, the Ship, and the Sailor.* Salem, Mass.: Marine Research Society, 1925.

Marshall's Naval Biography, Supplement part 1 (cited as *Marshall*).

Meany, Edmond S. *Origin of Washington Geographic Names.* Seattle: University of Washington Press, 1923 (cited as *Names*).

———. *Vancouver's Discovery of Puget Sound.* 1907. Reprint ed., Portland, Ore.: Binfords & Mort, 1957 (cited as *Vancouver*).

Meares, John. *Voyages Made in the Years 1788 and 1789. . . .* London, 1790 (cited as *Voyage*).

Du Ministère des affaires etrangeres. *Les combattants francais de la guerre americaine 1778–1783.* Paris, 1903 (cited as *Les combattants*).

Moziño, José Mariano. *Noticias de Nutka.* Trans. and ed. Iris H. Wilson [Engstrand]. Seattle, University of Washington Press, 1970.

Nelson, Edward William. "The Eskimo about Bering Strait," *U.S. American Ethnology Bureau. Report no. 18, 1896–1897,* part 1 (cited as "The Eskimo").

Newcombe, C. F., ed. *Menzies' Journal of Vancouver's Voyage.* Victoria, B.C.: William H. Cullin, 1923 (cited as *Menzies Journal*).

Nicol, John. *The Life and Adventures of John Nicol, Mariner.* London, 1822 (cited as *Life*).

Nozikov, N. *Russian Voyages Round the World.* Ed. M. A. Sergeyev; trans. Ernst and Mira Lesser. London: Hutchinson & Co., c. 1940 (cited as *Russian Voyages*).

O'Byrne, William Richard. *A Naval Biographical Dictionary.* London, 1849 (cited as *Bio. Dictionary*).

Official Documents relating to Spanish and Mexican Voyages of Navigation, Exploration and Discovery, Made in North America in the 18th Century. Trans. Mary Elizabeth Daylton. W.P.A. Project no. 2799. Seattle, 1939–40, typescript (cited as *Official Spanish Documents*).

Pelham, Cavendish. *The World; or, the Present State of the Universe. . . .* London, 1808 (cited as *The World*).

Pierce, Richard A., and John H. Winslow, eds. *H.M.S.* Sulphur *on the Northwest and California Coasts, 1837 and 1839.* Kingston, Ontario: Limestone Press, 1979 (cited as *Sulphur*).

Poesch, Jessie. *Titian Ramsay Peale and His Journals of the Wilkes Expedition.* Philadelphia: American Philosophical Society, 1961 (cited as *Peale*).

Porter, Edward G. "The Ship *Columbia* and the Discovery of Oregon." *New England Magazine* 6:472–88 (June 1892) (cited as "Ship Columbia").

Portlock, Nathaniel. *A Voyage Round the World. . . .* London, 1789 (cited as *Voyage*).

Postels, Alexandro, and Francisco Ruprecht. *Illustrationes Algarum.* Petropoli [St. Petersburg], 1860.

Proceedings of Massachusetts Historical Society. Old series 12 (1871–73) (cited as *Proceedings* 1871–73).

———. 2d series 7 (May 1892) (cited as *Proceedings* 1892).

Rawson, Geoffrey. *Bligh of the Bounty.* London: Philip Allen & Co. Ltd., 1930 (cited as *Bligh*).

Reichelderfer, F. W. "The Contribution of Wilkes to Terres-Magnetism, Gravity, and Meteorology." *Proceedings American Philosophical Society* 82: 583–600 (1940) (cited as "Contributions of Wilkes").

Ritchie, G. S. *The Admiralty Chart—British Naval Hydrography in the Nineteenth Century.* London: Hollis and Carter, 1967 (cited as *The Admiralty Chart*).

Russkii biograficheskii slovar' (cited as *Russ. bio. slovar'*).

Sarychev, Gavriil Andreevich. *Puteshestvie flota kapitana Sarcheva po sıev-erovostochnoĭ chastĭ Sĭbĭrĭ (Atlasa)*. St. Petersburg, c. 1802 (cited as *Puteshestvie*).

Sarytschew [Sarychev], Gawrila. *Account of a Voyage of Discovery to the North-east of Siberia, the Frozen Ocean, and the North-east Sea*. 2 vols. London, 1806 (cited as *Voyage*).

Sauer, Martin. *An Account of a Geographical and Astronomical Expedition. . . .* London, 1802 (cited as *An Account*).

Scott, James Brown. *De Grasse à Yorktown*. Baltimore, Maryland: Institut Français de Washington, 1931.

Shur, L. A., and R. A. Pierce. "Pavel Mikhailov, Artist in Russian America." *Alaska Journal* 8:360–63 (Autumn 1978) (cited as "Pavel Mikhailov").
——. "Artists in Russian America: Mikhail Tikhanov (1818)." *Alaska Journal* 6:40–48 (Winter 1975) (cited as "Mikhail Tikhanov").

Smith, Bernard. *European Vision and the South Pacific, 1768–1850*. Oxford: Oxford University Press, 1960 (cited as *European Vision*).

Sparks, Jared. *The Life of John Ledyard*. Cambridge, Mass., 1828.

Sperlin, O. B., ed. *The Brackenridge Journal for the Oregon Country*. Seattle: University of Washington Press, 1931 (cited as *Brackenridge*).

Stanton, William. *The Great United States Exploring Expedition*. Berkeley: University of California Press, 1975 (cited as *Great Expedition*).

Stejneger, Leonhard. *Georg Wilhelm Steller*. Cambridge, Mass.: Harvard University Press, 1936 (cited as *Steller*).

Steller, Georg Wilhelm. "De bestiis marinis." *Novi commentarii Academiae Scientiarum imperialis petropolitanae*, pp. 289–398. Leningrad: I Akademii Nauk, 1751.

Sykes, John. *A Log of the Proceedings of His Majesty's Sloop Discovery* [1791–95] . . . London: Public Record Office. Microfilm, University of Washington (cited as "A Log").

Tero, Richard D. "Alaska: 1779 Father Riobo's Narrative." *Alaska Journal* 3:81–88 (Spring 1973) (cited as "Riobo's Narrative").

Tikhmenev, P. A. *A History of the Russian-American Company*. Trans. and ed. Richard A. Pierce and Alton S. Donnelly. Seattle: University of Washington Press, 1978 (cited as *Russian-American Co.*).

Tily, James C. *The Uniforms of the United States Navy*. New York: Thomas Yoseloff, 1964 (cited as *Uniforms*).

Tyler, David B. *The Wilkes Expedition*. Philadelphia: American Philosophical Society, 1968 (cited as *Wilkes*).

U.S. Department of Commerce. National Oceanic and Atmospheric Administration. *United States Coast Pilot, Cape Spencer to Beaufort Sea*. 9th ed. Washington, 1979 (cited as *U.S. Coast Pilot, Cape Spencer*).
——. Coast and Geodetic Survey. *United States Coast Pilot, Dixon Entrance to Yakutat Bay*. 9th ed. Washington, 1943 (cited as *U.S. Coast Pilot, Dixon Entrance*).

U.S.N. Biographical Dictionary (cited as *U.S.N. Bio. Dict.*).

Vancouver, George. *A Voyage of Discovery to the North Ocean and Round the World*. 3 vols. 1798. Reprint ed., 1967 (cited as *Voyage*).

Vaughan, Thomas, E. A. P. Crownhart-Vaughan, and Mercedes Palau de Iglesias. *Voyages of Enlightenment*. Portland: Oregon Historical Society, 1977 (cited as *Voyages*).

Wagner, Henry R. *The Cartography of the Northwest Coast of America to the Year 1800*. 2 vols. Berkeley: University of California Press, 1937 (cited as *Cartography*).
——. *Spanish Explorations in the Strait of Juan de Fuca*. Santa Ana, Calif.: Fine Arts Press, 1933 (cited as *Spanish Explorations*).
——. Trans. and ed. *Journal of Tomás de Suría of his Voyages with Malaspina to the Northwest Coast of America in 1791*. Glendale, Calif.: Arthur H. Clark Company, 1936 (cited as *Suría Journal*).

Walbran, John T. *British Columbia Coast Names*. 1909. Reprint ed., Seattle: University of Washington Press, 1972 (cited as *Names*)

Waxell, Sven. *The American Expedition*. Trans. M. A. Michael. London: Wm. Hodge & Co. Ltd., 1952 (cited as *Expedition*).

Wilkes, Charles. *Autobiography of Rear Admiral Charles Wilkes, U.S. Navy, 1798–1877*. Ed. William James Morgan et al. Washington, D.C.: Naval History Division, Department of the Navy, 1978 (cited as *Autobiography*).
——. *Diary of Wilkes in the Northwest*. Ed. Edmond S. Meany. Seattle: University of Washington Press, 1926 (cited as *Diary*).
——. *Narrative of the United States Exploring Expedition*. 5 vols. New York: 1856 (cited as *Narrative*).

Withington, Mary C. *Manuscripts of Western Americana*. New Haven: Yale University Press, 1952 (cited as *Manuscripts*).

Wolfe, James. "Journal of a Voyage on Discovery in the Pacific and Beering's Straits on board H.M.S. *Blossom* [1825–28]. . . ." Beinecke Library, Yale University (cited as "Journal").

Wood, Bryce. *San Juan Island Coastal Place Names and Cartographic Nomenclature*. Ann Arbor, Michigan: University Microfilms International for Washington State Historical Society, 1980 (cited as *San Juan Island Names*).

Wyman, Thomas Bellows. *The Genealogies and Estates of Charlestown, in the County of Middlesex and Commonwealth of Massachusetts, 1629–1818*. Boston: 1879 (cited as *Genealogies*).

Index